Contents

LINDA HAVERTY RUGG

KING ALI

PICTURING OURSELVES

PHOTOGRAPHY & AUTOBIOGRAPHY

Linda Haverty Rugg is associate professor of German and Scandinavian in the Department of Germanic Languages and Literatures at The Ohio State University.

The University of Chicago Press, Chicago 60637
The University of Chicago Press, Ltd., London
© 1997 by The University of Chicago
All rights reserved. Published 1997
Printed in the United States of America
06 05 04 03 02 01 00 99 98 97 1 2 3 4 5
ISBN: 0-226-73146-4 (cloth)
ISBN: 0-226-73147-2 (paper)

Library of Congress Cataloging-in-Publication Data

Rugg, Linda Haverty.
 Picturing ourselves : photography and autobiography / Linda
Haverty Rugg.
 p. cm.
 Includes bibliographical references (p.) and index.
 ISBN 0-226-73146-4 (cloth : alk. paper).—ISBN 0-226-73147-2
(pbk. : alk. paper)
 1. Photography—Philosophy. 2. Autobiography. 3. Twain, Mark,
1835–1910—Views on photography. 4. Strindberg, August,
1849–1912—Views on photography. 5. Benjamin, Walter,
1892–1940—Views on photography. 6. Wolf, Christa—Views on
photography. 7. Self-realization in literature. I. Title.
TR183.R84 1997
770'.1—dc21 97-3996
 CIP

Illustrations

Acknowledgments

The writing of acknowledgments is a kind of confession—one of gratitude, of indebtedness, of connection. Like the autobiographer, the writer of acknowledgments signs his or her name to two implicit statements: (1) that nothing (including personhood and books) is achieved without the help of others and (2) that the ultimate responsibility (for both personhood and books) remains with the undersigned. In that spirit, I would like to thank the following persons and institutions.

Alan Thomas at the University of Chicago Press expressed early interest in the project and offered the encouragement necessary to carry it through to publication. His assistant, Randolph Petilos, kindly fielded questions and took care of the detail work. Colleagues and friends read the book in manuscript and/or offered other forms of support and encouragement, both intellectual and personal: Scott Abbott, Leslie Adelson, Hugo Bekker, Marilyn Blackwell, John Davidson, Johannes Evelein, Bernd Fischer, Carol Ann Johnston, Irene Kacandes, Dagmar Lorenz, Shierry Weber Nicholsen, Mark W. Roche, and Michelle Stott.

For encouraging and arranging a year away from Ohio State University as a visiting faculty member at Brigham Young University, I would like to mention David Frantz, Alan Keele, Mark Roche, Mark Sandberg, and Steven Sondrup. I would also like to thank the College of Humanities at Ohio State University for generous leave time and a Seed Grant.

Treva Sheets and Susan Farquhar provided much more than adminis-

trative support at Ohio State; they are the backbone of the German department and a great source of efficiency and kindness.

Thanks to my professors at Harvard University: Stephen Mitchell, who introduced me to the study of autobiography, and Dorrit Cohn, who (re)taught me how to read.

Many librarians and archivists assisted in the assembly of images and text: at the Strindberg Museum in Stockholm, photo-archivist Erik Höök; at the Mark Twain Center in Elmira, New York, Gretchen Sharlow, Jan Kather, Mark Woodhouse, and the late Daryl Baskins; photo-archivist Beverly Zell of the Mark Twain Memorial in Hartford, Connecticut; the staff of the Mark Twain Papers at the University of California, Berkeley, especially Robert Pack Browning and Simon Hernandez; A. J. Perkins of the Darwin collection at the Cambridge University Library; and the staff at the Bibliothèque Nationale in Paris for assistance in Benjamin research.

To the friends and family who housed and fed me while I researched: Rachel Conrad, Maud Tallroth and George Norrbom, Gideon Schor, Carol Ann Johnston, and Deborah Johnson and Rex Welshon. I thank my family in Nebraska, Sweden, and branch offices for their support of and belief in my projects and me: the Havertys, Ruggs, Tomlinsons, and Tallroths. Most of all thanks to my husband, traveling companion, and photographer, Brian Rugg, who first inspired me to think of photography in connection with autobiography.

This book is dedicated to my friend Deborah Johnson, who possessed that remarkable ability to make the most desolate situation an occasion for laughter and remembrance. Those of us who loved her lost her to cancer in 1992. I have a couple of photographs of her, and when I look at them it is possible to understand that she is gone and yet feel the warmth of her life. The reality of both her absence and her presence in those images helped me understand what I was trying to write.

To see oneself (differently from in a mirror): on the scale of History, this action is recent, the painted, drawn, or miniaturized portrait having been, until the spread of Photography, a limited possession, intended moreover to advertise a social and financial status—and in any case, a painted portrait, however close the resemblance . . . is not a photograph. Odd that no one has thought of the disturbance (to civilization) which this new action causes.

ROLAND BARTHES, *Camera Lucida*

Introduction

Over the past two decades, an essential question has been debated among scholars of autobiography: can we "touch the world" in writing?[1] Can an autobiographical text refer to a subject outside the text? Does a self create its autobiography, or does an autobiography create its self? A parallel and intimately related discussion explores the relationship of photography to the world. Are photographs evidence of the existence of things or people in the world? Or are they constructions, manipulable and manipulative, masquerading as fact? This book explores the intersection of these two debates—the point at which photographs enter the autobiographical act.[2] What (or how) do photographs mean in the context of an autobiography? Do they come to the rescue of autobiographical referentiality through the presentation of the author's body in the world, or do they undermine the integrity of referentiality through multiple or posed presentations? Did the invention of photography transform the way we picture ourselves?

The nineteenth-century invention and its proliferation did in some sense spawn a "disturbance to civilization" (as Barthes would have it), and part of my task in the following pages will be to examine the transformation of an author's self-image and self-writing when confronted with photographs of the self. But it may be more accurate to say that photographs, which can display many views and variant versions of the same person, simply supply a visual metaphor for the divided and multiple ("decentered") self, a self-image that gained momentum from Kierkegaard to

Nietzsche to Freud and beyond. Photography did not create the disturbance; photographic technology, like other human inventions, offers an extension and realization of already-imagined images. At the same time, however, photographs as physical evidence re-anchor the subject in the physical world, insist on the verifiable presence of an embodied and solid individual. If, as inhabitants of the poststructuralist world, we feel obliged to discount photography's evidential power, we should also remind ourselves of the small army of photographic selves that verify our status and agency in the world on passports, drivers' licenses, and so on.[3]

It is this double consciousness that informs the work of the autobiographers of my study: the awareness of the autobiographical self as decentered, multiple, fragmented, and divided against itself in the act of observing and being; and the simultaneous insistence on the presence of an integrated, authorial self, located in a body, a place, and a time. Photographs enter the autobiographical narrative to support both of these apparently opposing views; photography placed in conjunction with autobiographical texts helps to unpack the issue of reference in all its complexity.

It would have been possible (and rewarding) to write a book on the "naive" use of photographs as illustrations in popular autobiography, where simulacra of family albums for athletes, royalty, Hollywood figures, generals, and politicians appear as a "natural" and expected supplement to the autobiographical text. This is a subject deserving serious attention, for it is precisely uninterrogated presentations of photography and autobiography that can work toward the most powerful support of unconscious ideological assumptions.[4] But I decided instead to focus on four literary authors whose autobiographical texts and photographs express a consciousness of the problem of referring to the self in language and in image. These authors are themselves theoreticians (although not all of them would think of themselves as such), and they come to my aid with fascinating reflections on the presence of photography in their visualizations and articulations of selfhood.

An immediate and obvious objection can be raised about the lack of symmetry in my objects of study; in autobiography, the object and subject of the text are the same—the author writes his or her own life story. Photographs, on the other hand, most frequently interject a third party into the process of recording an image; the photographer and the photographed subject are usually not the same person. I can respond to this objection in several ways, and I do wish to consider it seriously, since it touches at the core of my arguments and my reasons for selecting these

particular four authors for study. First, and most superficially, it does sometimes occur that individuals make photographs of themselves, and this act is, in and of itself, interesting to any scholar concerned with auto-biography. One of the authors of this study, August Strindberg, worked on a textual and photographic record of himself throughout his life. Constantly retooling his philosophy and methodology, he took up the camera at various moments and pointed it at himself in order to create (as he thought) the "truest" possible image. His image of himself as self-photographer and photographed subject finds clear reflection in his textual self-image, as well.

Second, an individual can forge a photographic self-image through canny manipulation of photographers and the economic and cultural institutions surrounding the production and publication of photography, thus maintaining a kind of "authorship" of self-image. I was first inspired to study parallels between photographic and autobiographical self-imaging while studying the work of Mark Twain, whose staging of more than five hundred individual photographic self-images propelled him into the visual and cultural awareness of people throughout the world, allowing him to overcome through photography the limitations imposed on texts by difficulties of translation.

Taking another, more penetrating look at Strindberg and Twain uncovers a deeper layer of complexity in the act of self-representation, however. In both cases, the authors strove to achieve more perfect control of their self-images through a direct control of the photographic process. Strindberg strictly limited the number of photographic portraits by other photographers, proclaiming that his "soul . . . came out better in [his] own photographs than in others" (Ahlström and Eklund 1961, 182). For his part, Twain encouraged photographers, even inviting them into his bedroom, but he kept a fierce watch on the publication and distribution of his photographic image, threatening photographers with legal action when he felt they had overstepped their bounds. But what, precisely, are the bounds in this case? Who has final authority over images—the photographer or the photographed subject?

The English idiom "to take a photograph" begins to say something of the parasitic relationship between the photographer and the person or objects within the photographic frame. Photographers are said to "take" an image of a person precisely because we naturally assume at some level that images of us belong *to* us. It is not polite, for instance, to take a photograph of a stranger without asking permission. It would constitute a kind of betrayal to take a photograph of a friend secretly, blow it up to

life-size, and post it around the community. Actual photographic practice, however, opens up the possibility that strangers will see our image in public spheres, perhaps in a newspaper photograph, or in a school yearbook, or hung as an advertisement in a photographer's studio, where the photographer owns our image. Images can represent the most intimate expression of ourselves—our body, the self normally exposed only to those whom we see and/or know—and images allow the escape of our private or guarded public sphere into the unguarded public.

My emphasis in the lines above on the photographer's intrusion into the process of creating and distributing photographic images of individuals would seem to highlight the distinction between autobiography (by definition, the product of one person), and photographic portraits (the product of both the photographed subject and the photographer). I would like to argue, however, that the loss of control over the body's image inherent in photographic portraits strikes a respondent chord in the autobiographer's consciousness of the loss of control inherent in writing and (more importantly) publishing an autobiography.

Autobiography is itself an exertion of control over self-image, for in writing an account of one's own life, one *authorizes* the life, claiming a kind of privilege for one's own account. Thus we have biographies designated as "authorized" in order to endow them with a kind of superior authenticity, but autobiography requires no such label. Every autobiography is an authorized account. This by no means establishes that every autobiography is a "true" account, but the aura of authenticity nevertheless surrounds the autobiographer's tale. Absolute control over any published material is, however, an illusion, and it can be plainly shown that autobiographers are at some level aware that they can only attempt to perpetuate that illusion. To name one instance, the practice of waiting to publish an autobiography until after the autobiographer and/or parties mentioned in the text are dead might be explained as intended to spare the feelings of the living, but another ready explanation is that a published text is a text open to interpretation and rebuttal, even unto lawsuits. The first edition of Mark Twain's autobiography appeared (by his own design) after his death, and he earmarked whole sections of the manuscript for delayed publication—his editors were in some cases to wait up to one hundred years after his death.[5] He thus managed to escape life with the last word on himself, though he clearly hoped to exercise control over the conversation concerning himself for another century after his departure.

Twain's case may seem extreme, but indeed he only gives full voice

to the fear of all authors, a fear voiced eloquently by W. H. Auden in his elegy on the death of Yeats:

> Now he is scattered among a hundred cities
> And wholly given over to unfamiliar affections;
> To find his happiness in another kind of wood
> And be punished under a foreign code of conscience.
> The words of a dead man
> Are modified in the guts of the living.

Auden's lines refer to the reading of Yeats's poetry, but he also identifies Yeats with Yeats's words—not just his poetry, but "he" is scattered among a hundred cities—and in the case of autobiographical writing, the identification between writer and text is underscored, explicit. In a sense, the moment at which one human being photographs another enacts and embodies the autobiographer's situation, and not only because the photographer can be imagined as a "reader" of the subject. The autobiographer, in writing of his or her own life, also stands apart from the self, tries to envision and read the self from a vantage distanced by the passage of time.

The photographic situation, then, offers the autobiographer a representational image for the autobiographical act of looking at oneself, as well as a metaphor for the intrusive act of reading and interpreting that takes place after the publication of the autobiography. The photographer in such a metaphorical scenario is merely a cipher, a representation of the Eye, which can be either the alienated "I" of the autobiographer or the eye of the other, the reader. There is an obvious danger in arguing that the photographer has no authorial role to play in the photographic process; photographers pose, frame, edit, develop, and otherwise manipulate the photographic subject and context in such a way that they must be counted as agents. But here it is useful to remember once again the double consciousness attendant at the reception of photographs.

While we know on one level that photographs are the products of human consciousness, they also can (have been, are, will) be taken as "natural" signs, the result of a wholly mechanical and objective process, in which the human holding the camera plays an incidental role in recording "truth." Our belief in this aspect of photography allows us to admit photographs as evidence in courts of law and persuades some that the spirits of the dead or heavenly emissaries can be captured on photographic film. In this reading of photographs, it is possible to posit the metaphorical Eye mentioned above, an eye so close in character to that of the unknown and

5

invisible reader, or the eye of the observing and narrating autobiographer, or the eye of the state or of God, that it achieves a transcendent and disembodied quality. It is the idea of such an Eye that allows me to propose a parallel where common sense dictates that there is none, a parallel between autobiographical texts produced by (apparently) single entities and images "produced" by two persons—a photographer and a photographed subject. I could have said all of this more simply if I had first suggested a parallel between the subject/object relationship within an autobiographical narrative and the subject/object relationship in the photographic situation, but in order to make that apparently easy equation, I had to do the harder work of explaining how a separate consciousness (the photographer) comes to stand for an impersonalized consciousness, a bit of (black) magic that occurs through a "naive" reading of photography.

Mark Twain and August Strindberg struggle for the control of their experimental autobiographical projects with an intensity that reveals an anxiety about loss of control. Both produce hundreds and hundreds of pages, both are unable to provide synthesis or resolution for their autobiographical texts, both indicate their hope that after their deaths their editors will somehow make sense of the mass/mess they have left behind. A similar bid for control reigns in their photographic self-imaging. Twain's obsessive production of self-image reveals an awareness of posturing and imposture worthy of the postmodern artist Cindy Sherman.[6] He shares a postmodern anxiety and playfulness regarding images, as well, for unlike Strindberg, he was not concerned (in the production of his self-image, at any rate) with the search for truth. He did not believe that the truth (assuming it existed) could be located. He wanted to manufacture "truth," and he used photographs to help him do it. Both authors, however, were confronted with the plurality of selfhood and the need (both economic and psychological) to assert a singularity of selfhood for themselves. The difference between them arises from Strindberg's abiding (if anxious) faith that the fundamental self exists beneath its shifting surface, and Twain's conviction that it does not.

An essential uncertainty about the image-out-of-control and the problem of the all-seeing Eye provokes the first two authors of my study into a hyperproduction of images. While they differ in their understanding of the nature of photographic veracity and its potential role in the autobiographical process, they both attempt to harness the undeniable power of the photographic image for their own use in self-production. Another reaction entirely governs the second two authors of this study,

and for that reason the book falls into two halves, the first concerned with the end of the nineteenth century and the second with the developments that come to define the twentieth century: war and the rise and fall of totalitarianism.

Walter Benjamin and Christa Wolf, the last two authors of this study, lived a pivotal part of their lives at one of the greatest watersheds in twentieth-century history: Germany under National Socialism. Benjamin, a Jewish exile from Hitler's Germany, and Wolf, who spent her childhood under Hitler, both react against the dangerously objectifying power of photographs in their autobiographical narratives, which pointedly omit actual photographic images but embrace photography as a metaphor for history and memory. Like Twain and Strindberg, Benjamin and Wolf acknowledge the power of the photographic medium, but they choose to exercise control through a conversion of photograph into text. In these instances, it is precisely the absence of real photographs and the use of the photographic metaphor that lead us to question the ideology of photography.

Walter Benjamin's theses on the philosophy of history and essays on photography have attracted significant scholarly interest, but his lyrical account of childhood, *Berlin Childhood around 1900,* remains largely ignored, particularly by Anglophone scholars.[7] I approach *Berlin Childhood* as a testing ground for his theories of history and photography as they apply to his own experience, arguing that his photographic conception of history provides the impetus and structure for his text, while the absence of photographs or other clearly denotative signs of identity (his name, for instance) points up his situation as outsider within the totalitarian system. Christa Wolf's *Patterns of Childhood* ponders the close association between memory and photography nurtured in the twentieth century, as the narrator attempts to reconstruct her childhood by creating mental images of photographs that were lost at the end of the war. The missing family photograph album signifies a blind spot in Wolf's history and in the history of Germans generally, a spot that Wolf takes as her point of departure as she explores the ways in which she herself was constructed by National Socialism, using her text to reframe and recover her own self-image.

These four authors illustrate four possible approaches to the presence of photography in the making of autobiography. Strindberg photographs himself, Twain dictates to the photographer, Benjamin converts photography into theory and literature, and Wolf reenters, reclaims, and rewrites her childhood memories through the photographic frame. The four authors come from three different national cultures, but despite the

importance of each to those individual cultures, they also emerge from a rapidly expanding international culture, brought about in part through the agency of photography.

It would not be inappropriate to characterize Twain as the typical American positivist for his recognition of photography's market value, his decision to trademark his own image in order to make a profit from it, and his attempt to legislate and control the distribution of his image. But it is important at the same time to realize the cynicism behind the positivism; precisely because he knows so well how to manipulate images, he also must be aware of the slippage between photographic image and photographed subject. Strindberg was Twain's contemporary, and while not an American, he too understood the economic value of his photographic self-image. Paradoxically, the Swede shows himself to be more of a wide-eyed optimist than the American, claiming for photography a pure and supernatural representative power, though the photographs and autobiographical texts of his last years reveal the desperation behind his optimism. These two authors belong to the first generation of people whose lives from childhood on could be recorded in photographs, a fact that in some ways brings them in closer relation to one another than to their own parents. The admixture of exhilaration and suspicion apparent in their relation to their own photographic images bespeaks their cultural and historical position at the turn of the last century, as does particularly, I would say, their lifelong drive to produce more self-images.

The use of photographs to catalogue criminals and the insane had already begun in the nineteenth century, and the increasing threat posed to private space by the photograph was apparent from early on. But Benjamin's life (begun at the turn of the century) took shape under the threat of total state control of images, the passport photograph stamped with a J, and the propaganda films of the Olympic Games and of the Nuremberg party rallies. I place Benjamin and Wolf beside Twain and Strindberg not because they stand in absolute contrast to the two earlier writers; rather, their twentieth-century experience of a state that controls even self-images appears to be the realization of nineteenth-century fears. The loss of self-governance implied by the uninhibited reproduction and distribution of one's photographic image by others exists already in the minds of both Twain and Strindberg—it is their solutions to the problem that differ from Benjamin's and Wolf's.

There are, of course, many others whose autobiographical work could be discussed in light of their interest in photography; Walt Whitman, Marcel Proust, Vladimir Nabokov, Roland Barthes, Marguerite

Duras, Wright Morris, and Cindy Sherman spring immediately to mind. I will in fact deal with some of these artists, as well; but I wanted to focus on my four authors both for the historical and cultural contexts of their lives and work, and for the way I believe their similarities and dissimilarities point up both the historical and essential nature of photography. Although I take historical, cultural, and technological developments as key elements in the construction and understanding of both photography and selfhood, I do not necessarily see a purely linear development in attitudes toward photography and autobiography, nor do I intend to argue, as Barthes seems to do in the epigraph to this introduction, that the invention of photography necessarily provoked a cultural revolution. A number of revolutions were under way at the time of photography's invention, and the medium simply offered a new basis for reading and writing and experiencing the world. Photography is constructed as it constructs. Further, "naive" and "sophisticated" readings of photography and autobiography coexist, not only during the same historical period, but often in the same individual. It seems to me that large conceptual issues were brought into play from the moment of autobiography's contact with photography and that these issues remain in force.

If, as I have argued above, photographs and autobiographies work together as signs to tell us something about the self's desire for self-determination, it will also be necessary to explore the ways in which these images and texts relate to the body that both constructs and is constructed by them. To what or whom do autobiographies and photographs refer? How does a text or an image touch the world? How does the introduction of photographs and/or the photographic metaphor into autobiographical texts complicate autobiographical reference? In the following section, I will explore these foundational questions.

The Referential Paradox: In Reference to What?

"The self," writes Michael Robinson in his analysis of Strindberg's autobiographies, "is constituted only through language" (Robinson 1986, 81). This confident assertion draws on the work of Paul de Man (among others), who argues that autobiographies have no special referential power: "Can we not suggest," he writes, "that the autobiographical project may itself produce and determine the life?" (de Man 1979, 920). In de Man's reading, autobiography is indistinguishable from fiction, a proposition seconded by other postmodern theorists of autobiography.[8]

It is of course the case that autobiographical novels are not distin-

guishable from autobiographies in any readily discernible way if the reader has no outside knowledge of the conditions of the text's production. But there is something in many critics that resists the impulse to imagine the autobiographical self as a play of signifiers. Philippe Lejeune attempts a solution with his "autobiographical pact," in which autobiography is defined by a kind of contract established between reader and writer, based on the fact that the reader recognizes that the *name* of the author and protagonist are the same (Lejeune 1975). Lejeune shifts the emphasis from the writer's relation to his or her work to the reader's relation to the autobiographical text, a strategy employed by Elizabeth Bruss as well when she posits the notion of "autobiographical acts," a concept derived from the linguistic model of speech acts.[9] Lejeune's pact and Bruss's act both imply the existence of a society in which agreements are struck between readers and writers (and writers and publishers, for that matter) that the autobiographical text in question will be understood as the product of the author, who is writing about him- or herself. Juridical concepts of evidence and proof form the unspoken basis for such critical constructs; this becomes obvious when, for example, legalese seeps into Bruss's writing: "Rule 1. . . . (c) The existence of this individual, independent of the text itself, is assumed to be susceptible to appropriate public verification processes" (Bruss 1976, 11).

It is not surprising that the law edges into our discussion, because the abridgment of referentiality proposed by poststructural critics of autobiography strikes at the core of life and meaning.[10] Now we have arrived at the heart of the matter. The scholars who argue for autobiographical referentiality, for a self creating a text, are not necessarily naive readers. They are aware of the claims of poststructuralism—that the text's surface does not reveal its historicity, that history is in any case a construct, that even the body is perceived and formed through culture—"We *indeed know* all this," insists Lejeune; "we are not so dumb" (Lejeune 1989, 131). But they have a stake in preserving referentiality and the boundary between autobiography and fiction "despite knowledge," as Paul John Eakin writes, "that this distinction—or at any rate, its basis—may well partake more of fiction than fact" (Eakin 1992, 30).

The need for a continued assertion of autobiography's referential power is perhaps most obvious in studies of women's and minority autobiography, which deal with the culturally defined bodies of their autobiographical subjects. While the concept of "body" in such studies refers more to multiple cultural and historical constructions of bodies than a monolithic and independent physical entity, there is nevertheless an insis-

tence on coming to grips with the self in the world, "for subjectivity is not, after all, an out-of-body experience," as Sidonie Smith reminds us.[11]

Thus the belief in the text's reference to a body, even in the face of the pluralism of postmodern selfhood, has an ideological basis. It also seems to have a spiritual one, though scholars are less comfortable articulating matters of faith. Janet Varner Gunn, one of the most explicit on this question, upholds the "groundedness" of autobiography, adding that "the issues at the heart of narrative theory . . . are religious issues having to do with the sense we can make out of our experience in the world" (Gunn 1982, 23, 37). Paul John Eakin does not evoke religion, precisely, but rather the idea of belief in the face of opposition, typifying the reader's persistent allegiance to the idea of referentiality as "a kind of existential imperative, a will to believe that is, finally, impervious to theory's deconstruction of reference as illusion" (Eakin 1992, 30). And Lejeune, recognizing the embarrassingly spiritual implications of his convictions, voices them in a kind of parody of religious creeds: "It's better to get on with the confessions: yes, I have been fooled. I believe that we can promise to tell the truth. I believe in the transparency of language, and in the existence of a complete subject who expresses himself through it; . . . I believe in the Holy Ghost of the first person" (Lejeune 1989, 131). Selfhood, then, is apparently more a matter of faith (however one defines that) than proof.

But it seems that even poststructuralists, once they have dismantled textual referentiality, must have something in which to believe; and this is where photography enters the fray. Both Roland Barthes and Paul de Man, who profess disbelief in the referential power of language, seem to become remarkably gullible when it comes to photographs. It is, interestingly enough, at the moment when he is most suspicious of narrative that de Man lets photography in through the back door: "Are we so certain," he protests, "that autobiography depends on reference, as a photograph depends upon its subject?" (de Man 1979, 920). In this equation, photography emerges as a true referential art.[12]

To reverse matters now and borrow Lejeune's protest, Barthes and de Man are "not so dumb." Barthes knows, for example, that "the photographic optic is subject to Albertian perspective (entirely historical)," that "the inscription on the picture makes a three-dimensional object into a two-dimensional effigy," and that photographic images are read through cultural and historical experience. Nevertheless, he claims, he is a "realist"—he believes in the "*magic*" of photographs, that they are "emanation[s] of *past reality*" (Barthes 1981, 88). The parallel to discussions of

11

reference in autobiography should by now be evident. In the name of (magic) "realism," Barthes states his faith in photographic representation, even in the face of his knowledge that photographs are technological and cultural constructions. In this he resembles those scholars of autobiography who persist in the "naive" belief in the autobiographical self as reference to an embodied agent, despite their awareness of the opacity of language.

But is it not the case that photographs are a special order of sign? Certainly we perceive them as such. Since its invention, photography has been understood as *truer* than other representative images; photographs serve as scientific and juridical evidence that, as Barthes puts it, "*the thing has been there*" (Barthes 1981, 76). This sense of photographic honesty is grounded in the immediacy of photographic representation; as Alan Trachtenberg observes, the exactness of the early daguerreotypes and the absence of brush strokes and pencil lines assured the astonished viewers that the unreliable draughting hand had indeed been removed from the mimetic process, and that a new era of objectivity in recording historical "facts" could now begin (Trachtenberg 1989, 5).

At the same time, we know that photographs are not simply the things they represent, but must be read through the culture that creates and consumes them.[13] This is what Barthes describes as "the photographic paradox": "the co-existence of two messages, the one without a code (the photographic analogue), the other with a code (the 'art,' or the treatment, or the 'writing,' or the rhetoric, of the photograph)" (Barthes 1977, 19). He defines the two poles of his paradox as "denotative" (codeless) and "connotative" (encoded). Alan Sekula outlines a roughly analogous dichotomy when he writes of the "informative" and "affective" functions of photography; readers of photographs as informative signs ascribe the power of documentary proof to the image, while the affective function of photography inspires symbolic or spiritual readings (Sekula 1981). Of course, as both Barthes and Sekula confirm, the affective or connotative perception of photographs, which assigns them symbolic or ritual meaning, derives from the belief in their denotative or informative power. It may be because we perceive photographs as absolutely truthful that we accord them the power of seeing through things, recording the invisible as well as the visible. A remark from W. J. T. Mitchell applies very well to this dual perception of photography: "The notion of the image as 'natural sign' is . . . the fetish or idol of Western culture" (Mitchell 1986, 90).

12 Although we have been confronted with photographic fakery

throughout the medium's history (and most recently have witnessed the photographic rewriting of history through photographic illusion in films such as *JFK* and *Forrest Gump*), the belief in photography's denotative power (which leads to affective and connotative readings) persists.[14] But it should be added that not only "naive" but also "sophisticated" belief in photography partakes of ideology. As in our analysis of referentiality in autobiography, we have now arrived at the place where belief (in this case, "naive" and "superstitious" belief) in the transparency of signs is poised against the belief in the opaque and constructed nature of signs. One of the more illuminating moments in plotting the convergence of photography and autobiography occurred when I began to realize that the two media (as media for constructing selfhood) occupy the same sort of territory, which one might typify as "the marches."

Autobiography, like photography, refers to something beyond itself; namely, the autobiographical or photographed subject. But both autobiography and photography participate in a system of signs that we have learned to read—at one level—as highly indeterminate and unreliable. Below that level of doubt rests, in some persons, the desire to accept the image or the text as a readable reference to a (once-) living person. The insertion of photography (either as object or metaphor) into an autobiographical text can thus cut both ways. On the one hand, photographs disrupt the singularity of the autobiographical pact by pointing to a plurality of selves; not only this image but this one, this one, and that one are the author. On the other hand, photographs in an autobiographical context also insist on something material, the *embodied* subject, the unification (to recall the autobiographical pact) of author, name, *and* body.

In writing of Barthes and his relationship to referentiality, Paul John Eakin observes that it is "curious" that Barthes begins to turn toward "reference and . . . a more conventional view of the subject" just when scholars like Foucault were proclaiming the death of the author (Eakin 1992, 22). This is a perceptive observation, but it should not strike us as curious.[15] *Camera Lucida,* the autobiographical essay that, more than any of Barthes's other works, asserts the referential power of photography, takes as its point of departure the death of Barthes's mother—and Barthes's own impending death (he died in 1980, the year of the book's publication). Barthes's insistence on the knowable presence of his mother in the world revolves around a photograph taken of her as a child, which, he claims, achieves "*the impossible science of the unique being*" (Barthes 1981, 71). It is his reading of the features of her face, the residual trace of color (in the black-and-white photograph) of the pupils of her eyes, the awk-

ward way she stands holding one of her fingers, that registers photographic "truth" for him. He recognizes her, the departed, as present in the photograph. It is, in other words, a reading of the body, though the image he "recognizes" represents his mother long before he knew her.

Barthes's turn toward referentiality is not curious because it takes place as an assertion of life and being in the face of death and the body's dissolution. It is not unlike a deathbed conversion. This is always the case in both photography and autobiography, as I will discuss further below. Michel Beaujour makes a similar point about Nietzsche's autobiography *Ecce Homo,* finished months before the philosopher's departure into madness: "*Ecce Homo,* especially as it turns morality into hygiene, cannot conceal beneath the bluster of the First Man the lament of a sick body protesting against glorious hypostasis, sublimation, and soaring metaphor: incarnation is here and now" (Beaujour 1991, 324). The retention of referentiality, particularly photographic and autobiographical referentiality, insists on the body's presence to spite sickness, death, and poststructuralist claims for the self's demise. For this reason, Barthes turns to referentiality at the close of his life. For the same reason, protests by some scholars against the denial of referentiality begin to occur once claims have been made for autobiography's demise.[16]

The integration of photographs into the autobiographical act highlights the presence of the author's body, and seems to claim the body as the source and focus of the autobiographical text. At the level of "naive" or "primitive" reading, photographs denote the subject of the autobiography, much as the name underwrites the authority of the autobiographer in Lejeune's autobiographical pact. But the suspicious, deconstructive reading of photographs in the autobiographical context gleans a different tale. In that reading, photographs perform as the world's most effective masks. To explore further the role of photograph and autobiography as referential signs, I would like to examine the relation between autobiographer and self-photograph and autobiographer and body, looking at the ideological and representational implications of self-objectification. While the autobiographical act, whether textual or photographic, begins with a disassociation (the self's observation of the self as other), I will argue that the introduction of photographs into autobiography not only effectively represents that disassociation but also offers a possibility of reconciliation or reintegration. The eye of the reader is one theater where the drama of divorce and reconciliation can take place. In the following section, I will show how the inclination, particularly strong among post-

structuralists, to regard the autobiographer or the photographed subject as a corpse leads to an untoward emphasis on the dissociative aspect of autobiographical and photographic discourse.

Corpse? Corpus? Living Body?

Why complicate in this way an experience which we have many times every day—the experience of looking at a photograph? Because the simplicity with which we usually treat the experience is wasteful and confusing. We think of photographs as works of art, as evidence of a particular truth, as likenesses, as news items. Every photograph is in fact a means of testing, confirming and constructing a total view of reality. Hence the crucial role of photography in ideological struggle. Hence the necessity of our understanding a weapon which we can use and which can be used against us.

JOHN BERGER, "Understanding a Photograph"

John Berger's question and the answer he provides lead us into speculation on the ideological power of photography, which is written, as his statement implies, on the living body (as a "weapon which we can use and which can be used against us"). He unpacks both the naive (uncomplicated) and sophisticated (critical) readings of photographs in this short paragraph, and he manages to argue for an understanding of photographs as both constructed and constructing entities. My contribution to his observation will be the admixture of autobiography; if we are to understand photographs as weapons in an ideological struggle, how are we to read photographs of ourselves in that struggle? What do photographs contribute to the ideological debate surrounding the construction and survival of the self?

At first glance, it seems that photographs provide evidence of the living body. Michel Foucault's important essay "What Is an Author?" concerns us because it proposes a substitution of a corpus of works for the corpse of the dead author (Foucault 1977). In this view, the only pertinent literary remains of an author's life are textual, not biological. Foucault offers a vision of the literary theory of a (utopian?) future in which the underlying critical question will be, "What matter who's speaking?" (Foucault 1977, 138). Though those scholars who argue for a self constructed solely through language would seem to fulfill Foucault's prophecy, it remains only partially realized. The proponents of the importance of referentiality, which include scholars of minority and women's autobi-

ography, have moved instead to a reassertion of the biological author, even as they argue against essentialism, affirming that even biological identity is constructed through culture.

Michel Beaujour, in his introduction to a genre he defines as the "self-portrait" (as distinct from autobiography), proposes that "the self-portraitist's relation to his own body is . . . complex and . . . paradoxical, for while self-portrayal is obviously not reducible to a description of the writer's body, he cannot ignore it either" (Beaujour 1991, 298). In textualizing the body, the self-portraitist renders it as sign, and thus the body becomes a metaphor in the text, standing in for something that is not there. That something, Paul John Eakin proposes, may be the autobiographical subject itself, for the body is a sign of desire and of agency in the world, the first site of will and action (including writing).[17] At the most elemental level, the body provides a point of origin for language. As Janet Varner Gunn writes, "the autobiographical self always comes *from* somewhere" (Gunn 1982, 15). Photographs in autobiographies show the reader that somewhere: a place, a time, a body.

Where autobiographies come from, the physical, cultural, and historical position from which they emerge, occupies a central place in discussions of women's and minority autobiography. Nicole Ward Jouve speaks for a good number of feminist scholars of autobiography when she declares that "we have lost ourselves in the endlessly diffracted light of Deconstruction. I say 'we' meaning all of us, but especially women. For we have been asked to go along with Deconstruction whilst we had not even got to the Construction stage."[18] Jouve's protest addresses the denial of referentiality inherent in poststructuralist readings of autobiography, which consequently denies the subject the power of self-construction. Feminism in fact has its own program of deconstruction—the dismantling of restrictive and oppressive gender constructions—and to this end, feminism makes use of poststructuralist discursive practice. But the danger looms large that the power of self-agency will be lost in the midst of arguing that the self is constructed solely through language.[19] The trick, then, is to escape construction by others through language, to resist being made into nothing more than a body by reintegrating body and language through the power of subjecthood and referentiality.

The photographic image has been a contested site in feminist practice, for feminists have recognized in photographs the objectification of the body, the creation of the body as passive image that cannot resist construction from the viewing subject. Feminist cinematic studies in particular have construed the viewer as male and the objectified body as female.[20]

Interestingly, the situation in which a person looks at a photograph of him- or herself carries similar implications. Roland Barthes declares that "the Photograph is the advent of myself as other: a cunning dissociation of consciousness from identity" (Barthes 1981, 12). While I might reformulate his argument to state that the photograph is not the "advent" of the self's otherness, but a convincing piece of evidence for something already suspected, it is useful to see the way in which we objectify ourselves in the act of viewing ourselves photographed.

Photographs in autobiographies produce visibly the "otheredness" always implicit in autobiographical discourse. Elizabeth Bruss makes this argument in her essay on autobiographical cinema, arguing that the autobiographical self "decomposes" into filming subject and filmed object (Bruss 1980, 297). While Bruss refers here to a situation in which the autobiographer/filmmaker films him- or herself, the same disruption of the "I" of autobiographical narrative occurs when the subject views a photograph in which he or she appears as an object for the lens, and an object for the disengaged spectator (in this case, the self). The photograph presents an image for what Louis Renza calls the "phantom third person" of autobiographical discourse; thus Renza describes not only the autobiographical but also the photographic paradox when he states that "the manifest paradox confronting the autobiographer within his act of textual composition has been his experiencing his signified past self as at once the same as his present self, continuous with it, and yet strangely, uniquely, as *other* to it" (Renza 1977, 317).

Considering the act of autobiographical objectification in light of feminist criticism, it is not surprising to find that a hint of violence emerges. Strindberg characterizes the autobiographical body as split in two, one half playing the coroner and the other a corpse undergoing autopsy. Christa Wolf accuses herself of child abuse for abandoning her younger self. And writers frequently imagine themselves dead in order to attain the separation from the world necessary to commit the autobiographical act. The autobiographical trope of speaking from the grave occurs in Twain, Chateaubriand (*Memoirs d'outre tombe*), Nietzsche, Heine, and, explicitly or implicitly, many others. And a similar air of violence and coercion hangs over the photographic situation. Susan Sontag, in her classic essay *On Photography,* states the danger of photographic objectification bluntly: "To photograph people is to violate them, by seeing them as they never see themselves, by having knowledge of them they can never have; it turns people into objects that can be symbolically possessed" (Sontag 1973, 14). We might begin to ask ourselves at this juncture how

we read Sontag's statement in a situation in which the self regards the self photographed.

In viewing photographs of ourselves, we see ourselves framed and "shot" (as photographic language has it). Since photography arrests the flow of life and creates memorials to moments, persons, and objects, the medium was from the first associated with death; early photographer Hippolyte Bayard enacted this when he took a photograph of himself as a drowned man, and consumers of photographs clearly understood it as well, as evidenced in a nineteenth-century enthusiasm for photographs of the dead. The posing of daguerreotypes during the early days of photography involved the use of a brace to force the subject into absolute stillness, and the combination of such devices with a stifling bourgeois decor, arranged and controlled by a Rasputin-like photographer, led Walter Benjamin to compare the studio to a torture chamber (Benjamin 1980a, 261). August Strindberg, who himself planned to establish a photographic studio for the production of "psychological photographs," described his photographic subjects as "victims" (Paul 1915, 37). Further, the use of photographs in the service of bureaucracy introduces the threat of surveillance. The last two authors of my study, Walter Benjamin and Christa Wolf, live under the eye of dictatorship, which employs photographs in the oppression of the individual: the identification papers (in Benjamin's case, marked with a J), the passport (which can limit movement as easily as it allows it), the records of the secret police. For these authors, photographs of themselves could serve as incriminating evidence—and not surprisingly, they exclude photographs from their autobiographies. Benjamin erases traces of his photographed physiognomy, while Wolf's family photo album is lost at the end of the war.

In dealing only with absent photographs, however (and this is important), both Benjamin and Wolf acknowledge the referential power of photographs (in their cases, a negative, destructive referentiality). They remove their photographed images from the public eye, but they retain references to photography and photography's influence; Benjamin structures his autobiography in "images," alluding to his theory that history is experience in photographic flashes of that conjoin and illuminate past and present experience. Wolf constructs her autobiography around the *memory* of lost photographs, always returning to the images as a source for her personal history. But rather than allowing photographs to objectify the subject, to make the subject nothing more than a body, Benjamin and Wolf endow the subject with agency. They draw the photographic frame

according to their own constructions, challenging the readings imposed on their texts and images (their self-constructions) from without.

Thus the presence of photographs in autobiography cuts two ways: it offers a visualization of the decentered, culturally constructed self; and it asserts the presence of a living body through the power of photographic referentiality. Alan Trachtenberg offers an analysis of the photographed body in his discussion of some images of African-American slaves taken in 1850: "Our viewing of the pictures becomes an imaginary form of what Hegel described as the 'master-slave relation,' the intersubjective dialectic between persons in unequal social positions. By stripping these figures of all but their bodies (and eyes), the pictures depict the base degradation of such relations" (Trachtenberg 1989, 59). Viewing the images of slaves creates a metaphor for the viewing of other images, as well, for in every photographic situation, the objectified body is under the controlling inspection of the unseen viewer. But the situation of these particular photographic subjects is not only metaphor, as Trachtenberg powerfully contends. Responding to the historical and cultural place from which these photographs were taken, Trachtenberg wants to allow the photographed subjects their agency, emblematized in their eyes: "[The slave images] also encompass the possibility of imaginative liberation, for if we reciprocate their look, we have acknowledged what the pictures most overtly deny: the universal humanness we share with them. Their gaze in our eyes, we can say, liberates them" (60).

Trachtenberg's reading of these photographs offers an amicable conjunction of "naive" and "sophisticated" interpretation. Understanding photographs as representative of ideological constructs regarding race, gender, and class, he nevertheless ascribes to the images the power of self-construction, liberation, and life. Do we really want to call the empowerment of the photographic subject "naive"? Is it not the belief that the people photographed in these images look back at us that returns to them their dignity and permits us the liberty of looking at them at all? In their original context, the slave photographs were used by Harvard scientist Louis Agassiz as evidence to "prove" his thesis of the "separate creation" of the human races (Trachtenberg 1989, 53). Here the boundaries between naivete and sophistication, connotation and denotation, documentation and effect, become blurred. The categories impinge on one another and redefine one another. The body's status as commodity and the subject's ownership of his or her own body are unveiled in this case as obvious factors in the photographic and textual debate on referentiality.

Let me approach the problem from a different angle. In an essay entitled "Posing," Paul Jay includes autobiographical photography in his vision of discursive self-construction; photographs are only poses, just as the self in autobiographical texts exists solely in language. But this sweeps aside the hard kernel of referential truth that Barthes (among others) wants to claim for photography—the "that has been" phenomenon that appeals to our desire for evidence of being. Jay discusses Cindy Sherman's deconstruction of self-image through self-photography; she creates photographic constructions of various stereotypes of feminine identity in order to point out the ways in which the body is constructed through image in a cultural context. Sherman's enactment of Barthes's "repertoire of images" has become emblematic of postmodern models of discursive selfhood. But it is of tremendous importance, I would argue, that we see at the same time that all of these images refer to a single body in different poses. Recognition of the continuity between images (which resides in Sherman's body) must take place in order for the deconstructive discursive practice to function. And that the photographed woman's name is Cindy Sherman, that she is the instigator of the images as well as their subject, sustains her materially as an artist. This is her work, exhibited in museums under her name. Is it assuming too much to suppose that this system of referentiality puts food on the Sherman table, sustains the Sherman body for future deconstructive use?

The insistence that the self is constructed solely through language and a repertoire of images projects a world onto a playing field that is safe for literary scholars: the playing field of linguistic and imagistic discourse, a monopoly game in which the most canny players own both Boardwalk and Park Place. But monopoly money will not pay the mortgage on anything other than small plastic houses. The issue of the economy of images and writing (an issue explored by Foucault) is transformed into mere discursive practice in these debates; but in the end, we depend on notions of author's copyright in the economy of our own profession. Foucault's question, "What matter who's speaking?" matters a great deal in the market of ideas and creativity, and despite theories of intertextuality and deconstruction, we still subscribe to notions of originality as subjecthood, as witnessed by our elaborate systems of citation and strict policing of plagiarism. Note that I am not arguing for the survival of an ideal of originality and ownership in scholarly discourse; I would only contend that we ignore it at our own risk.

The trick is seeing both the material body and its constructed nature at the same time. This is what Eakin argues in his discussions of referen-

tiality in autobiography; it is what some feminists demand of our reading of history; it is what Mitchell claims as Barthes's insight into photography; it is what Trachtenberg's reading of the photographs of slaves implies. The four autobiographers of this study work with this paradox in various and revealing ways, understanding the image and its body as commodity and agent, subject and object, all at once.[21] Thus photographs in autobiographies, or even the references to photographs, cue the reader into a complex play of signifiers that indicates the presence of a player, a person, upon whom text and images rebound.

When Twain and Strindberg proposed to incorporate photographs of themselves into their autobiographical works,[22] they fortified these images with captions that were meant to convey what they were thinking at the moment the photograph was taken; a peculiar idea when one thinks of it, but an idea accepted readily by the photographic viewer because of the easy confusion between the photographic representation of interior and exterior (mental and physical) space. The viewer receives the message that somehow this surface image conveys the essence of what is happening inside the photographed subject, rendering thoughts visible. Thus (reading from a naive vantage) the subject's voice is reintegrated with the subject's body in the autobiographical photograph.[23] Their attempt to integrate image and "voice" presages sound film, which, although it *seems* more real, is simply a more convincing illusion. The images of sound film are, like the captioned photographs, completely mute and motionless; it is the manipulation of the cinematic apparatus that creates the illusion of motion (as Bergman points out in his *Persona*) and voice (as we are made to understand in the brilliant *Singing in the Rain*). Photographs in autobiographies perform a similar trick in their association of the author's "voice" and "body"—one might say that the inclusion of photographs envisions a revitalization of the corpse of the author, a re-membering of the autobiographical self.

Another function of photographs, both actual and metaphorical, is their reference to remembering, which is a bringing of the past into the present moment. All photographs (even Polaroids) represent past time and stand in the present as a link to the past. In that way, photographs also represent the physical (or, at least, metaphorically physical) principle of reintegration in autobiography and photography: subject and object, self and other, body and voice. In the next section I will consider the power of memory, its reintegration of past and present selves, and the role autobiography and photography play in that task.

Photography and Mnemosyne

Speak, Memory is the title of Vladimir Nabokov's autobiography. In it, he includes an array of photographs. His first thought was to call it *Speak, Mnemosyne,* but his publishers advised him against an unpronounceable title; they feared it would inhibit sales (Nabokov 1989, 11). But Mnemosyne, however difficult to say, is particularly evocative in the autobiographical setting, as she is the goddess of memory and mother to the muses. Asking the goddess to speak conforms to the classical traditions of seeresses and the voice of the muse, yet memory has traditionally been figured as visual; classical mnemonic strategies for rhetoric, for instance, depended on a visualization of architectural or spatial structures. Michel Beaujour claims that this ancient practice provides the structural apparatus for a modern genre of writing that he defines as the "self-portrait"; while I do not distinguish as rigidly as he does between autobiography and self-portrait, I concur with his argument that modern (and postmodern) self-narrative draws on the mnemonic power of visual imagery, which can in some cases lead the autobiographer to adopt a fragmented text, constructed in flashed "images": "self-portraits . . . resort to mnemonic places and images to invent their textual space" (Beaujour 1989, 139).

Nabokov's narrative does not occur in flashes—but he does explore deeply the matter of place, vision, and memory in photographs and text, explicitly formulating the task of rewriting his autobiography as an effort to *visualize* the past. In the following passage, he conveys how he was able to correct a small detail of an earlier edition of the version, in which he had originally remembered finding a pair of glasses in the grass along a path: "Finally I made a great effort, and the arbitrary spectacles (which Mnemosyne must have needed more than anybody else) were metamorphosed into a clearly recalled oystershell-shaped cigarette case, gleaming in the wet grass at the foot of an aspen on the Chemin de Pendu" (Nabokov 1989, 11–12). Mnemosyne does not speak—she sees, though badly. Particularly arresting is the detail he himself emphasizes: the "lost" object is first perceived as a pair of spectacles, as if to acknowledge the difficulty of looking into the past.

It is but a short step from imagining Mnemosyne with eyeglasses to imagining her with a camera. W. J. T. Mitchell, while he wants to argue that photography does not necessarily occupy a unique ontological position, is at pains to distinguish between various kinds of "Image (likeness, resemblance, similitude)," dividing the images into "graphic (pictures,

statues, designs), optical (mirrors, projections), perceptual (sense data, 'species,' appearances), mental (dreams, memories, ideas, fantasmata), and verbal (metaphors, descriptions)" (Mitchell 1986, 10). In this typology, memories are classed as a type of mental image, but as Mitchell readily admits, our perception of image does not place such strict boundaries between mental and physical categories—otherwise there would be no call to create or outline a typology. Instead, we create metaphors for images that break through the boundaries between categories, yoking words with pictures, "real" pictures with dreamed ones, and photographs with memories.

A consequence of equating photography and memory (or other "real" images with ephemeral ones) is the confusion of outer and inner realms.[24] Once we have established that the mind is a camera, then the camera takes on the qualities of the mind. In the case of photography and memory, photography acquires the power to supplant memory, and our image of the mental process of remembering then comes to resemble photography. In both instances, the vehicle and the tenor of the metaphor cross to play each other's roles.

Evidence of the urge to imagine photography as memory and vice versa exists already in 1859, when Oliver Wendell Holmes, in an early burst of enthusiasm over the new technology, proclaimed photography "the mirror with a memory" (Holmes 1859). In the early twentieth century, George Santayana argued for an essential similarity between mental images and photographic ones, the signal difference being the relative permanence of the photograph: "The eye has only one retina, the brain a limited capacity for storage; but the camera can receive any number of plates, and the new need never blur nor crowd out the old" (Santayana 1981, 259). Inevitably, the line between memory and photograph blurs, with photographic-era children uncertain as to whether their memories of childhood are memories of events they witnessed or photographs they have seen. The photographic industry has not ignored the potency of the memory/photography confusion; the slogan urging customers to "capture the memories" promotes a latter-day effort to capitalize on the power described by Holmes and Santayana.

In the autobiographies of authors living during the photographic era, photography becomes an obvious metaphor for memory. The process of remembering and the subsequent inscription of the memory, both essential to the autobiographical act, find a perfect image in the photograph. All four autobiographers studied in this volume confuse the categories of remembrance of things past and photographs of those things (and remem-

bered photographs of those things). But there are structural and philosophical consequences involved in mixing memory and photography, as well. Mark Twain relates that "of the multitudinous photographs [his] mind [had taken] of people," only one clear one of his mother remains. As he tells it, his mother's life was made of up of "flashlight glimpses" in his memory, in this context a direct reference to photographic flashes (Twain 1924, 1:115). This image is remarkably similar to that employed by Walter Benjamin when he creates a figure for "the true picture of the past," which "can be seized only as an image which flashes up at the instant when it can be recognized and is never seen again" (Benjamin 1969, 255). In *Berliner Chronik,* an early version of his autobiography, Benjamin describes the human memory as a photographic plate.

August Strindberg expresses the equation between memory and photography in a slightly different way; for him, photography provides a metaphor for the act of seeing, of inscribing something on the visual field: "As he wandered home alone now through the night and sought to reconstruct the features of the affair, he noticed again the oddity that he couldn't call up 'her' exterior; as an old agent, he was so used to photographing people and scenes, landscape and interiors with his eye that he couldn't understand this" (Strindberg 1916, 37:111). "Call up" is a translation of the original Swedish verb *framkalla,* which commonly refers both to memory and to the process of developing photographic images (*framkalla bilder*). Christa Wolf compares the mind to the camera obscura of prephotographic technology, and her dependence on the lost photographic images of her childhood to reconstruct her history indicates once again the erasure of the boundary between mental and photographic imagery.

Once memory (both individual and historical) is equated with photographic flashes, in some autobiographers an altered form of narration suggests itself, one consonant with the photographic experience of the past.[25] Twain chooses to dictate his autobiography in daily sessions, narrating events in no particular chronological order, branching off or changing subjects when the fancy hits him, sometimes breaking off a narrative at the conclusion of a session, sometimes picking it up again at the next. Strindberg achieves a fragmentary autobiography through repetition of the autobiographical act; while some of his texts conform to traditional autobiographical narrative practice, others do not—and the sum total of his autobiographical work includes a myriad of genres and approaches. Benjamin's method differs from Twain's in that each vignette in his auto-

biographical narrative achieves closure—but the work is composed of thirty such vignettes, which he calls *Bilder* (images), unconnected to one another and in no apparent order. In all of these cases, the operative metaphor of photography as memory seems to play a role in determining the fragmentary, experimental narrative form of the text.

Christa Wolf's memory of the lost photographs of her childhood allows her to reenter that world and establish herself as a thinking subject in her own history. Precisely because the original authoritarian framing structure of the photographs is gone, a subjective site of remembrance can be positioned in the recollected images. Benjamin borrows the model of the panorama as a metaphor for the structure of his text, which presents the reader with a circular series of images. Reading his theses on history and essays on photography in tandem with the autobiography reveals a tacit consonance between his ideas on the photographic nature of history and his presentation of his own history.

Photographs, it is clear, represent more for us than the objects and persons contained within their frames. They introduce a new arena for visualizing the structure of history, and they perform as metaphor for the processes of perception and memory. In this sense they act as "hypericons," to borrow W. J. T. Mitchell's term, a category of images (like Plato's Cave) that "figure the practice of figuration" (Mitchell 1986, 5). Thus while Barthes proposes that photographs are analogues of reality, I would like to propose that they are that but not only that; I would argue that they are also analogues of memory, and consequently analogues of thought (Barthes 1977, 17).

From memory we proceed easily to memorials, which both represent an originating act of remembrance and serve to invoke the act of remembrance in those who view the memorial. Frequently, however, the viewer is asked to "remember" something that does not belong to his or her specific past. When I view the list of names representing the war dead on the facade of the county courthouse in a certain town in Tennessee, I am "remembering" men who died long before my own birth, and additionally (because some of the names are listed under the heading "Colored"), I remember something of our sad history that the makers of the memorial might not have intended. By focusing on this particular list of names (there are hundreds, perhaps thousands of such lists around the country), I am able to see that such memorials work to integrate the viewer with a past beyond the sphere of his or her own personal experience—they create communal history by proclaiming the fate of strangers

as important to our own. At the same time, they alienate; this is not my personal history, perhaps I have some solid objections to my inclusion in their narrative.

Autobiographies and photographs enjoy the same double function of representing remembrance and inciting "remembrance." Their message might be summarized on the one hand as "remember me," and on the other as "memento mori"—for no matter what the reader's attitude to the memorialized subject at hand, it is unavoidably true that the reader *will* enter the community of people requiring remembrance to survive, the reader's name will, in other words, be entered in the lists of the dead. My last introductory section will meditate briefly on the nature of autobiography and photography as a special kind of memorial.

Cenotaphs

A cenotaph is a monument that marks an empty tomb. Rune stones sometimes function as cenotaphs; in such cases they memorialize a Viking who died far from home, whose remains, as the rune stones would have it, were eaten by the ravens or the eagles or the wolves or the fishes. ("The words of a dead man / Are modified in the guts of the living.") Cenotaphs are often erected to soldiers whose bodies have been rendered unrecognizable by the weaponry or obscurity of chaotic battlefields. A superstitious reading of the cenotaph would be that without the marker, the souls of lost bodies wander ungrounded, homeless. Another reading, perhaps no less superstitious, would suggest that the memory of the lost body finds its expression in the marker, the memorial. In *whose* memory are such markers erected? In ours.

Photographs and autobiographies have both been identified with death, as I indicated above. Nietzsche proclaims that he writes "with one foot in the grave" (*mit einem Fuß jenseits des Lebens*) as he pens his autobiography. The autobiographical author, anticipating his or her death, raises a memorial marker. Photographs, for their part, indicate a moment of life that has passed forever, reveal a body that no longer exists, in the sense that the photographic body is frozen in time, shed, like a snake's skin, by the living body. "Every photograph snuffs," proclaims Cathy N. Davidson, and there is a truth in that (Davidson 1990, 672). Both photographs and autobiographies could be imagined as cenotaphs, for they indicate through their presence what is no longer here—the body of the author.

But cenotaphs do not only memorialize death. The postmodern pre-

occupation with death and autobiography, death and photography favors one metaphoric function of the cenotaph over another. Michel Beaujour, in his study of the self-portrait, cites another cenotaph: the Christian narrative of the resurrection, which marks an empty tomb. He asks: "Could it be that the narrative of the Resurrection, transformed within the self-portrait into that of *my* own resurrection, is the archetype of [self-portraiture]?" (Beaujour 1991, 298). The empty tomb of the gospels is made to act as a witness to resurrection in a peculiar way; the mere absence of the body is offered as sufficient proof: "He is risen, he is not here; see the place where they laid him" (Mark 16.6).

Autobiographical texts and photographs likewise indicate both an absence (of the body) and a presence (of life); they announce life in the midst of death as much as they anticipate death in the midst of life. They mark the place from which the autobiography came, even as they attest to the absence of the autobiographer. Although the metaphor of the empty tomb is a compelling one, cenotaphs do not have to be read through a Christian lens. The desire for immortality is inscribed in all memorials, from rune stones to photographs. Current debates over the referentiality of autobiographies and photographs rest on the same uneasy fault line as debates over the author's death or immortality, and perhaps one of the best answers to the conundrum is an investigation of desire.

Numerous scholars of autobiography have charted the ways in which the reader enters into a relationship with the autobiographer—trusting that the autobiographer will attempt to tell the truth as she or he experiences it, confident that the autobiographer's tale will reflect in some way on the reader's own life, will have relevance as well as referentiality (see Bruss 1976; Eakin 1992; Gunn 1982; Lejeune 1975 and 1989; Neumann 1994; and others). These desires are repeated in our viewing of photographs as well; that somehow, the photograph will open a window on the past and the past will return our look, as Barthes imagines in *Camera Lucida,* or Trachtenberg in his reading of photographs of slaves. Although we understand the presence of fakery, the importance of historical situation and cultural construction, the indeterminability of text and the de-centeredness of the self, some of us still retain the desire for the returned glance, however impossible. My discussions of Mark Twain, August Strindberg, Walter Benjamin, and Christa Wolf will explore the conflict between knowledge and desire concerning autobiography and photography, as that conflict finds rich and complex expression in the autobiographical texts and photographs of each.

I *Illumination and Obfuscation: Mark Twain's Photographic Autobiography*

Of the authors treated in this study, it is the earliest one who most thoroughly grasped the power of photographic illusion. Mark Twain painstakingly molded a self-image as product, forged in part from the proliferation of his photographic image. At the same time, his anxiety about impersonators and copyrights, brought about by processes of duplication and dissemination, undermined his confidence in the construction of selfhood. In response to the uncertainties surrounding identity and ownership, he created a self-image that would also serve as a self-ironizing mask, working through photographs and an experimental, endless autobiography.[1]

Comic performance, often in the form of pretended candor, characterizes both photographs of Twain and his autobiographical text. The photographic record of Twain's life forms an integral part of the author's autobiography, and not only because he developed a fascination with photographs of himself; a photographic sensibility guided the production and narrative style of his experimental autobiography as well. *Mark Twain's Autobiography,* the only one of Twain's many autobiographical works to be officially authorized as an autobiography, reflects the author's determination to get beyond the depiction of the "clothes and buttons of the man" common in autobiographies that focus on the deeds of the narrator (Twain 1924, 1:2). His aim was to unveil his thoughts to his readers, because in his view a writer's "*thoughts,* not [his acts and words], are his history" (1:2). But how does an author get beyond words in an autobio-

graphical text? Twain attempted this utopian project by eliminating the traditional chronological structure of autobiography. Instead he produced a series of dictations in which he wandered achronologically from memory to memory as the process of association led him. In this way he means to make the reader party to the machinations of his mind rather than the (retroactively imposed) evolution of a career. Thus Twain's autobiography professes to be more about the process of remembering than about the events of his life.

Two decades before Walter Benjamin wrote his historical theses, Mark Twain had already conceived a form of historiography in "flashlight glimpses" of memory, which he explicitly links to photographic flashes. Twain's autobiography, like Benjamin's, adopts a nonlinear, fragmentary form to reflect this concept. Dictating the autobiography also gave Twain the opportunity to perform in his "Mark Twain" persona, with a stenographer, secretary, and biographer as audience. His appointment of Albert Bigelow Paine as biographer and editor of the autobiography allowed him to introduce photography into the autobiographical scene, for Paine had been a professional photographer and was eager to collaborate in the formulation of Twain's image. A series of photographs taken by Paine at the time of the autobiographical dictations were intended for inclusion in the text, though they did not appear in the autobiography until the third edition, edited by Charles Neider (Twain 1959).

These seven images (figures 1.10–1.16, to be discussed below) include captions that appear to narrate what Twain was thinking at the moments the shots were taken. Like Twain's autobiographical text, the photographs profess to uncover the "thoughts" of the man—but there is a catch. While on the face of things, Twain seems to share Strindberg's view that the photographic surface (like the dictated autobiographical text) can yield the subject's innermost soul, the captions mock that very sentiment. They relate instead a self-effacing joke, typical of Twain's comic production, in which the author tries to decide whether to "be good," and winds up resolving that he is "good enough" as he is. Taken together with the autobiographical dictations, the seven photographs (and their captions) constitute a message that subverts itself.

The first surviving image of Twain is an imposture, attesting to his ambivalent attitude toward photography and its representational powers. When this daguerreotype was made in 1850, he was fifteen years old, a printer's devil for a newspaper in Hannibal, Missouri. The daguerreotype portrays young Sam Clemens, who holds a printer's stick containing the letters that spell his name: SAM (figure 1.1). But as John Seeleye makes

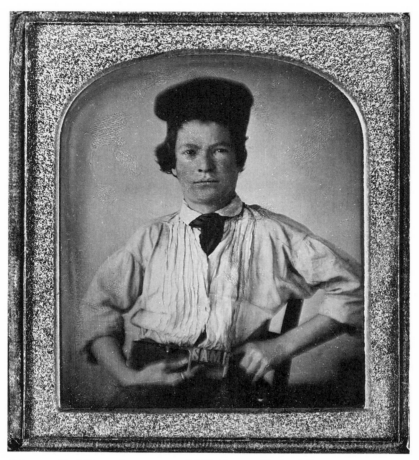

1.1 *Mark Twain, daguerreotype, 1850. Courtesy The Mark Twain Project, The Bancroft Library, University of California, Berkeley*

clear in his analysis, this early image reveals the author's precocious awareness of photography's power of illusion (Seeleye 1977, 3). The pose of the daguerreotype is ironic, for it depends on the boy's insight that the daguerreotype functioned as the typesetting of his period did; that is, that the image produced would be a mirror image of its original. To create the portrait, he held the letters in reverse order. Sam is his "real" name, but it does not appear in the image as it "really" was. (Figure 1.1 re-reverses the image to show the "true" picture.)

This early image teaches us that photographs are always double exposures. By this I mean that there are two ways to view a photograph, just

31

as W. J. T. Mitchell claims that we must see every image as "there" and "not there" in order to understand that it is, indeed, an image (Mitchell 1986, 17). For instance, when we look at an image of a person, we recognize the subject of the photograph *as* that person, even though we understand that the image cannot *be* the person. But the dichotomy "there/not there" "real/not real" often eludes the photographic viewer. While most viewers, given the chance to think about the issue, would not try to claim that the photograph of Twain *is* Twain (though Strindberg comes close to such a proposal about portrait photographs toward the end of his life), we do perceive the photograph as the same as the thing *seen*. The young Samuel Clemens immediately grasped the concept of photographic duplicity, but Twain's later comments on photography envision a dichotomy a bit different from "there/not there," as the following passage illustrates:

> No photograph ever was good, yet, of anybody—hunger and
> thirst and wretchedness overtake the outlaw who invented
> it. . . . The sun never looks through a photographic instrument
> that does not print a lie. The piece of glass it prints is well
> named a "negative"—a contradiction—a misrepresentation—
> a falsehood. I speak feelingly of this matter, because by turns
> the instrument has represented me to be a lunatic, a Solomon,
> a missionary, a burglar and an abject idiot—and I am neither.[2]

Twain's professed frustration with the lying camera stems from his professed belief that a photographic image conveys a single, readable (if inverted) message to the viewer, and that this message, because of the inviolable truthfulness of photographs, will be believed above his protests. He understands the "there/not there" quality as a reversal rather than an absence; the photograph is not so much an image of something that is no longer present as a negative of what is ("character," in this case).[3] He grants the photographic image a power that overwhelms human critical capacities (though he does not, it must be admitted, place much confidence in human critical ability generally). If, as Twain claims, photographs force negative interpretations, the only solution is to give back the lie: reverse the negative by posing, by embedding it in narrative (e.g., captions), or by fiercely controlling duplication and proliferation of images. The 1850 daguerreotype represents a graphic image of re-reversal.

The most fruitful employment of photographs, as Twain comes to understand it, plays upon their reputation as dependable truth-tellers, which makes them splendid liars. They become an instrument of invention for him ("My name is SAM," "You now see me in the act of creation,"

"You are present at my most intimate moments"). The same principle guides his autobiographical narrative, which claims utter truthfulness as outpourings of a soul from beyond the grave. He admits that his memoirs are compromised, however, by far-from-photographic memory:

> I used to remember my brother Henry walking into a fire when he was a week old. It was remarkable in me to remember a thing like that, and it was still more remarkable that I should cling to this delusion for thirty years, that I *did* remember it— for of course it never happened, he would not have been able to walk at that age. . . . When I was younger I could remember anything, whether it happened or not, but my faculties are decaying now, and soon I shall be so I cannot remember any but the things that never happened. (Twain 1924, 95–96)

Thus the narrator from beyond the grave unmasks the "negative" nature of his autobiographical mirror; it is likely that only "things that never happened" are reflected therein. This is further substantiated by the conclusion of the chapters from the autobiography published in the *North American Review,* which reads, "That is the tale, and it is true. Or at least some of it" (Twain 1990, 242). And in an interview with the New York *Sun,* Twain clinches the parallel between his performances in photographs and autobiography: "I never yet told the truth that I was not accused of lying, and every time I lie someone believes it. So I have adopted the plan, when I want people to believe what I say, of putting it in the form of a lie. That is the difference between my fiction and other people's. Everybody knows mine is true" (Budd 1983, 158). Since Twain's attitude on lying can be understood ironically, we can read his remarks as an elaborate re-re-reversal, in which he exposes his own weakness to insure himself against charges of dishonesty or inaccuracy. Still, placed in conjunction with his observations on the lying nature of photographs, Twain's insistence on his own dishonesty makes obvious the relationship between his autobiography (true fiction? fictional history?) and his photographic record.

My analysis of Mark Twain's image-crafting in his autobiography and in photographs grants the author a significant amount of conscious control. Other scholars, like John Seeleye and Hamlin Hill, have noted a loss of control during the final years of Twain's life. Hill maintains that the later autobiographical dictations begin to lose their literary value, evolving into "compulsive and aimless monologue," because "the artist was becoming tone deaf about his own work" (Hill 1973, 190–91), while

Seeleye's book implies that Twain's id breaks forth in the later photographs of the elderly Twain dandling young girls on his knee. Certainly the autobiography itself veers out of control—inconclusive, wandering, never fully edited or published, ultimately ignored by Twain's greater readership. But Louis Budd and James Preston Waller, concentrating on the photographic image, emphasize the author's consummate skill in molding a selfhood. Somewhere between these two poles flies a spark of scintillating truth. Apparently accepting an inevitable loss of self control, Twain portrays himself out of control, appearing half-dressed in public, admitting to amnesia and lies, and abandoning traditional autobiographical form in favor of a reflection of an inner chaos.

In the sections that follow, I will explore at several convergences the links between Twain's photographic record, which extends over his lifetime from 1850 on, and his experimental autobiography, composed predominately near the end of his life. I have chosen to focus on *Mark Twain's Autobiography* rather than including the vast (and difficult to define) array of autobiographical texts in Twain's corpus, for the work denoted clearly as "autobiography" by its author seems to exemplify most compellingly the link between Twain's thoughts on photography, his photographic record, and his autobiographical act. My first point of concern will be the referential power of both author's name and photographic image in an autobiographical context. The name reversed by the daguerreotype mirror is not the one the author now usually goes by. Thus for us, the image must be both reversed and renamed to be recognizable. The young man depicted there (is there a smile twitching at one side of his serious face?) understood the relationship between photographing and naming a body—both the name and the image are supposed to denote a person. But he also knew (we see this as he grew older and assumed a second name) that the systems of photographic and nominal denotation can be scrambled to create a more perfect (because more effectively masking) image.

Photographing and Naming: The Photographic Record and the Pseudonym

Is a pseudonymous autobiography like a faked photograph? Both subvert denotation and referentiality. In his study of *Mark Twain's Autobiography,* Thomas Couser maintains that when readers accept the use of a pseudonym in an autobiographical setting they "relinquish, to some degree, the historicity ordinarily associated with autobiography: the idea that the text

arises from and refers to some verifiable extra-textual reality" (Couser 1989, 82). Further, the "author's pseudonym [as it functions in an autobiographical text] is practically a synonym for duplicity" (82). The importance of the author's signature has become a point of contention for scholars of autobiography. Some, like Philippe Lejeune, identify the act of naming as the gesture of self-referentiality that distinguishes autobiographical from other texts.[4] Others, like Paul de Man, question the possibility of unambiguous referentiality.[5] The stakes in this controversy are high, for the existence of autobiography as a genre and our accepted concepts of selfhood and identity depend on our response to this question. This is why Couser's charge of duplicity regarding Twain's use of a pseudonym has such resonance.

Photographs, like names, refer to specific subjects. But Paul de Man, in countering Lejeune's argument regarding the significance of the proper name in autobiography, draws a stark line of distinction between photographic and linguistic reference: "Are we so certain," he protests, "that autobiography depends on reference, as a photograph depends upon its subject?" (1979, 920). I would first like to turn the tables on this analogy to examine its premise about photography. It seems that de Man identifies autobiography as a constructive act, while he conceives of photography as purely referential. His use of photography as a foil in this context indicates that he views the medium, surprisingly enough, in much the same way as Oliver Wendell Holmes or Paul Valery, who believe that photographs and the objects they depict have a "natural" relationship.

But photographs, like narratives, are constructed in part through human agency; their creation involves framing the subject, a decision about the quantity of light used to expose the image, chemical processes of development, and final cropping. Taken together, the various treatments leading to a finished photograph are not unlike editing, producing variations in content and style, texture, and atmosphere. The resulting photographic image is thus hardly an uncomplicated reference to a subject. There is ultimately (as Twain knew already) the possibility that a photograph is lying to us, making us believe false testimony.[6] While de Man's analogical use of photography seems insufficiently complex, the underlying assumption of his argument still holds: that there is a specific point of origin for the photographic image of a person, which is a body that existed in time and space at the moment of photographing. He would like, however, to remove that point of origin for autobiography: "Can we not suggest . . . that the autobiographical project may itself produce and determine the life . . . ?" (920).

It is precisely the insertion of photographs into autobiographical narratives that reveals why autobiographers would refuse de Man's suggestion: such images connect the image to the text and at the same time to the writer's body, employing the photograph to remind the reader of the hand holding the pen. In many cases, the author specifically chooses an image of the *writing* self to represent the body as writing subject.[7] These gestures insist on the referential power of texts through drawing an association (rather than de Man's contrast) between autobiography and photography. We can dismiss the presence of the living subject in neither the photograph nor the autobiography, but we must at the same time attend to the deconstructive potential of both image and name.

To address the power of naming first: one sign of the referential difficulties attached to the use of a pseudonym is the confusion regarding the propriety of its use. Through the creation of the persona "Mark Twain," Samuel Clemens established a product that was readily identifiable because he used his own body as its representative, and to secure this invention, he made a trademark of both his face and pseudonym.[8] In linking "Mark Twain" to the body originally named Samuel Langhorne Clemens, however, he both constructs a new subject and interrupts the denotative power of his original name. Scholars have long struggled with the problem of how to write about Mark Twain (Samuel Clemens?), an author whom they cannot properly name.

Some call the author "Clemens," arguing the impropriety of using only the last half of the pseudonym, since "Mark Twain" is an expression from riverboat piloting that cannot be halved and still make sense. Others use the pseudonym, but refrain from splitting it for much the same reason. For John Seeleye, who belongs to the latter group, "Mark Twain" names an authorial construct; Seeleye aims to expose "Mark Twain" as a mask covering an oedipal nightmare (Seeleye 1977). Perhaps the most obvious sign of the confusion involved in naming the author is Bernard DeVoto's use of "Mark" in his edition of Twain's autobiographical material, *Mark Twain in Eruption* (1940). DeVoto's desire to place the author firmly in the Western tradition leads to an easy first-name familiarity that strikes most readers as oddly casual.[9]

Susan Gillman refers explicitly to the problem of naming in her book *Dark Twins,* which focuses on the cultural implications of imposture and identity: "I have tried to adhere to the usual convention of using 'Clemens' to refer to Samuel L. Clemens in his extra-authorial identity and 'Twain' to refer to the authorial self" (Gillman 1989, 11). That the boundary she has just attempted to draw is permeable does not escape

her; she continues, "Unfortunately, the two selves do not remain fixed in their proper categories" (11). In surveying the diverse naming practices of scholars, it becomes clear that there is an attempt to identify one of the names with a particular function/persona of the author. The "usual convention" that Gillman mentions tries to distinguish between what Foucault terms the "author function" and a biological person, thus describing a being who is, as Nietzsche puts it, situated with "one foot beyond life."[10]

Louis Budd would like to dismiss the fuss over "Mark Twain" with the observation that the author "could sign letters as just Mark and respond to either half of the pseudonym" (Budd 1983, 20). But far from quieting postmodern anxiety over the signature and its referent, this fact merely points out that the author himself subdivided the already divisive pseudonym. It was his great genius to confuse the public and the private, the authorial and the personal. In fact, as Maria Ornella Marotti claims, "[Twain's] ambivalence between a drive to be public and a drive to be private permeates his experimental works" (1990, 23). The boundaries between private and public, body and authorial persona/corpus that "Mark Twain" moved to both inscribe and transgress are, as Jacques Derrida, investigator of the signature, has written, not static but kinetic.[11] These areas of contention are not points, nor even lines, but rather resemble marches, where readers still wander in search of the name that will define a singularity among the bewildering forest of signifiers elicited by the words Mark Twain.

Since photographs also work to disrupt the division between public and private, the deconstructive process continues with the entrance of photographic images into the fray. In looking through the heaps of photographs of the author, we find one signed "Your old friend, Sam L. Clemens," and another inscribed "Very Truly Yours, Mark Twain" (figures 1.2 and 1.16, respectively). What determines the signatures? The first is an older image, taken in 1867 in Constantinople, while Twain was on the journey he would portray in *Innocents Abroad*. The pseudonym had been invented by that time, but he did not use it here. Is it because he had not yet started to use the pseudonym in personal exchanges? Because of his relationship with this particular "old friend"? Because he does not adopt a caricatured "pose" here, but merely sits for a "natural" portrait?

In the second case, one of the series of autobiographical photographs to be discussed below, the signature plays a role in a practical joke (figure 1.16, which appears later in this chapter). Is this why the comic pseudonym is used? Or is it because the author is older and has begun to use

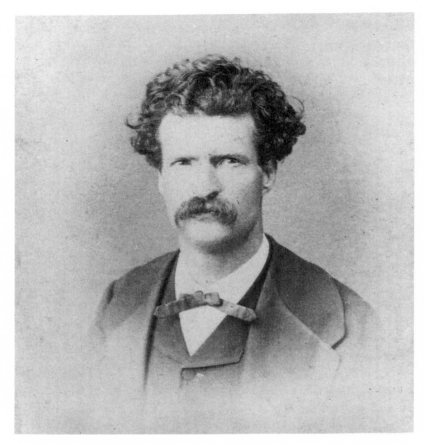

1.2 *Mark Twain, carte de visite, 1867. Courtesy The Mark Twain Project, The Bancroft Library, University of California, Berkeley*

his second name in both public and private settings? Perhaps he signs with his pseudonym because the photograph is not inscribed *to* any particular person, but is addressed to his general public, which is the author's public. All of these questions can be investigated, but our answers cannot be conclusive. What remains certain is that two different names have been assigned to photographs purportedly representing the same body.

But how do we know that the figures in the two photographs, signed with different names and differing widely in appearance, represent the same man? This final question leads us into the essential philosophical issue regarding selfhood and identity lurking behind all studies of autobiography. How is the person narrating the autobiography related to the

person described there? Photographs of the author at different times of his or her life foreground that question—make it real. At the same time, we cannot escape from the origins of the photograph—that is, the body that it depicts. This body has a real presence in the world that can be converted to material good if reflected in the proper images and disseminated wisely, and the money, in most cases, returns to the body. Though potential for photographic fraud always lurks in the background, images of people point back to the fact of the body, even if the image does not give up the body's secrets.[12]

The pseudonym and photograph work together to create an illusion of access because the pseudonym first draws an imaginary line between a public persona (Mark Twain, lecturer, author, and publicist extraordinaire) and a supposedly private one (Sam L. Clemens). Once the difference between public versus private has been denoted, the public receives an invitation, through the depiction of a real body in widely disseminated photographs in the press, to join the Mark Twain persona in various private settings. This (apparent) opening of private to the public inherent in Mark Twain's image-making is typical both of autobiography as a genre and of photography as a medium.

And so "Mark Twain" evolved through an interplay of naming, image-making of diverse sorts, and image dissemination. The first images of "Mark Twain" as literary persona occur not in photographs, for which he at first retained a conservative setting, but in caricatured engravings.[13] For *The Innocents Abroad* (1869) he preferred to publish humorous images of himself with no reference back to his photographed self; Beverly R. David records that "it was a conscious choice to use Mark Twain in caricature rather than in portraiture" (David 1986, 36), citing a letter from Twain as evidence: "They want to put a steel portrait of me in, for a frontispiece, but I refused—I hate the effrontery of shoving the pictures of nobodies under people's noses in that way, after the fashion of quacks and negro minstrels" (Wecter 1949, 84).

Somehow David interprets this to mean that Twain hesitated to publish an engraving based on a photograph of himself (a "true" image) in his first full-length book because there would be no money in it. While not an untoward supposition given Twain's obsession with money, it seems to me that the passage above alludes to something else. Both "quacks" and "negro minstrels" are impostors, pretending to be something they are not. (I take "negro minstrels" in this context to mean white performers in blackface.) A photograph, unlike a caricature, places a "real" person before the reader, in this case an unknown person. When a "nobody" puts

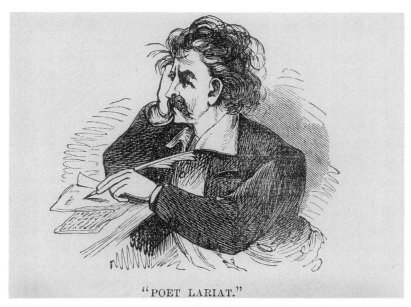

"POET LARIAT."

1.3 *"Poet Lariat," engraving from* Innocents Abroad *(1869). Courtesy William Charvat Collection of American Fiction, The Ohio State University Libraries*

his photographed image forward, he pretends to be "somebody" (worth knowing as himself, his "real," photographed self). "Samuel Clemens"—who is he? He is nobody until his book has been read and his reputation established. He is nobody, in other words, until he is recognized as "Mark Twain."

And how does Samuel Clemens achieve recognition as Mark Twain? He does it by nurturing an image that is an amalgam of his photographed image and his literary persona. A comparison of the calling card photograph supplied to the engravers for *Innocents* and the caricatures in the book reveals the artists' dependence on both the physical features of the photograph and the (exaggerated) characteristics of the narrator as he is portrayed in the text. "Poet Lariat" (figure 1.3) shows the author in the heat of creation, pen in hand, brow wrinkled, and mass of hair in wild disorder.[14] "Return in War-Paint" makes much of his traveling posture (suitcase in hand, energetically moving into the future), his bushy hair and moustache (once again), and his hat (worn only when outside and thus on the move, again emphasizing his status as traveler) (figure 1.4). Twain learned that caricature, with its exaggeration of specific physical and personal characteristics, made for a powerful tool to establish public

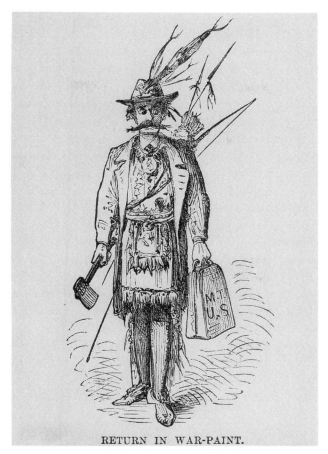

RETURN IN WAR-PAINT.

1.4 *"Return in War-Paint," engraving from* Innocents Abroad *(1869). Courtesy William Charvat Collection of American Fiction, The Ohio State University Libraries*

recognition; Louis Budd, who has most thoroughly charted the creation of the "Mark Twain" image, argues that "the public Twain evolved out of the subscription trade," which in turn provided the distribution for caricatures of the author (Budd 1983, 142). An interesting development subsequently begins to emerge in the photographic record: Twain begins to construct a photographic image that refers back to his caricatures, as we shall see as we go on. It is imperative that Samuel Clemens resemble Mark Twain—and so he becomes his own impersonator.

Photographs of Twain from the 1850s and 1860s were for the most part posed formally in a studio (as in figure 1.2), and by the 1870s such

images served as accompanying props for his lecture trade. Twain had dozens of copies of selected poses printed up on calling cards for distribution to his audiences and other interested parties.[15] The use of photographic reproduction in calling cards offers the recipient an image as a substitution for the photographed person, who may have called on an occasion when the object of the visit was not available to visitors. The photograph is in such cases left as a record of presence, the proof that a visit was intended and that the subject of the photograph was a visitor. It indicates to the recipient that he or she has suffered a loss (in not actually seeing the visitor), but proffers a substitute in the form of the photograph, the body's double, which reminds the host or hostess both of the intended presence and continuing absence of the visitor, thus lending the images an air of longing or nostalgia.

Photographs of celebrities also arouse longing in viewers. Celebrity images promote the body as product, the self as marketable commodity. These photographs and engravings (drawn from photographs) promoted recognition among the public of a face that would then be associated not only with a name, but with the power of making money through the body's appearance onstage. Twain's most successful product was his pseudonymic self, born of an association between his body's image and his literary and lecturing persona; later he would establish its use as a representative for various commercial ventures.[16] Crowds paid money to see this body reunified and identified with its disseminated image and name; Gillman contends that Twain's public "paid as much to see [the] author in person as to read his books" (Gillman 1989, 29).

Walter Benjamin writes that the work of art in the age of mechanical reproduction loses its aura of originality, of genius, through its sheer reproducibility (Benjamin 1969, 217–42). But he finds that early photographs transferred "cult value" from works of art (which are only valuable as "originals") to human faces: "The cult of remembrance of loved ones, absent or dead, offers a last refuge for the cult value of the picture" (226). It seems to me that he makes a mistake in limiting the cult value of portrait photographs to the early era of photography, for the idolatry of human images persists even now, both in the adoration of loved ones and in the worship of celebrities.[17] Benjamin apparently distinguishes between early portrait photographs of loved ones and "the cult of the movie star," which does not "preserve[] the unique aura of the person but the 'spell of the personality,' the phony spell of a commodity" (231). Yet can we in all honesty make this distinction? Is personality really more constructed in movie stars than in loved ones? He is correct, I think, in claiming that

our perception of the image depends on our associations with the subject pictured. Yet the fascinating aspect of photographic portraits lies in how sensations of "knowing" can be conjured for those we do not know, and the sense of longing can be aroused in us for those who are neither absent nor dead. The body's image, in other words, projects both familiarity and distance, no matter who is pictured. When a human body is infinitely reproduced and disseminated in photographs, the body's aura grows as more and more people see the photographic image. The body is the original, fully imbued with the power of authenticity through its existence as model for copies.

But then another reversal takes place. Naturally, the public would assume that the appearance of the body in question would guarantee the presence of a whole galaxy of other associated values; in Twain's case, they would identify the presence of humorous entertainment with the presence of the body, and if they were disappointed in that hope, they might begin to suspect that the *body* before them was a fake, a counterfeit. The image, on the other hand, could not be. A Jenny Lind who was not in voice was not "Jenny Lind," no matter how much she might resemble her reproduced and circulated images. It becomes the body's task to approximate its images.

Twain alluded to the fear of not living up to his image in a session with his biographer, Albert Bigelow Paine, when he recounted a recurring nightmare in which he attends a party dressed as a tramp or in his nightshirt, and no one recognizes him (Paine 1912, 3:1368–69). There is an alarming loss of authority implicit in the creation and widespread distribution of an image that is then taken as positive proof of identity for the body itself. This is the actual effect of the passport photograph, which takes over the body's authority by forcing the body to conform to it. If, in crossing a border, you do not resemble your passport photograph, it is not the photograph that will be punished.

We might imagine that the dissemination of "accurate" photographic images would dispel the fears of slippage between body and image, but for Twain this is clearly not the case. One of the immediate dangers of the infinitely reproducible image is the loss of control over that image when it is released to the public. As Gillman notes:

> In . . . an age of mechanical reproduction, to use Walter Benjamin's phrase, the author may suffer a fate similar to the one that Benjamin ascribes to the work of art: "what is really jeopardized" by technical reproduction is "the authority of the object," its "authenticity," its "unique existence." In Twain's case, though,

43

the threat is not so subtle as a diminution of aesthetic response; it is loss of literal authenticity, that is, of the *author's* control over the work. At the same time that books were mass-produced, imitated, and pirated, so in some cases did the writer himself become a commodity, marketed as platform artist, lecturer, reader, and personality. The problem of emerging technology of mass reproduction were thus intertwined with analogous concerns with artistic identity. (Gillman 1989, 29)

Gillman's remarks pinpoint the danger of unchecked photographic distribution. For example, studios owned the copyrights for the photographic calling cards they produced; most frequently the card announced the studio's address and the possibility of purchasing more copies of the image there. Once the photograph has left its subject's hand, any voyeur may take a long look at it, order reproductions, and distribute those among people quite unknown to the photograph's subject. A celebrity, whose money-making aura depends on the "image-repertoire" (Barthes 1981, 11) released to just such an unknown public, must take care that those images collectively enhance his or her livelihood. In this connection, McCauley remarks that "the mystery in this vast marketing of the rich and powerful [in photographic cartes de visite] is not why such images were popular, but why the sitters themselves allowed such profanation of their faces" (McCauley 1985, 82).

Alan Gribben records the ferocity with which Mark Twain protected his autobiographical writings (and the events of his life) as valuable property (Gribben 1984, 39–55). Not surprisingly, Twain came to treat photographic images of himself with the same jealous defensiveness as he did his writings. Several incidents recorded in his secretary's diary and in his correspondence document his insistence on absolute economic rights over photographic images of his body, particularly toward the end of his life, when the number of images of him rose sharply, as did their numbers in circulation.[18]

One such exchange occurred in the summer of 1904, when Twain had retreated to a summer residence in the Berkshires. Joseph G. Gessford, a New York studio photographer who made portraits of the elite of that city, had a branch studio in Lee, Massachusetts, where he photographed the same people at play. He made several portraits of Twain for *Berkshire Topics,* which met with Twain's explicit approval, as relayed to the photographer by Twain's secretary, Isabel Lyon. She asked on Twain's behalf for enlargements and copies of several of the images and inquired

about the cost. The gratified artist responded with the requested price list and was understandably startled by Twain's angry reply: "I asked you for prices. But it was merely a formality, I always do that. But I always expect the pictures to be sent to me free of charge. I was expecting it in this case, for I had expended upon you more than a hundred & fifty dollars worth of my time—gratis, as it turns out" (unpublished letter, 7 August 1904, MTP).

The photographer's response to this tirade, a plaintive "I could no more afford to *give* you these pictures than you can afford to write books for free" (unpublished letter, 8 August 1904, MTP), makes explicit how problematic Twain's stance is in this matter. While Gessford does not err in assuming that Twain certainly would not give away his writing, he fails to see that Twain imagines that photographic images, in the case of celebrities, belong to the body with which they are associated. Twain does not recognize the photographer as the creator of these images, perhaps in part because of the implicit understanding of photographs as "natural" art, but mostly because he conceives of himself as the creator of his own image—the photograph is made in his image.

Twain's objection that he has already donated valuable time to the photographer implicitly points to his status as celebrity; ordinary people, whose images interest none but the most restricted circles of acquaintance, must be satisfied to pay the photographer for his time and for the images of their own bodies. The time during which Twain is photographed, however, is part of his celebrity time, his professional time, and must be remunerated in kind by the photographer, who is expected to trade his professional time and materials for Twain's (the material in this case being of course the body's image). Photographs, acting as records of the passing of particular moments of time, serve as a kind of receipt for this exchange.

The initial request for a price list apparently was to be understood as a secret handshake between members of a fraternal order: the guild of artist/publicists. While Twain knows he is not just an ordinary customer, and he expects that the studio photographer knows this as well, he must play his accustomed role as ordinary citizen and ask how much he owes the photographer. The problem is that the photographer, unaware of the ironies of Mark Twain's pose, stubbornly insists upon interpreting the "ordinary citizen" gesture at face value, so to speak.

This misunderstanding between the photographer and his subject might be regarded as an individual case of miscommunication were it not for a similar occurrence in the summer of 1907. This involved the large

wire organization Underwood and Underwood, which had distributed stereoscopic views of Twain in the past and which was responsible for a wide dissemination of images of Twain in the nation's newspapers and journals. Again, a flurry of letters between Isabel Lyon and the hapless photographer H. D. Ashton record the history of a photographic interview requested, granted, performed, and finally botched through misunderstanding; Ashton published some of the photographs from the session before Twain had seen them.

In a letter, Ashton assumes the whole blame for the affair: "And regarding the Tuxedo [New York] photographs I am afraid that the matter is up to me instead of U[nderwood] & U[nderwood]. It was entirely an oversight of mine as I thought the matter had been attended to. . . . Of course Mr. Clemens is entitled to the pictures and we shall be only too glad to send them and at the same time apologize for not doing so before" (unpublished letter, 15 October 1907, MTP). Displeasure at such an indiscretion does not seem unwarranted or unusual, but the level of anxiety and anger evident in Twain's responses to these issues and the frequency of their recurrence (I have given only two examples) lead one to imagine a person who feared and distrusted any slippage between his body's image and his body, between production and control.

Another instance of loss of control over the body's image occurs through impersonation and imposture. Nelson Goodman contends that resemblance does not necessarily imply representation: "An object resembles itself to the maximum degree but rarely represents itself; resemblance, unlike representation, is reflexive. Again, unlike representation, resemblance is symmetric: B is as much like A as A is like B, but while a painting may represent the Duke of Wellington, the Duke doesn't represent the painting" (Goodman 1976, 4). Goodman's analysis seems eminently sensible, and it is a pity to go against good sense. But to take up the last part of his argument first, I have been arguing (to put it in his terms) that we expect the Duke of Wellington to resemble his image in bearing, dress, and style if he is to be received as a true Wellington. Further, in response to the first part of his argument (which he himself tempers with the word "rarely"), there are indeed occasions when an object represents itself.

When Samuel Clemens walks onto a stage as "Mark Twain," he represents Twain, who is also himself. It might be argued that he is playing a role, much as an actor plays Hamlet, and therefore does not represent himself but a fictional character. Still, while many people may play Hamlet, only Samuel Clemens may play Mark Twain. Or at least, so he main-

tained while he was alive. Twain addresses the problem of resemblance and representation in *The Prince and the Pauper,* but it was of personal concern to him as well. In *Life on the Mississippi,* for instance, one narrative strategy revolves around Samuel Clemens's "incognito" return to a steamboat, where he proposes to collect material for his book, *Life on the Mississippi.* Here an interesting dilemma arises. Returning to the Mississippi River where he once worked as the pilot Samuel Clemens, the man who is both Samuel Clemens and Mark Twain attempts to pose as a "nobody" in order to avoid detection as Mark Twain (a "somebody"). The problem is that the nobody and the somebody share the same body, whose image has been reproduced and passed hand to hand under the rubric "Mark Twain" in both photographs and caricatured engravings. As James Cox puts it, "it is not Mark Twain reconstructing the life of Samuel Clemens as his own life but the record of Samuel Clemens returning to the Mississippi in the person of Mark Twain whom he cannot hide" (Cox 1984, 105). Twain professes dismay at his exposure: "How odd and unfair it is: wicked impostors go around lecturing under my *nom de guerre,* and nobody suspects them; but when an honest man attempts an imposture, he is exposed at once" (Twain 1982, 112).

Louis Budd estimates that illegitimate Twain impersonators may have appeared as early as 1868, and Twain made efforts to apprehend those who used his name for their gain (Budd 1983, 48). By the late 1870s, on the other hand, he had the pleasure of watching an impersonator perform as "Mark Twain" (Budd 1983, 55). There is, however, a significant difference between the experience of hearing that someone is stealing your image from you in some distant place and observing the theft yourself. In the second case, the "theft" is acted out before you and an audience, who can compare the impersonator with the original on the spot.

Susan Gillman's use of the word "imposture" illuminates the issue of Twain impersonators as I would like to discuss it; she writes that "Since 'posture' already implies posing or faking, 'imposture' is the pose of a pose, the fake of a fake: the word implies no possible return to any point of origin" (Gillman 1989, 5). Certainly if we take the Mark Twain persona as just that, a persona (or mask), the people who pose as Twain are impostors in the sense that they pose as a pose. And as Gillman has it, "imposture" does not necessarily imply deceit or theft, for the imposter's persona cannot be traced to "any point of origin," that is, a legitimate claimant to that persona (6). But the Twain impersonators not only assume the Mark Twain persona; they also attempt to approximate Mark Twain's physical appearance, his body. With the proliferation of images of

the author (both lithographs and later, photographs), it became necessary to try to *look* like him. By forcing his body back into the circle of referentiality—that is, by sitting in the audience and observing his impersonator—Twain reclaims his own right to imposture. Only he is allowed to pose as Mark Twain. This episode uncovers the body's importance in the act of imposture, and hints that even a "fake of a fake" has serious implications when it refers to a living body.

The impostors who performed as Mark Twain independent of his presence and control brought to the fore issues of authority, legal responsibility, and economy, all of which are associated with the ties between the name, the image, and the body. Twain's battle with the United States Congress and others over the issue of copyright laws further substantiates his anxiety about imposture and the economic implications of identity theft. For the work of the plagiarist or the imposter poses the same threat: loss of identification between the body and its product. In analyzing the phenomenon of Twain impersonators, Susan Gillman speculates that as his popularity grew (that is, as his image was disseminated more and more) "he became less and less in control of his book/product, his audience/consumer, and his own image" (1989, 24). The fear that the duplicated image could in fact become more powerful than its original emerges in the dreams mentioned above, in which the "real" self, dressed as a tramp or in a nightshirt, does not find recognition among people who would recognize only the duplicated images they have received.

If we may set aside for the moment Twain's reaction to *Also sprach Zarathustra* ("Oh damn Nietzsche! He couldn't write a lucid sentence to save his soul"),[19] we see that Twain and Nietzsche share an understanding of autobiography and its propensity for self-reproduction: "ich bin ein Doppelgänger," Nietzsche writes (Nietzsche 1977, 44), a sentiment echoed throughout Twain's life and work.[20] But while Nietzsche apparently reacts to his insight about the fragmentation and ultimate reproducibility of the self with something like euphoria, Twain's effort to stage and control his own duplication through photographs and autobiography points to a fundamental uneasiness.[21]

Mark Twain impersonators, his errant duplicates, continue to perform today,[22] and as predicted in "No. 44," their cloning sometimes spins out of control. Hal Holbrook has been plagued by impersonators who pose as Hal Holbrook posing as Mark Twain, and though this would surely qualify under Gillman's rule of imposture ("a pose of a pose"), Holbrook just as surely has some entitlement to his name and livelihood. Though we might be tempted to imagine the body as construct, it continues to

make its material claims. Pseudonymity may complicate the issue of iden-tification, but it cannot erase the tie between the body and its poses.

Candor and the Photographic Autobiography

To investigate the idea and presentation of candor in photographs, I will first examine a stereoscopic view of Mark Twain in his study at Quarry Farm in 1874 (figure 1.5). He sits turned in profile, his head bent slightly over his work, apparently absorbed. In a chair at the side of the desk and in the right foreground of the image sits his hat. We can make out the stem of a pipe held in his left hand and a pen in the right.

This image marks a significant departure from the studio photographs of the earlier years. It introduces the viewer to a private space, the study, the secret heart of the creative process. The anonymous and eminently interchangeable studio space of Twain's earlier photographs has given way to a particular background of bourgeois household objects that now, by virtue of their appearance in the same photographic space as Twain's writ-ing body, may be associated with the "private" man. "His" desk, "his" chair, "his" hat . . . although in fact it may happen that none of these things belongs to the writer at all.

The stereoscopic view insists that we see this as the author's envir-onment, giving us the illusion that we now "know" more about him than before. At the same time, the image reiterates things we may have "learned" about Twain from caricatures: his perpetual use of tobacco, his prominent moustache, his identity as writer. Although he is seated and apparently at rest (with his legs crossed), the observer still receives in his upright posture the implicit message of concentrated activity. The au-thor's writing hand connotes not only physical movement, but a move-ment into the future, when the words will be transmitted to the viewer. The light hat so prominently yet casually positioned in the foreground of the picture (near the point of entrance for the viewer) signifies hat-at-hand—soon to be hat-in-hand or hat-on-head—which refers back to the caricature of the hurried and innocent traveler.

In this image Twain approximates caricatures of himself like those from *The Innocents Abroad*. In "Poet Lariat" he reveals himself in the act of composition; "On the Warpath" indicates his roughness and readiness through the presence of his pipe and his hat. But he recasts the humor-ously exaggerated features that brought him fame into a "serious," tem-pered setting, where they reiterate the physical features that link Sam Clemens to Mark Twain without betraying their comic origin in the cari- **49**

1.5 *Mark Twain, half of a stereoscopic view, 1874. Courtesy The Mark Twain Archives, Elmira College, Elmira, New York*

cature. James P. Waller, looking at the same stereoscopic image, remarks: "All the motifs are there: the pen and manuscript; the books that recall his reading; the full trash can that attests to his efforts; the tobacco that was always his signature; . . . This was the photographic image: he was real, authentic, original" (Waller 1990, 417). Of course, this authenticity, like the three-dimensionality of the stereographic image itself, is carefully staged and thus far from "authentic" in the ordinary sense. The opening of a private space to the public has a function related to the one I mentioned earlier, namely the guise of posing as oneself.

When the stereopticon image was taken in 1874, it was not possible for the subject of the photograph to be unaware of the photographer, as

the image seems to indicate that he is. Our easy familiarity with snapshots might trick us into believing that such an image could be "candid," and it is in fact the intention of Twain and the photographer that the image be read as unposed, though it clearly was not, as Twain's inscription to Howells on the back of the stereopticon image reveals: "Do you mind that attitude? It took me hours to perfect that" (Smith and Gibson 1960, 25). Here Twain's humbuggery becomes apparent; as in the early daguerreotype, he is posing as himself. He is also posing—and here is where the paradox and the difference from his earlier studio images occurs—as his private self, the self at home.

This image of Twain at work pretends to a reality beyond the act of being photographed, and it is more self-consciously constructed than any other of Twain up to this date. In studio photographs, Twain's pose was that of the subject being photographed in a studio, and was recognizable as such to the viewer. In this one he masks the presence of the photographer by turning away from him and by setting the photograph in a space no longer recognizable as belonging to the photographic apparatus. The effect resembles a stage-setting, with the fourth wall removed and left open for spectatorship by the photographer's position. Finally there is the important fact that this staged scene was presented to the public not in two dimensions, as it is reproduced here, but in three, with the aid of the stereoscopic device. This gesture of opening private space to "visitors" was therefore enacted not only in the surface imagery but also in the illusion of opening up the closed surface of the photograph itself. The space between the stage and the audience is removed through the agency of the stereoscopic device. This is perhaps what is meant by Jonathan Crary when he states that the "stereoscope as a means of representation was inherently *obscene,* in the most literal sense. It shattered the *scenic* relationship between viewer and observer" (Crary 1990, 127).

Crary argues that although stereoscopic imagery involves the use of photographic technology, by rights it should be considered as "thoroughly independent of photography" in terms of its "conceptual structure" (118). The stereoscope's unique "aim [is to] simulate the actual presence of a physical object or scene, not to discover another way to exhibit a print or drawing" (122) or "tangibility" (124). In his study of the history of the conception of visualization and the observer in the modern world, Crary suggests that we cannot know, as twentieth-century viewers, what a stereoscopic view looked like to an observer of the nineteenth century. To clarify matters, he cites one nineteenth-century individual who declares that "after viewing such a picture and recognizing in it some object like a

house, for instance, we get the impression, when we actually do see the object, that we have already seen it before and are more or less familiar with it" (124).

I would argue that this effect takes place in viewers of photographs as well, but it seems reasonable to assume that the "reality effect" of the stereoscope would carry with it more of the conviction of familiarization, in part because the nature of the stereoscope required a plethora of objects in order to produce its effects. The most popular settings for stereoscopic views were precisely the kind of bourgeois interiors depicted in the image of Twain's study at Quarry Farm, for the illusion of binocular vision required the presence of objects at different positions in the field to convey the sensation of depth.

Oliver Wendell Holmes, in his enthusiastic endorsement of the stereoscope, claims that

> the first effect of looking at a good photograph through the ste-
> reoscope is a surprise such as no painting ever produced. The
> mind feels its way into the very depths of the picture. The
> scraggy branches of a tree in the foreground run out at us as if
> they would scratch our eyes out. The elbow of a figure stands
> forth so as to make us almost uncomfortable. Then there
> is such a frightful amount of detail, that we have the same
> sense of infinite complexity which Nature gives us. (Holmes
> 1859, 77)

Clearly Holmes has been convinced by the illusionary "depth" of the binocular image, but between the lines of his commentary runs a vague uneasiness and discomfort: the trees aim to "scratch [the viewer's] eyes out," a photographed figure's elbow threatens to jut into our physical space, and the mind reels from the sheer weight of detail presented by the image. The stereoscopic image poses a kind of threat to the viewer, even if it is nothing more than the fear that the photographed space will invade the viewer's real world.

Conversely, returning to the stereoscopic image of Twain in his study, the hat in the foreground refers to a world outside the frame of the image, to the space outside the room from which and toward which Twain is imagined to have moved and move, but also a stereoscopic gesture made to pull the viewer into the space represented. The stereoscope offers a visual representation of what every photograph performs: integration of past and present moments, of the here and there, the then and now. In this particular represented space, writing is taking place, or at least the

semblance of writing. The message Twain sends to the viewer is that the writing moment is the *real* moment, a glimpse of his real self as opposed to the posed self of the studio. The viewer is admitted into the writing space, which traditionally has been a solitary one, in which writers isolate themselves from the reading world precisely in order to write.

It requires a suspension of suspicion on the part of the viewer to believe that a writer can be photographed at work, for, if we think about it, it is evident that only under voyeuristic circumstances would such an image be possible. Even if the photographer is well hidden, the true work of writing, the process of imagination that transforms thoughts into written language, cannot be depicted in an image. In having a stereoscope made of himself writing, Twain *performs* writing, for although he is pictured alone and turned away from the observer, absorbed in his apparently solitary activity, the format and illusionary quality of the stereoscopic image countermands those signals and tells the viewer that the writer has opened the scene of production to the public. This gesture will become particularly relevant when we consider the experimental nature of Twain's autobiography, which also professes to confront the public with the moment of creation.

The play between public and private selves hinted at in the use of the pseudonym and the posed "intimate" stereopticon view becomes more obvious as Twain's photographic record responds to the technological developments in photography, which began to move from posed studio images to "candid" shots. If we equate "candor" with sincerity or openness, it is clear that the mercilessness of the photographic eye might seem to act as an enforcer of candor, since photographic images are identified as a moment of "truth." In early portrait photography, however, where the photographic subject was forced to hold poses for uncomfortable minutes, our contemporary notion of photographic candor was not possible. The idea of candor in such images was different; it would not derive from the viewer's belief that the subject had been caught unawares, but instead depended solely upon the viewer's belief in photography's power to depict without embellishment or variation the body presented to the camera's eye. The pose of that body and the circumstances under which the body's image was recorded were strictly limited by the physical nature of photography at that time, which required long exposures and unwieldy equipment. Not only the tradition of painted portraiture demanded a face-on, frozen aspect in its subject—early photographic technology demanded such a pose as well.

While the technology existing at the time of the stereoscopic image 53

did not allow for a "candor" on the level of the intimacy of Twain at his desk, the photographic medium promised the possibility of candor. By this I mean that the generally accepted "truthfulness" of photographs indicated the potential to develop the medium in order to catch people "in the act." Long before technology had evolved to the extent necessary to make cameras roving, invisible eyes, people understood that the move from the camera obscura, in which the image was viewed and recreated from the interior of the device, to the photographic camera, which is exterior to the viewer and the object viewed, would eventually mean that the photographic camera could be positioned and used as a "private eye." Walter Benjamin predicted that "the camera will become smaller and smaller, more and more prepared to grasp fleeting, secret images" (Benjamin 1969, 215). In Benjamin's view, the voyeuristic camera has the potential to supplant and overwhelm the human eye and memory with snippets of absolute reality.

The idea of "candor" in connection with photographic images undergoes a strange transformation. Ordinarily, we suppose that candor involves a relationship between two or more people, in which one of them "opens up" to the other(s), expresses something honestly. In the photographic situation it is not the subjects of the "candid" photograph who are candid, for they are supposedly unaware that anyone is looking at them, and therefore cannot necessarily be understood as behaving honestly or openly toward the photographer. Nor are the photographer and his device candid, for they have positioned themselves in such a way as to conceal their activity from the photographed subject. It is only apart from the act of photographing that candor takes place between the image and its eventual viewer; the image is candid as image toward its viewer, or at least it has the appearance of being so. It is the image that pretends an honesty about what it captured: "This is an unposed snippet of reality." But here again we see where the problem with "candor" in photographs comes in; it is not possible for the viewer to determine, in looking at the image, whether it is "candid," because it has been removed from the scene of its creation. The viewer cannot see the relation between the photographer and the subject, for the photographer is invisible to the viewer.[23]

In the case of the stereopticon image, the technologically informed viewer knows that the candor is illusion. But once portable cameras had been perfected (with Kodak opening the international market to amateurs by 1888), it was in fact possible that an image may have been taken without the subject's knowledge, and that the viewer therefore has a privileged look into the unaware subject's life. Paradoxically, the possibility

1.6 *Mark Twain and his wife, Olivia Clemens, 1895, photograph by Major James B. Pond.
Courtesy The Mark Twain Archives, Elmira College, Elmira, New York*

of real candor made illusion easier, and Mark Twain knew how to produce
the illusion of candor to his advantage.

Thus we find a growing number of photographs, starting from the
1890s, in which Twain is depicted in his "private" life, inasmuch as the
moments when he is not obviously posing for the photographer can claim
to be "private." Major James B. Pond, platform lecture impresario, trav-
eled with Twain at the beginning of his world lecture tour and assembled
a large number of "candid" snapshots of the author on the road, using one
of Kodak's early pushbutton cameras.[24] One of Pond's images captures
Livy Clemens, in hat and veil, speaking to her husband (figure 1.6). Here
Twain is not only not looking at the photographer but is absorbed in
something inaccessible to (yet contained within) the photograph's frame:
the act of conversation. The image does not reveal whether the photog-
rapher's presence was obvious to the photographed subjects. Like the

1.7 *Mark Twain, 1895. Courtesy The Mark Twain House, Hartford, Connecticut*

stereopticon view, this photograph both invites the viewer to a private
family space (the relationship between Twain and his wife) and conveys
the presence of activity beyond the power of the photographic reach (be-
cause it is not visual). Livy's veiled face provides an analogue for the pho-
tographic text; while admitting the gaze of others through its translucent
surface, the veil nevertheless connotes a defense of the most private self.[25]
Other "candid" shots of Twain reveal him in the act of reading, smoking
(figure 1.7), having his shoes shined, or waiting for a train, always appar-
ently unaware of the presence of the photographer.[26] The candor of such
images creates the impression of opening private space to the viewer;
while the surface of the studio portrait is smooth and closed, defying a
reading that enters the private sphere of the subject, the "candid" portrait
offers an apparently unguarded surface, with a psychological effect not
unlike the visual effect of the stereopticon.

56 Thus far I have limited my observations to the "candor" inherent in

images produced by supposedly hidden cameras. Other situations may be typified as "candid" as well, in which the photographic subject frankly acknowledges the voyeuristic interest of the photographer by posing as unposed. The dictionary describes "candid" photographs as "unposed and informal," while I might be more inclined to say that we ordinarily use the word to denote "unposed *or* informal" images (Neufeldt 1988, 203). The line between "posed" and "unposed" is difficult to draw, and here too Mark Twain plays to his advantage in the interstices.

Once the illusion of candor characterized the photographic scene, Twain began to work even more intensively on the disruption of the line between public and private space, a development that is most apparent in his practice of being photographed in bed.[27] Louis Budd, in an essay dealing with the bed photographs, speculates as to their purpose: "In allowing the bed photographs Twain was both confirming and indulging the general perception of two of his characteristic qualities: his unconventionality and his spontaneity" (Budd 1984, 180). This view attributes the making of the bed photographs to Twain's candor, which he would have liked. Paradoxically, he uses his eccentricity to make himself seem more like "one of the folks"; it is the same democratic impulse that moved Richard Nixon to air his household finances and Lyndon B. Johnson to expose his operation scars to television audiences.

With the gesture of inviting the public into the bedroom and revealing himself in dishabille, Twain makes the viewer his intimate—apparently, we are as close as family members, as lovers. On the other hand, as Budd points out, the situation smacks of His Majesty receiving guests in the royal bedchamber, a scenario that conforms to the name given to Twain by the loyal members of his household: "the King." Thus the private and intimate moment of sitting with the nightdress-clad author in his bedroom also works to distance or discomfit the viewer, especially if the viewer in question is the photographer, who is actually on the scene.

Both sides of this paradox are present in one of Pond's images from the beginning of Twain's 1895 lecture tour around the world, in which Twain grants an interview to Vancouver reporters from his bed (figure 1.8). The fully clothed reporters, clearly aware of the camera (one man gazes directly at the photographer), and Twain, apparently blithely indifferent to it, effectively communicate the conundrum of this photograph, which conveys both comfort and discomfort, studied informality and stilted formality. Budd remarks that "once [Twain] suggested having a bed made up for a visitor if that would help him feel at ease" (Budd

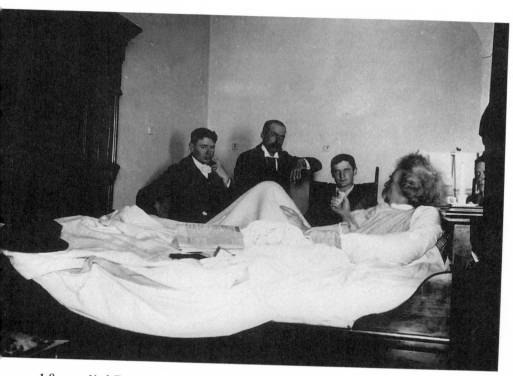

1.8 *Mark Twain giving an interview in bed, 1895, photograph by Major James B. Pond. Courtesy The Mark Twain Archives, Elmira College, Elmira, New York*

1984, 180), which hints that Twain was aware that a fully clothed visitor who confronts a half-dressed host does not necessarily experience unmitigated pleasure.

We may note that in this instance, Twain restages the nightmare of appearing in his nightclothes at a formal gathering, but here he takes control of the situation, placing the onus of inappropriate dress upon his visitor. His act of apparent self-exposure thus becomes an act of manipulation, disarming the fear of self-exposure by exposing another to embarrassment. This game (for it was at some level clearly a game) resembles in some respects the Fort-Da game described by Freud in *Beyond the Pleasure Principle* (Freud 1924–1934, vol. 6), in which the child takes pleasure in throwing away and recovering an object, uttering the German words *fort* (gone) and *da* (here). As Freud tells it, the pleasure the child feels is invested in the sense of power gained from controlling a similarly terrifying moment: the departure of a parent. Further, Freud speculates

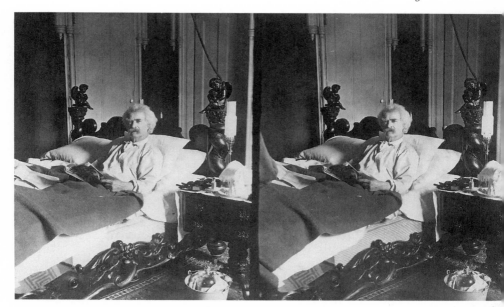

1.9 *Stereoscopic view of Mark Twain, 1906, photograph by Albert Bigelow Paine. Courtesy The Mark Twain House, Hartford, Connecticut*

that the child acts in revenge upon the departing parent by sending the parent away rather than allowing the parent to depart of his or her own accord. Twain's situation offers an interesting twist to this arrangement, in that it is his own appearance and disappearance that he engineers, his own covering and uncovering. He reveals himself to and distances himself from the viewer, who is made to experience the discomfort he felt in his dream at his own exposure, but also the pleasure he now feels in the release from the constraint of societal expectations. Like the child playing the Fort-Da game, Twain's performs his act of self-exposure again and again, with circulation of the bed images spreading in journals and newspapers beginning in the spring of 1906 (Budd 1984, 179).

Though the first bed photograph of Twain appears in 1895, it was not until 1906 that the bed pose became a kind of obsession, repeated in multiple views, published at home and abroad, reproduced in a cartoon and a lithograph and, appropriately, a stereopticon view (figure 1.9). The concurrence of the increased production of bedroom views, the reinitiation of autobiographical dictation, and the introduction of a photographer/biographer into the Twain household was no simple coincidence; Albert Bigelow Paine arrived on the scene in January 1906, and his pres-

ence sparked the repeated enactment of the Fort-Da game, not only in the photographic record, but in a parallel way in Twain's autobiographical narrative, which I will now explore.

As from the Grave

Two aspects of Mark Twain's experimental autobiography relate the text to his use and understanding of photographs. The first of these is the dissolution of boundaries (in his photographs and his autobiography) between public and private, life and death. The second is Twain's explicit association of memory with photographic visualization, a link that finds reflection in the structure he adopts for the autobiographical narrative. I will first discuss Twain's transgression of the boundary between public and private selves, this time in his autobiographical text.

Louis Renza calls Twain's autobiographical *Life on the Mississippi* "a work in a state of narrative dishabille," which also applies, I would argue, to the photographic record and to the transcribed dictations that form the larger part of *Mark Twain's Autobiography* (Renza 1987, 158). With "narrative dishabille" Renza refers to the messiness of *Life on the Mississippi*, a "loose narrative series of chapters comprised of miscellaneous conventional genres, whimsically inserted digressions, episodes, anecdotes, jokes," etc. (158). But what Renza perceives as unintentional undress (like a slip showing) in *Life on the Mississippi* reveals itself as part of a strategy of self-presentation when we look at Twain's carefully staged autobiographical photographs and dictations.[28]

Here I will appropriate Renza's phrase for my own purposes, positing textual "narrative dishabille" as a situation in which the narrator coyly reveals himself *as* narrator, oscillating between hidden and exposed positions in a kind of authorial striptease, not unlike the flirtation of the bedroom photographs. As the "candid" photographs required a pose, so the experimental form of Twain's autobiography demanded a performance situation, as these remarks to Albert Bigelow Paine reveal:

> The idea of blocking out a consecutive series of events which have happened to me, or which I imagine have happened to me—I can see that is impossible for me. The only thing possible for me is to talk about the thing that something suggests at the moment. (Twain 1924, 1:269)

Twain means "talk" literally; he made several false starts at committing the earliest years of his childhood to paper before he "hit upon the right

way to do an Autobiography" (1:193). Rather than subscribing to "the plan that starts you at the cradle and drives you straight for the grave, with no side-excursions permitted on the way,"[29] he devotes himself to the depiction of the mind's side-excursions, and in so doing makes remembering (rather than memories) the focus of his project. Maria Ornella Marotti describes Twain's method as "digression as a formal principle. . . . The text becomes an unmediated product, the result of an attempted symbiosis between word and thought. . . . Such writing . . . is meant to transcend the separation between written and oral performances" (Marotti 1990, 2). While I hold with Marotti that Twain's project represents "a paradox and contradiction in itself," I cannot agree that this writing "does not envisage an addressee, an audience, a listener, a reader" (2). On the contrary, Twain created an audience for his autobiography so that readers could envision themselves as addressed. He began dictating his autobiography to his secretary, Isabel Lyon, in Florence in 1904, and approximately two-thirds of Paine's edition of the autobiography originated in sessions where Twain would dictate his thoughts to a stenographer or secretary, often with Paine, his biographer, sitting in. Many more pages of dictated material remain unpublished. This autobiography was an oral performance with a captive audience.

It may be argued that the dictation sessions simply provided the raw material for what would later be edited and transformed into written text; Twain's secretary notes numerous occasions when she and the author went over the completed typescripts, and a perusal of the typescripts reveals a good many editorial changes in Twain's hand.[30] Yet in his editing, he does not cleanse the text of signs of dictation; instead, *Mark Twain's Autobiography* remains firmly rooted in the performative situation in which it was created. Twain's references within the text of the autobiography to the act of dictating, his habit of directly addressing his listeners, the repeated meditations on his autobiographical strategy—all of these refer back to the physical scene of production. Like the stereoscopic image of Twain in his study, the autobiography proposes to show the author at work.

An opening up of the writing space occurs most strikingly in the passages that refer to the autobiographical experiment. While it is not unusual for autobiographers to explain the premise for their narratives (particularly at the outset), Twain's repeatedly discusses his unique methodology: "Within the last eight or ten years I have made several attempts to do the autobiography with a pen, but the result was not satisfactory; it was too literary" (Twain 1924, 1:237); "This Autobiography is dictated,

not written" (2:246); "this autobiography is like a mirror" (2:311); "It is this sort of thing which makes the right material for an autobiography. You set the incident down which for the moment is to you the most interesting" (1:288).

Signs of the act of speaking occur when Twain interrupts himself to say, "I seem to be overloading the sentence and I apologize" (2:238) or "Now let me see, there was something I wanted to talk about, and I supposed it would stay in my head. I know what it is——" (1:270) or "Well, Twichell said—no, Twichell didn't say, *I* say" (1:343). Not only does the narrator imply ("Well," "Let me see," etc.) that he is speaking; he also lets the reader see that he is addressing someone. In some cases, the interlocutor remains silent and unidentified: "Did I dictate something about John Malone three or four days ago? Very well then, if I didn't I must have been talking with somebody about John Malone" (1:328). Here an exchange has taken place, though only one side of the conversation is presented. In another instance, we read the name of the addressee and his response:

> Mr. Paine, you and I will start that magazine, and try the experiment. . . . Are you willing?
> *Mr. Paine.* "I should be very willing, when we get time to undertake it." (1:336)

The typography of this short passage as it appears in the first edition differentiates between Twain's spoken words and Paine's, which are set apart with his name (as in a drama) and quotation marks. Twain's remarks, because they make up the primary text of the autobiography, do not appear as a citation. Yet the interpolation of clearly identified spoken language into the text alerts the reader to the scene of performance and sends a message: all of the unmarked text should be understood as a monologue with occasional asides to a real audience. Twain's asides, whether they touch on his autobiographical experiment, himself as speaker, or the presence of his audience, direct our attention to the narrator in the act of narrating. It is Twain's idea to create an autobiography that acts as a "mirror"; while narrating he claims that he is "looking at [him]self . . . all the time" (Twain 1959, xiii).

Thus the structure of his autobiography relies upon a constant reference to his image at the moment of narration, from which all of his memory associations are made. Like the frontispiece bed photograph from the first volume of the autobiography (taken by Paine), the narrative reflects

upon the self in bed (where Twain purportedly dictated the autobiography). The camera and the eyes and ears of the audience act as the autobiographical mirror to which Twain alludes, as he uses the audience to see himself. In Twain's case, the specular, reflexive situation, imagined by many critics of autobiography as taking place within the narrator or between the narrator and a projected reader, refers explicitly to the body as it is heard and seen by others at the time of the dictations. Further, the casual nature of Twain's voice, edited to allow the scene of narration to shine through, points to the intimacy of the narrative situation. Like the bed photographs in which he appears in his nightclothes, Twain's autobiography purports to show us the "unbuttoned" man:

> In this Autobiography I shall keep in mind the fact that I am speaking from the grave, because I shall be dead when the book issues from the press.
>
> I speak from the grave rather than with my living tongue, for a good reason: I can speak thence freely. . . .
>
> It has seemed to me that I could be as frank and free and unembarrassed as a love letter if I knew that what I was writing would be exposed to no eye until I was dead, and unaware, and indifferent. (Twain 1924, 1:xv–xvi)

Twain's comparison of his autobiography to a love letter is particularly striking in light of the author's proclivity for bedroom intimacy with his public; but given the presence of an audience for the dictations, the author's entanglement with his immediate audience *and* his reader might more accurately be described as a ménage à trois.

While in his preface Twain cites the posthumous publication of his autobiographical revelations as a reason for loosening his tongue, he actually continues to engage in a Fort-Da game with the manuscripts produced during these intimate sessions, releasing twenty-five chapters for serial publication in the *North American Review* during 1906–7 (i.e., while he was still alive), with the following note:

> Mr. Clemens began to write his autobiography many years ago, and he continues to add to it day by day. It was his original intention to permit no publication of his memoirs until after his death; but, after leaving "Pier No. 70" [i.e., after his seventieth birthday], he concluded that a considerable portion might now suitably be given to the public. It is that portion, garnered from the quarter-million of words already written, which will ap-

pear in this *Review* during the coming year. No part of the auto-
biography will be published in book form during the lifetime of
the author.—Editor N.A.R. (Twain 1906, 321)

Thus it is clear from the beginning that the *North American Review* chapters,
which publish an edited version of early written and dictation manuscript
materials, represent but a fraction of an enormous text—the editor al-
ludes to a grand "quarter-million of words." And what sort of revelation
is held in reserve for the reader of the future?

Ostensibly Twain chooses to hold back certain portions of the auto-
biography that air dangerous political, religious, and personal beliefs, as
Isabel Lyon (his secretary) affirms:

> I sat in my study this morning and listened to the dictating. It
> struck at the fundamental parts of the Christian creed and isn't
> to be published for 500 years. Miss Hobby [the stenographer],
> who has strained points in her wish for chaperones, won't need
> one now I think, because discussion of the Immaculate Concep-
> tion doesn't leave much uncovered. Not if Mr. Clemens is do-
> ing the discussing.[31]

In recounting Miss Hobby's dilemma, the secretary also inadvertently un-
covers the essential paradox in her employer's plan to "speak from the
grave." If, as Twain proposes in his foreword, he plans to address the
reader as intimately as a lover, then the stenographer is justified in her
plea for a chaperon. The sexual nature of the material that Twain enjoys
airing under the rubric of blasphemy plays the same game with the ste-
nographer that the bed photographs play with the photographer and ulti-
mately the viewer. He allows himself the liberty of talking to a lady about
such matters because he is posing as a dead man. Her disregarded re-
quests for a chaperon indicate that she is neither prepared to regard him
as dead, nor is she able to place herself in the position imagined for her
by the dictating situation: that of the enlightened reader of 500 years
thence. The secretary, Isabel Lyon, performs the reader's role when she
eavesdrops on the dictations from the next room; like her, we are audi-
ence to an audience.

That certain portions of the text would be released only upon his
death has less to do with the inflammatory nature of those passages than
with the games Twain likes to play across the lines of public and private;
or more seriously, between life and death. Twain's desire to survive textu-
ally beyond his physical death (to speak as from the grave) may be ascribed
to the need to draw out the publication of the autobiography in order to

provide more liberally for his heirs (as it turned out, only his daughter Clara survived him).[32] There is, nevertheless, also a sense that the repeated practice of promising, revealing, and then concealing continues the game of imposture played out in the bedroom photographs, emphasizing the imminence of death in the pose of the white-haired author in the white of the shroud.

Twain is not the first autobiographer to ascertain the advantage of discourse from a place outside of life; Chateaubriand's autobiography, *Memoirs d'outre tombe* promotes the same idea in its very title, while Heinrich Heine remarks in his *Memoiren* that he feels able to touch upon the most painful incidents in his life only because his illness in exile has made him dead to society. His play upon the French pronunciation of his name underscores his social death: Henri Heine = *un rien* (Heine 1964, 411). In an analysis of Friedrich Nietzsche's autobiographical *Ecce Homo,* Jacques Derrida brings forward Nietzsche's meditation on the essential presence of death in "life-writing"; Nietzsche, too, imagines himself writing "with one foot *beyond* life"—in other words, with one foot in the grave (Nietzsche 1977, 45). Autobiography, which projects the living writer beyond his or her life, acting as a conduit between the dead writer and the living public, creates for itself a space between life and the grave. This grows not only out of the necessity for writers to protect themselves from the recriminations of an angry response to their texts, but out of the essential nature of autobiography, which upon the author's death substitutes a text (or corpus—body of texts) for a living human being.[33]

Derrida imagines the relationship between the autobiographer and the reader as a contractual one, extending beyond the author's death (not unlike the contract Twain envisions for his legatees):

> If the life that [the autobiographer] lives and tells to himself ('autobiography,' they call it) cannot be *his* life in the first place except as the effect of a secret contract, a credit account which has been both opened and encrypted, an indebtedness . . . , then as long as the contract has not been honored—and it cannot be honored except by another, for example, by you—[the autobiographer] can write that his life is perhaps a mere prejudice. (Derrida 1988, 9)

As Derrida would have it, the *bios* (life) does not exist until the text has found a public, and since Twain meant to withhold his text until after his death, he indeed would seem to speak from a place outside life—if he had not insisted upon a live audience. The presence of the audience re-

veals the death mask as a pose, and in both withholding and performing the text, Twain attempts to straddle the grave. Understanding that writing as from the grave is merely a pose, he still sets out to enact and portray that pose, dictating from his bed (the listener and stenographer acting as the ears of the future) and posing for photographs while dictating in bed (speaking from the crypt).[34] While I am not sure that Twain was convinced that he was actually speaking as from the grave (it seems more likely that he enjoyed being both *da* and *fort*/here and not here), it is certain that the "ghostly" nature of photographs (both of Twain and generally) supports Twain in his pose.

Photographs, like autobiographies, occupy a strange territory between death and life.[35] The bed/sepulcher photographs of Twain, through their association with the autobiographical text, only make explicit what lies implicit in all photographic images: that the person depicted is a dead person, no longer, at least, living in the moment depicted. As in the first daguerreotype, where Twain pretends to give us his name, here he exhibits a profound understanding of photography's illusory and uncanny nature, which he extends to the arena of his autobiographical dictations. But while photographs may be understood as relics of things past, they also assert the once-living presence of the person depicted.[36] The photographs of Twain "at work" and the dictated narrative of his autobiographical text conspire to remind the reader that there was a viewer, a listener, and a speaker—and they were all alive.

The photographs of Twain in bed—taken by his biographer and others in tandem with his work on the autobiography, published concurrently with excerpts from the autobiographical text, and represented by a single example in the first edition's frontispiece—illustrate his position between life and death. The sepulchral darkness of his heavily carved, dark bed and the white dressing gown and sheets framing the old man's face conscientiously reflect the space beyond the grave, even as his apparent "activity" (reading, smoking, etc.) subverts that reading of the image. Toward the end of Twain's life, there were rumors abroad that he had died. His reply, "The reports of my death have been greatly exaggerated," has become a signature of his particular brand of humor. But through his autobiography's frontispiece photograph and preface ("As from the Grave"), the author's death becomes the focal point of his narrative, and so it is Twain himself who prematurely announces his death. By the time the autobiography was published in 1924, the report was no longer exaggerated.

Flashlight Glimpses

Mark Twain's autobiographical experiment bears a structural resemblance to photographic narration in that it is a "combined Diary *and* Autobiography," as Twain put it (Twain 1924, 1:193), adopting a diaristic structure to reflect more accurately (in Twain's view) the process of memory. To highlight the resemblance between his autobiographical method and the journal form, Twain began in 1906 (with the addition of Paine to his staff) to head each entry with the date and locale of the dictation session. But while Twain assumes a pose of confidentiality (speaking as from the grave, speaking like a love letter) in his autobiography, it is not the intimacy of the journal form that he seeks to emulate. The diarist might indeed conceive of a readership, but he or she is imagined as creating in solitude; Twain dictated the greater part of his autobiography before an audience, as I discussed in the last section. The most important resemblance between Twain's autobiographical experiment and the diary form lies instead in the dependence of both on the present moment as a point of departure. The imbrication of past and present that occurs in autobiography, diary, and photograph provides a model for Twain's conception of historiography.

In this, Twain foreshadows Walter Benjamin's theoretical writings on historiography, in which Benjamin insists on historical narrative that illuminates the past in fragmentary moments, linked inextricably to the historian's present moment: "It is not the case that the past throws light on the present or the present its light on the past, but the [true historical] image is a constellation, in which that which has been meets the present moment as if in a flash of lightning" (Benjamin 1980a, 695). It is, I believe, no accident that Benjamin chooses words like *Bild* (image, picture) and *blitzen* (flash). *Blitzlicht* (literally, "lightning light") is the German word for a photographic flash, and given Benjamin's theoretical interest in the power of photography, one might say that photographs embody Benjamin's historic moment, for the viewing of photographs always enacts the imbrication of past and present moments, forcing them into a constellation in the viewer's mind.

Twain's autobiographical structure reflects Benjamin's notion of historiography in taking the moment of dictating as a point of departure and return ("I am looking at myself [in a mirror] all the time"). In this mirror we see reflected Twain's image (in the frontispiece and the series of photographs he meant to include in the autobiography, discussed above) and

"the associative processes of his mind" (Hill 1973, 138). Not the life, but the memory of life comes to the fore in *Mark Twain's Autobiography,* with Twain constantly referring to himself in the act of remembering. Moreover, in *Life on the Mississippi* he characterizes the process of memory as "photographing": "I would fasten my eyes upon a sharp, wooded point that projected far into the river . . . and go to laboriously photographing its shape upon my brain" (Twain 1982, 278). The identification of photography with memory is of course not original with Twain; it is an association that was made immediately after the invention of the daguerreotype and arises from the classical equation of visualization with memory.[37]

That Twain links photography to his autobiographical method is clear in a passage from the autobiography concerning his mother:

> I am not proposing to . . . give her formal history, but merely make illustrative extracts from it, so to speak; furnish flashlight glimpses of her career. . . .
>
> What becomes of the multitudinous photographs which one's mind makes of people? Out of the million which my mental camera must have taken of this first and closest friend, only one clear and strongly defined one of early date remains.
> (Twain 1924, 1:115)

In this passage, the "flashlight glimpses" convey the analogy for memory I described above: mental photography. His subsequent reference to "the multitudinous photographs which one's mind makes of people" indicates that with "flashlight" he means a photographic flash.[38] In Twain's "flashlight glimpses" metaphor, the mind is envisioned as a darkness in which brief moments are illuminated by memory, much as Benjamin imagines the conjunction of the present and past in a historical image.

Twain insists that he recreate his personal image of his mother in this way, shunning a "processional" account for "flashlight glimpses." The reason he offers for this method, "technically speaking, she had no career" (1:115), may not precisely apply to his own case; but he chooses in his autobiography to avoid the account of his "career" as such in favor of recording the act of remembering as faithfully as possible. The plan he "finally hit upon" for his autobiography hangs on precisely this idea: that the "flashlight glimpses" of his past, brought to light through narration, should take precedence over a cohesive account of his "career." It would not be safe to say that photography exposed the humbug of the unified self for Twain, but it would be accurate to note that in his case, the photographic fragmented record of each moment provides a model for his experimen-

tal autobiography, which grew inward from the moment at hand, rather than linking moments in a causal relationship.

Here is a difficult paradox that I will more thoroughly explore when I turn to Strindberg's work with photography and autobiography: the notion that photographs can capture the inner self. There are times when Twain appears to embrace photographic vision (flashlight glimpses) as the illumination of inner reality, as in this letter to his friend, William Dean Howells:

> Everywhere your pen falls it leaves a photograph . . . and only you see people & their ways & their insides & outsides as they *are*. . . . There doesn't seem to be anything that can be concealed from your awful all-seeing eye. (Smith and Gibson 1960, 245–46)

As it is described here, Howells's photographic vision may be understood as X-ray vision, since it penetrates the "outsides" and gets to the "insides" of people. Twain's choice of the photographic metaphor for vision that is both penetrating and truthful (why else would it be characterized as "awful," nearly God-like?), seems to imply a faith in the evidentiary power of the photographic image that some might characterize as naive. Similarly, he uses the photographic metaphor in a description of his powers of vision in dreams: "Waking, I cannot create in my mind a picture of a room . . . but my dream self can do . . . this with the accuracy and vividness of a camera" (Twain 1935, 350). It is the dreaming self, the unconscious self without inhibitions, that possesses the eyesight of a camera. In this passage photographic vision is again accorded an accuracy and clarity of vision unavailable to the conscious mind.[39]

Likewise, in his autobiographical text Twain stresses his efforts to deliver up more than a superficial account of his life, to render the unconscious self visible, even as he acknowledges the impossibility of such a project:

> What a wee little part of a person's life are his acts and his words! His real life is led in the head, and is known to none but himself. All day long, and every day, the mill of his brain is grinding, and his *thoughts,* not those other things, are his history. His acts and words are merely the visible, thin crust of his world . . . and they are so trifling a part of his bulk! a mere skin enveloping it. The mass of him is hidden—and its volcanic fires that toss and boil, and never rest, night nor day. These are his life, and they are not written, and cannot be written. Every

69

day would make a whole book of eighty-thousand words—
three-hundred and sixty-five books a year. Biographies are but
the clothes and buttons of the man—the biography of the man
himself cannot be written. (Twain 1924, 1:2)

When Twain writes "biography" in this passage, he seems to mean all life
stories, including autobiography, and it is instructive that he does not
distinguish between the two genres. Traditionally, autobiography's advan-
tage over and distinction from biography has been understood as the
genre's interiority; only the autobiographer can know the "volcanic fires
that toss and boil" within. But Twain denies that this is an advantage; in
fact, the size and number of those fires overwhelms the autobiographer,
who can never finish his story until they (and he) are extinguished. As
Twain has perceived the matter here, the account of a life is the sum
of the emotions and thoughts of the life, moment to moment; thus his
projection for so many volumes, thus the "quarter-million words" cited
by the *North American Review* preface, and thus his apparent inability to
bring the autobiographical dictations to a satisfactory conclusion.[40] Both
life-writing tasks, the autobiographical and the biographical, become
equally impossible.

Nevertheless, he attempts in his associative method to shape an alter-
native to traditional autobiography that will offer an image of how the
mind looks from the inside: flashlight glimpses. But when he turns to
actual photographs, aiming to include them in his autobiographical text,
he himself unmasks the idea of "flashlight glimpses" as nothing more than
metaphor, as wishful thinking about photographs. Even as he proposes a
photographic model for illuminating the darkness of interior mental
spaces, his use of ironic captions that seem to reveal his thoughts precisely
point up the impotence of photographs. Both the believer and the cynic
present themselves in the autobiography, just as the text on the "volcanic
fires" proclaims the impossibility of what Twain is about to do for the
next hundreds of pages. The last photographs we will inspect, like the
first daguerreotype of 1850, are a joke on the photographic medium, but
they also constitute an undoing of the premises of Twain's autobiographi-
cal experiment.

During the summer of 1906, the autobiographical dictations begun
in New York continued in the Clemens family summer residence in Dub-
lin, New Hampshire. Albert Bigelow Paine was in attendance, camera in
tow, as witnessed by a series of shots taken in one sitting on the portico
of the Dublin house in late July or early August (figures 1.10–1.16).

Twain was particularly fascinated by this set of photographs, apparently seeing in their slightly varying similarity and shifts in perspective the possibility for a kind of photographic narrative with captions. He subsequently numbered the photographs 1–7 and wrote a set of captions for them that would link them conceptually as well as visually. Then he placed them among his autobiographical typescripts with the following note:

> The pictures which Mr. Paine made on the portico here several weeks ago have been developed and are good. For the sake of the moral lesson which they teach I wish to insert a set of them here for future generations to study, with the result, I hope, that they will reform, if they need it—and I expect they will. I am sending half a dozen of these sets to friends of mine who need reforming, and I have introduced the pictures with this formula:
>
>> This series of photographs registers with scientific precision, stage by stage, the progress of a moral purpose through the mind of the human race's Oldest Friend.[41]

Here, with the aid of captions, Twain purportedly offers us a view of his innermost thought processes. The words he chooses for each photograph find support in the physical gestures captured by the image, making use of the body's drama. In converting these gestures into the language of quoted thought, Twain plays on the perception that photographs deliver a message of unvarnished truth—that they reflect interiority, and that thoughts speak more honestly than words. But of course the captions are themselves words; they belie the notion that photographs in and of themselves give up a reality that is closer to the bone. If photographs were so powerful, they would not require captions at all. The entire series points up, of course, the deceptive nature of photographic verisimilitude.

The captions imply that the camera's eye sees into the mind of the photographed subject, "register[ing] with scientific precision, stage by stage, the progress of a moral purpose." Cameras that see into the body (using X-rays) were already in use by 1906; the idea of a camera that sees into the mind thus seems not such a great leap of faith. Paine and his camera were not invisible during this picture-taking session, but Twain knew how to create invisibility for the camera by refusing to acknowledge its presence, and he knew how to create omniscience for the camera through the addition of captions. In none of the portico shots does he look directly at the photographer, though in number 7 (figure 1.16), at least, Paine must have stood well within his field of vision. A problem

arises, however, when Twain abuses his own insight into the nature of photography. Once again he uses his control of the images (a control that creates feigned speech for the images) to portray himself out of control: a reckless Sabbath-breaker. Artfully inserting ellipses to both break off his own thoughts and tie the flow of meditation from one image to the next, he matches the stages of the supposed argumentation with his body's various postures.

Beginning with figure 1.10, we see Twain in a frontal view, eyes focused on something off-camera; the caption leads us to believe that he in fact is drawing a bead on an interior notion rather than an exterior object. The impetus for his thought processes is the question that purportedly occurs to him in the first image, namely "*Shall* I learn to be good?" Once he has resolved to "sit [there] and think it over," figure 1.11 shows him from approximately the same angle, but the camera has drawn back and he has leaned forward with his hands folded, brow slightly wrinkled in apparent concentration. From the distance imposed between the viewer and the meditator, the viewer receives the message that the author is now left alone with his thoughts, and the impression that an act of meditation is taking place is underscored by the presence of the cigar and the rocking chair. Figure 1.11, with its look of dark concern, professes to represent the author's confrontation with the many difficulties involved in being good. So difficult, in fact, are these difficulties, that the *word* difficulty is broken off with an ellipsis: "There do seem to be so many diffi"

Figure 1.12 draws us still farther away from the thoughtful meditator and shifts our perspective to the author's opposite side, in keeping with his reversed position on the issue of goodness in this frame. Rather than dwelling on the "diffi" of being good, he now seems ready to make an effort: "And yet if I should *really* try" The ellipsis here serves to propel the viewer into the opening ellipsis of figure 1.13, where his thought is completed with an optimistic lean forward in the chair: ". . . . and just put my whole *heart* in it" Figure 1.14, on the other hand, suggests a wilting of enthusiasm as the author sinks back in his chair, considering a particular drawback with his hand held pensively to his cheek: ". . . . But then I couldn't break the Sab" Literally breaking the Sabbath into two syllables, one of which then fades into nothing, Twain reveals his irreversible position on the matter. This is further substantiated by figure 1.15, where he has once again assumed an upright position of confidence as he sees his natural inclinations supported by his own brand of rationale: ". . . . and there's *so* many other privileges that

perhaps"[42] Finally figure 1.16 brings the viewer back to a position in front of Twain, looking at him from roughly the same angle as in number 1, though from a greater distance. Hands relaxed on the arms of his chair, he reassumes his initial physical position along with his customary moral position: "Oh, never mind, I reckon I'm good enough just as I am."

We do not know whether these photographs were posed with this short moral history in mind; it seems more likely that Twain, in viewing them subsequently, saw a potential for arranging them to portray a mental perambulation, much as his autobiographical dictations were meant to reveal the wanderings of his memory. The suggestion that these photographs and their captions could perform some sort of missionary work among those in need of reform unmasks the series for the serious joke it is, related to Twain's many send-ups of "good" Christians such as the Widow Douglas in *Huckleberry Finn*, and "The Good Little Boy" in the short story of the same name, who comes to grief precisely because of his annoying goodness.

In arranging the photographs and their captions as he does, Twain exhibits a grasp of what constitutes the deceptive power of photographs, namely their ability to convince the viewer of their honesty. Like the "true" autobiography that could never be written, these photographs show life moment by moment, and they profess to look not only at the "clothes and buttons" of the man but at his inner conflict. It is a measure of Twain's insight into photographic power that he disarms it with irony, forcing the medium to portray him and mask him at the same time.

Throughout my analysis of Twain's photographic record, I have uncovered elements of his self-construction strangely reminiscent of the concerns of poststructuralists. I am not alone in noting this parallel; Susan Gillman, James Cox, and Maria Ornella Marotti have all remarked on it, with Marotti observing that "The fragmentation of the text, the self-referential quality of many passages of the [unpublished Twain] Papers, and the allusions to the writing process reveal the writer's concern with issues that are very real to us" (Marotti 1990, 152). Certainly, Twain's anxieties about his fragmented identity and the subterfuges he uses to get around those anxieties strike us as oddly familiar. Particularly his subversion of the photographic image foreshadows such contemporary performers/writers as Cindy Sherman, who unmasks the illusion of photography by playing against that illusion.

But I have wanted to argue as well that Twain commands a binocular vision of his autobiographical self, in that he both undermines his image even as he insists on his body's presence. Whatever we might say about

73

1.10–1.16 *Mark Twain, Dublin, New Hampshire, 1906,*
1.11

photographs by Albert Bigelow Paine. Courtesy The Mark Twain Project, The Bancroft Library, University of California, Berkeley

1.12

1.13

1.15

1.14

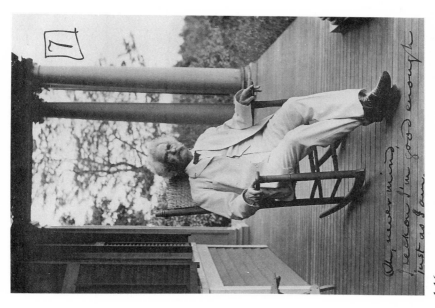

1.16

the illusionary tactics he employs, or the sympathy such tactics arouse in our postmodern hearts, we must not fail to take this into account: Mark Twain wanted to be seen, recognized, and remembered. The Dublin series and the bed photographs insist on the meaning of a physical presence, the gestures and attitudes of a body. That the appearance of the body changes from image to image does not seem to diminish its identifiability; even today, this year, there will be people who will appear as Mark Twain, and what will they use as their model? In most cases they will put on the moustache and unruly white hair of his older days, the identifying marks of a body carefully preserved in photograph after photograph. Captions point up the photograph's lie, and as postmoderns, we have learned that lesson well. What remains to be seen and understood is the secret language of the body, only hinted at in the photographs we take and keep.

How do we account for the stubbornness of the naive, superstitious view of photography? What could possibly motivate the persistence in erroneous beliefs about the radical difference between images and words, and the special status of photography? Are these mistaken beliefs simply conceptual errors, like mistakes in arithmetic? Or are they more on the order of ideological beliefs, convictions that resist change?

W. J. T. MITCHELL, "The Ethics of Form in the Photographic Essay"

Photographing the Soul: August Strindberg

One afternoon in 1906, August Strindberg (1849–1912) invited a friend into his Stockholm apartment, where "all the chairs, tables, and sofas . . . were occupied by photographs, great and small and almost all depicting [Strindberg] himself" (Ahlström and Eklund 1961, 182). Strindberg explained to his apparently puzzled visitor that "the reason he worked with photography . . . was that all the photographs that others had taken of him were poor. 'I don't care a thing for my appearance,' he said, 'but I want people to be able to see my soul, and that comes out better in my own photographs than in others'" (Ahlström and Eklund 1961, 182). The photographs in this impromptu exhibition, then, were taken by Strindberg himself, and his purpose in taking them was to capture and exhibit his soul.

How do photographs reveal the soul, particularly if, as Strindberg asserts, appearance counts for nothing? He seems to regard his self-photographs not as appearances but as apparitions; like the spirit photographs so popular during his lifetime, these images are supposed to present a world invisible to the unaided human eye. Yet the Strindberg of Strindberg's photographs, unlike the disembodied hands and translucent beings depicted in spirit photographs, stands there as solidly as the clothing and furniture enclosed in the photographic frame, his eyes burning with an excess of mental energy. These "spirit" photographs were taken of a living body.

The answer to this conundrum lies in Strindberg's conception of pho-

tography's power, which depends upon a negotiation of two apparently diametrically opposed poles: naturalism and the occult. It has often been remarked that a break occurs in Strindberg's dramatic production precisely between these two poles; he begins as a naturalist with *Miss Julie* and *The Father,* but turns suddenly, after his "Inferno crisis," to Swedenborgian occultism and modernism.[1] Certainly his autobiographical texts seem to conform to this pattern, beginning with the naturalist autobiographies of 1886 and proceeding to the supernatural preoccupations of *Inferno* and *The Occult Diary.* Yet a closer look at Strindberg's textual and photographic work indicates that naturalism and the occult should not be construed as discrete categories or as stages in a trajectory of evolution, but rather as poles between which a productive and dramatic tension exists, mutually dependent rather than mutually exclusive.[2]

The tension in Strindberg's autobiographical work between the objective approach of naturalism and the introspection of modernism indicates an awareness on his part of the tenuous separation between interiority and exteriority. His autobiographical work and self-photography attest to a desire to hold body and soul together, though his obsessive repetition of self-writing and self-photographing points to a fear that the center will not hold, that the integrated self threatens to fly apart.

The same tension between naturalism and the occult occurs in interpretations of photography. Roland Barthes, W. J. T. Mitchell, John Berger, and Alan Sekula have drawn up polarized schemata for the reception of photography, poised uneasily between the connotative and the denotative (Barthes 1977), textual and nonverbal (Mitchell 1989, 9), presence and absence (Berger 1974), and informative and affective (Sekula 1981). These categories align roughly with one another as they all evolve from early debates surrounding photography's status as art versus documentation, magic versus science. Photography has been conceived both as a means of capturing the precise details of the exterior world and as a sorcerer's instrument for plumbing beneath the surface of appearances. But the key to understanding such polarities lies in perceiving, as all of these critics do, that the two poles are not antithetical but dependent on one another. Do we define as naturalistic or supernatural photography's perceived power to capture the world much more penetratingly than the human eye? A look at two scientifically oriented observers reveals the easy slide from one end of the spectrum toward the other.

Samuel F. B. Morse, the inventor of the telegraph, wrote a letter home to America on first seeing daguerreotype images in 1839:

> No painting or engraving ever approached [the exquisite
> minuteness of the delineation of the daguerreotype]. For ex-
> ample: in a view up the street, a distant sign would be per-
> ceived, and the eye could just discern that there were lines of
> letters upon it, but so minute as not to be read with the naked
> eye. By the assistance of a powerful lens, which magnified fifty
> times, applied to the delineation, every letter was clearly and
> distinctly legible. . . . The effect of the lens upon the picture
> was to a great degree like that of the telescope in nature.
> (Newhall 1982, 36)

Morse's statement lies safely within the realm of the empirically know-
able, but his enthusiasm for the medium's power lays the foundation for
the notion that photographs can penetrate beyond surface appearance. A
remark by pioneer naturalist Émile Zola takes us a bit further in that
direction:

> To my mind, you cannot say that you have seen the essence of a
> thing if you have not taken a photograph of it, revealing a multi-
> tude of details which otherwise could not be discerned.
> (Émile-Zola et Massin 1979, 11)

Zola was in part responsible for the reputation naturalists achieved
among their critics as "mere" photographers. According to the detractors
of naturalism, the flaw in adopting photography as a means of arriving at
"truth," either practically or metaphorically, was the medium's focus on
the exterior world; as Virginia Woolf writes, "It is because [materialist
writers] are concerned not with the spirit but with the body that they
have disappointed us."[3] According to their critics, then, the characters in
works by naturalist authors are little more than zombies, carcasses with-
out souls.[4]

But Zola's remark on photography implies that looking at things (or
people), observing their details (as only, in his estimation, a photograph
can do), actually *unveils* the object and reveals its essence. In this, Zola
allies himself with Charles Darwin, whose 1872 work on the expression
of emotion in humans and animals (1955) insists on the body's potency
as sign; and Darwin uses photographs in the text to back his claims. While
it is possible (if not positively necessary) to take issue with Darwin's use
of photographs of actors pantomiming human expression, what interests
me here is not the absolute scientific validity of his proof but the implica-
tions of his argument for Strindberg, who drew on Darwin's thought, I

83

would argue, throughout his life, and not just during his explicitly naturalist phase.

Darwin contends that physical expression reveals interior emotion, with or without the exercise of conscious will on the part of the emoting subject, and that humans and other animals also have the ability to read expressions of emotion, though they are not consciously aware of all of the physical signs for any given mood (Darwin 1955, 352–55). His project in the book on expression is to make visible in photographs those details that ordinarily go unperceived (and are thus, in a sense, invisible). Further, he means to link these imperceptible exterior signs to their unconsciously driven, truly invisible sources: the body's nervous, digestive, respiratory, and circulatory systems, as well as the genetic encoding from earlier evolutionary forms (though the details of the last-named remained beyond the reach of science during his lifetime). Because Darwin insists on the inherited and unconscious production of expression, Frank J. Sulloway claims that Darwin preceded Freud in his understanding of the unconscious forces driving human behavior (Sulloway 1979, 238–76). The photographs of Darwin's study are to be read as a psychoanalyst would read notes from a session with a patient—with an eye for messages from the unconscious.

Darwin's use of photography as an aid in revealing and explicating the physical manifestations of the unconscious finds a twentieth-century parallel in the work of Walter Benjamin, whose autobiography I will discuss in the next chapter. Benjamin cites cinematic motion studies, which broke movement into perceptible photographic segments, as evidence for photography's ability to uncover the seen-yet-unseen world: "The camera introduces us to unconscious optics as does psychoanalysis to unconscious impulses" (Benjamin 1969, 237). In Darwin's system, in the studies mentioned by Benjamin, in Freud's analysis of human consciousness, and in photography, a revolution in perception takes place, and it is in each case a revolution that involves the atomization of experience and anatomy. Strindberg's autobiographies return repeatedly to the idea and process of self-anatomy, drawing on both Darwinian and Freudian theories of analysis.

The autobiographer at the threshold of the twentieth century stands before an array of diverse yet apparently infallible photographic representations of him- or herself, the possibility of a unified truth of selfhood infinitely further removed than in the eighteenth or nineteenth centuries. Roland Barthes gives voice to this experience:

> What I want is that my (mobile) image, buffeted among a thou-
> sand shifting photographs, altering with situation and age,
> should always coincide with my (profound) self; but it is the
> contrary that must be said: "myself" never coincides with my
> image; for it is the image which is heavy, motionless, stubborn
> (which is why society sustains it), and "myself" which is light,
> divided, dispersed. (Barthes 1981, 12)

Barthes's concerns point to a conundrum; he perceives a "mobile [photo-
graphic] image" opposed to something he would like to claim as his "pro-
found self." Though he will ultimately argue for photography's reference
to a self, his worries about how that process of reference actually takes
place are voiced in this passage. It is the photographic "mobile image" that
acquires weight, becomes (for viewers) the only perceivable representa-
tion of the profound self, while in Barthes's own eyes, the self supposedly
represented by its diverse image flies apart and away. What Barthes wants
is a rescue of his profound self through the solid evidence of photography;
what he finds instead in the multiplicity of photographs is proof of his
soul's lack of substance, and he is betrayed, finally, by photography's abil-
ity to appear more real than he does himself. His photographs will survive
him—they, along with his literary corpus, will become the only Barthes.
Thus photography both extends the promise of the truest kind of self-
revelation, only to raise the suspicion that there is no "profound self"
after all.[5]

Strindberg, like Barthes, acquires a knowledge of photography's Me-
phistophelean character through a close study of his own photographed
images. In them he imagines he has found a window into the invisible
interior; along with Darwin and Zola, he turns to the photograph for
scientific proof of the unseen essence of things—in particular, he turns
the camera on himself for the proof of his own nature. But the profusion
of photographs created over time provides all too clear a mirror for the
kind of self imagined by Darwin and Freud: a self patched together from
irreconcilable sources, divided against itself, atomized and dispersed.
Ultimately self-photography, which Strindberg continues to refine
throughout his life in the hope of finally arriving at a true self-image (a
profound self), uncovers nothing more than an anxiety at the inevitable
disintegration of the self.

Strindberg's autobiographies, which he produced in many forms over
a twenty-year period, offer the same pattern of repetition and revision.

Photographing the soul, either in photographs or autobiographical texts, preoccupied Strindberg throughout his life. "Strindberg's larger project," writes Michael Robinson in *Strindberg and Autobiography*, "establishes a context in which all his writing demands recognition as in some degree autobiographical" (Robinson 1986, 9). Known to most English speakers primarily for his dramatic works, Strindberg's reputation in Sweden rests on his many prose texts as well: anthropological and nature studies, histories, scientific essays, novels, short stories, polemics (they might all be termed polemics), and autobiographies (they might all be termed autobiographies). But so pronounced is his tendency toward the autobiographical (in his drama as well as in other works) that it is difficult, as Robinson indicates, to define precisely which works should be classed as "autobiographies." Strindberg offers to perform this task for posterity in a letter written to his German translator:

> One thing, while I remember it. If I die soon, will you collect and publish, in *one volume,* under the title "The Son of a Servant" these works:
>
> 1. The Son of a Servant
> 2. Time of Ferment
> 3. In the Red Room
> 4. (Fourth part of this work, manuscript at Bonniers)
> 5. Die Beichte eines Thoren
> 6. The Quarantine Officer's Second Story
> 7. Inferno
> 8. Legends
> 9. Alone
> 10. The Occult Diary since 1896
> 11. Correspondence, letters.
>
> This is the only monument I desire: a black wooden cross and my story![6]

While the first three works (and possibly no. 7, *Inferno*) might comfortably be termed "autobiography" in that they profess to be nonfictionalized accounts of the author's experience, the others present difficulties. *He and She,* the fourth part of *The Son of a Servant,* comprises an edited collection of letters written during Strindberg's courtship of his first wife, who was still married to her first husband at the time. *Die Beichte eines Thoren,* a novel published first in French as *Le Plaidoyer d'un fou,* thinly disguises as fiction Strindberg's anguish about the stormy dissolution of his first marriage. The other works are short stories, a novella,

a wildly surreal diary kept up over many years, and a voluminous corre-
spondence. From a purely practical vantage it seems absurd to insist that
these thousands of pages should be compressed into a single volume. Be-
sides, one might ask—what about the station plays *To Damascus* and *The
Great Highway*? Are these not as "autobiographical" as the novella *Alone*?

And so the list Strindberg left us proves more a riddle than an answer;
or if it is an answer, the answer is that Strindberg cannot be contained,
that he spills over all kinds of bounds, including the covers of that single
volume he asks his publishers to create. In this sense he resembles Twain,
whose autobiography has yet to achieve the form he prescribed to *his*
editors. In both cases, I would argue that the experience of being photo-
graphed (and viewing photographs of the self) played a significant role in
the conceptualization of a self existing in a series of present moments (as
in snapshots). Strindberg's autobiographical texts, like Twain's, grew in
close proximity to and were informed by his photographic record, most
of which he created himself, as self-photographer.

There are three points of contact between Strindberg's photographic
and autobiographical activity that I would like to address in the pages
following. Strindberg begins taking photographs of himself in 1886 while
writing the first volumes of his naturalist autobiography, *The Son of a Ser-
vant*. This early foray into autobiography juxtaposes the revelation of inti-
mate details of his life with a distancing third-person narrative, inspired
by a fascination with science and reflective of the distance between the
parts of himself residing in photographer and photographed object. He
evokes the image of a scientist performing an autopsy on a corpse to de-
scribe the relationship between the narrating subject and object of his
texts, thus stressing the atomization of the individual implicit in both
Darwinian and Freudian theory. At the same time, he resists dismember-
ment and dispersion by reinventing an authoritative textual subject,
whose presence is underscored by the creation of a suite of photographs
to be published with the autobiography.

At the onset of his "Inferno Period," he does not turn away from the
task begun in *The Son of a Servant*, but takes it to a new level of intensity
as he moves from dissection of the self to penetration of the soul. In 1892,
Strindberg proposed opening a photography studio in Berlin with the ob-
ject of taking "psychological" photographs, in which the thoughts and
character of the person photographed would be first elicited telepathi-
cally by the photographer (Strindberg) and then captured on the photo-
graphic plate. It is at this time that he more fully develops his conception
of experience that in essence erases the boundaries between the interior

and exterior worlds, between the seen and the unseen. This development is documented not only in the "psychological photograph" project, but in his autobiographical text *Inferno* (1897), which offers a reading of the world as sign for the presence of other worlds and invisible powers.

The final phase of his experimentation in self-portrait photography evolved in 1906, in the wake of his third and final divorce and the publication of the autobiographical novella *Alone* (1903). His goal was to produce photographic portraits of faces at natural scale using the "Wunderkamera," a device he had developed specifically for this purpose; the scene described at the beginning of this chapter is an informal exhibition of Strindberg's photographic self-portraits taken with the Wunderkamera. It had become Strindberg's aim toward the end of his life to reproduce as accurately as possible the experience of looking at the human face and body, an aim connected with his conviction that photographs could provide a window into the soul, and driven by the need to assert the presence of himself and others in the world, a world in which increasing solitude and illness prefigured the self's final dissolution in death. The body photographed at full size becomes for him a stand-in, an iconic duplicate with the power of the original. It is in this phase of Strindberg's autobiographical and photographic portraiture that a growing anxiety surrounds the acts of viewing and being viewed. For while Strindberg seems to insist on his own hyperpresence when inviting a friend into a room full of Wunderkamera photographs of himself, the diverse images also serve to undermine photography's referential function—rather than shoring up the body's authority and presence, they suggest that the body has been something and somewhere else, is not a dependable continuity or singularity, cannot be counted upon.

In his autobiographical novella *Alone* (1903) Strindberg begins to doubt the ultimate significance of seeing and being seen as he reflects on his own voyeuristic obsessions, unmasking himself as an invisible spectator who revels in the power of looking, but who also longs to be discovered, to be seen. At the end of *Alone* the aged narrator leaves the circle of spectatorship/voyeurism to take up a position of solitude beyond the public gaze. This emphasis on withdrawal, on absence, brings up questions about the stubborn insistence on the body's presence implied by the life-sized "Wunderkamera" photographs. Photographic images always mark both a presence (in the past of a real body) and absence (the body as it is depicted no longer exists). Strindberg's approach to both photography and autobiography conveys his distress at the inevitable absence of

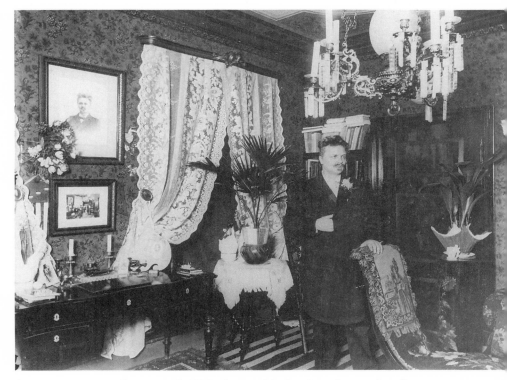

2.1 *August Strindberg in Lund, 1897, photograph by Lina Jonn. Courtesy Strindbergsmuseet, Stockholm*

the body, an absence that in fact only becomes more obvious as the image is enlarged and the texts and photographs duplicated and reduplicated.

I would like to offer a revealing photograph to act as the illustrative emblem for my inquiry into Strindberg as self-photographing autobiographer (figure 2.1). The photograph in question, taken by Lina Jonn in 1897, gives us Strindberg in a self-conscious attitude, a Napoleanic pose typical of the daguerreotype portraits from earlier in the nineteenth century. Strindberg looks away from the photographer in a studied gesture of noninvolvement, though of course every line of his body and countenance registers an awareness of being photographed. On the other hand, perhaps the most arresting feature of the photograph is the presence of a second Strindberg framed on the wall, a photographed Strindberg who does in fact seem to look in the photographer's direction.

Our image is thus a doubling of Strindberg, but this doubling also

superimposes a number of apparently irreconcilable contradictions: presence and absence, intimacy (private home, engaged gaze), and distance (studio pose, averted gaze), self-consciousness and unselfconsciousness. This study of Strindberg will explore the paradoxical nature of his obsession with self-representation. Concentrating on the three works mentioned above and the self-photography produced in tandem with them, I will discuss the intimate relationship between Strindberg's thinking about photographic representation and autobiographical writing, showing how his belief in photography as a medium for self-revelation informed the structure and presentation of himself textually in his autobiographies. When we consider Twain's manipulation of the photographic medium in creating a public persona, we can see that his strategy depended in part on people like Strindberg, who proclaimed photography's power to unmask the soul, wanting to believe in the body as a sign for the self. At the same time, Strindberg's doubt in his own faith remains achingly apparent; his repeated attempts to bring his soul into focus both cover over and reveal an anxiety about absence.

The Self as Anatomized Object

In 1886 Strindberg's considerable energies focused on three projects: an ethno-photographic report on the life of French farmers, a voluminous autobiography written in the third person, and his first forays into photographic self-portraiture. It is of course not a matter of simple coincidence that these efforts take shape simultaneously; inspired by the work of the French naturalist movement, Strindberg treats both the French farmers and himself as specimens in a literary and photographic experiment that aims to uncover the determinant forces in the make-up of society and individual. With Zola, Strindberg espouses the belief that an account of the physical details of lives—landscape, furniture, tools, architecture, climate, dress, and physiognomy—can deliver information on the secrets of interior lives: desires, predilections, fears, ideals, etc. And better still than accounts, which, after all, are infected with the subjectivity of the writer, are photographs, which he perceives as purely objective reports.

When applied to the task of writing his autobiography, Strindberg's scientific objectivity takes on a grisly cast; he remarks that he has "merely taken the corpse of the person [he] knows best and learned anatomy, physiology, psychology, and history from the carcass" (Strindberg 1916, 5:344). Thus in Strindberg's autobiography, Rousseau's confessional gesture of baring his heart finds a much more ruthless expression; the self

divided against itself in this case does not stop with opening the "heart," but goes on to all of the organs, the nerve endings, the body in all of its mechanical (and, we imagine, gory) components. Strindberg's figural violence to himself in the autobiography comes in the wake of a violent outburst against him; in 1884 he stood trial for blasphemy in Stockholm, and although he was supported by cheering crowds and subsequently acquitted, the sense that he was within reach of powerful enemies never left him.[7] His self-dissection could therefore be understood as a preemptive act, particularly because once he has established a clinical distance between his writing and experiencing selves, he uses that distance to reassert his own authority. He writes a script in which he holds the pen, the camera, and the knife.

Committed to the scientific methodology of French naturalism, Strindberg hit upon autobiography as the one acceptable medium: "imaginary writing will gradually cease to exist. The future should see the setting up of offices at which at a certain age everyone anonymously handed in a truthful biography; it could become the data for a real science of man if such a thing were needed" (Mörner 1924, 168). The aim of an anonymous autobiography would seem to diverge significantly from that of autobiographical literature that seeks to establish a defense for the self against society, as does Rousseau's, or undertakes to analyze the origins of the individual's success and fame, as do Goethe's and Benjamin Franklin's. The anonymous autobiographer is nothing more than a representative specimen, fit material for the naturalist's microscope—a single example of the type "man."

In Strindberg's first professional photographic project, undertaken the same year he began his autobiography (1886), we see this principle of anonymous and objective scientific investigation applied to anthropological research. With Zola's example in mind, Strindberg set off on a journey through rural France in order to make a cultural record in essays and photographs of the life of French farmers in various regions. Though none of the photographs survived the journey (technical and personal problems apparently intervened), Strindberg's eagerness to make use of the photographic medium in this particular setting reveals his faith in the camera as ethnographic tool; here he sets forth his plans for the journey:

> In small towns portraits of peasants were to be bought by the
> photographers in order to establish an ethnographic collection.
> In addition, there was a photographic flash apparatus that was
> to capture types of landscape, farmhouses and implements

91

from the carriage window, if possible, or from the main road. (Hemmingson 1989, 147)

It is striking that Strindberg emphasizes *types* of landscape and houses, and that he wants portraits of anonymous farmers in order to establish an iconography of ethnic and cultural types.[8]

The same idea seems to guide his autobiography when he writes in the third person, gives his younger self the common name "Johan," and emphasizes the class origin of the subject under his autobiographical knife—"the son of a servant." On the face of things, his autobiography conforms to the model of the citizen handing in his anonymous text for the public record, and Strindberg's reference to the dead past self on the autopsy table offers a parallel to the anonymous French farmers, represented in dead photographic images. But this is on the face of things; matters become more complicated when Strindberg inserts his own celebrated face into the anonymous text, both literally and figurally.

As Kerstin Dahlbäck has noted, *The Son of a Servant* "creates immediate problems" when held up to Philippe Lejeune's criteria for autobiography (Dahlbäck 1991, 84–85). The reader will recall that Lejeune demands that the name on the title page match the name of the protagonist, who is also the narrator. In spirit, Strindberg neither wholly fulfills nor wholly disappoints Lejeune's conditions, for his given name was in fact "Johan"—his middle name was August. Dahlbäck concludes that Strindberg does not satisfy the autobiographical pact, for indeed, the author's name on the title page fails to match the name of the protagonist. It appears that Strindberg, ignorant of Lejeune and all other theorists of autobiography but fully cognizant of the intricacies of autobiographical referentiality, plays an elaborate shell game with his (sometimes hostile) public, evading the responsibility of a pact.

August Strindberg's name was on the title page of *The Son of a Servant.* This August Strindberg was (in)famous throughout Sweden at the time of the autobiography's publication due to the enormous popularity of his first novel, *The Red Room* (1879), which included satirical sketches *à clef* of prominent Swedes, and because of the 1884 blasphemy trial. The third and fourth volumes of the autobiography were entitled, respectively, *In the Red Room* and *The Author.* Given the relatively small size of the Swedish reading public (the entire population hovered around five million during Strindberg's lifetime), it would come as a great surprise if more than a few readers failed to recognize the Strindberg behind "Johan." The mask of anonymity and objectivity assumed in *The Son of a Servant* is, then, pre-

cisely that—a mask; Strindberg knew that his audience knew who "Jo-han" was. Or at least, they thought they knew. Strindberg's autobiography has a double and conflicted task: to present the self as a composite of arbitrary forces of environment and heredity, a citizen like any other in this regard, and to preserve his own copyright over his selfhood, to reinscribe his authority in his autobiographical text. Both of these goals are attempted in a mock interview and a series of photographic self-portraiture that was intended as a pendant to the autobiography.

Characteristic of the interview and the photographs is an ironic play-fulness, apparently at odds with the serious, even grim naturalistic intent of Strindberg's autobiographical project. While the autobiography fre-quently adopts a tone of high seriousness (even, one could say, in re-counting rather trivial episodes), the interview pits an impetuous and im-perious author against a bumbling straw man of an interviewer (both parts scripted by Strindberg, of course). The author's lines outnumber the in-terviewer's by a factor of at least three, and at every turn, the author denies the interviewer any insight into his work:

> INTERVIEWER. Tell me exactly what kind of book is this latest work of yours. . . .
> AUTHOR. It's just what the title page says it is. . . .
> INTERVIEWER. In other words, a psychological novel? . . .
> AUTHOR. Not a novel and not merely psychological. . . .
> INTERVIEWER. All right, but it is something altogether new, isn't it?
> AUTHOR. There's nothing new. . . . (Strindberg 1975, 1–2)

And so on. Here, as in the image of self-autopsy, Strindberg splits himself into two parts, one of which is at the mercy of the other. The highly manipulative nature of the controlling author in the "interview" provokes the question—how does the author of *The Son of a Servant* manipulate the body under his autopsy knife?

To create a narrative structure that adequately represents his situa-tion as "experimenter and object of the experiment at the same time" (Strindberg 1916, 13:262), Strindberg chooses to write of himself in the third person. Philippe Lejeune, discussing the significance of third-person autobiographies, proffers the notion that the protagonist of such a narra-tive (providing that the "autobiographical pact" allows the reader to un-derstand that the author is actually writing about himself) is nothing more than a figure of narration, a "'nonperson' implied by the third person [which] functions here as a figure of enunciation within a text one con-

tinues to read as first-person discourse" (Lejeune et al. 1977, 28). By this Lejeune seems to mean that the third-person pronoun operates in much the way the name "Johan" does; it provides a transparent mask for the author. At the same time, however, a sensation of distance between the narrating and narrated selves comes into play with the use of the third person. Lejeune's use of the phrase "non-person" indicates the extent to which the narrator "disowns" the former self, adopts a pose of disassociation, "cuts" the former self, as one cuts a person one refuses to recognize.

Unlike Twain, Strindberg does not make use of the autobiographical topos of narrating from beyond the grave. In his instructions regarding the disposition of his autobiographical texts, he refers to his autobiography as a monument marking his grave, but *Son of a Servant*'s narrator does not present himself to the reader as a dead man, as Twain's first-person narrator does. However, both autobiographies do present their readers with figures of the dead: Twain in the first person and Strindberg in the third. By positing his younger self as an object rather than a subject of discourse, Strindberg effectively kills his younger self, creating a gulf between the younger and narrating selves that closes the younger self out of present experience, consigning him to the world of the already finished.

It is at the moment of Strindberg's creation of his anatomized third-person self that he begins his experiments in photographic self-portraiture. Thus Cathy Davidson's contention that "every photograph snuffs" resonates both in Strindberg's self-photography and in his autobiographical text. An observation by Barthes bridges the practice of third-person autobiography and self-photography: "The photograph is the advent of myself as other: a cunning disassociation of consciousness from identity. . . . Today it is as if we repressed the profound madness of Photography: it reminds us of its mythic heritage only by that faint uneasiness which seizes me when I look at 'myself' on a piece of paper" (Barthes 1981, 13). In writing of himself as "Johan" and "he," Strindberg sees himself as an other, just as he must imagine himself as an other when snapping his own photograph. But as in the mock interview, Strindberg creates a controlling narrative of captions for the photographic suite that seeks to establish authority over the separated self.

The immediate impetus for Strindberg's urge to capture himself and his family on film was, according to Strindberg himself, a photographic interview by the French photographer Nadar of the chemist Michel-Eugene Chevreul, published in *Le Journal Illustré* of 5 September 1886. The piece, entitled "The Art of Living to Be 100" (Chevreul was one

hundred at the time), provoked unusual excitement due to its innovative form; Nadar and Chevreul were photographed during the interview, and a stenographer recorded the spoken segment (figures 2.2–2.5). Nadar's idea closely resembles Twain's plan for his autobiography, and like the captioned series of Twain at Dublin, the postures of Chevreul and Nadar vary only slightly from frame to frame (despite Chevreul's penchant for dramatic Gallic gestures). The viewer encounters in each photograph Nadar's impressive bulk from the rear, usually in a pose of rapt attention (head resting on hand), lending an anchor of continuity to the series. Such a strategy of depiction gives the impression that little appreciable time has passed between the images taken, that the reader is, in effect, getting it all. In this sense, the Nadar piece exhibits an ingenious precognition of the documentary film.

The influence of Nadar's photographic interview is not immediately visible in Strindberg's series of images; there are in fact (as Per Hemmingsson points out) some rather striking differences in Strindberg's approach to the assembly of a series of photographs depicting himself and his family (Hemmingsson 1989, 39). Employing a delayed shutter, Strindberg poses for his own photographs, and indeed, he does pose. None of the Gersau images attempts candor; in all of them the subject faces the camera, sometimes with a rather unsettlingly fixed gaze into the lens (figure 2.6), while the Chevreul piece pretends (with Nadar's back so determinedly turned to the camera) an innocence of the photographer. Nadar's article reproduces speech supposedly uttered while the images were taken; Strindberg writes captions for his own photographs that must be read more as emblematic subscriptions than quotations of real speech. Finally, though Strindberg constructs a suite of photographs to be viewed together, there is no connection between images to suggest that they were taken in a single sitting. The viewer is not witness to an event, which seems to be the point of Nadar's presentation.

Wherein, then, lies Strindberg's inspiration? We can find it in two aspects of the Chevreul piece: the interview format, and the use of a series of photographs to capture the "essence" of the photographed subject. The title of Nadar's article, "The Art of Living to Be 100," proposes to reveal a secret: the essence of Chevreul's longevity, his reason, literally, for being alive. The Gersau series does not attempt the moment-to-moment account of the Chevreul interview, but it does present a testament to Strindberg's character as artist and *pater familias*. Both the Nadar article and Strindberg's Gersau suite offer photographs as evidence— Nadar's proves the existence of a lively centenarian and Strindberg's

5. — Je n'ai jamais bu que de l'eau et pourtant, je suis président de la Société des vins d'Anjou, — mais président honoraire seulement ! »

6. — C'est là l'inconvénient de cette philosophie du jour, de cette philosophie de viveurs, de grands diseurs de riens. On se contente de mots et de paroles creuses... »

2.3

2.2–2.5 Nadar's interview with Chevreul, photographs from Le Journal Illustré, 5 September 1886

7. — « Remarquez que je suis loin de blâmer ce que je ne puis expliquer ; mais je vous dirai qu'il faut qu'on me prouve, qu'il faut que je voie. »

2.4

8. — « Alors, puisqu'ils non-seulement qu'ils dirigent à leur volonté, leur ballon, qu'ils viennent me prendre ici, à cette fenêtre, tous les jours, de s'amie à l'Institut et qu'ils me ramènent ! Cela m'évitera de descendre et de monter mes deux étages d'escaliers. »

2.5

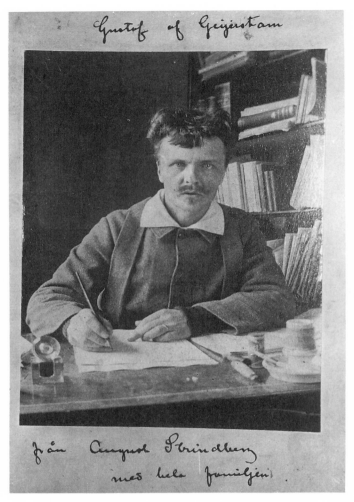

Gustaf of Geijerstam

från August Strindberg
med hela familjen.

2.6 *August Strindberg, Gersau, 1886, photograph by August Strindberg. "To Gustaf af Geijerstam from August Strindberg and the whole family." Courtesy Strindbergsmuseet, Stockholm*

responds to those who accuse him of misogyny and blasphemy with evidence of blissful domesticity (figures 2.6–2.12).[9] Sending the photographs to his publisher for consideration, Strindberg explains their purpose:

> With today's post was dispatched a parcel containing eighteen impressionist photographs (with text) taken by my wife, who has asked me to negotiate the transaction, if possible. The pho-

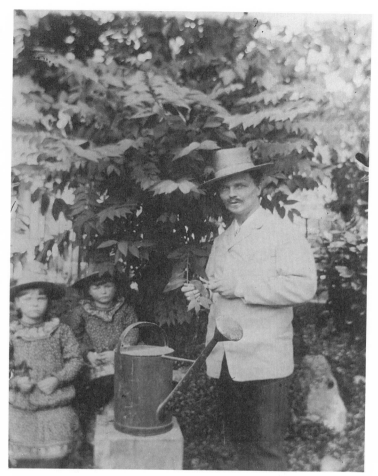

2.7 *August, Karin, and Greta Strindberg, Gersau, 1886, photograph by August Strindberg. Courtesy Strindbergsmuseet, Stockholm*

tographs depict that dreadful misogynist Aug. Sg. in eighteen re-
alistic situations (the idea being taken from the Chevreul issue).
The pictures are as you can see not examples of beautiful photo-
graphs but are—what they claim to be. (Strindberg 1961,
101–2)

 A number of points in this letter deserve closer inspection. To con-
tinue the discussion of photographs as windows into the essence of things,
we can turn to the last sentence of the passage, in which Strindberg imag-

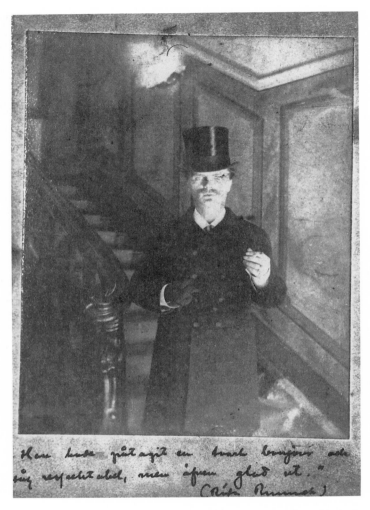

2.8 *August Strindberg, Gersau, 1886, photograph by August Strindberg. "He had put on his black frock coat and looked respectable, but happy as well* (The Red Room)." *Courtesy Strindbergsmuseet, Stockholm*

ines the "claims" of photography. In his reading, photographs speak for themselves; they are naturalistic (i.e., not beautiful, not fictionalized), and they cannot lie. Göran Söderström notes, however, that "despite the naturalistic point of departure, the photographic series carries the stamp of a rather romantic composition and idea" (Söderström 1991, 22). The source of this romanticism, which can best be construed as a belief in a

100 universalizing vision, lies in Strindberg's faith in photography's ability to

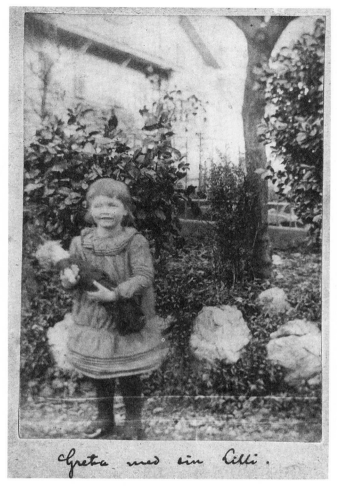

2.9 *Greta Strindberg, Gersau, 1886, photograph by August Strindberg. "Greta with her Lilli."*
Courtesy Strindbergsmuseet, Stockholm

convey the essence of indifferent objects and persons. A passage describing one of the lost photographs from the ethnographic tour of France conveys Strindberg's sense of photography's power:

> One photograph looks like this: earth and air divided by a straight line; the earth is dark, the air is light. On the straight line appear: three haystacks, a tree, two windmills. This is the snapshot that grasps the matter summarily. (Strindberg 1916, 10:40)

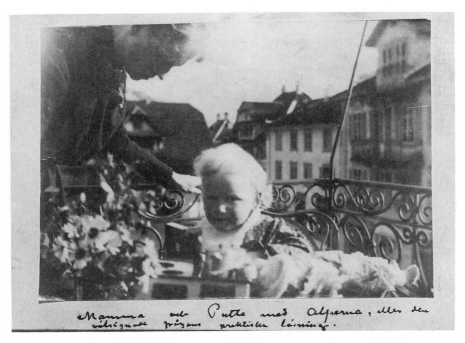

Siri and Hans Strindberg, Gersau, 1886, photograph by August Strindberg. "Mamma with Putte and the Alps, or the everlasting question's practical solution." Courtesy Strindbergsmuseet, Stockholm

For Strindberg, this photograph opens up a realm of the purely symbolic, in which things merely stand for themselves but, in doing so, explain themselves wordlessly. Like the pictures of his family in Gersau, the photograph of the French country horizon construes the deeper meaning of things, rather than simply recording random objects. Here, the composition within the picture's frame is everything. One understands that the "straight line" running across the photograph is the land; and it acts as a foundation upon which all the elements of farming are based, through which they are connected. In the Gersau series, the "straight line" is Strindberg himself, who appears in the majority of the images and whose presence as father and artist is implied everywhere.

But even as the Gersau photographs are enlisted to capture the true essence of Strindberg, they represent a split into photographer and photographed, photographing subject and photographed object. Per Hemmingsson, citing evidence from other sources (including Strindberg him-

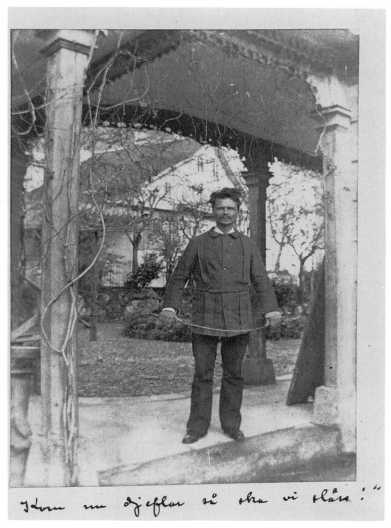

"Ikom nu djeflar så ska vi slåss!"

2.11 *August Strindberg, Gersau, 1886, photograph by August Strindberg. "Come on, you devils, and fight!" Courtesy Strindbergsmuseet, Stockholm*

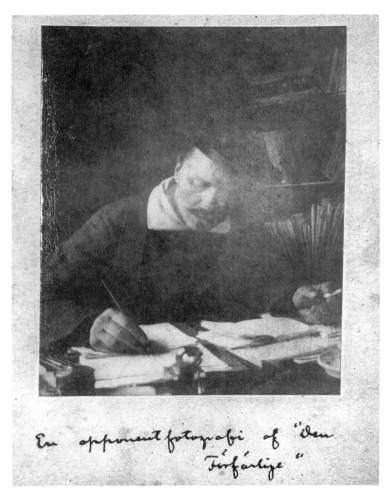

2.12 *August Strindberg, Gersau, 1886, photograph by August Strindberg. "An opponent photograph of 'The Terrible One.'" Courtesy Strindbergsmuseet, Stockholm*

self), contests Strindberg's statement that the photographs were taken by his wife: "To say that Siri had taken the photographs is a half-truth—she had assisted in taking some of them" (Hemmingsson 1989, 150). According to Hemmingsson, Strindberg's obfuscation arose from his "strained financial relations" with his publisher; he identified his wife as photographer in order to elude possible claims the publisher might rightfully make for payment of debts. But while the photographer himself is of course not visible in the images, we hear his authorial voice from off-

stage in the form of captions, which echo the split and ironic distance of the mock interview in their treatment of the photographed subject.

Though Strindberg argues on the one hand for the absolute verisimilitude and monosemy of his images ("they are what they claim to be"), his use of captions uncovers the unavoidable duplicity of self-photography. He is, in these photographs, both subject and object, as he was in *The Son of a Servant,* and this split undoes the illusion of absolute clarity or integrity. Like Twain's captions, Strindberg's reveal the photographed figure *as* figure, much in the same way the third-person Johan is read as a figure rather than being identified with the author. In several cases, the photographs' captions are actually citations from Strindberg's successful satiric novel, *The Red Room.* In these instances the quotation marks around the captions could either identify the pictured author as the source of the remarks or to mark the words as coming from another source—in this case, a fictional source. One caption explicitly identifies its source as *The Red Room;* this is in figure 2.8, where Strindberg stands at the foot of a flight of stairs, dressed to go out for the evening. The caption reads, "'He had put on his black frock coat and looked respectable, but happy as well' (*The Red Room*)."

In citing his own novelistic work in this context, Strindberg identifies himself with his fictional character, rendering himself a figure of discourse and object of observation at the same time. Another image (figure 2.12) shows the author, complete with artist's beret, at his writing table, apparently deep in concentration, pen in one hand, cigarette in the other. Down to the conjunction of tobacco and writing, this photograph recalls the stereoscopic image of Twain in his study at Elmira. Like Twain, Strindberg wants to create the illusion that the viewer voyeuristically observes him in the heat of creation, but the caption, once again, is ironic: "An opponent photograph of 'The Terrible One.'" In this photograph and in the caption for figure 2.11 ("Come on, you devils, and fight!"), Strindberg plays at presenting himself as his critical public sees him: a demon, a troublemaker. Then he subverts his public image with the quotation marks around "the terrible one," and in the conjunction of the "fighting words" image with photographs like the one of his daughter with her doll ("Greta with her Lilli," figure 2.9), his wife and son (figure 2.10) and the father with his little daughters (figure 2.7).

Strindberg's letter to his publisher regarding the Gersau photographs makes it clear that he meant for the images to be published: "The intention was of course to print them in photogravure. Could that be managed in time for Christmas?" The Gersau photographs, if published at Christ-

mas, would not only make the all-important holiday trade, but also accompany the several volumes of his autobiography on bookstore shelves. The photographs, in other words, were envisioned as an essential part of his autobiographical production of 1886. Reading the photographs and their captions in tandem with the autobiography and its mock interview reveals a dispersed subject who nevertheless hopes to interject an authoritative voice—Strindberg wants to have it both ways: anonymous yet recognized (all of his reading public would recognize the photographs as Strindberg), distanced yet engaged (polemically), servant yet master, interviewer and interviewee. His own game of self-anatomization (a game he enters seriously, convinced of its scientific value) creates a process of disintegration that too closely resembles his critics' dismemberment of his image; Strindberg cannot follow the process all the way through. He must bring it to a halt with the insertion of an authorial voice.

Unfortunately, however, the act of dismemberment implied in his autopsy image and the fissure opened by the ironic voice finds a subsequent reflection in his own life. After the series of photographs of Strindberg as *pater familias* are rejected by his publisher as too costly, he goes on to write a second volume of the work that brought about his blasphemy trial: *Getting Married*. This time his wife feels too strongly the strain of being exposed to the world; she is convinced that the public must associate her with the ugly images presented of wives in the second volume. Unwilling to participate in Strindberg's exhibition of their family and personal interiors, Strindberg's first wife ultimately leaves him, taking the children.[10] The authorial voice of the mock interview and the photographic image of the artist-father fail to block what seems like an inevitable dissolution. Now Strindberg, left on his own, will turn his gaze more penetratingly inward. From the body's autobiographical and photographic dissection, he will begin the task of excavating the soul.

The Soul Made Visible: Inferno

The turn of the century saw the invention of X-ray photography (1896) and an accompanying wave of interest in (and fear of) photography's power to reveal the invisible.[11] John L. Greenway notes that "'Photographing the Unseen' (the title of several early popularizations) immediately involved radiology in the widespread *fin-de-siècle* speculations concerning spiritualism and the occult" (Greenway 1991, 31). Such speculations were not as divorced from mainstream science as one might suppose; scientific and medical journals of that time reflect a reconsideration

of occult photographs and telepathic suggestion following the discovery of X-rays. Strindberg decided that Roentgen's discovery was a hoax, because he believed that the ability to penetrate apparently opaque surfaces was a property of ordinary light; as Greenway remarks, "[Strindberg] simply could not believe in a form of energy which ran counter to other known forms" (Greenway 1991, 39). This did not, however, imply that Strindberg was skeptical of photography's occult powers. On the contrary, he believed that not only X-rays but ordinary light possessed the power to penetrate surfaces, and this led in turn to meditations on the possible role of light as a transmitter of thoughts, which prompted his belief in a telepathy whose results could be captured by the camera.

As I discussed above, the suspicion that the sharp eye of the camera could take in and register the invisible details of the world found expression in the earliest analyses of the medium, which focused on natural as well as supernatural phenomena. The idea that an individual's "aura" or the presence of a departed person's spirit could be made visible on a photographic plate predates the invention of the X-ray photograph by almost a quarter-century; the first alleged "spirit" photograph was taken in 1872 (Eggum 1989, 31). Strindberg himself wrote an article entitled "Sciences Occultes" for *La Revue des Revues* in 1896, in which he maintains the authenticity of a spirit photograph taken of a medium in St. Petersburg. This image depicts a disembodied, translucent hand above the medium's head, shining out from a dark background. Strindberg's enthusiasm for such "spirit photography" arises from the confluence of telepathy (suggested in the medium's contact with the spirit world) and photography. But even before the spirit photographs broke on the scene, there were intimations of spirit photography in the work of art photographers such as Henry Peach Robinson (in his staged photograph of a "dying" child) and Oscar G. Rejlander. I would like to discuss Rejlander's work briefly, for like Strindberg's it occupies a pivotal position between the dichotomies of art and science, naturalism and the occult, the conscious and the unconscious.

Oscar Rejlander (1813–1875) was a Swede who lived and worked most of his life in Victorian England.[12] He achieved fame as an "art photographer," staging photographic subjects and manipulating the medium to create dramatic tableaux, a practice that would eventually win the scorn of documentary photographers of the naturalist period.[13] Yet Rejlander concerned himself with some of the same topics as the naturalists: urban poverty, child labor, and the ways in which the human body speaks in gesture and expression. In fact, Darwin worked closely with Rejlander

2.13 *"Contempt or Disdain," from Charles Darwin,* The Expression of the Emotions in Man and Animals *(1872), photograph by Oscar Rejlander. Reproduced by permission of the Syndics of Cambridge University Library*

in the creation and selection of images for his book on expression of emotion (1872). In some of these photographs, Rejlander himself appears, acting out various emotional responses (in figures 2.14 and 2.15, contempt or disgust). Figure 2.13 represents a young woman expressing "contempt or disdain"; Rejlander staged a scene for this image, from which we have only the expressive head, in which the subject was supposed to be "tearing up the photograph of a despised lover" (Darwin 1955, 254).

The interplay between conscious and unconscious expression is difficult to parse in reading these images and in reading Darwin's book. While the photographs obviously represent consciously enacted expression, Darwin maintains that the actors produce details of each gesture unconsciously, working only with the suggestion of what emotion they might feel in a given context. The curl of the lip, the averted eyes, the wrinkled nose, Darwin argues, are all physiologically motivated movements that have been engrained through habit:

> We seem . . . to say to the despised person [with the wrinkling of our noses] that he smells offensively, in nearly the same manner as we express to him by half-closing our eyelids . . . that he is not worth looking at. It must not, however, be supposed that such ideas actually pass through the mind when we exhibit our contempt; but as whenever we have perceived a disagreeable odour or seen a disagreeable sight, actions of this kind have been performed, they have become habitual or fixed, and are

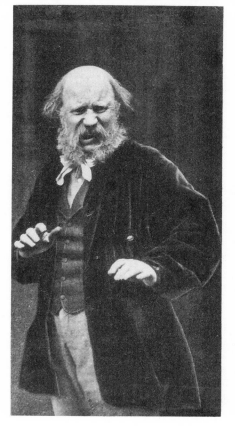

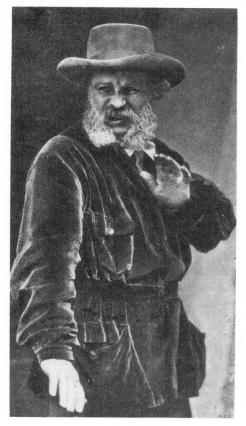

2.14 *"Revulsion," no. 1, from Charles Darwin,* The Expression of the Emotions in Man and Animals *(1872), photograph by Oscar Rejlander. Reproduced by permission of the Syndics of Cambridge University Library*

2.15 *"Revulsion," no. 2, from Charles Darwin,* The Expression of the Emotions in Man and Animals *(1872), photograph by Oscar Rejlander. Reproduced by permission of the Syndics of Cambridge University Library*

now employed under any analogous state of mind. (Darwin 1955, 255–56)

Rejlander's photographs, then, though consciously acted, mean to portray unconscious movements and make them visible to the viewer through the theatricality of his photography. That Rejlander photographs himself in the act of making these gestures increases the aura of consciousness, for he knows not only that he must make an exaggerated expression of a particular emotion but that he is being photographed while

making it, and thus must be sure of the gesture's visibility for the camera's eye. Also of interest is his use of a photograph as prop in the depiction of disdain; the young woman's expression treats the photograph as if it were in fact the object of her contempt, thus underscoring the point that all of the photographs of Darwin's book are to be taken as "real" or equivalent to real persons. It is only when photography can be taken as evidence of the real (equally expressive of the real) that it can be used in a scientific setting.

Here we begin the peculiar crossover into the realm of the unreal, at the moment when photographs are admitted into the real. The young woman's belief in the totemic value of her lover's photograph coincides with the naive reception of photography invoked by W. J. T. Mitchell in the epigraph for this chapter. Even those who call such belief in the "real-ness" of photographs naive (or worse, "primitive") would hesitate, I think, to tear into shreds the photograph of a loved person. Belief and cynicism exist side-by-side in viewers of photographs, and Rejlander manipulates the medium (as early as 1860) because he understands its duplicity, much as Twain did. Another manipulation (which, while manipulative, is by no means cynical) occurs in Rejlander's art photograph of 1860 entitled *Hard Times* (figure 2.16). The reader may recall that a novel of the same name was written by Charles Dickens in 1854. Dickens's novel, which deals with the misery of industrialization in a manner rather distinct from his comic works, has been taken as a forerunner of literary naturalism, and Rejlander's photograph plays on Dickensian themes; an unemployed craftsman (perhaps displaced by increasing industrialization) sits hunched with worry at the side of a bed where his wife lies with his child. But Rejlander introduces into the scene a curiously spiritual image: through double exposure, he superimposes a translucent image of the same man standing with his hand stretched out and resting on a woman's head (per-haps his wife, perhaps in benediction). The child kneels at the father's feet, eyes closed and hands clasped in prayer. Beaumont Newhall specu-lates that this may be the first composition photograph, a method for which Rejlander later gained significant (if short-lived) fame.

Rejlander's *Hard Times* fascinates for a number of reasons. It reflects, first of all, the belief in photography's power to reveal the invisible. Be-cause the woman's face has been carefully superimposed over the man's brooding head, the viewer has the impression that the double exposure represents the man's thoughts. But, one might object, Rejlander can cer-tainly not himself believe that thoughts can be captured photographically,

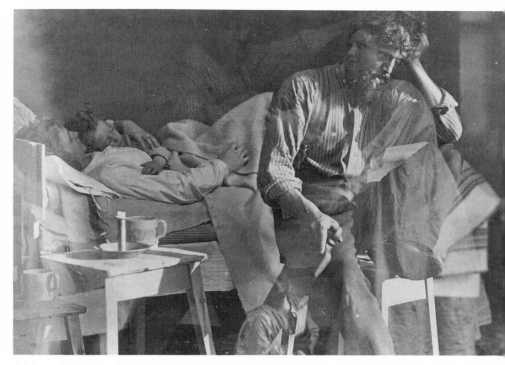

2.16 *"Hard Times," 1860, photograph by Oscar Rejlander. Courtesy George Eastman House, Rochester, New York*

since he knows that he produced the effect through artificial means. Of course the use of a double exposure in such a setting (whether learned by accident or achieved through laborious effort) represents a conscious artistic decision. This is true also of Rejlander's photographs of himself performing emotional expressions for Darwin. But in both cases, the contrived image seeks to represent something conceived on some level as real—the signs of interior physiological and / or psychological conditions (which Darwin characterizes as equivalent, in any case). The translucent figure, typical of the effect of double exposure, more than adequately conveys the sign our culture has traditionally assigned to the representation of the not-present-yet-present, such as the spirit world. And it is precisely that, the not-present-yet-present, that photography in all cases represents.

This may seem a circular argument, but I am not, after all, arguing for the existence of visible thought waves. Instead I am asking the reader **111**

to consider the oscillation between believing and not believing that occurs in the production and viewing of photographs. On one level, the viewer knows that the image of a person is not that person, but a piece of paper treated with light and chemicals. On another level, a deep superstition exists that this piece of paper represents the person it depicts so mysteriously that tearing or burning the image would constitute some abridgment of the relationship between the viewer and the photographed subject.[14] As a photographer, Rejlander also works between the pole of believing and not believing; even if he does not accept the presence of "real" visible thought waves, he can create them through photography.

I have discussed the reaction to the discovery of X-rays and Rejlander's work in order to place Strindberg's photographic and autobiographical production of the 1890s in the proper perspective. Seen in their historical context, Strindberg's psychological photographs and occult autobiography can be understood as part of a broad cultural movement and not as the rantings of an unbalanced mind.[15] In fact, Strindberg's work in this area offers a bridge between the Darwinian impulses of naturalism and the Freudian innovations of modernism, especially expressionism but even surrealism.

In 1892 Strindberg's first marriage ended in divorce, and he left Sweden for Berlin. It was at this juncture that he conceived of a career in photography, for setbacks in his writing led him to consider himself primarily a scientist, with a commitment to chemistry and ultimately to alchemy. It was his plan to establish a studio in Berlin where he could take "psychological portraits" of the bourgeoisie. Adolf Paul, a friend at that time (and subsequently an enemy), describes Strindberg's method:

> To start with, he wanted to be a photographer—despite Ibsen, who in Strindberg's opinion, had tried to create a caricature of him in his immortal photographer Hjalmar Ekdal.
>
> His efforts in the field of photography were not entirely lacking in individuality. Of course, his primitive camera [Strindberg had devised a lensless apparatus consisting of an old cigar box with a hole in it] necessitated a longer exposure time than usual—at least thirty seconds. And that gave Strindberg the opportunity of taking what he called "psychological" portraits.
>
> "I have prepared a story for myself," he said, "which contains all possible moods. I tell this story to myself while I am exposing the plates and gazing fixedly at the victim. Without suspecting that I am forcing him to do so, only under the influence of my suggestion, he is obliged to react to all the moods I

go through in the meantime. And the plate fixes the expression on his face. The whole thing lasts exactly thirty seconds—my story is carefully calculated to fit the measurement. In thirty seconds I have captured the whole man! But, of course, it does not work with every possible idiot. I have nothing to do with bounders. Only rich people. And high prices!" (Paul 1915, 36–37, trans. in Hemmingsson 1989, 157–58)

Even taking into account Paul's inclination to satirize his erstwhile friend, this presentation of Strindberg's photographic method uncovers intriguing commonalities with (and deviations from) Darwin's theory of emotional expression. Like Darwin, Strindberg believes that the photographed subject, asked or incited to produce an emotional response, will give unconscious physical signs of his or her emotional state, which can then be immortalized for study on the photographic plate. One difference is that Strindberg believes that he can incite a psychological and physiological response in his "victim" through telepathic suggestion. Another difference is that Darwin concerns himself in each case with the expression of a single emotion (or a constellation of closely related emotions), while Strindberg hopes, through the long exposure, to see the whole range of an individual's expressive repertoire.

Strindberg's proposal (technologically unsound as it is) to concatenate emotional responses photographically does not deviate from his understanding of Darwinism, for he imagines the Darwinian subject as a jumble of inherited and learned responses, a "characterless character" (to cite his foreword to *Miss Julie*), with no fixed nature but a reactive one. This is why the application of his telepathic will in the photographic situation represents a further expression of his understanding of Darwin; in any given setting the subject does not exist in solitude but responds to its environment (both human and nonhuman) according to its own strength. All such interactions should be imagined as battles between stronger and weaker forces, in which the stronger power will prevail in determining the weaker power's parameter of reaction. The situation in the psychological portrait session (as Strindberg imagines it), involves the victory of his own will (as photographer) over that of the photographed subject, who is forced to respond to his suggestion. Such psychological struggles form the basis for any number of Strindberg's dramas, both before and after the Inferno Period, including *Miss Julie, The Father, Dance of Death, The Stronger, The Creditors, The Ghost Sonata,* and so on.

Thus Strindberg's characterization of the photographed subject as

"victim," and his emphasis on the idea that the victim should be strong (capable of putting up a fight) and rich (worth defeating) should be understood as Strindberg's reading of Darwin's "survival of the fittest." An interesting parallel to Strindberg's photographic scenario will come up in my discussion of Christa Wolf's autobiography in chapter 4; the image of the photographic situation as a struggle for the supremacy of subjective agency continues into our own time, with historical as well as psychological implications. If we imagine in one sense photography as a record of the dead, we must also think of the psychological murder of the photographic situation, and the photographed subject's struggle to remain hauntingly alive. It is significant, therefore, that the only apparent "psychological portraits" to survive were taken by Strindberg of himself. One of these is figure 2.17. The specks on the image are a result of impurities in the printing process, yet despite the print's flaws, the expression in Strindberg's eyes as he stares into the camera does indeed seem to convey the depth of the despair he experienced at this stage of his life.

In Strindberg's first autobiographical texts, discussed in the preceding section, the manipulation of the self by another is played out in the narrator's separation of himself from his weaker, younger self, whom he anatomizes. In *Inferno,* an autobiographical text written in 1897, Strindberg imagines yet another intersubjective struggle of wills, but this time he situates it differently. *Inferno,* the text that charts Strindberg's religious conversion, takes as its point of departure the presence of unseen powers in the world, divine powers (whether heavenly or infernal or both) that concern themselves specifically with Strindberg and his destiny. *Inferno* depicts Strindberg's struggle with these spiritual forces, which ultimately bend him to their will through physical and psychological violence.

As the book opens, Strindberg finds himself alone, in a position of utter vulnerability: "Looked upon by society as a bankrupt, I was born again in another world where no one could follow me. Things that would previously have lacked significance now attracted my attention. The dreams I had at night assumed the guise of prophecies. I thought of myself as one of the dead, passing my life in another sphere" (Strindberg 1975, 115). The narrating subject now imagines himself as the dead body which lies under another's knife—but whose? The whole of *Inferno* is devoted to learning the script of "The Unseen Hand," as the first chapter identifies the invisible powers. The new dispensation Strindberg describes as "another world" and "another sphere" coexists with the old world, but now Strindberg sees the signs in the world around him as intimately linked to his own person, his fears, hopes, and designs. *Inferno* involves an exterior-

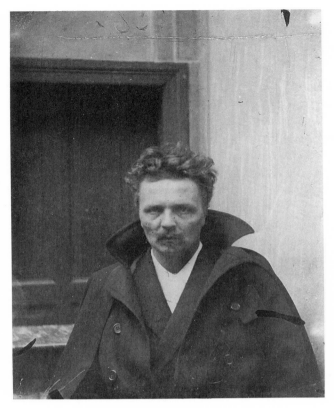

2.17 *August Strindberg, Berlin, 1892, photograph by August Strindberg. Courtesy Strindbergsmuseet, Stockholm*

ization of the subject to such an extent that it is mirrored everywhere; the world, like a photographic portrait, becomes a site for reading the interior activity of an individual's mind.

Often the "signs" from the unseen world are quite literally signs: "when I at last lowered my gaze I became aware of a dye-house sign on my right, in the Rue Fleurus. Ha! here I saw something undeniably real. Painted on the window of the shop were my own initials, A. S., poised on a silvery-white cloud and surmounted by a rainbow. *Omen accipio*" (Strindberg 1975, 116). Other important signs include Parisian street signs, which are often named for famous individuals, and Strindberg recalls the biographies of these individuals, marking them as indications of his own successes or failures, thus merging his life's text with those of others. This has, of course, interesting implications for autobiography; **115**

Strindberg's belief in telepathy and his exteriorization of selfhood indicates an effacement of the boundaries between persons, even as it asserts the strength of the Ego.

This theory of correspondences, which Strindberg draws from his reading of Swedenborg, supports his earlier idea of psychological photography in the sense that exterior signs (such as found objects or the expressions of the photographed body) can give evidence of the life within. Strindberg's insistence that his signs be *real* (as the sign at the dyer's shop) and thus visible to anyone, further underscores his faith in photographs, for this medium registers the real; in fact what it registers cannot be considered unreal by the naive reader of photographs. Not surprisingly then, in *Inferno* Strindberg feels he has hit upon a truer naturalism. In describing a drawing of a Madonna for which the artist claimed to use a formation of floating waterweeds as his model, Strindberg exclaims: "A new art discovered. Nature's own! A natural clairvoyance. Why scoff at naturalism now that it has shown itself capable of inaugurating a new kind of art, full of youth and hope?" (Strindberg 1975, 148).

Strindberg's definition of naturalism in this context diverges quite sharply from that of Zola, but he is not alone in making an occult religion of naturalism. In his discussion of German naturalist writers, Dieter Kafitz indicates that French and German conceptions of naturalism differ in that the French are concerned primarily with social issues and concentrate on purely physical phenomena and experiences, while the Germans create a monadic, idealized naturalism, which professes the presence of a single unifying and transformative power in the world.[16] A belief in animism characterizes both Strindberg's naturalism and that of his German contemporaries, which leads to a naturalism that looks like romanticism. This unexpected confluence of thought and styles exists already in Strindberg's Gersau photographs, just as it appears in Rejlander's (and thus Darwin's) work. The photograph, with its reference to a real world, its supposed ability to more deeply penetrate that world, and its power to reveal the interior world in external signs, provides a perfect site for such idealized naturalism.

When Strindberg places himself under the knife (or eye) of the unseen powers of *Inferno,* it would be tempting to imagine that he sacrifices the authority of his own subject. The Swedish word for "victim," which he uses in his description of the psychological photograph, is *offer,* a word equivalent not only to "victim" but to "sacrificial offering." But Strindberg firmly resists self-annihilation; in fact, in erasing the bounds between self and world, the subject comes to inhabit everything, and everything re-

lates to (inhabits) the subject. To preserve the subject is to act in accordance with the unseen powers, who are involved in the subject's formation: "All that I know, little as that may be, springs from one central point, my Ego. It is not the cult but the cultivation of this which seems to me to be the supreme and final goal of existence. . . . to kill the Ego is to commit suicide" (Strindberg 1975, 168). His insistence on the central agency of the Ego, however, battles with the image of the self that exists everywhere, that has no centrality.

Strindberg stubbornly retains the image of his body as scientific proof of the Ego's existence even as he moves into arenas (theology, psychological photography, telepathic communication, etc.) that do not, according to our thinking, fall into scientific categories (or even psychoanalytic ones). In fact it is Strindberg's adherence to the notion of visible proof in writing about and photographing himself that renders his later autobiographical writing and self-portraits so poignant; unlike Twain, who adopts a cynicism in his manipulation of textual and photographic self-images, Strindberg continues trying until the end for an integration of his dispersed self, even as it becomes more apparent to him that his efforts are destined for failure. The struggle between self-resignation and self-affirmation continues in his effort to capture his own image in photographs and autobiography, particularly in his late autobiographical novella *Alone,* to which we now turn.

Alone: **The Anxiety of a Vanishing Self**

Ett isolerat liv kan strängt taget icke föras. (One cannot, strictly speaking, lead an isolated life.)

AUGUST STRINDBERG, "Själamord" (Psychic murder)

We return now to the scene described at the beginning of this chapter, where Strindberg invites a friend to inspect an informal exhibit of his photographic self-portraits. The year is 1906, and the images displayed represent the author's final innovation in photographic portraiture: the "Wunderkamera." Strindberg held that the greatest feature of this camera was a special lens, an unpolished piece of glass, for he believed that "the simpler the lens, the better the picture" (Ahlström and Eklund 1961, 182). By "better" he actually means less focused; the unpolished lens diffused the light cast through it and softened the lines of the photographed object. His friend comments on the results: "All of the portraits possessed a certain indistinctness of line, which had an almost compelling

effect, since few people if any see objects as clearly in reality as they appear in photographs" (Ahlström and Eklund 1961, 182).

Here Strindberg's friend falls into agreement with another of Strindberg's photographic conundrums. The most "realistic" photograph is not one that produces a sharper image (a picture of what the thing is), but one that most accurately reproduces the experience of seeing an object. He engaged a photographer friend to assist him in his quest for "truer" images; figure 2.18, produced by Strindberg's friend Herman Andersson, indicates the retreat from standard photographic values. Strindberg's drive to produce life-sized images clearly arises from the same need to approach the experience of reality as closely as possible. In Strindberg's imagination, photographs are charged with the task of performing as stand-ins for their subjects, a task they perform best when they convince the observer that the subject is as good as present. Excessive clarity of line and reduction of size destroy that illusion.

Strindberg's "naive" understanding of photographs endowed the images with telepathic powers, both passive and active. In a 1901 entry in his *Occult Diary,* during his difficult courtship of his third wife, Harriet Bosse, he writes: "Woke firmly determined to release myself from B[osse]. Sent both photographs of her to Germany and felt freer!" (Strindberg 1975, 290). Images of a person who bore him ill will could, he felt, convey that individual's evil intentions. Similarly, he believed that his own thoughts could be communicated to a photographed person via his or her image; on 29 July 1906, he notes: "My little child is thinking of me! She probably feels it when I walk past her image in the hall and nod at her" (Strindberg Papers). At one desperate juncture in his life, his desire to have contact with his estranged second wife and her child was so strong that he wished the child ill, thinking that a mild illness would bring about a reunion. He used her photographic likeness as a telepathic conduit. When instead his three children from his first marriage fell seriously ill, he was overcome with remorse, convinced of the effectiveness of his telepathy despite its missed target (Hemmingsson 1989, 107).

Through all of these instances runs a common thread: Strindberg's conviction that possession of a person's photograph provides a means of direct contact with that individual. He conceives of the act of looking at photographs as relational; not only does he look at the photographed subject, but the subject looks back at him, feels his presence and acknowledges it. Yet photographs also signify their subjects' absence—it is precisely because of the longed-for person's absence that Strindberg approaches the image for communication. The photographs become sym-

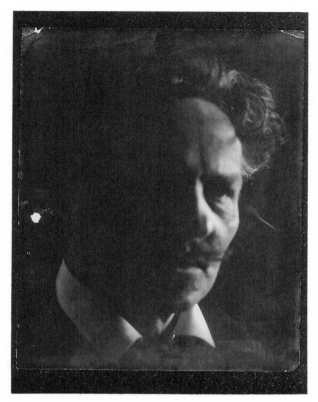

2.18 *August Strindberg, 1906, photograph by Herman Andersson. Courtesy*
Strindbergsmuseet, Stockholm

bolic of his longing and his solitude, even as he contrives to make them
work against his loneliness. During the difficult period of separation and
divorce from his third wife, Strindberg kept a life-sized photograph of
her behind a curtain in his apartment. According to a colleague, the au-
thor treated the image as a sort of icon in moments of distress, going off
into the room where it hung, drawing the curtain, and standing silently
before the image for a few moments. Afterward he would wash his hands
in cool water to calm himself (Falck 1935, 74–76). In his *Occult Diary*
from this period, Strindberg records that despite their separation, Harriet
Bosse would telepathically approach him and force him into sexual inter-
course. Her photograph asserted her continued presence in his life when
he was most in need of it.

In his solitude after the breakup of his third and final marriage, Strind-
berg's experiments with the "Wunderkamera" represent his attempt to 119

reinsert himself into the circle of relationships, the circuit of seeing and being seen. The photographs of others are meant to reinstate their presence in his life; his photographs of himself, which multiply during this period, reveal an anxiety about his own coming absence (his death), which is foreshadowed in his solitude. Not content with enlargements of photographs of his estranged wife and daughter, he turns to life-sized portraits of himself, searching out old original plates of photographs from his youth for enlargement (Hemmingsson 1989, 111). His autobiographical novella *Alone,* written in 1903 during his separation from Harriet Bosse, contains an image of the vanishing self, longing to see and be seen.

Listed by Strindberg as one of the volumes to be included in his definitive autobiography, *Alone* offers a peculiar vision of the autobiographer as voyeur. Freud claims in his *Three Essays on Human Sexuality* that sexual perversions in the widest sense (for Freud wants to define "perversions" as extensions of the normal) occur in pairs; that is, sadists are also unconsciously masochists, and voyeurs also derive unconscious pleasure from exhibitionism (Freud 1953, 7:167). The yoking of voyeurism with exhibitionism seems to point to the voyeur's hidden agenda: self-identification and self-visualization. If the voyeur unconsciously longs for the return of his or her gaze (as Freud's thesis implies), then is not the focal point of the voyeurist's look directed ultimately back at the self?

Recent treatment of voyeurism in cultural studies has focused on the cinema, and in doing so, has moved from Freud's inter- and intrasubjective perception of voyeurism to an interpretation that centers on a subject/object split between viewer and viewed. Taking their impetus from Laura Mulvey's groundbreaking article "Visual Pleasure and Narrative Cinema," feminist theorists in particular have concentrated on the implications of voyeurism for the female object of the male gaze, citing the cinema's role in reasserting the power structure of patriarchal society: "Woman . . . stands in patriarchal culture as a signifier for the male other, bound by a symbolic order in which man can live out his fantasies and obsessions through linguistic command by imposing them on the silent image of woman still tied to her place as bearer, not maker, of meaning" (Mulvey 1989, 15). The male plays the role of subject/observer, with the female as passive object of his gaze. While scholars writing in response to Mulvey have taken issue with her assumption that the viewer of narrative cinema must always be figured as male, the object of the viewer's gaze always as female and passive, her analysis does point up the problem in cinematic voyeurism/exhibitionism of the absence of real reciprocity be-

tween the viewer's and actor's looks. Thus the cinematic screen interrupts the joining of the voyeuristic and exhibitionistic impulses that in Freud's essay occurs in the same individual.

In *Alone,* Strindberg creates a portrait of himself as voyeur that underscores that element of voyeurism least adequately treated by cinematic studies: the desire to be seen, the formation of the ego. Mulvey does address this issue when she discusses two aspects of the "pleasurable structures of looking"—the first a scopophilic pleasure that derives from objectifying the person viewed, the second, "developed through narcissism and the constitution of the ego, comes from identification with the image seen" (Mulvey 1989, 18). But the cinematic situation seems an inadequate substitute for the pleasure (and the terror) of truly being seen by another subject in the voyeuristic situation.

Another recent approach to cinematic voyeurism, perhaps the one most relevant to my discussion of *Alone,* comes from Judith Mayne, who wants to reinscribe the role of the filmmaker—in particular, the female filmmaker—and *her* point of perspective in creating the voyeuristic spectacle of cinema. Mayne's force of concentration moves from the spectator in the theater to the creator—that is, the *original* spectator of the film. In this sense, her analysis could complement Christian Metz's proposition that the cinematic spectator identifies primarily with the cinematic apparatus itself, partaking of the activity of "making" the film in the viewing of it.[17] With this in mind, it makes sense to consider the role of the cinematic author, despite the controversy surrounding the *auteur* theory of filmmaking.

Mayne writes of "films which are remarkable explorations of the desire . . . to see and be seen, to detach and fuse, to narrate one's own desire and to exceed or otherwise complicate the very terms of that narration" (Mayne 1990, 123). This occurs in the authorial enactment of the voyeuristic scene, in which the filmmaker alternately conceals and reveals her contradictory (and illicit) desires. Of particular interest are two recent films by women directors, Chantal Akerman and Ulrike Ottinger, in which they appear as key figures in their own narratives. This presentation of the self as object for voyeurism and the disruption of the strict subject-object dichotomy such a presentation entails lead us to a consideration of Strindberg's autobiographical work.

Like Akerman and Ottinger, Strindberg creates a narrative in which he observes himself as an object even as he is also the subjective source of the gaze. One might say that all autobiographical texts function in this way, but Strindberg's, like those of the filmmakers, operates on a visual

121

plane where he watches others, watches himself, and comments on himself watching. Strindberg's figuration of himself as voyeur highlights the self-objectification inherent in autobiographical narrative, indeed, the self-objectification necessary for the formation of an ego, following Freud and Lacan. That his voyeuristic sessions tend toward the narcissistic rather than the scopophilic side of the spectrum indicates the ultimate object of his gaze, but what turns him back on himself is the repeated refusal of the female objects of his gaze to be objectified—they insist on their status as subjects, rejecting the narratives he has composed for them from his dark lookout point. Strindberg finds himself confronted, finally, with a blank page and solitude.

Photographs enter the scene as a means to capture or engrave the viewed objects. Strindberg's narrator does not actually carry a camera on his window-gazing jaunts through Stockholm, but he brings in photography as metaphor in an attempt to describe his process of "fixing" views for subsequent use in his writing. The photograph, like the cinematic apparatus, separates the voyeur and the object of his gaze from the original scene of activity. If the narrator were to take photographs, he could count on an image that would function much like the object of the viewer's gaze in the cinematic situation: passively, conforming endlessly to the voyeur's frame. But the narrator ironizes his position as voyeur by revealing how he does *not* take photographs, the object does *not* conform to his frame; as a first-person narrator commenting on his only marginally successful voyeuristic adventures, he shows himself up as someone who understands the notion of narcissistic self-delusion.

The title *Alone* reflects the narrator's chosen state, for he insists that he needs to escape from the society of others, but from the beginning this writer, though he eschews social gatherings and the company of his friends, finds himself drawn into the observation of others. He becomes taken up with speculations concerning the thoughts of strangers he meets on the street, strangers he observes through his binoculars and through their apartment windows, strangers who, he sometimes imagines, are also looking at and speculating about him. The author's rambles around Stockholm serve as a necessary prelude to his writing, for he "burns with longing to set to work, but first . . . must go out" (Strindberg 1916, 38:154) for some contact with the outside world: "And so I walk my streets; and when I see people's faces they awaken memories, give me thoughts" (38:163). Authorship is thus inevitably linked to a process of using the visual stimulation of other people's bodies as a means of inspiration. Interestingly, however, the thoughts these other faces give him tend

to reflect back on the writer himself. Repeatedly meeting the same people on his walks, he imagines their reactions to him. Of a retired officer he remarks, "I have even got an impression from his eyes that he doesn't hate me, but perhaps likes me" (38:131), while another man "has tasted life's knowledge in its most bitter form; has fought against the current and been broken" (38:131)—clearly attributes Strindberg ascribes to his own experience. In his solitude, the world and its inhabitants have become nothing more than a reflection of his inner consciousness.

These simple acts of surveillance on the street amount to a kind of voyeurism because the narrator tries to penetrate the public surfaces and enter the private thoughts of passersby, much as the voyeur enters the private space of the boudoir through the keyhole. The true object of his gaze, however, is himself. The passing strangers' eyes act as mirrors for the narrator's own fears and desires—to be loved, to be hated, to be recognized for what he was and what he might become. The people on the street have become roving cameras, recording the narrator for himself. In the manner of the voyeur who is at the same time exhibitionist, the narrator projects his own voyeuristic desires onto those he encounters.

More traditionally voyeuristic are the moments when the narrator sights unaware objects through windows or through his binoculars. The first of these is presented as part of a habitual practice:

> If I go out in the evenings, when darkness has fallen and lights are lit, my circle of acquaintances grows, for then I can see into upstairs apartments as well. I study the furniture and arrangement, and I get family interiors, scenes from life. People who don't close their blinds are especially disposed to show themselves and so I don't need to worry about intruding. Besides, I take snapshots and work out what I have seen later. (38:164)

This passage deserves close attention, not least because of the image it summons up of the author, standing in the darkened street, gazing up at the illuminated windows and making a "study" of the heedless inhabitants. As the narrator relates this incident, we must imagine his perspective matching ours—he too shares our vision of the voyeur, he sees himself watching as he shows this image to us. His description of himself in this attitude of voyeurism is in fact a fulfillment of his desire to be seen, for in his writing, he observes himself and his secret shame, and he shows the scene to us.

His excuse, that a laxness about pulling the blinds implies a willing-

ness (or desire) to be observed, is precisely that—an excuse—a blind behind which his feelings of guilt are still visible. He has projected his exhibitionistic desire onto the inhabitants of the scenes he surveys. The "besides" of the next sentence makes it clear, however, that he recognizes the tenuousness of that projection; *besides,* he only stands there long enough to take a snapshot with his invisible camera. The word he uses, *ögonblicksbild,* is the expression commonly used for snapshots in Swedish, but is also a compound of *bild* (image) and *ögonblick* (blink of an eye, moment). He gazes, in other words, only for a moment, then brings the recorded image, the take (he "gets" family interiors), home to work out. Of course he does not mean this literally; the "snapshot" here acts as a metaphor for a kind of mental shorthand, in which the seen moment is inscribed on the memory in order to be removed from the scene. In imagining these scenes as snapshots, Strindberg invents for himself the cinematic situation in which the viewer can view the object in full confidence that the object will not challenge his gaze. Such a situation is, however, only a product of his imagination; as voyeur he seeks on the one hand to contain and determine the object (in a photographic frame), and on the other hand claims the object as a *bekantskap* (acquaintanceship), which reveals the desire for his relationship with the objects of his gaze to be mutual, that the act of looking might be reciprocal.

This first instance of window-gazing to which the reader is party (with our gaze, like the narrator's fixed on the gazer as well as the object), seems at first a typical act of voyeurism. The primary object of the gaze is a young woman, who sits somewhat apart from her companions in the well-lit room, knitting while they play cards. But while the gaze of the author performs the voyeuristic task of delimiting, framing, and objectifying, a pivot occurs that changes the force and purpose of looking:

> Then [the young woman] lifts her knitting and considers it as if she were reading the time from a clock; but she looked out over time and the knitting and into the future—and then her gaze ran out through the window, past the urn, and met mine out there in the dark without seeing it. I thought that I knew her, that she spoke to me with her eyes, but of course she didn't. (38:165)

The young woman directs her own gaze out into the darkness, and in doing so, she breaks out of the frame of the narrator's observation. For now the scene has left the carefully articulated room of the past and gone out, in the woman's gaze, into the future and the unknown. Though the

narrator would like to posit himself as the ultimate point of her focus, he knows he cannot do so. She is looking at something he cannot see. With this pivot, Strindberg has performed a kind of shot/reverse shot, changing the perspective from one originating outside the room to one from inside the well-lit space.

Freddie Rokem has observed Strindberg's use of this technique in his dramas as well; in *The Ghost Sonata,* for example, the first scene takes place on the street below an apartment building. The second moves to the interior of the apartment building, from which the actors can look down onto the street. This shift in perspective does not simply entail a change in location of action, but accompanies or causes a change in knowledge or understanding on the part of the characters and/or the viewers of the scene, either uncovering new knowledge or undermining previously gained "knowledge." In this first recorded instance of voyeurism in *Alone,* the woman's gaze forces the narrator from his position of knowledge (he has analyzed the details of the furnishings and categorized the people in the room) into a position of uncertainty; he would like to imagine that she is gazing at him, but knows that this is impossible.

Perhaps most important in this scene for our purposes here is the ultimate object of the narrator's gaze. Though the episode seems to present a trite instance of mild sexual interest, in which a male voyeur makes an unaware female an eroticized object of desire, the narrator's most pressing concern seems to be the wish to be seen himself, to enter the scene. While he stares up into the window, he creates a narrative for the situation framed there; the people in the room, he decides, are waiting for someone. Particularly the knitting young woman, looking at her knitting as if she wanted to read the time from a clock, is killing time until the arrival of the missing party. The narrator unmasks his desire to be the one who breaks up the scene through his arrival when he imagines her eyes meeting his in the darkness—but just as he predicted, the awaited party does arrive, and at that moment, a passerby accidentally knocks against the author:

> [I was] awakened so brusquely that I literally felt myself cast
> out onto the street, out of that room where I had been in spirit
> for two long minutes, living a fragment of those people's lives.
> Ashamed, I walked on. (38:166)

The distinction between body and spirit here is important. There is a way in which the narrator wants a knowledge of his physical self, to be seen, to be awaited, to be acknowledged. It is a physical blow that recalls him

to the realization that only his "spirit," his mind, has penetrated the window of the bourgeois home. This is not, however, necessarily an indication of the erotic nature of his gaze. It is most essential to him that he become the object of someone else's gaze, that he see himself mirrored in that person's eyes. He is the ultimate object of his own gaze. That true penetration (either spiritual or physical) is impossible becomes clear first when the woman does not return his gaze and then when the passerby recalls him to his own physical presence. In his mind, he had traveled into the room in order to observe himself through the eyes of the woman. Such an act is not possible when he consciously occupies his own body, as he does after the blow from the passerby. His shame as he walks on, and the narrator's retrospective allusion to that shame, points up his awareness of the illusion.

The next voyeuristic episode also seems at first a typical act of erotic voyeurism: the author sits at his desk and watches a young girl through binoculars. It is his habit, when he needs refreshment in his writing but does not want to go out into the street, to look through a pair of binoculars at a certain spot on the coast. One day, however, he observes a small drama at the usually deserted site; he says that he "got a whole little scene in [his] binoculars" (38:174), once again emphasizing the act of "taking" a scene, as one "takes" pictures. At first he is annoyed by the intrusion of a young girl into "his" landscape ("What are you doing there?" [38:174]), but he soon becomes interested in observing and interpreting her movements. Significantly, however, he fails utterly in scripting a narrative for the girl. He predicts that she will throw stones into the water, as all children do, but once she has fulfilled that prophecy, she veers out of his control. The fact that she carries a little axe disturbs him, because he cannot draw a plot for that action: "An axe in the hand of a child? I could not easily link those two concepts, and so it seemed mysterious, almost awful" (38:174). When she begins to cut branches from an evergreen, things become even more bewildering. He cannot decide whether she is a city or country child, whether she is gathering fuel for a fire or branches to dress a house in mourning (as is the Swedish custom), or. . . . Rather than taking voyeuristic pleasure by setting the girl within the frame of his observation, the voyeur is disappointed by the girl until he finally sets down the binoculars in disgust: "Imagine! To be drawn into such distant dramas from his peaceful home! And then to be persecuted by musings about what the evergreen branches were for!" (38:174).

Unlike the first episode, when the author entered the well-lit room of his own accord and felt certain of the nature of the scene staged there,

in this instance the object of his gaze enters his territory without his permission and does not respond according to his inner script. The important thing, in fact, is not what the girl does, but what exists in the narrator's mind about what the girl ought to do, ought to be. When she does not reflect his inner notion, he ceases observing her. His final comment reflects a kind of outrage at the girl, as if she had deliberately duped him. She pulled him into speculations by her errant actions, almost as if she were aware she was being watched, and refused to cooperate with the invisible camera's eye. Once again in this case, as with the woman seen through the window and the people passed on the street, the real object of desire is the author himself, who observes not the others, but a reflection of the workings of his mind and the presence of his own person. He wants to assert his authorial privilege, but the world will not conform to his design—it will not even look at him. In both episodes of blatant voyeurism, the narrator is aware of himself as a voyeur, and a light self-ironization breaks through when he is interrupted or interrupts his reveries. In writing, he observes himself as a voyeur, and is both amused and ashamed.

The final two voyeuristic events provide a kind of justification for voyeurism, because these two instances turn out perfectly according to script. The question is, however, who scripted them? Once again the author has taken to the streets, and chance seems to have led him to the apartment building where he lived as a bachelor. While he stands gazing up at his former building, a rather odd thing happens: someone comes up behind him and lays a hand on the nape of his neck, "as only an ancient acquaintance can do" (38:206). This is the first moment in *Alone* when someone intentionally touches the narrator, and it is done in such an intimate way as to have the power of authority, though the person who touches him is actually his junior: a young composer with whom he is acquainted, and who now lives in his old rooms.

This young man breaks through the self-imposed solitude of the older writer not only by touching him as if an old acquaintance, but by seeing him, by watching him look. "Were you thinking of going up to your place?" he asks, having noticed the focus of the narrator's gaze. The Swedish construction of this sentence offers richer possibilities for interpretation: "ämnar du upp till dig?" is the original question, which could also be read, in a more literal sense, as "are you thinking of going up to you [yourself]?" As the author has scripted plots for the objects of his gaze, so now the composer writes out the author's intentions to return to an earlier stage of his life. Though the narrator has not explicitly stated a wish

to go into his old rooms, he now accompanies the young man up the stairs for the last acts of voyeurism, under the composer's supervision.

As the author sits in his former apartment (now occupied by the composer), the young man begins to play for him.

> And when he began to fill the little room with notes, I felt as if I were in a magic circle, where my present self was erased and my self from the 1870s appeared.
>
> I saw myself lying in a sofa-bed that had stood just where I was sitting, in front of a sealed-up door. And it was one night . . . (38:207)

The night he remembers while in this "magic circle" was a particularly horrifying one, during which a neighbor, whose movements he could easily perceive through the door that separated them, succumbed to an illness and died.

> At the neighbor's it was quiet, absolutely silent, but there was something disquieting coming from there; a cold stream of air, an attention directed at me, as if someone in there were listening to me or looking in the keyhole at what I was up to. (38:207)

The layers of observation here become very complex. Who is looking through the keyhole, and when? If we imagine that the young man lying on the couch feels the eye of an observer, it could of course be his fantasy at that time that his dying neighbor is spying on him. The cold air could blow from the youthful narrator's presentiment that the neighbor has in fact died, and that he is lying inches away from a corpse. But the piece as a whole hints at another possibility. The person "at the keyhole," the one who observes the young man on the couch, is the narrator himself: "I saw myself lying . . ." The narrator as a young man feels the eye of his own old age, feels the cold blast of his solitude—or at least, this is the sensation "remembered" by the old narrator. (One thinks here of Poe's "The Tell-Tale Heart," in which the narrator actually hears the sound of his own heart beating, but believes it to be the sound of his murdered victim's heart.) This projection of the self into the past and the past self's presentiment of the future does indeed form a *trollkrets,* a magic circle, sparked by the music played by the young composer. The episode also indicates, in a different way from the ways I have sketched above, the self-reflexive nature of the narrator's gaze. It is not the old man, who is, after all, probably dead, that observes the young narrator. It is the narrator himself who feels the cold impact of his own eyes.

That the young composer has an object of his own in mind becomes clear when he notices the older man's gloomy countenance and begins to play a more lighthearted music:

> The force of the notes seemed to crowd me out of the narrow room and I felt a need to throw myself out through the windows. So I turned my head and let my gaze go out behind the musician; and since there were no shades, it ran out and across the street into an apartment in the building opposite, which lay somewhat lower, so that I arrived in the midst of a little family's evening meal. (38:209)

Unbeknownst to the narrator, the family consists of the young pianist's lover and her little nephew, whom she treats as a son. The vision of this Madonna—a virgin and yet a mother—acts as Strindberg's model of the perfect woman, pure and yet maternal. His image of her fades to a screen of purest white as he gazes at the white glass of milk on the white tablecloth, the white crysanthemums, the white tile oven and the white faces:

> everything was so white in there, and the young girl's motherliness toward this child whom she had not borne herself shone so white now as she bunched up the napkin, dried the little one's mouth and kissed him . . . (38:211, ellipses in the original)

The fade to white is accompanied by the narrator's sensation that he is meant, as voyeur, to act as a bridge between this young woman and the composer; his vision of her does not direct her gaze to the narrator, but serves telepathically to draw her closer to the young man who plays the piano so passionately across the street. This scene represents a transformation in the voyeuristic act, for up until this time, the narrator has watched his objects furtively; the introduction of the young composer into the narrative creates a metatextual audience for the narrator, first when the composer discovers him outside his old apartment building, and now when the young man "forces" the gaze of the older man onto his own desired object. The telepathic nature of the scene recalls Strindberg's experimentation in psychological photography, but now it is, tellingly, the younger man who is "the stronger."

The focus and concentration of looking has now changed position as well; no longer is the narrator looking solely for himself, nor does he seem to will the returned look of the object of his gaze. Instead he imagines himself as a conduit of desire, and thus his attention is also diverted from himself. The magic circle that bound himself to himself seems to have been broken through the intervention of another looker, and in his

role as conduit, his vision goes blank. The final scene of voyeurism (and the final scene of *Alone*) takes place once more in the narrator's old apartment, but this time he sits in the room by himself. The young man has arranged for his access to the apartment whenever he wishes, and now the narrator gazes across the street at a scene that is complete without him; the composer has joined his lover (now his fiancée) and her foster child. (This of course constitutes, from the perspective of the composer, another shot/reverse shot.) Watching them in their happiness together, the narrator concludes his tale:

> Glad to have come as far as I had come, that I could rejoice at
> the happiness of others without a trace of bitterness, loss, or
> fantasized terrors, I walked out of my youth's vale of sorrows
> and turned home toward my solitude, my work and my battles.
> (38:214)

Thus *Alone* ends on an apparently victorious note, with the narrator content with his own removal from the circle of seeing and being seen. Yet the reader is left with the suspicion that some sorrow and some bitterness may reside in this victory, especially a reader familiar with the events of Strindberg's later years. The group of three whom he observes from his lonely outpost is precisely the group to which he wants to belong: father, mother, and child. (He and Harriet Bosse had a daughter together.) In old age, Strindberg's narrator visualizes himself as ready to give up the attempt to insert himself into the path of another's gaze. These final scenes in the old room, unlike those in which the narrator peers through his binoculars or stares up into a well-lit room from the street, do not receive even a lightly ironized treatment. In the end, the narrator has written his voyeuristic self out of the tale, and the page of the novella, like the window across the street, fades to white. Three years after the publication of *Alone,* Strindberg begins his experiments in life-sized photographs. Surrounding himself with images of himself and of those he loves, he combats the blankness of solitude and a growing sense of the mortality of the body depicted in images.

It is easy to dismiss Strindberg's conception of photography as naive, even diseased. But his views are not, as I have tried to argue, as eccentric as they seem. A reader of Roland Barthes's *Camera Lucida* confronts much the same attitude when Barthes insists on the "look" of the photographed subject, imbuing the image with the power of returning the gaze. His need to argue for photograph animism is easily traced; the writing of *Camera Lucida* is a response to the death of his mother—or better, a re-

sponse to a photograph of his mother, which he imagines as revealing her essence. Paul John Eakin has commented on the paradox of Barthes's early insistence on a world (and thus selves) constructed of language, and his later reversion to a simple faith in photographic referentiality. But both the anxiety of the lack of postmodern selfhood and the responsive grab at photography as a lifesaver occurs already in Strindberg's work. What we would like to ascribe to a diseased mind or to the quirks of an earlier, more "naive" historical period belongs fully to us—we, too, live in the world and age of believing and not-believing, not-believing yet hoping, a world born in looking at photographs.

The Angel of History as Photographer: Walter Benjamin's Berlin Childhood around 1900

Walter Benjamin (1892–1940) produced some of the twentieth century's most provocative and influential analyses of photography as medium and metaphor. Yet in contrast to Mark Twain and August Strindberg, he does not include photographs of himself as part of his autobiographical record; *Berlin Childhood around 1900*,[1] the autobiography described by its author as a series of images (*Bilder*), contains no photographs. Further, his collection of images breaks with Lejeune's ideal of the autobiographical pact in that only peripheral figures are named (and very few of those); the child of the "childhood" remains anonymous. *Bilder* but no images, an autobiography with no named *autos*—Benjamin's *Berlin Childhood* presents immediate challenges to the study of photography and autobiography as I pursued it in the preceding chapters. How can it be discussed in terms of autobiography and photography at all?

The importance of Benjamin's writing on photography, particularly the essay "The Work of Art in the Age of Its Mechanical Reproduction," has been widely acknowledged, while his autobiography, which *creates* the photographic effect explained in his essays, remains largely unexplored, especially as it relates to his theory of photography.[2] But what does it mean to say that an autobiography represents a theoretical program? Is it not the case that the autobiography primarily represents a human life? Representation, particularly representation of history and of self, will be one of the key issues in discussing Benjamin's autobiography, which I would term a photographic autobiography in disguise. The reasons for

that disguise have to do with the historical context(s) in which the autobiography was produced, which in turn influenced the tenor of Benjamin's theoretical writing.

For contrast, let us consider the first two authors of this study, who imagined photography as a tool for self-revelation. Twain exhibited a degree of cynicism about photography's revelatory powers, recognizing in the public's gullible acceptance of photographic infallibity the chance for a flawless confidence game. Strindberg, himself one of the gulls, aimed to use the photograph as an X-ray of the soul. Despite their differences, both men imagined photographs of themselves as part of the autobiographical record and as central to the creation and maintenance of celebrity. Photographic images of Twain and Strindberg, like their writings, were meant to be reproduced extensively and sold as part of the author's corpus.

My discussions of Twain and Strindberg virtually neglected the specific national situation of each writer in order to position him in the international photographic arena. One of photography's roles as an invention, in fact, was to invent internationalism. It is the popular assumption that images, unlike language, do not require translation, and photographs, infinitely and inexpensively reproducible shortly after the medium's invention, could reach across both national boundaries and classes, speaking to the literate and illiterate alike. The circumstances surrounding the invention of photography, which crystallized in France, England, and other (disputed) locations around the world simultaneously, seemed to imply that the medium's invention was less an act of human genius than a "natural," long-awaited birth.[3] Corporate development of photography as product also stressed the possibility (and desirability) of a world market; George Eastman christened his fledgling company "Kodak" precisely because the word did not mean anything in any particular language—he wanted a name that would be defined by the product and its consumers, rather than a particular national setting.[4]

The international, corporate aspect of photography's growth as a medium most closely aligns with the photographic-autobiographical projects of Twain and Strindberg, who hoped to establish their public images through the controlled production, reproduction, and distribution of photographic images in tandem with their autobiographies. Both authors worked the worldwide market; Twain's image circulated in the international wire services and popular journals, while Strindberg traveled in self-imposed exile through Europe, writing in both French and Swedish, and producing photographs of himself intended for sale as part of his au-

tobiography. For this reason, though both authors stand at the very fore-
front of their respective national canons, each serving as *the* exemplary
author for his nation, I have chosen to emphasize the underlying interna-
tionalism at the core of their production and self-promotion.

Benjamin's case is different. Though he stresses the revolutionary
(and international) transformative force of photography, he also critiques
the state's bid for control over photography, and thus the role photogra-
phy plays in supporting constructions of nation: "When Daguerre and
Niepce achieved success at the same moment after around five years of
effort, the state, at an advantage because of the patent difficulties that
assailed the inventors, took hold of the matter and made the invention
public property" (Benjamin 1980, 368). In "making the invention public
property," it would seem that the government of France granted the pub-
lic a favor, motivated in those early days, perhaps, by the suspicion that
photography belonged more to the realm of natural processes than to
human genius. But transferring photography from private ownership to
the public arena meant also that the state could itself achieve a freer use of
the medium, and it is not long from the announcement of photography's
invention in 1839 to the use of photographs to identify and watch citizens,
as Benjamin writes:

> Technical means had to come to the aid of the administrative
> process of control. . . . In the history of methods of identifica-
> tion, the invention of photography represents a breakthrough.
> It meant no less for criminology than the invention of printing
> had meant for writing. Photography makes possible for the first
> time the preservation through time of a person's unequivocal
> tracks [*eindeutige Spuren*]. (Benjamin 1980a, 550)

It would seem that the state and the autobiographer share the same
task, then; but the state has as its object the classification, location, and
surveillance of its citizens' activities through the use of passports, identi-
fication cards, and criminal photographic records. When Benjamin de-
scribes what the photograph records, he uses the word *Spuren*—the Ger-
man word for trace or track. He imagines photographs in the hands of
the state as a means of tracking prey, as the spoor left by the individual's
face on the photographic plate.[5] Key to understanding his objection to
the use of such *Spuren* in tracking photographed subjects is the qualifying
adjective "unequivocal." In Benjamin's own reading, signs are always
multivalent, multivocal, dense, and often self-contradictory. Signs must
be read against the grain. That the state (and other institutions, and even

private persons) read photographs as "unequivocal" already poses significant philosophical and political problems.

Both in Benjamin's theories and in his personal situation, this unequivocal reading of photographed images represents a destructive element, one that goes unaddressed in the work of Twain and Strindberg, who desire photographic exposure and feel that they can manipulate it to their own ends. As Manfred Schneider notes in his analysis of *Berlin Childhood,* photography aids the "state and administration" in the destruction of the individual's incognito, defined here as "the state's ignorance of the individual," a destruction that also entails the erasure of the individual's aura, a Benjaminian concept especially relevant to his understanding of photography to which we will return (Schneider 1986, 111).

Photography exposes the individual to the harsh light of constant scrutiny, opens up the possibility of being looked at without being able to return the look, a situation Michel Foucault describes in *Discipline and Punish* (or in French, more apt for my purposes here, *Surveiller et punir*). The absence of photographs of Benjamin in his autobiography, the withdrawal of references to his friends from successive drafts of the autobiography (which he characterizes as the erasure of their physiognomies), the removal of explicit uses of photography as metaphor from later drafts—all of this turns in part on Benjamin's suspicion of photography as an instrument of oppression and his situation as a German Jew exiled during the Nazi period.[6]

The red signal flag "eindeutig" (unequivocal) opens up the field for a discussion of Benjamin's theoretical positions on photography, language, and representation, all of which find voice in his autobiography. Eduardo Cadava, in his essay on the relation between Benjamin's theories of photography and history, captures the nature of the problem when he explains that "what structures the relationship between the photographic image and any particular referent, between the photograph and the photographed, is the absence of relation" (Cadava 1992, 89). On the surface, this assertion seems counterintuitive, yet it describes succinctly both Benjamin's distrust of actual photographs and his fascination with the meaning of photography. In the following passage, Benjamin uses a metaphorical image (in Mitchell's terms, a hypericon) to describe the shock of (self) recognition and (self) alienation both symbolized and enacted in photography:

> Anyone can affirm that the length of time in which we receive
> impressions has no correlation to the fate of these impressions
> in our memories. Nothing precludes the fact that we retain,

more or less, memories of rooms in which we spent twenty-four hours, while others, where we lived for months, are totally forgotten. . . . Perhaps more frequent are the cases in which the twilight of habitude for years denies the plate the necessary light, until one day it flares up from an outside source like ignited magnesium, and now the image is captured as a snapshot on the plate. But we ourselves always stand at the center of these curious pictures. And that is not so puzzling, because such moments of sudden illumination are at the same time moments of being-outside-ourselves, and while our wakeful, habitual, daytime self mixes, active or sorrowful, into events, our deeper self rests elsewhere, and is stricken by shock like the magnesium by the flame of a match. This sacrifice of our deepest self to shock is what creates the most indestructible images for our memory. (Benjamin 1988, 83–84)

Benjamin engages photography as an image for the human mind and its response as the historical moment, which is a moment of being outside the self in awareness of the self as other. Thus Cadava's assertion about the "absence of relation" inherent in photography becomes clear. Photography drives a wedge between the photographed self and the observing self, between the living self and the "dead" photographed self, between the present moment as experienced and the present moment as observed. The photographic flash interrupts and freezes time. Benjamin's image of the split self, the self looking at the self, finds another emblematization in the act of writing autobiography, also an exercise conducted between live and "dead" self, experiencing and observed self—a bringing of the past into the present. Perhaps most resonant in the passage above is the allusion to the "sacrificed" deeper self, a self "sacrificed" to the image. In Benjamin's *Berlin Childhood,* the writing and experiencing selves seem reduced to the objects and sites contemplated there; they have been sacrificed to the autobiography's series of images.

If photography's historiographical role ought to be to force self-awareness through shock, it seems clear that the actual use of photographs in culture (as opposed to the use of the photographic metaphor) most frequently undermines photographic power by lulling the viewer into accepting the photograph as perfectly consonant with perceived reality, rather than experiencing it as a shocking dissonance. In an essay that precedes Benjamin's writings on photography and most certainly influenced them, Siegfried Kracauer warns that "in order for history to present itself, 137

the mere surface coherence offered by photography must be destroyed" (Kracauer 1995, 52). "For Kracauer," observes Miriam Hansen, "the politicophilosophical significance of photography does not rest with the ability to reflect its object as real but rather with the ability to render it strange" (Hansen 1993, 453). This is Benjamin's agenda as well—to foreground shock, to make strange, to force an "unnatural" understanding of images and signs.

If we take Benjamin at his word (an uneasy task at best, but worth pursuing), we can, along with him, regard the fragmented series of texts in *Berlin Childhood* as a collection of images. But given his position on the danger of "unequivocal" readings of representational signs, it seems necessary to look carefully at why and how he employs his "images." In the following section, I will offer a detailed reading of one of the segments of Benjamin's *Berlin Childhood*. Going into the surface of this "image" at the pixel level will uncover the way in which Benjamin's autobiography enacts his theories of photography, likeness, and language—and breaks with the denotative system of referentiality commonly associated with both photography and autobiography.

Rätselbilder/Bilderrätsel/Vexierbild

The German word for "rebus" is *Bilderrätsel,* or "picture puzzle." Rebuses, familiar to many of us since childhood, depend on images to evoke sounds, which in their turn evoke semantic units, words. "To be or not to be" could thus appear as a series including the numeral 2, a drawing of a bee, a drawing of an oar, a drawing of a knot in a piece of wood, another 2, and another bee. The trick of reading a rebus is to lay aside the ordinary system of reference used for interpreting images—to see the drawing of a bee *not* as a bee, but as the *sound,* which can then be understood, through another act of translation, as "be." Such picture puzzles thus demand a revocation of accustomed systems of reference between the written and signified, the written and the spoken. One of the sections of *Berlin Childhood* bears the title *Zwei Rätselbilder* (Two puzzling pictures), a term that, in its inversion of *Bilderrätsel,* could stand for a reversed rebus: words meant to be read as images. How do we see a word as an image? Benjamin offers a number of possibilities, which will help us as well in understanding how and why his autobiography functions as a collection of images.

The section opens with the narrator's memory of some postcards from his collection (a collection he mentions elsewhere in other con-

texts). These particular cards are of special interest, he tells us, not for the sake of their images, but because of the writing on the reverse side. It is not unusual to save personal correspondence, but the narrator has specifically said that these cards belong to his collection of *Ansichtskarten,* a collection that would ordinarily emphasize the images on the face of the cards rather than the writing on the reverse. Thus the opening sentence replaces the expected "images" with text. What the narrator proceeds to do with that text, however, corresponds to the reversal implied in the word *Rätselbilder,* for he now will look at the text as image.

The prized postcards carry the "beautiful, easily legible signature: Helene Pufahl" (Benjamin 1987, 34). In Benjamin's worldview, the beauty and legibility of his former teacher's signature offer an image that opens insight into the inner nature of the signatory, for in his essay "On the Mimetic Capacity" he notes: "Graphology has taught us to recognize images in handwriting that the unconscious of the writer has placed there" (Benjamin 1980a, 212). In the earlier version of the piece on mimesis, "The Doctrine of Likeness," he puts it a bit differently: "Contemporary graphology has taught us to recognize images, or rather, picture-puzzles [*Vexierbilder*] in handwriting that the unconscious of the writer has placed there" (Benjamin 1980a, 208). The word *Vexierbild,* omitted from the second version of the "Likeness" essay, carries significant clues for the decoding of Helene Pufahl's signature.[7]

Like the English word *vex,* the German *vexieren* means "to puzzle or tease," with the added implication of "to stymie." The *Vexierbild,* however, is not only "vexing" in a general way, but has a specific application; Benjamin's *Rätselbilder* (puzzle-pictures) are constructed to be legible in at least two ways, depending on how the viewer "reads" them. One of the most famous examples is the Duck-Rabbit drawing, in which it is possible to see either of the two animals (figure 3.1). Each of the "readings" vexes or confounds the other; when we insist upon seeing a rabbit, we struggle with our vision of the duck, and vice versa.[8] When Benjamin suggests that graphologists can identify puzzle-pictures as products of the unconscious in handwriting, he seems to say that the reader must decipher these "images" as something other, something contrary to (or at least, different from) what the written text seems to mean. The form of the handwriting, its visual appearance, thus undoes its ordinary representational system of visual signs. We might think of this as "reading against the grain" in a microcosmic sense, or as a precursor to deconstruction.

Looking at Helene Pufahl's "beautiful" and "easily legible" signature, **139**

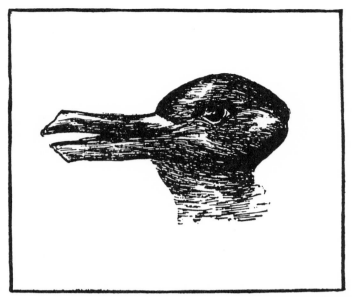

Do you see a duck or a rabbit, or either ? (From *Harper's Weekly*, originally in *Fliegende Blätter*.)

3.1 Vexierbild: *the Duck-Rabbit drawing*

the narrator responds by breaking her surname down to its constituent signs in order to extract the meaning he apparently sees in the image of her handwriting:

> The P with which it commenced was the P of *Pflicht* (duty), of *Pünktlichkeit* (punctuality), of *Primus* (head of the class); f was *folgsam* (obedient), *fleißig* (industrious), *fehlerfrei* (without error) and as far as the l at the end was concerned, it was the figure for *lammfromm* (meek), *lobenswert* (praiseworthy) and *lernbegierig* (eager to learn). And so this signature, had it, like the Semitic, consisted only of consonants, would have been not only the seat of calligraphic perfection, but the root of all virtues. (Benjamin 1987, 34)

Certainly Helene Pufahl's signature, reduced to its Semitic, consonantal root (the root of all virtues), *could* be read as the narrator wants to read it. By bringing forth the letters of the name as individual signs with semantic valences, the narrator "vexes" the ordinary reading of the name as a denotative sound system and introduces a reading of the name that strikes one as both deeply meaningful and highly arbitrary. Why does "f" stand for

fleißig (industrious)? Could it not just as easily stand for *faul* (lazy)? This reading of P-f-l seems to be aiming for another concept Benjamin explores in his "Likeness" essay, namely, the magical interpretation of script that hearkens back to the reading of stars, entrails, and, at a later period, runes (Benjamin 1980a, 209–10). In a magical system of writing, letters can be read as meaningful signs on their own, not necessarily associated in any discernible way to the word in which they appear. As an example of the multivalent character of letters, Benjamin draws our attention in the "Likeness" essay to the Hebrew letter beth, which represents the sound "B" as well as the word for house (*beth*).

This does not quite explain why P-f-l contains the root of all virtues, and in fact, the intricacies of reading suggested by Benjamin's essays on likeness and mimesis open up the possibility for readers of *Berlin Childhood* to invent *Vexierbilder* of their own. As Werner Hamacher suggests in his own magic reading of the autobiography, "to apprehend this distortion, to *read* it, assumes that one pay attention not so much to the proximate semantic contents of the words as to their formal and thus entirely non-sensuous correspondences, anasemantically" (Hamacher 1986, 137). The term "non-sensuous correspondences" is a less-than-happy translation of *unsinnliche Ähnlichkeiten,* which appears peppered throughout the two essays on likeness and mimesis, essays produced contemporaneously with the genesis of *Berlin Childhood.*[9]

Non-sensuous would seem to imply "not of the senses, not perceivable with the senses," while the readings aimed for in this connection would certainly make use of the senses (sight, hearing, speech) more than ordinary reading does. Rather, *unsinnlich* seems to touch upon a way of reading that, in rejecting the ordinary sense-pathways of interpretation, goes beyond the normal reach of senses—perhaps even beyond sense. The term hints at transcendence without referring specifically to the transcendent (there is another word, *übersinnlich,* which would have been more appropriate in that case), and it carries at the same time a trace of *Unsinn* (nonsense), which in this situation would not indicate "nonsensical" precisely (the German word *unsinnig* covers that), but rather "not sensical" or "not sensible." In "The Word Wolke—If It Is One," Werner Hamacher brilliantly exposes the kind of conflicting echoes sounded by the words of Benjamin's autobiography; I would like to work further along the same lines, bringing in the masked visual cues as well. We can start the game with Helene Pufahl's name.

One of the arresting features of Semitic script, as our narrator points out, is its reduction of words to their consonantal roots. If vowel mark-

ings are eliminated, each word becomes a *Vexierbild,* open to a variety of readings. Thus the reader should not feel bound by the narrator's interpretation of his teacher's name as the "root of all virtues." If we read the name as P-f-l (setting aside the phonetic reading of the signs as well), we might think of the word *Pfeil* (arrow, dart), in this case, Cupid's dart, which has clearly pierced the heart of the narrator. The forbidden, erotic side of the child's love for his teacher has been glossed over in the narrator's interpretation, but we can find its resonance in *Pfahl* (as in *Pfahl im Fleisch,* a thorn in the flesh) or *Pfuhl* (cesspool, as in *Sündenpfuhl,* sink of corruption). Even a pronunciation of the unusual opening syllable of the name *Puff* (bordello) breathes forbidden sexuality. Like handwriting perused by graphologists, Benjamin's text (which he himself shows us how to read) reveals a wealth of contradictory signs, pointing to the unspoken darkness of language revealed in its script.

Once the narrator's reading of "Helene Pufahl" has given us a hint as to how to read *Vexierbilder,* he moves on to another captivating name, that of one of his schoolmates, Luise von Landau. "The name had drawn me under its spell," he writes, though he does not explain why (Benjamin 1987, 34). The child of *Berlin Childhood* is prone to falling under spells of various kinds—at his mother's sewing table (71) and by the otter's lair in the zoo (45), in the moonlight (75) and under the gaze of the little hunchback (77). In every case the spell involves a sudden, uncanny awareness of the disjointedness of his situation, of his self-alienation, of his presence as an Other: "When I went back to my bed at those times," he writes in the segment "The moon," "it was always with the fear that I would find myself already stretched out there" (75). In the case of Luise von Landau, the disassociative spell under which he falls is the spellbinding image of his own death. He remembers his attachment to her name (not to her, necessarily) because it (the name) was the first of his age group to be "accented by death" (34). In other words, hers was the first death to make him conscious of his own mortality, to see his life as something finite and himself as a corpse.

The circumstances in which the narrator meditates on Luise von Landau and her fate reflect in a curious way the content of her name. *Land* in German is also *land* in English, and *Au* can denote either a small river (in archaic usage) or a river meadow. After Luise von Landau has died, the narrator frequently thinks of her as he walks along the Landwehr Canal by her house, gazing across the water at a garden that lay on the other side. This blooming garden draws his attention in an odd way: "And in time I interwove so intimately the garden and the beloved name that I

finally came to the conviction that the flowerbed that graced the opposite shore was the cenotaph of the little departed one" (34). To understand why the name and garden conjoin in the narrator's mind, it is once again necessary to look at the components of the name and their possible significance. The flowerbed is a plot of land on the river (*Land + Au*); it also blooms like a meadow (*Au*). The narrator's situation across the river from the site of a grave calls to mind the mythological and folkloric tradition of the river separating the land of the living from the land of the dead— the river Styx, the river Jordan. But why an empty grave, a cenotaph? The narrator now takes one more linguistic and imagistic turn to invest the empty tomb with another layer of meaning.

Immediately after the meditation on Luise von Landau's cenotaph, the narrator presents another name and another *Vexierbild*. The child graduates from the circle of the beloved Helene Pufahl and enters his true schooling under the harder hand of Herr Knoche (*Knochen* = Bone).[10] The bone of Mr. Knoche's name refers in part to his hardness or sternness, and in part to his grisliness; in their singing class he has the children practice a military song from "Wallenstein," in which the beauties of war are glorified: "On the field, a man is still worth something / There the heart is still valued / weighed" ("Im Felde, da ist der Mann noch was wert, / Da wird das Herz noch gewogen," 34). It is the final phrase of this snatch of song that opens a well of uncertainties for the writer. *Gewogen,* in this case the past participle of *wägen,* refers in a concrete sense to weighing; the heart is literally weighed. Of course the mind immediately turns from that unacceptable concrete meaning to an abstract one; we understand instead that the "heart" is not the heart, but the seat of courage, and "weighed" refers to weighing as gold is weighed, to assess its value.[11] But this abstract meaning does not shine forth for the children of Herr Knoche's class. The narrator assigns the role of seer or prophet to this teacher, remembering that he had asked whether any of his students could understand the image of that last line of the song: "das gewogene Herz" (the weighed, as in valued, heart). As a "seer," the teacher is happy to predict that his students, who are baffled by the image, will understand it as adults: "Das werdet ihr verstehen, wenn ihr groß seid" (You'll understand that when you're older).

Herr Knoche's coy suggestion that the future will hold greater comprehension of his song attaches a forbidden, quasi-sexual sense to a military setting; the students are thus taught to associate manliness, sexuality, and death. And he foreshadows death both in his prediction and in his name—he is, himself, the death's head, the bone that is able to predict 143

the future of the students in his class, many of whom will experience "the field" for themselves in the coming conflagration of the First World War. With strict classroom discipline (the narrator writes of Herr Knoche's *Strafgerichte,* punishment tribunals) and militaristic enthusiasm, such teachers not only heralded but themselves brought on the catastrophe of war and the deaths of their former students. The children sitting in classrooms and confronted by such phrases as "das gewogene Herz" would naturally have searched their visual inventories for an appropriate representation, and one can imagine that the result would have been a gruesome one, a bloody heart ripped from a soldier's chest and placed upon a scale; and then this terrifying image receives the same dismissive sentence that a sexual innuendo might receive—you'll understand when you're grown. No wonder that their teacher's question is met by a bewildered silence.

The path to the cenotaph now becomes clearer. Benjamin writes, "At that time [the time of Herr Knoche's 'prophecy'] the shore of adulthood appeared as separated from me by the river (*Flußband*) of many years as that shore of the canal from which the flowerbed gazed across at me, the one I had never walked hand-in-hand with my nanny" (34). Now the river is a river-band, or a band of river, a word that seems to echo *Fließband* (assembly line), particularly since the compound *Flußband* does not exist in ordinary German. The flowing river represents the inexorable assembly line of time with death on its farthest shore, symbolized by the crossing over into the adult and soldierly "field," or over the mythical river Styx into the realm of the dead. On the opposite side of the river is the future. The narrator tells us that once he can determine the course of his own rambles through the city, he sometimes actually takes his walks quite near the flowerbed-cenotaph, but now the garden and he have achieved a different understanding: "Of the name that we had once maintained together, the flowerbed no longer retained anything other than that verse of the soldier's song" (34).

Once, he claims, the garden and he had preserved the little girl's name—the boy upheld the name in his walks on the land beside the river (*Landau*), and the garden "remembers" the name because it *is* the flowering *Land-Au,* her cenotaph. Now he tells us, however, that the flowerbed does not flower as it used to—it is more land than meadow—and it retains from its relationship with the narrator only the image from Herr Knoche's song, the valued/weighed heart. The grown boy now understands Herr Knoche's abstract meaning, but he also recognizes that the flowerbed "means" something else, though he cannot say what. Perhaps

it has something to do with the mysterious sexual association Herr Knoche seems to make, since the vanished classmate is a little girl and since the narrator came to know her in the unconsciously erotic atmosphere of Helene Pufahl's circle. These are the two "Puzzling pictures" to which the title of the segment refers: the empty grave and the valued/weighed heart. The narrator ends by saying that "life" will continue to owe him the solution of these puzzles.

"Life" must continue to owe the solution because the solution resides in death. The empty grave across the canal, a grave constructed by the child's imagination, is in fact his own grave, his intended mausoleum, hinted at already in the opening segment of the autobiography entitled "Loggias." With the death of a child of his own age, he becomes aware of his own mortality, and that other child's name speaks to him of the situation of death, the land by the opposite shore of the river of forgetfulness and time. His nearer approach to the site of his own death (the walk near the flowerbed) signifies the growing proximity of death, but the meaning of the sign has grown even more obscure as he comes closer. Even his adult comprehension of the metaphorical meaning of "a valued/weighed heart" has failed to clarify anything.[12]

The complex segment "Two puzzling pictures" gives up a wealth of information about the thought that produces *Berlin Childhood,* even as it refuses to provide a solution to its own puzzles. If we examine the problems posed by the mere two pages of densely written text, the writer's strategy and sources emerge. First, the segment makes an explicit reference to the substitution of text for image and the reading of text as image, a move encouraged by the thoughts expressed in "The Doctrine of Likeness": "it is the literal/lettered [*buchstäbliche*] text that is the one and only foundation on which the puzzle-picture [*Vexierbild*] can be formed" (Benjamin 1980a, 208). The German word *buchstäblich* in Benjamin's sentence signifies in two potentially conflicting directions, which at this point should come as no surprise. Benjamin means that we must read the "literal" text (the text as it stands, as it "normally" signifies), and the *letters* (*Buchstaben*) of the text, which may interfere with the "literal" meaning. Thus the vexing/vexed reading of "Pufahl," thus the deconstruction of "Landau," thus the conflicting readings of "the weighed/valued heart" by Herr Knoche, his class, the grown narrator, and the flowerbed.

And now we might ask (because it seems truly vexing), how does a flowerbed read at all? And how do the boy and flowerbed preserve a name together, achieve an understanding? An answer to this riddle may reside in Benjamin's essay "On Human Language and Language in General." In

this piece, Benjamin argues for a spiritual understanding of language, in which humankind is characterized by the power of language—specifically, naming. The human naming of other humans, animals, plants, and objects (animate and inanimate, "real" and abstract) is in fact the very thing that defines humanness. "If lamps and mountains and the fox were not to communicate themselves to the human, how would he be able to name them? But he does name them; *he* communicates himself in naming them" (Benjamin 1980a, 143). In "Two puzzling pictures," the flowerbed across the river communicates itself to the boy, takes its shape in his mind, and receives the name "cenotaph." "Cenotaph" is, however, the result of the boy's communication of himself; he creates the image of the empty tomb to house his own mortality.

In the end, Benjamin writes in his essay on language, the original sin of language is its denotative function. The name should speak the thing itself, should make the thing as God's speech creates the world. But the human names for things instead point to something else: "The word is meant to communicate *something* (outside itself). That is effectively the fall from grace [*Sündenfall*] of the spirit of language [*des Sprachgeistes*]" (Benjamin 1980a, 153). In not being or speaking the thing, language becomes a *Vexierbild,* open to complications, turnabouts, and interpretation.

In the whole of *Berlin Childhood,* Benjamin gives only four surnames for personal acquaintances. The first of them, his Aunt Lehmann, receives her name in part because it is a misleading sign, a non-name; his Jewish aunt (whose Jewish identity he does not specify—no one in *Berlin Childhood* is explicitly identified as a Jew) possesses a "good north-German name" (Benjamin 1987, 31). The remaining three appear in "Two puzzling pictures": Helene Pufahl, Luise von Landau, and Herr Knoche, those vexing names that revert immediately to *Rätselbilder.* Nowhere in the text does he name his own name, which, were it to appear in the pages of the autobiography, would seem to the reader to function as an uncomplicated denotative sign, a function Benjamin at every moment interrupts in his use of language. In the place of his own name, he gives the reader images of the things and places he resembles.

To understand this, let us return once more to "The Doctrine of Likeness": "Our gift to perceive likeness is nothing more than a weak rudiment of the once powerful compulsion to become alike and act alike. And that lost capacity to become alike extended far beyond that narrow band of perception, in which we are still able to perceive likeness" (Benjamin 1980a, 210). This same idea appears in *Berlin Childhood,* in the section entitled "Die Mummerehlen," with a clarifying addendum: "The gift of

being able to recognize likeness is indeed nothing more than a weak remnant of the old compulsion to become alike and act alike. Words worked this compulsion on me. Not words that made me resemble model children, but those that made me resemble apartments, furniture, clothes" (Benjamin 1987, 59).

In *Berlin Childhood* the doctrine of likeness finds clearer articulation than in the essay of that title; indeed it serves as one of the primary forces of the autobiography, for it explains why the book, with its collection of odd places and things and no name, no faces, no *bios,* is in fact a form of autobiography. "I was displaced by a likeness with everything that surrounded me," writes the narrator in "Die Mummerehlen" (51). The child in the autobiography is represented by the things and places that surrounded him, by the words that forced him to resemble those things by forcing him to contemplate them, preoccupy himself with them and become occupied by them. Additional instances of the doctrine of likeness occur scattered throughout the text: in "Butterfly hunt," the child comes to resemble more and more the butterflies he pursues (20); in "The colors," he turns the same colors as the landscape around him and becomes the soapbubbles he blows (70). In "The otter," mysterious resemblances develop between creatures (including human creatures) and their habitats: "Just as one makes an image of one's own nature from the dwelling where one is housed and the neighborhood where one lives, I made images for the animals of the Zoological Garden" (43).

The boy stands at the fence of the otter's enclosure and waits for the sleek animal to emerge for just a second from the depths of its pool: "When I had success with my waiting, it was certainly only for a moment, because in the flash of an eye the gliding inmate of the cistern had once again disappeared into the wet night" (44). The otter is a creature formed by the water in which it lives, "the sacred animal of rainwater." The boy watches the otter as the rain falls, and this rain becomes for the boy his own element, his "future rushing toward him" (45). Like the canal in "Two puzzling pictures," the water in its movement and its depth and its function as divider (the rain as a curtain, the canal as a boundary) signifies (life)time. And like the canal, the rainwater and the water of the otter's "cistern" permeate the city, run underground and connect each part to the other: "Of course in truth it was no cistern, where they kept the otter. Still, when I gazed into his water, it always seemed to me as if the rain was plunging into all the gullies of the city just to run into this pool and feed its animal" (44).

Thus water, rainwater, becomes the element that encloses the expe-

rience of both the otter and the boy (who, of course, according to the doctrine of likeness, become like one another and like the water as well). And his rapt contemplation of the otter becomes a deep well of thought, in which likeness flashes forth like the otter suddenly breaking surface in his dark pool. I have spent some time on the image of the otter and water (as in Low German, the English pronunciation of one contains the other) because a final feature of likenesses implicit in "The otter" brings us finally to a fascinating connection with Benjamin's theory of photography.

In "The Doctrine of Likeness" we read: "[The perception of likeness] is in any case bound to a flash. . . . And so the perception of likenesses also seems to be bound to a moment of time. It is like the emergence of the Third" (Benjamin 1980a, 206–7). A little further on he adds that "likenesses flash briefly out out of the river of things, only in order to sink again immediately" (209). The perception of likeness bears a striking resemblance not only to the otter, but to Benjamin's explication of photography and historiography. Earlier I cited a passage from *Berlin Chronicle,* which compares the photographic moment to a magnesium flash of memory that leaves its trace on a "photographic plate" in the mind. The shock of that flash creates the effect of looking at the self as if the self were another—the photographed self, the dream or memory self. And in the theses of history, we find one of the links that Eduardo Cadava cites as evidence of the connection between photography and history in Benjamin's thought, from his "Theses on the Philosophy of History": "The true picture of the past flits by. The past can be seized only as an image which flashes up at the instant when it can be recognized as is never seen again" (Benjamin 1969, 255).

The picture of the past, like the likeness, flashes upon our consciousness and causes a kind of disassociative shock, for it transforms our present and our tranquil perception of the reality of things, thus transforming our own being. The perception of likeness, Benjamin says, creates a "Third" (*ein Dritter*); if we think of likeness and photography and Benjamin's autobiography in tandem, we can imagine this "Third" as the product of the child's perception of likeness, which occurs like a flash in the consciousness, slowly takes form on the photographic plate of the narrator's memory, and emerges in the pages of the autobiography, a strange tale of a child's likeness with the city and objects that made his life. In this setting, the narrator sees the self as an Other (a Second, the child), but also as a Third (the Likeness, the "photographic" and historical image). Thus Eduardo Cadava, in writing of the autobiography in the con-

text of Benjamin's theses of history and theories of photography, can call it "a series of snapshots in prose" (Cadava 1992, 89).

The "picture" or snapshot of the past blasted from the course of history represents a confrontation of the past with the present moment, a recognition of the relevance of the past to the present moment, "for every image of the past that is not recognized by the present as one of its own concerns threatens to disappear irretrievably" (Benjamin 1969, 255). In fact, the photographic moment erases the distinction between past and present by interrupting time, taking a frame of time out of its context for perusal in the future. Cadava writes, "within this condensation of past and present, time is no longer to be understood as continuous and linear, but rather as spatial, an imagistic space that Benjamin calls a 'constellation' or a 'monad'" (Cadava 1992, 99). The textual fragments of *Berlin Childhood* perform as "true historical pictures" in that they break the flow of (narrative) time, exist as fragments, and lay past upon present upon future.

While all autobiography (like all photography) impresses present on past and vice versa, *Berlin Childhood* is driven by a peculiar chronological imbrication that pushes it toward the surreal or magically real. Ultimately, the magical effect enacts the process of death and rebirth again and again. This is achieved through an odd and complex narrative strategy. Peter Szondi remarks that the book's "tense is not the perfect, but the future perfect in the fullness of its paradox: being future and past at the same time" (Szondi 1986, 153), while Anna Stüssi entitles her book-length study of the text *Memory of the Future* (*Erinnerung an die Zukunft*). What is meant by this can only be understood in looking at two of the segments of *Berlin Childhood*.

"Announcement of a Death" deals with an episode from the time around Benjamin's fifth year. One evening his father comes to say goodnight after the child has been put to bed. But instead his father stays to give the boy a detailed account of the death of an older cousin, a person whom the child knew but slightly. The narrator continues, "I did not take in all of his narrative. But that evening I impressed my room upon my memory as though I had known that I would have business there again one day. I was already long grown when I heard that my cousin had died of syphilis" (Benjamin n.d., 49). Typical of *Berlin Childhood* is the child's awareness (however dim) of the future, as if he had some insight into his fate. But because the autobiographical self narrates from the present looking back to the past, it is as if the future were remembered back into the child, implanted there by the act of narration. In this way, the frag-

ments of the past find reactivation in the act of prophecy; the child's experience contains the germ of premonition that pulls it into the future and brings the child's perception into unity with the narrator's.

"News of a Death" communicates part of the text's structure of remembrance; the child, looking forward to the future ("remembering" into the future through the agency of the narrator), ultimately sees death—the child is described as clinging to his place in the loggia of his building as if it were a "mausoleum long intended for him" (Benjamin n.d., 15). Death has value in Benjamin's work as a stopping place, a point of removal from the flow of life, a position *in extremis,* which allows for a panoramic view of events. Bernd Witte reminds us that Benjamin began his revision of *Berlin Chronicle* at the moment he had methodically planned his suicide (Witte 1991, 131–34). Like Goethe's *The Sorrows of Young Werther,* the autobiography thus becomes a substitute for suicide, a marker over one of the narrator's graves. It is useful to remember here photography's relation to death and its monumental quality; the "photographic" fragments of *Berlin Childhood* stand over the pieces of a lost self.

But the tomb Benjamin describes is always marked as eerily impermanent, for it is eerily empty, like the flowerbed on the canal or the intended mausoleum in the loggia. The emptiness of the autobiography's tombs brings the tomb out of the realm of pure stasis and moves it into the arena of action, either past or future, either impending burial or neglected burial or resurrection. In "Victory Column" Benjamin describes the monument of that name that stands in the center of Berlin and commemorates the German victory over the French in the Franco-Prussian war: "With the defeat of the French, world history seemed to have sunk into its glorious grave, over which this column was the stele" (Benjamin n.d., 18). The victory column thus represents the halt of history, as well as marking its burial site. But beneath its rigidity, the column promises reactivation: "it stood on the broad square like the red date on the tear-off calendar" (Benjamin n.d., 18). If the single, erect column represents a date, it must be the *first* day, number one. The column marks not only the end of something (world history) but the first day of something else: "The awareness that they are about to make the continuum of history explode is characteristic of the revolutionary classes at the moment of their action" (Benjamin 1969, 261). The destruction of the continuum of history brings with it the promise of revolution; thus the gravestone Victory Column doubles as a red-letter date.

Here it is important to see that the images Benjamin presents, the blocks of "spaced time," are static, yet dynamic. They are representative,

yet not clearly denotative—they have multivalence and offer a wealth of interpretative possibilities. Benjamin means to disrupt the ordinary stasis of photographic denotation by using the photographic metaphor and making *Vexierbilder* of words and images. The "photographs" of *Berlin Childhood* are pointedly not like the snapshots of a family album; he writes in his introduction that "the biographical features, which are usually found in the continuity rather than in the depth of experience, recede wholly from these experiments. And with them the physiognomies of my family as well as my friends. Instead I have taken pains to get hold of the *images* in which the experience of the metropolis precipitate in a child of the bourgeoisie" (Benjamin 1987, 9). He wants to include not the images that pretend resemblance and support ordinary denotative reception of signs, but disruptive, disassociative, magic readings of both images and words, images that become strange precisely in the act of resembling. Thus the boy appears as soapbubble in all the colors of the landscape, thus the flowerbed appears as cenotaph and the teacher's name as an emblem of forbidden (and hidden) erotic yearnings.

Benjamin's autobiography fairly resonates with the click of the photographic shutter as he moves from fragment to fragment, moment to moment, likeness to likeness. At the same time, it undoes our expectations both of photography (image, self-image) and autobiography by forcing "unnatural" connections, "resemblances" that call into question our ordinary system of denotation and resemblance. I would suggest that we read *Berlin Childhood* as a photographic autobiography in disguise, not only because it was politically and personally important for Benjamin-in-exile to erase all traces of his identity and reject the state's power of photographic and institutional identification (a point I will discuss later in more depth) but also because it was theoretically important for him to enact his concepts of language, likeness, photography, and history in the formation of his own self-image. His self-image is not his physiognomy, nor his acts, nor his career, nor his family, nor any of the "biographical features" with which we normally associate a life. Instead it is a site, a city-as-theater, structured by and appointed with his thoughts on representation and history.

Benjamin's experimental autobiography (he refers to the segments as *Versuche*—attempts or experiments) represents a transformation of the position of photography in autobiography in keeping with the political, historical, and aesthetic transformations of the twentieth century; yet it also belongs to the same arena of thought as Twain's flashes of memory or Strindberg's photographic voyeurism. Thus *A Berlin Childhood around 1900* 151

continues and evolves the nineteenth-century response to photography as an unavoidable factor in the production of self-image and self-history in the photographic age. Chief among the unspoken revelations in Benjamin's autobiography is a growing suspicion of photography—a growing camera shyness as the ungovernable aspects of photography's political power make themselves known in the lives of the photographed. Of perhaps greater importance is an insight that accompanies that suspicion, namely, that with our growing belief that film media can reveal the shape of our world, even the shape of ourselves, we must counter photographic power with a return to older, mystical ways of reading, valuing the magical nature of photographs and language over their (only apparently) denotative nature. Part of that return involves a new look at the use of allegory.

Bios in Bilder: Photographs as the Allegory of History

In 1981 a manuscript for Benjamin's *Berlin Childhood,* dated 1938, was discovered in the Bibliothèque Nationale in Paris. Benjamin's flight and suicide in 1940 and the ensuing German occupation of France buried the manuscript for forty years; in all, the evolution of *Berlin Childhood* spans sixty-one years, from the appearance of the first germinal pieces in *Literarische Welt* in 1926 to the publication of the lost manuscript in 1987.[13] Like Twain, Benjamin constantly reworked his autobiography, changing his mind about experimental narrative strategies, writing in small textual fragments, publishing the fragments before the whole (sometimes under a pseudonym), and leaving, finally, a massive task for editors.[14]

Recent readers of Benjamin's autobiography, like those of Twain's, are confronted with the problem of a number of variant versions, though the problem would seem to have been solved with the discovery of the Paris manuscript, the so-called *Fassung letzer Hand* (last version). Still, because an edition of *Berlin Childhood* was published in 1950, reappearing in the *Gesammelte Schriften* (in a slightly extended version), a considerable amount of critical attention focused on the earlier version of the autobiography. Is the 1950 edition "legitimate" because it has been read and assimilated into the author's corpus, though it does not represent the final word? Does the newly discovered manuscript render the earlier version (and critical readings of it) illegitimate? Is it not possible that Benjamin might have drafted yet another version (carried, perhaps, on his flight from France in the lost black briefcase), and that it lurks somewhere,

waiting to be discovered? How do these complications channel our read-
ing of the autobiography?

The structure of *Berlin Childhood,* with its series of elegiacally de-
scribed objects (telephone, stocking, sewing box, postcards) and places
(loggia, zoo, apartment, covered market) leads the reader into the laby-
rinth of the author's childhood and into a maze of interpretative possibili-
ties. There is no connective narrative between the text-images; most are
two or three pages long, with the longest spanning seven pages. There is
no obvious red thread running between the texts, though a few images
or thoughts echo from one segment to another, and the closing text pro-
vides a provocative principle of order (which I will discuss in the last
section of this chapter). Here is a work that cries out for an interpretation
of its separate parts and their organization; indeed, the reader can
scarcely refrain from attaching meaning to the sequence of the monadic
texts and divining their relation to one another. Not only on the level of
letter and language (as I discussed in the last section), but also on the level
of overall structure, *Berlin Childhood* is a work that foregrounds the act of
interpretation, brings it forward into the conscious realm of reading.

It is in fact the framing of the narrative in "images" that places such
weight on the order of the segments and gives them such density. The
shift from a continuous to a discontinuous structural principle occurs in
the transformation of *Berlin Chronicle* into *Berlin Childhood. Berlin Chronicle*
was undertaken in 1931 as Benjamin's response to the request by a journal
for memories of life in Berlin. In 1970, thirty years after Benjamin's
death, his friend Gershom Scholem took on the daunting project of
assembling the unfinished text. Though Benjamin abandoned the *Berlin
Chronicle* project in 1932 in order to transform the text into *Berlin Child-
hood,* Scholem felt that the chronicle merited publication for its function
as a source for the later text and its biographical value; as he notes, *Berlin
Chronicle* retains the "direct autobiographical references to memories and
events of his childhood, school and university years," while Benjamin him-
self writes that in *Berlin Childhood,* the "biographical features recede en-
tirely" (Benjamin 1988, 93; Benjamin 1987, 9).

The metamorphosis from chronicle to picture book involves primar-
ily a system of deletion and restructuring. Passages in which Benjamin
recalls his father's use of the telephone, the practice of "losing himself"
in the city, a postcard collection, a prophetic dream, and several others
appear in both *Berlin Chronicle* and *Berlin Childhood* texts. But in revising,
Benjamin tears away the context of each episode, leaving an unconnected

(a *dis*connected) series of images/objects. He then creates gaps between objects, heading each section with a title ("Zoo," "The stocking," "Sewing box"). In the case of the narrative concerning the telephone, for instance, *Berlin Childhood* erases *Berlin Chronicle*'s account of the mysterious business transactions carried out on the telephone by Benjamin's father, foregrounding instead the apparatus itself, and he then places the title "The telephone" at the head of the segment. A long analysis of the Benjamin family's habits of purchase and consumption, which offers a background for his father's business connections, also falls away in the later version.[15] As Scholem points out, in the conversion of the chronicle to *Berlin Childhood,* "the numerous references to [Benjamin's] convictions regarding socialism and the class-struggle disappear almost entirely" (Benjamin 1988, 94). These aspects and the "physiognomies" of friends and relatives are omitted in the process of spatializing the narrative of a life.

In *Laokoon,* an Enlightenment study on the (inimical) relationship between plastic and literary art, G. E. Lessing prescribes a sharp distinction between the spatiality of pictorial art and the temporal nature of narrative. Lessing takes a particularly sharp jab at allegory as a decadent form, because it attempts an illegitimate crossover between narrative and picture. But in Benjamin's work, allegory's spatialization of narrative (its depth, if you will) achieves a special purpose and design. In his *Origin of German Tragic Drama,* Benjamin stresses the frozen, fragmentary nature of the allegory: "Allegories are in the realm of thoughts what ruins are in the realm of things" (Benjamin 1980a, 354). In conceiving allegory as ruin, Benjamin subscribes to the baroque vision of the world, which in its turn takes its color from the Thirty Years' War, a disaster of apocalyptic proportions. The death's head emerges from the tortured allegorical iconography of the baroque period as the central image, signifying *vanitas,* the allegorical expression of decay and the fleeting nature of human life: "Everything that was unseasonable, painful, mistaken in history from the beginning expressed itself in a face—no, in a skull" (Benjamin 1980a, 343). Considering the issue more closely, we might say that the skull represents the reduction of the human being to pure space; the individual's skull indicates the removal of that individual from the flow of history. All of the period's iconography, both visual and literary, worked to stress the ruin and illusion of the world.

It comes as no surprise to modern readers that the baroque period regains significance in light of events in twentieth-century Germany. Not only Benjamin returns to the period in his study of tragic drama, but Bertolt Brecht treats the Thirty Years' War in *Mother Courage,* and Günter

Grass makes the fictional meeting of some of the great minds of the period the focus of his *The Meeting at Teglte*. All of these authors draw on the wretched circumstances of the seventeenth century to reflect on Germany's twentieth-century plight; Benjamin's analysis of baroque metaphor can thus also be read as a metaphor for the context of his own time. The objects depicted in his autobiography, contained as they are in fragmentary texts, provide a modern parallel for the ruins of baroque allegory, and Benjamin's understanding of photography offers another analogue for his reading of allegory. This is an argument, however, that must be made in increments.

Baroque allegories do not *represent* nature—rather, Benjamin contends, in the seventeenth-century perception of the world, nature existed in order to be made up into emblems. Historical events occured only to provide material for such emblems, which in their turn conveyed the deeper meaning of experience. Allegories, in other words, do not depict anything, certainly not in a mimetic sense. The woman holding the scales (to cite an allegory recognizable in our own time) represents neither a woman nor a pair of scales. Instead, she articulates a word in a secret language, a glimpse into a cultural construct obscure to the uninitiated.

The emblems of baroque culture, by that token, are obscure to us, resistant to analysis. They stand before us as a "frozen, originary landscape," captured as "fragment, ruin" (Benjamin 1980, 343, 354). In the segment from his autobiography entitled "Victory Column," Benjamin recounts his fascination with the figures who stood at the foot of the monument: "My favorite was the bishop who held the cathedral in his gloved right hand. I could have built a bigger one with my Ankerstein set. I have never since encountered a Saint Catherine without looking around for her wheel, or a Saint Barbara without looking for her tower" (Benjamin n.d., 18). In fact, one could not be certain that one *had* encountered Saint Catherine if her wheel were not present in the representation; the reader of allegory recognizes figures through the presence of their objects, which in turn refer to the narrative of the figures' lives. But the viewer must know the narrative in advance of looking at the object—otherwise, the wheel is nothing more than an indifferent wheel, the tower a tower. Further, the miniaturization of the objects (the wheel is not meant to represent a real wheel, the cathedral is but an indication of a cathedral) repeats the message that it is the symbolic language, and not the world from which it is drawn, that is important.

Benjamin's own autobiography functions as an array of untranslatable allegories. The objects of his childhood—sewing chest, stockings, the **155**

covered market, boys' books, butterflies and the net to catch them—all of these can function as allegorical objects that define the child and give up his life narrative. Unfortunately, because the reader does not know (and the text only helps the reader guess) the allegorical language, the objects lay in a fragmented, ruinous state. Only the effort made to connect (reactivate) the fragments can move toward a syntax for the allegorical language of the turn of the century.[16] Benjamin's images in *Berlin Childhood* are both the thing itself and the sign. To borrow Susan Buck-Morss's definition of Benjamin's "dialectic of seeing," his images "make conceptual points concretely, with reference to the world outside the text" (Buck-Morss 1989, 6).

This would seem at first glance to be a difference between allegory and photograph—this denotative reference to the world outside the text, for allegories are not meant to represent an actual object in the world, and it seems that photographs cannot help doing so. But it is not that allegories do not refer to objects from nature or experience, for they always *seem* to refer to persons and/or objects; it is that these objects have meaning only in their performance in the allegorical code. Roland Barthes writes in "The Photographic Message" that photographs are "messages without a code," which would again seem to place photographs in opposition to the heavily encoded objects of allegory (Barthes 1977, 19). But Barthes counters himself later in his discussion of the photograph of his mother that inspired *Camera Lucida,* his long meditation on the elegiac power of photography. Dwelling on a description of the image and informing the reader of the photograph's significance for his study, Barthes nevertheless declines to reproduce the photograph for the book, precisely because he feels that his readers lack the code to interpret it properly (Barthes 1981, 73). The photograph of Barthes's mother as a little girl in a winter garden (which very likely resembles, in its presentation of the nineteenth-century bourgeois studio, the photographs of Benjamin and Kafka of my discussion below) enacts the connection between photography and allegory because it, too, is an originary image (for Barthes, at least), a fragment of the past that requires more exposure and actualization than Barthes is prepared to provide for his readers.

Like allegorical objects, photographs function as "fragments" in that they are moments blasted from the continuum of time, rendered spatial and shrunk to miniatures. Their capacity for cutting space into fragments can be seen most clearly in those photographs that do not center their objects in a frame; an odd angle or a chopped-off building or body part renders visible what might ordinarily be overlooked—photographs do

not capture the whole world in their frames but only an arbitrary part of it. Benjamin's use of object images in his autobiography reflects the enigmatic and capricious nature of "meaning" assigned symbolically in the twentieth century. The allegorical language that was once a common property of a culture at a particular historical moment becomes a highly personal language, which none but the individual subject can decipher (as in Barthes's reading of his mother's photograph). In Benjamin's text, stockings, a plate of porridge, snowflakes, butterflies—all of these are inescapably personal, pictures understood by only one. In writing the autobiography, however, Benjamin hopes to reinscribe these personal signs into a communal language; his book is not "My Childhood in Berlin around 1900," but "*A* Childhood in Berlin around 1900." In this sense, the book and its images are meant to speak the communal language of a generation growing up in a particular place at a particular time. He is performing an archeological dig for himself and his contemporaries.

Benjamin sets roughly on par the metaphors of photography and archeology in his writing. Like the ruins of baroque allegory, the fragments from which Benjamin constructs his autobiography must be excavated from the recesses of memory in which they are buried. His use of the archeological image (which also plays a central role in Freud's work on memory and the unconscious) appears in *Berlin Chronicle:*

> [Memory] is the medium of the experienced as earth is the medium in which dead cities lie buried. Those who want to approach their own buried pasts must conduct themselves like a man who digs. . . . They must not be afraid to return again and again to the same facts; to strew them about as one strews earth, to root around in them as one roots around in earth. For facts are only layers, stratae, which only after the most careful research deliver the true values hidden in the earth's interior: the images, which broken loose from all earlier associations stand as precious objects in . . . our later insight like rubble or torsos in the gallery of the collector. (Benjamin 1988, 40)

As Benjamin revises *Berlin Chronicle* and transforms the text into *Berlin Childhood,* he removes more of the "earth," that is, the context from the objects he depicts. The language of the passage above creates a definitive connection between Benjamin's autobiographical method and his thinking on allegory; this association continues in his thoughts on the philosophy of history, in which photographs take on the qualities of allegorical emblems more explicitly.[17] Like archeological ruins extracted from the earth, pho-

tographs are removed from the context of experience; photography itself pulverizes the flow of life into decontextualized fragments. This is the guise in which the city appears in *Berlin Childhood*.

In the opening segment of the autobiography, the segment he describes as his self-portrait, Benjamin recalls the view of the city from the window of a train. He looks out over the Berlin urban landscape and catches glimpses of the loggias where he slept as a child, the courtyard he imagines as his intended mausoleum. The city he watches is as depopulated as the empty grave, a gridwork of buildings and streets, with the window of the train acting as a frame. Benjamin's decision to foreground urban spaces and objects to the virtual exclusion of human figures (including, most importantly, his own) brings to mind his fascination with Eugen Atget's photographs of Paris.

Working just at the turn of the century in Paris (during the years remembered in *Berlin Childhood,* that is), Atget produced more than four thousand images of the city. Benjamin hails him as a forerunner of Surrealism in that he broke with the conventions of bourgeois studio and street photography, photographing anonymous streets rather than monumental, "postcard" images, picking out odd details of buildings or coming at them from odd angles. The striking detail of the open transom window in figure 3.2 or the shadow of an invisible tree in figure 3.3, which portrays the entrance of an obscure street, mark Atget's impulse as subjective rather than oriented toward the consumption of the city's "sights" as they had been constructed by the tourist industry or traditional historical narrative. Atget's street scenes photographically enact Benjamin's imperative to see things in a new light, to blast them out of the parameters of ordinary perspective. As in Benjamin's allusions to the grave in *Berlin Childhood,* these photographs contain both the melancholy of loss that the little death of photography confers on ordinary places, and the regenerative force brought into play by seeing the ordinary as new. Atget's concentration on apparently "meaningless" details, his fascination with the obscure, his drive to break out of the ordinary frame for looking at things and achieve a new and surprising angle of perspective—all of this finds a reflection in Benjamin's *Berlin Childhood*.

But perhaps most enthralling for Benjamin is Atget's proclivity for empty street scenes; discussing the Parisian photographer's work in his "Short History of Photography," Benjamin writes: "The city in these images is cleaned out like an apartment that has not yet found a new tenant. It is in these instances that surrealist photography prepares a healthy estrangement between the environment and humans" (Benjamin 1980b,

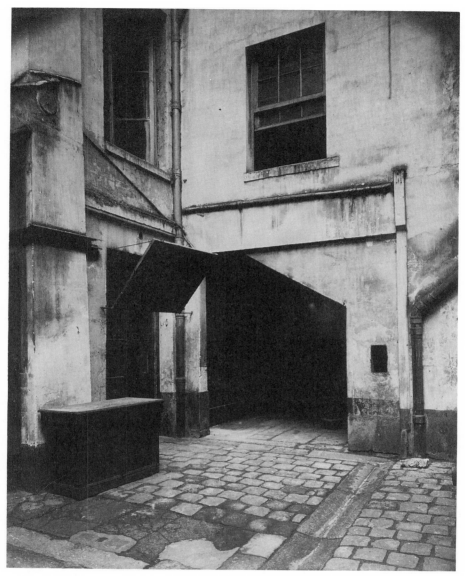

3.2 *Vielle Cour, 22, rue Saint-Sauveur, Paris, ca. 1898–1927, photograph by Eugene Atget.*
Courtesy The Museum of Modern Art, New York

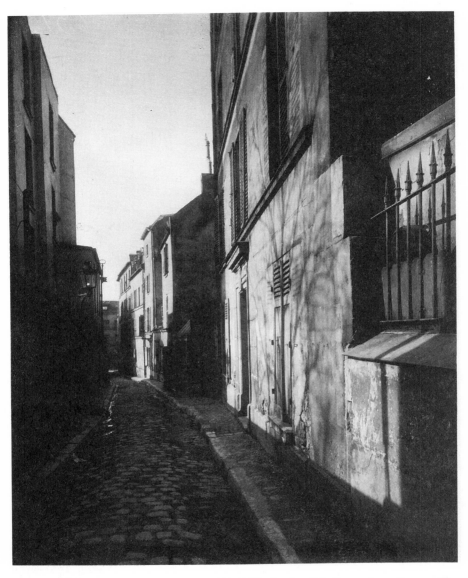

3.3 *Rue Saint-Rustique, Paris, ca. 1898–1927, photograph by Eugene Atget. Courtesy The
Museum of Modern Art, New York*

379). Atget's depopulated urban images thus provide a model for the depopulated segments of Benjamin's autobiography, which depict the streets and buildings of another city. Looking back now at the passage from *Berlin Chronicle* in which Benjamin describes the photographic shock effect of memory, we recall that he stresses the appearance of his self-image at the center of every "photograph." But his autobiography follows instead the model of Atget's photographs, in which figures have been effaced. The self resides in the image of the city—the city is the true face of the self, and so we see why the segment "Loggias," which describes the architecture of the city and makes no mention of the child's physiognomy, becomes (in Benjamin's eyes) his truest self-portrait.

Benjamin likens Atget's photographs of the empty Parisian streets to crime scenes; one has the sense, he suggests, that a crime has just taken place and the perpetrators and victims have recently cleared the area. A contrast can be drawn between Atget's empty streets and the crowded Paris of Benjamin's flaneur. Among the milling bodies of the crowd, the flaneur conducted his furtive observations, performing detective work as well as keeping up his incognito. But that was in the mid-nineteenth century, the age of physiognomies. In the age in which Benjamin resides, the twentieth-century police state, the flaneur has cleared the street to make way for the all-seeing camera. Atget's photographs represent the culmination of this process; the detective camera records the scene, but the apparatus itself is invisible—only the scene, not the photographer, survives. With the vanished flaneur, and then the vanished apparatus, we have come to the end of a series of disappearing acts, which brings us to the discussion of the ramifications of disappearance for Benjamin's notion of the "aura," another important photographic concept enacted in his autobiography.

Aura/Auricle

The works Benjamin left behind, most of them brief, resound with the echoes of words, concepts, and images that repeat from text to text, altering import by degrees with each resonation, as sound waves bend differently from different surfaces. One such echo is produced in the repetition of the word *aura,* which, although most frequently cited in his discussions of the photographic and the ritual, carries within it the sound of hearing and the ear. In this section I will follow some of the aura's echoes, with special attention to the air of nostalgia surrounding both the aura and its disappearance. A pattern of deep conflict emerges in Benja-

min's advocacy of the aura's destruction on the one hand, and his mourning at its loss on the other. This position finds a splendid articulation in writing on photography and his autobiography.

I would like to begin with a discussion of loss—our loss of Benjamin and the way that loss is inscribed in his own work (particularly in his autobiography) and in Benjamin scholarship. To understand the tone the latter often takes, it is necessary to return to the well-known story of Benjamin's final days. If it were a photograph, the story of Walter Benjamin's life would be in the sepia tones of nineteenth-century images, imbued with the color we have come to associate with nostalgia and regret. As a Jew and a Marxist, he was accorded no place in Hitler's Germany, and he left his homeland permanently in 1933. Declining several chances to escape the European continent because of a dedication to his final writing project, Benjamin committed suicide at the age of forty-eight at the Spanish border, convinced that he was about to be arrested by the Gestapo.

Lisa Fittko, who led the group who fled France with him, reported that during their strenuous climb over the Pyrenees he carried a heavy briefcase containing a manuscript. Recalling their flight in a later interview, she notes, "It seems to me that his life was worth less to him than the manuscript" (Heinemann 1992, 149). Benjamin apparently took an overdose of morphine just after he was told that he would be returned to France; after his death, his companions were in fact allowed to pass into Spain and continue to safety. The briefcase and its unnamed contents disappeared. For many readers of Benjamin, all of his writing absorbs the color of his ending: the missed chances, the loss of strength and faith, the loss of the writer, the loss of the fullness of his legacy, emblematized in the lost manuscript.[18]

I would not want to suggest that Benjamin staged his end for tragic effect. But readers confronted with his final episode look back over his writing and find the correlative features of mourning there, as if prophetic, as the child of *Berlin Childhood* "remembers" into the future. In the past several years (around the fiftieth anniversary of his death), a near-cult of Benjamin scholarship has sprung up. Some of this interest (especially among Anglo-American scholars) has to do with Benjamin's impact on the work of literary theorists such as Jacques Derrida and Paul de Man. But some of it seems grounded in the act of recovery, restoring the lost, ignored, or obscure Benjamin to a position of authority, even prophecy.[19] To use Benjamin's own terms, it is as if an aura had been created around the writer and his work that enforces the sense of loss and threatens to

make a sacred object of Benjamin: a martyr, enclosed in the opaque reliquary of his prose. Naturally it is difficult to avoid participating in the construction of an aura of melancholy if one takes Benjamin's personal and historical situation seriously. But I hope to get beyond the point of static contemplation through a consideration of the paradoxical nature of Benjamin's work.

To begin an examination of these contradictions, I confront the auratic story of Benjamin's death with an (apparently) anti-auratic essay, "The Work of Art in Its Age of Mechanical Reproduction," in which the invention of photography, with its power to destroy the aura through mechanical reproduction, emerges as one of the major transformative forces in art and culture. Even within this single text, however, the concept of "aura" plays in counterpoint against itself, alternating between the danger and desirability of illusion.

"What is aura?" Benjamin asks himself rhetorically in "A Short History of Photography": "A strange web of time and space: the unique appearance of a distance, however close at hand" (Benjamin 1980b, 209). His phrase "appearance of a distance" refers not only to a perception of spatiality, however, but also to a metaphorical construction. A rough summary of the argument of "The Work of Art" could run as follows: A work of art exists uniquely, in a single time and place, and its uniqueness encloses it in an aura, which creates a ritual and mystic setting for art. But photographs, through the process of mechanical reproduction, become available to all—anyone can possess a photograph of the *Mona Lisa,* while the original is a shrine, encased in glass, surrounded by pilgrims who have made the voyage to approach it. Not incidentally, the unique work of art (the "original") commands a high price on the market, while the photograph brings the semblance of the work of art within everyone's range, thus leading to the desirable demystification and politicization of art that Benjamin associates with art in the Soviet Union, where, he believes, photography's destruction of the aura leads to a full public participation in art.

Benjamin proposes that film can take the destruction of the aura yet further in producing "an aspect of reality that is free of all equipment. And that is what one is entitled to ask from a work of art" (Benjamin 1969, 234). Cinema's erasure of its apparatus, in this argument, brings the spectator closer to the cinematic "reality," for no trace of the technology of the film's production remains evident to estrange the viewer.[20] As he sees it, the negative counterpart to the positive politicization of aesthetics is the attempt to reinvest photographically reproduced images

with mysticism, a trend he observes in the Hollywood star system and National Socialism: "The violation of the masses, whom Fascism, with its *Führer* cult, forces to their knees, has its counterpart in the violation of an apparatus which is pressed into the production of ritual values" (Benjamin 1969, 241). That both Soviet and Western film depend on the aura of the illusion of reality (using different methods, to be sure) does not enter his analysis here, though I will contend that he later implicitly acknowledges the inherently illusionistic nature of film without, however, giving up his own attachment to the tone of nostalgia he associates with the aura.

A political urgency drives the argument of "The Work of Art," which was written in exile between 1935 (first version) and 1939 (second version). The circumstances under which the essay was produced inspired a tone of forced optimism coupled with a dark pessimism—Benjamin seems to want to see the possibility of a positive development in art through mechanical reproduction and the shattering of the aura, but in the epilogue to the essay he equates the aura's destruction with the violence of war: "instead of dropping seeds from airplanes, [society] drops incendiary bombs over cities; and through gas warfare the aura is abolished in a new way" (Benjamin 1969, 242). With this, the destruction of the aura as a purely positive matter has slipped away. And the presentation of the aura in "A Short History of Photography" (1931) takes on yet another tone. The essential notion is the same—aura as distance, embued with nostalgia and reverence—but Benjamin's attitude toward the aura rings with a kind of nostalgia of its own, a sadness at the disappearance of the aura, which in this essay he identifies with early forms of photography! The first photographs "[emerge], so beautiful and unapproachable from the obscurity of our grandfathers' days" (Benjamin 1980b, 345). His association of beauty and loss with the early photographs does not alter the theory of the aura (Benjamin is writing about daguerreotypes here, which cannot be mechanically reproduced), but his palpable regret at the loss of such images indicates the measure of his ambivalence.[21]

In his foreword to Benjamin's collected correspondence, Theodor Adorno underscores Benjamin's double-edged treatment of the aura, writing that Benjamin's outline of the concept in "The Work of Art" represents "an act of identification with the aggressor" (Benjamin 1994, xxi). Adorno's reading of the essay assumes that Benjamin promotes the reproducible image as an agent for political change, but Adorno also sees that Benjamin resisted the power of mechanical reproduction in other contexts; he recalls, for instance, the "pleasure [Benjamin] took in the physical act of writing—he loved to prepare excerpts and fair copies" (Ben-

jamin 1994, xxi). An accomplished graphologist, Benjamin attached particular importance to the appearance of handwriting (his own and others') and to the quality of the writing paper used in letters, matters which he often addresses in reference to and in his own correspondence.

In response to a sharply critical letter from Gershom Scholem, for instance, Benjamin fails to produce the expected polemical reaction, and instead turns his attention to the physical letter: "I admire the generosity you reveal by [the letter's] being handwritten; this tells me that you did not even preserve a copy of this document for yourself" (17 April 1931 in Benjamin 1994, 376). Of particular note in this remark is the suspicion directed against mechanical means of production (typewriters), which are seen as inextricably linked with mechanical means of *re*production— in this case, carbon copies. It seems that Benjamin, who acclaimed the smashing of the aura surrounding works of art as a counter to both capitalism and fascism, wished to retain an aura around letters as original and unreproducible objects, unique expressions of individuality. The idea of photography as it appears in *Berlin Childhood* encompasses both the shattering of the aura (in the autobiography's photographic/fragmentary structure), and the reinstatement of aura (in its repeated expressions of loss).

Berlin Childhood opens from exile: "In 1932, while abroad, I began to realize that I would soon have to take a fairly long and perhaps permanent leave of the city where I was born" (Benjamin n.d., 12). Benjamin is aware himself that this opening sets the stage for the expression of regret, and he attempts to counter the sense of sadness by characterizing the writing of *Berlin Childhood* as a kind of innoculation: "On several occasions I had experienced the process of immunization as a healing one in my inner life; I followed it in this situation as well, and deliberately evoked in myself the images that most tend to arouse homesickness in exile— those of childhood" (Benjamin n.d., 12). Benjamin's use of the idea of immunization or innoculation against psychological sickness implicitly refers to his reading of Freud's *Beyond the Pleasure Principle,* in which Freud argues that neurosis functions as a kind of immunization (or in Freud's terms, *Reizschutz*) against more devastating forms of fear—in particular, against shock.[22] Thus the images of *Berlin Childhood* are framed as small photographic shocks, small disassocations, manipulated in this case to ward off the devastating shock and disassociation of permanent exile.

Benjamin asserts that he succeeds in protecting himself from creeping nostalgia in *Berlin Childhood* by concentrating on "the inevitable social irretrievability of the past" as opposed to "contingent biographical irre-

trievability" (Benjamin n.d., 12). In other words, this is his motivation for removing the particularity of the self, the self's relations, the *physiognomies* of the text. He erases the faces to avoid missing them too much, and at the same time claims a political higher ground for his depersonalized autobiographical images. But there is an irony here that ultimately works at cross purposes with Benjamin's stated intention. For the removal of context, of particulars, of names and faces, injects into the reader a sense of absence, an awareness of an enigma that lies just beyond our grasp—an awareness of an aura. What Benjamin administers as the proper dosage of antinostalgia innoculation for himself enters the reader's consciousness at certain points as unadulterated sorrow.

In comparing Benjamin's description of the Kaiser panorama in *Berlin Childhood* with the overall structure of the autobiography, Bernd Witte notes that the child's sadness at the sound of the bell marking the retreat of each image resembles the reader's experience at the gaps between the text of the autobiography (Witte 1984, 583). This impression finds reenforcement in the closing mood of many of the segments, which reverberate with loss: "Loggias" ends with a reference to a mausoleum, "The telephone" ends with the child's surrender to the device, "Butterfly hunt" closes with a description of the never-seen holy Jerusalem, "Winter morning" expresses Benjamin's regret at having made the wrong wish as a child, in "Boys' books" the books ultimately evade the child's hands, "The fever" records the number of Benjamin's absences from school, "The otter" finally dives out of sight, the boy is tardy in "Too late" and finds that he must work to the end of the hour without having his name called—and "there is no blessing in it."[23] Almost every segment is "saturated" (to use Benjamin's term from "Kaiserpanorama") with the sense of mourning. A use of the conditional voice at the conclusion of several segments further underscores the sense of lost chances, could-have-beens: "If I had only paid better attention," "I would have been consoled for the rest of my life," "As if she wanted to bless me." The reader of *Berlin Childhood* receives the impression of fragmentation not only from the brevity of the texts that make up the work, but also in the repeated topos of incompleteness and lack. Despite Benjamin's political desire to see the aura smashed (expressed in "The Work of Art"), he builds an aura around the ruins of his childhood with a surety born of his own experience in exile.

Perhaps the most fascinating evidence of the auratic in *Berlin Childhood* occurs in precisely what is *not* there—in the gaps where passages have been erased. These erasures, primarily of passages involving physiognomy or visual media (including, of course, photography) correspond to

the disappearance of the cinematic apparatus in "The Work of Art" essay in that they conceal the narrator's method, his apparatus.[24] The first of these appears in Adorno's 1950 edition of *Berlin Childhood* in the section "Mummerehlen," which deals with the problem of mimesis: "In time I learned to disguise, *mummen,* myself in words, which were actually clouds. For the gift of seeing likenesses is nothing but a weak vestige of the old compulsion to become and act like something" (Benjamin n.d., 59). When Benjamin says that the words are clouds into which he disappears, he unveils something about the nature of his writing—namely, its obscurity, its prediliction for masks.[25] Like the child, the narrator disappears into the cloud/words of his text. He offers an image of this vanishing in a parable:

> [The story] comes from China and tells of an old painter, who showed his friends his newest painting. A park was depicted in it, a narrow road along the water and through a stand of trees; the road ran up to a little door, which opened into a cottage. But as the friends looked around for the painter, he was gone and in the painting. There he strolled up the narrow road to the door, stood quietly before it, turned around, smiled, and disappeared through the crack. (Benjamin 1980a, 262–63)

"Mummerehlen" thus presents the reader with a figure for Benjamin's withdrawal from his autobiography; the child, groomed for compulsive mimesis in the bourgeois world that builds identity through the accretion of things, disappears into the world of objects depicted in the text. When the allusion to the Chinese painting disappears from the final version of *Berlin Childhood,* we have an erasure of an erasure.[26] The second erasure removes Benjamin's reference to his own aesthetic method, and it is in this way that I associate it with the removal of the cinematic apparatus from the screen of the cinema.

The next vanished passage, also from the earlier version of "Mummerehlen," alludes specifically to two photographs (figures 3.4 and 3.5). The photographs themselves were not meant to appear in the autobiography, but a close look at the text and the photographs it describes confirms that Benjamin took his examples from actual images, carefully erasing the names of the photographic subjects for inclusion in the autobiography.[27] In this long piece from "Mummerehlen," the experience of being photographed once again serves as a model for the alienation and fragmentation of the self from itself:

Wherever I looked, I saw myself rearranged by canvas screens, **167**

3.4 *Walter and Georg Benjamin, c. 1899. Courtesy Günther-Anders Archive, FORVM,*
Museumstr. 5, A-1070, Vienna

cushions, pedestals that thirsted for my image the way the
shades of Hades thirst for the blood of the sacrificial animal. Fi-
nally I was offered to a crudely painted propect of the Alps, and
my right hand, which had to hold up a little hat decorated with
a tuft of chamois hair, cast its shadow on the clouds and snows
of the canvas. *But the tortured smile on the mouth of the Alpine boy*
does not make me as sad as the look that sinks into me from the child's
face that stands in the shadow of the potted palm. It comes from one
of those studios with their footstools and tripods, tapestries
and easels, that have something of the boudoir and the torture

3.5 *Franz Kafka, 1888. Courtesy Theodor W. Adorno Archive, Frankfurt am Main*

chamber about them. I am standing there bareheaded; in my
left hand a mighty sombrero, which I let hang with studied
grace. . . . I, however, am disfigured by my likeness to every-
thing that surrounds me here. As a mollusc lives in its shell, I
lived in the nineteenth century, and the century now lies hol-
low before me like an empty shell. I hold it to my ear.[28]

In the sentence italicized above, Benjamin's narrative moves from an ac-
count of the alienating experience of being photographed in mountain-
eering gear to a description of another photograph, one in which the
subject gazes out of the picture at the narrator. Acting as a kind of tempo-
ral and spatial conduit for the gaze of the two children, the narrator then
enters the second photograph and becomes its "I," erasing the borders of
time, space, and individuality in an easy turn of narrative perspective.

But who is this "I," precisely? The description of the second photo- **169**

graph from the passage cited above occurs (almost word-for-word) in two other passages in Benjamin's work. One of these appears in "A Short History of Photography," and the other, cited below, in Benjamin's essay on Kafka:

> There is a childhood photograph of Kafka . . . It was probably made in one of those nineteenth-century studios whose draperies and palm trees, tapestries and easels placed them somewhere between a torture chamber and a throne room. . . . Palm branches loom in the background. And as if to make these upholstered tropics still more sultry and sticky, the model holds in his left hand an oversized, wide-brimmed hat of the type worn by Spaniards. Immensely sad eyes dominate the landscape prearranged for them, and the auricle (*Muschel,* shell) of a big ear seem to be listening for its sounds. (Benjamin 1969, 118–19)

The details of the two passages (the palms, the sombrero/Spanish hat held in the child's left hand) are reflected in the photograph of Kafka (figure 3.5), as are the "immensely sad eyes" and the prominent "auricle of a big ear" in the second passage. Kafka's image seems to be placed as a kind of mirror for the "Alpine" photograph, for both images repeat the experience of alienation, and in both, the children are described as holding a hat—one in his left hand, the other in his right. But the photographs do not show the doubling of the hat; Kafka indeed holds a wide-brimmed hat in his left hand, but Benjamin carries a walking staff in his right, not a costume hat. An effort has been made to create the effect of a mirror, to mould Benjamin and Kafka as a single photographed entity, and this effort overrides the actual photographs. Unlike Twain and Strindberg, who pile photograph upon photograph in an attempt to delineate an identity distinct from all others, Benjamin sets photograph against photograph to show how they cancel out individual features, disrupting the denotative value of photographs and opening them to a reading of *unsinnliche Ähnlichkeit* (nonsensual resemblance).

Selfhood, in both of the photographs described in "Mummerehlen," is determined by what the child is not. Conditioned from an early age to resemble his suroundings, the child at the threshold of the twentieth century finds it impossible to resemble himself: "Words exercised [the compulsion to become and act like something] on me. Not those that made me resemble models of good behavior but those that made me like dwellings, furniture, clothing. Only never like my own image. And that is why

I was at such a loss when resemblance to myself was demanded of me. That happened when photographs were taken." All around the child are the things he is not, the "prearranged landscape" that does not accommodate what the child is, but rather determines the child's identity through negativity: I am not this Alpine mountaineer, not the person who holds this wide-brimmed hat, I am not my photographed self. The self is the empty space delineated by its surroundings.

In this vision, rather than revealing a truer self, photography is, as Hubertus von Amelunxen writes, "the allegory of the "not-me" (Amelunxen 1988, 10). Benjamin's insertion of Kafka's image into his autobiography expresses the "not-me" in yet another way; since both children are enclosed in the alienating setting of the photographic studio, they are not precisely themselves, nor precisely each other. The physical bounds between self and other evaporate in this construction, and the two bodies are dismembered in the sense that they are torn from their association with the individual; they become interchangeable. And Benjamin's descriptions of the photographs hint at dismemberment in their fascination with parts of each body: eyes, mouth, hand, ear.

Dismemberment at first seems to be equivalent to Benjamin's idea of the destruction of the aura; but then we look into the "immeasurably sad eyes" of the Kafka photograph, which evoke the presence of auratic distance and longing. Particularly Benjamin's repetition of the ear/shell motif seems to reweave the fabric of the aura in a web of complex connotation. In the description of the photograph of Benjamin and his brother, the shell (*Muschel*) held to the child's ear embodies the environment of the nineteenth century: "I dwelt in the 19th century as a mollusk dwells in its shell, and the century now lies hollow before me like an empty shell" (Benjamin n.d., 59). The shell is both prisonhouse and protection for the young child, and with his escape/exile from its confines, it becomes his oracle/auricle. There is another instance as well (from "The Work of Art" essay) in which Benjamin imagines the aura as shell: "To pry an object from its shell, to destroy its aura, is the mark of a perception whose 'sense of the universality of things' has increased to such a degree that it extracts it even from a unique object by means of reproduction."[29]

In comparing the two photographs and creating (through photographic means) a single entity of the two children, Benjamin enacts the destruction of the aura, prying the children from the shell of their uniqueness and the shell of their surroundings. His analysis of the two photographs indicates that he understands the studio setting in each not as situated in a particular place, but as ubiquitous, part of the nineteenth-

century landscape, which, because of the proliferation of photography, was familiar to everyone. Once again, with the photographic destruction of the aura, the elimination of distance (and even the elimination of the barriers between bodies) occurs.

But then there is another echo of "shell," when Benjamin writes that Kafka's ear is a shell listening to his surroundings; while Benjamin presses his ear against the shell of the nineteenth century, Kafka's ear *is* a shell (in German, the outer ear is called a *Muschel,* or shell). The double listening ears of Kafka and Benjamin, almost pressed against one another through the series of textual resonances, recall Jacques Derrida's notion of *otobiographie.* Derrida posits the "ear of the other" as the place into which the autobiography is told, and in which the autobiography takes form. An autobiographical text becomes autobiography only in its hearing, in its transit through the winding surfaces of the ear's shell, an image both Derrida and Benjamin employ.[30]

Derrida takes his cue from Nietzsche, whose autobiography *Ecce Homo* returns again and again to the importance of the listening ear; but Derrida's reading of Nietzsche wants to substitute the ear for the eye, hearing for reading.[31] "It is the ear of the other that signs," Derrida writes, and in this sense the ear (not one's own, but that of the other listener) offers an antidote to the logocentrism he fears from the structuring influence of the all-seeing eye (Derrida 1982, 51). Benjamin resists visuality only partially—he does not expunge the influence of the omniscient eye, but he separates it from its ear, as we shall see. In Benjamin's autobiography, the senses of hearing and seeing are separated out, dismembered. The idea of a continuous narrative for a life, of a continuous physical entity that could be identified as Benjamin (and not Kafka, for instance)—these are the illusions that lie, shattered into fragments, in Benjamin's work, even as the ordering principle of the eye remains, allowing the aura of a lost childhood to remain intact around the fragments.

A final passage erased from the earlier versions will serve to illustrate the way in which the aural and visual are separated out for the destruction of illusion, and how the structuring order of vision is put into place. This deletion comes out of the segment entitled "The little hunchback":

> I imagine that the "whole life" that is supposed to pass before the eyes of the dying is made up of the kind of pictures that the little man has of all of us. They flash quickly past like the leaves of those stiffly bound books that were once the forerunners of our cinema. Thumbs pressed slowly along the edges of the pages, and second-by-second pictures appeared, scarcely

differing from one another. In their fleeting course they would
reveal the boxer at work and the swimmer fighting his waves.
The little man has the pictures of me as well. He saw me in my
hiding places and in front of the otter's den, on the winter
morning and in front of the telephone in the kitchen corridor,
at the Brauhausberg with the butterflies and on my skating-rink
with the music of the brass band, in front of the sewing chest
and over my drawer, at Blumeshof and when I lay sick in bed,
in Glienicke and at the train station. (Benjamin 1980a, 304)

The images of the hunchback's book represent, of course, the segments
of Benjamin's autobiography, and in this way the traditional notion of
memory experienced before death—"life flashing before one's eyes"—
takes on a relationship to the flashing photographs of cinematography,
thus linking photography to the idea of a text written *in extremis.* The
flashing pictures also point up the illusion in cinematic continuity, since
what we experience as "motion" in film depends on our inability to per-
ceive the gaps between photographs. In the same sense, the fragmentary
structure of Benjamin's autobiography (emblematized in the picture
book) also reveals the illusionistic quality of narrative continuity.[32]

In *Berlin Childhood,* Benjamin has constructed a series of images from
which the illusion of continuity has been torn; as in the example of the
book that acts as a forerunner to cinema, we can see the spaces between
the images and understand it as a discontinuous, "truer" representation
of life. The little man's book regresses to a time before film, particularly
before sound film, for the ripple of the flipping pages inserts a reminder
of the separation between them, and thus the illusionary quality of the
book's "movement." Even as he makes the case in the "Work of Art" essay
for a closer approach to "reality" in cinema, Benjamin also seems aware
of the cinema's illusionary power, *and* the possibility of unmasking that
power through cinematic technology, which has the ability (through slow
motion) to undress itself, to reveal its mask and component parts.

As slow motion unmasks the cinema, so does the little hunchback's
book unveil Benjamin's "photographic" apparatus. But while both versions
of the autobiography close with the little hunchback, in the last version
of *Berlin Childhood,* his book disappears, exactly like the photographs of
Kafka and Benjamin and the Chinese painting. The presence of the voice
and the absence of the picture book cannot, however, be taken as a final
victory of sound over sight, for the little hunchback remains in the final
version as the invisible watcher who sees the various scenes depicted in

the autobiography's segments: "I never saw him. It was only he who saw me" (Benjamin n.d., 79). Aside from the passage in which we read of what the little hunchback has witnessed, no explicit sign is given in the autobiography of how each segment relates to the others; and the separate short texts pretend complete ignorance of one another. On reading that the little hunchback has been secretly watching the narrator, we have a way of imagining, if not a continuity of time, plot, or space, at least one of perspective. But because the introduction of the little hunchback and his unifying vision occurs only at the end of the text, it functions as a *da capo*. The reader now realizes that the little man was watching all along, and this is a revelation that demands a rereading, or at least a rethinking, of the entire text. In the little hunchback, we have a model for reading; we are now invited to flash quickly through the images offered, all the time retaining our awareness that the motion we perceive is illusory, since we have already experienced the fragments as separate images.

Thus the visual perspective is not removed; on the contrary, it acquires power through the hunchback's invisibility. Instead, the visual is torn from its voice. Like the disappearance of the Chinese painter into his painting, the vanished picture book remains implied in the structure and method of Benjamin's work; the vanishing can still be perceived, the vanished thing reconstructed, its absence noted, its aura felt. In erasing the picture book, Benjamin pulls the apparatus out of the lens, making the technology disappear from the illusion, as the cinematic apparatus disappears from the illusion of narrative film. Benjamin's ambivalance about the all-seeing eye and listening ear reflects an embedded conflict of priorities—the blasting of images from the illusion of historical continuity, and the reinstatement of an aura, of magic, around these images. If *Berlin Childhood* is an empty crime scene in which this conflict has dismembered or effaced the autobiographical self-image, the little hunchback, from his sheltered, invisible perspective, should be able to offer clues as to the whereabouts and identity of the body and its murderer.

German Childhood?/Jewish Body?

The little hunchback of the last segment of the autobiography enjoys an unusual relationship with both the narrator and the child of Benjamin's text. Anna Stüssi claims that "Benjamin, the autobiographer, hides behind the little hunchback: this character is introduced as the 'author' of the memory images" (Stüssi 1977, 60). On the other hand, Burkhardt Lindner notes the hunchback's resemblance to the child whom he observes;

like the child, the hunchback is left behind by the objects and events of life, watching as they retreat (Lindner 1992, 248). The apparatus of identification between the hunchback, the child, and the narrator is in fact very complex, since the uncanny figure is neither child nor adult (Lindner 1992, 248), and he is an outsider/voyeur who represents both a threatening Other and a self-image. In his use of the little hunchback, Benjamin forwards the argument that self-image is not constructed (or controlled) by the self alone, but by the state, society, and the historical moment.

In her work on the construction of bodies in history (particularly women's bodies in German history), Leslie Adelson emphasizes the importance of positionality, which she imagines as not only discursive but physical as well: "More than a matter of mere 'representation' in a web of signifiers and signifieds, positionality . . . becomes a mark of physical experience, which does not by any means render it identical to the physical body." Instead, the physical body exists in a field of experience, in which it constructs itself and is "implicated in the *construction* of meaning in specific, politically charged contexts" (Adelson 1993, 19, 20). Benjamin's use of the little hunchback as metaphor in his own self-construction evokes precisely the forces of politics and history in which his body, both German and Jewish, is implicated. I will argue that Benjamin scholarship has tended to obscure or deny Benjamin's physical (and physically politicized) positionality, and that a closer look at the little hunchback will help us uncover the cloaked body.

A tangled web of seeing and looking maintains the patterns of identification between narrator, hunchback, and child. The text begins with a confession of voyeurism; while taking walks as a child, the narrator would stand on sidewalk grilles and peer into the windows of basement apartments below. Both the child and the narrator experience the child's looking as illicit; the narrator characterizes it as "stealing" glances of the hidden life underground, while the child's excitement and fear at his own daring become evident in the disturbing dreams inspired by these outings, dreams in which the tables are turned, and he is now the object of glances "shot out of such basement holes" by "gnomes with pointed caps" (Benjamin n.d., 78). The little hunchback enters the child's consciousness in connection with these gnomes: "I knew immediately what I was dealing with when I happened one day on verses in my *Deutsches Kinderbuch* which read: "When I go down to the cellar, / There to draw some wine, / A little hunchback who's in there, / Grabs that jug of mine" (Benjamin 1969, 6). The verses in question come from the rhyme of "The little hunchback," and so the child imagines the evil gnomes (a "race . . . intent

on pranks and mischief . . . at home in the cellar") as co-conspirators with the little hunchback.

The narrator indicates that the hunchback and the gnomes return the child's curious gaze malevolently; but in fact the child fails to catch a glimpse of them for all his looking, for it is only when he does not actually see anything in the basement apartments that he dreams of the gnomes, and of the hunchback he says: "I never saw him. It was only he who saw me" (Benjamin n.d., 79). Michel Foucault's *Surveiller et punir* describes a similar situation in prisons, with the watchman able to keep an eye on the inmates at all times, and Benjamin refers to the hunchback as "the gray watchman/bailiff" (*der graue Vogt*). Indeed, the hunchback has the power to "arrest" the child; he has but to look at him, and the child will drop and break whatever he holds in his hands at that moment. Yet at the same time, we are led to connect the narrator to the hunchback, for only the hunchback and the narrator command the fragmented logic of the narrative—only they were both there with the child in all the segments, at the skating rink and the fish otter's cage and the winter morning. Thus the little hunchback plays both guard and prisoner in his identification with the narrator and with the child who, after all, the narrator once was.

In Benjamin's text, the internalized gaze of the guard indicates that the structure of watching and being watched exists within a single body. In historical terms, Benjamin constructs himself both as Jew and German, which reflects the actual experience of his exile, as well; when Germany invaded France, German citizens were rounded up and placed in French concentration camps, regardless of their political affiliation in the Reich. In the eyes of the French (and all of the Allies), Germans were monolithically German. Thus Benjamin came to spend some time in a French concentration camp, imprisoned for the German citizenship he had been forced to flee. In his autobiography, imagining a self constructed both of prisoner and guard, Benjamin reinscribes the complexity of his physical and historical position, in defiance of all those who would reduce his image to simply German or simply Jew.

An optical illusion in *Berlin Childhood* further connects the narrator with the hunchback/voyeur, and underscores the plurality of the narrator's self-image. Benjamin writes, "When [the little hunchback] appeared, all my efforts were for nothing. Efforts from which things retreated, until from one year to the next the garden had become a gardenette [*Garten/ Gärtlein*], my chamber a chamberette [*Kammer/Kämmerlein*], and the bench a banquette [*Bank/Bänklein*]. They shrivelled up, and it was as though they grew a hump that made them the property of the little man"

(Benjamin n.d., 79). In citing the transformations that occur with the appearance of the little hunchback, Benjamin has chosen word pairs that echo the a-ä shift that takes place when shrinking a *Mann* (man) to a *Männlein* (little man). He does not explicitly show us this transformation as he does the others, but we are led to imagine the hunchback as a *Mann* who, in the eyes of the child, shrinks into a *Männlein,* because the other objects undergo this transformation, and because the little hunchback is so closely linked to the narrator's perspective that the segment contains a *Mann* and his shrunken *Männlein* counterpart. This "little man" (that is, the little hunchback) can be understood as an embodiment of the child's fear who represents a force that makes him clumsy and bewilders him. In fact, the "little man" can also be taken as the feared outcome of the child's clumsiness and bewilderment—that he will in effect never grow up but always remain a *Männlein.* In this sense, the transformation of man to little man may also represent one of the "prophetic" moments of the text, in which the narrator's vision offers the child a vision of the future; the narrator knows that he will not achieve the independence he desires. A failed academic in exile, Benjamin often pondered the stymied course of his life, as we see in the segment of the autobiography entitled "Winter morning," in which the child uses his one wish to receive more time to sleep, when he should have wished for security and a profession.

Having positioned himself to see from both his own and the child's perspective, Benjamin's narrator sees how the child would see, but he also sees (from his vantage point in the future) what the child cannot. He sees the man (himself?) watching the child. As he adopts the child's perspective and converts it to his own position of perception, however, the image of the man watching, like the other objects of the scene, shrinks and becomes distorted.

The idiom Benjamin uses to describe his shrinking visual perspective, *Nachsehen haben,* could be translated as "to be left behind, looking after things as they retreat."[33] This perspective offers a link between the hunchback, the child, and Benjamin's Angel of History, whose gaze is fixed on the field of the past as he is blown helplessly backward into the future. While objects draw away into the past for the angel, they retreat into the future for the child. In both cases, however, an arrested helplessness characterizes their positions: the angel is confronted with the detritus of history just as the child Benjamin stands before the shards of glass, broken because of the little hunchback's intrusion: "[The person the little man looks at] stands bewildered before a pile of shards."[34] Finally, the reader achieves the same position; like the shards of glass and the rubble of his-

tory, the segments of Benjamin's autobiography lie strewn before us as we turn to look at the little hunchback looking. It is at this point in the narrative that we realize that we will now have to read backward in order to gain the proper perspective. The autobiography, which begins as a book in European script, to be read from left to right, now becomes a Hebrew text, which we must read from right to left.[35]

That the hunchback casts an invisible voyeuristic eye on the boy sounds further echoes with Benjamin's philosophical texts and his personal situation. One of the more unsettling aspects of the photographic age is the suspicion that at any given moment, a secret camera could be recording one's every intimate move. Benjamin's detective-flaneur moves through the urban landscape in much the same way as the little hunchback, keeping an eye on the crowd. The anxiety about possible photographic voyeurism first emerges during the last half of the nineteenth century, when nervous Victorians saw the diminishing size of the camera and increasing facility of its use as a real threat to their privacy. Benjamin himself remarks in "A Short History of Photography" that "the camera will become smaller and smaller, more and more prepared to grasp fleeting, secret images whose shock will bring the mechanism of association in the viewer to a complete halt" (Benjamin 1980b, 215). Not only does the camera become smaller in *Berlin Childhood;* it disappears entirely, and as the photographic flash freezes a moment on film, the little hunchback's gaze brings the child Benjamin's experience of the world to a complete and bewildered halt. It is the little hunchback's gaze that shatters the continuum of Benjamin's childhood, though it is also the little hunchback's plea for an intercessory prayer at the conclusion of the book that infuses the autobiographical fragments with the sadness of the aura.

While the hunchback's vision of the child's experience enjoys the clarity and precision of photographic vision, the reader's lack of orientation (until the end) and the air of mystery (of missing connections) renders the text nearly opaque at certain moments. There is, I think, a reason for this, for Benjamin writes, to quote the relevant passage once again: "If I entertain any hopes for [the book's] fate in the world, it is because, of everything I have written, this work may be most liable to be misunderstood" (Benjamin 1988, 24).

This cryptic utterance becomes somewhat less obscure in light of a remark in a letter to Gretel Adorno, written from exile in 1933: "If I did not have growing and more detailed knowledge of how much secrecy is now particularly warranted for studies like those in *Berlin Childhood,* the fate of this series' publication would have meanwhile driven me to de-

spair. Now, however, things are at the point where this fate only reinforces my conviction that the cloak of secrecy is necessary for this kind of thing to be developed" (Benjamin 1994, 428). Benjamin could not publish under his own name in Germany once Hitler had taken power; his identity as a Marxist and a Jew prohibited it. Not only his name and any reference that might point to his name but all references to his Judaism must likewise be erased if he expected his work to appear in Germany. Thus, too, the disappearance of the twin images of Benjamin and Kafka, which could be read as a kind of Jewish typology (see my discussion below), and the effacement of physiognomies generally, for those of his childhood would be, primarily, Jewish physiognomies.

It has been the tendency of poststructuralist theorists to equate Benjamin's act of self-effacement in his autobiography with the kind of defacement described by Paul de Man in his essay on autobiography (e.g., Thiel 1992, 126). De Man contends that the act of textual self-construction in autobiography works to create a new physiognomy through the agency of prosopopeia, thus dis-figuring (transforming) the writing self (de Man 1979, 926). De Man's notion of textually creating a new face—like those created for criminals in detective novels who wish to escape their past through a new identity—aligns interestingly with Benjamin's "cloak of secrecy." But de Man applies his argument indiscriminately, to anyone who writes an autobiography. In his theory of autobiography, the real desperation of a situation like Benjamin's becomes equivalent to an aesthetic game, the play of signifiers. Cognizant of the fact that any self-image constructed in an autobiography (or elsewhere) must also confront the image of the self constructed elsewhere, Benjamin introduces the cloak of secrecy for purposes other than play, though his means of dealing with the forces surrounding him do resemble techniques of deconstruction.

Scholars reading Benjamin's autobiography recognize some of his social and political concerns, though in doing so they seem to shrink from any mention of his Judaism. Anna Stüssi, for instance, reads the passage in which the child peers into the basement apartments as an instance of a type of voyeurism analogous to that described in *Surveiller et punir;* a child from a well-to-do family exercises his right of surveillance over the lower classes, thus asserting his position above them. Ultimately, she argues, the man that child becomes is able to place himself in the position of objects of his gaze, for he assumes a place at the bottom of society; he becomes a poor exile, with no fixed address and no foreseeable future (Stüssi 1977, 62–63). Because the balance of power will be inverted in his future, the

prophetic child of the autobiography has a dream in which those looked upon look back. Manfred Schneider, like Stüssi, imagines that the childhood scene of boomeranged voyeurism reflects something of Benjamin's political situation as an adult, and proposes that Benjamin's erasure of physiognomy and name presents a general response to the situation of exile, in which the state functions as the voyeur.[36]

While both of these readings seem justified, they miss or avoid the veiled references to anti-Semitic images of the Jewish body and character that are repeated throughout the short text. References to Jewish culture appear in the work of most Benjamin scholars, particularly those who choose to emphasize his interest in Messianic or mystic Jewish thought; but allusions to the construction of a "Jewish body," the physiognomy that required a secret cloak, seem nonexistent, as if the cloak were still in use. A closer examination of the little hunchback uncovers an emblematic representation of the mechanism used to inspire hatred of Jews through a distorted construction of Jewish body image. Benjamin's use of that image, however, provides a locus for reflection of the fact of distortion and its real effects. The web of identification woven between the narrator, the hunchback, and the child in the segment might at first glance seem to represent an acceptance of anti-Semitic propaganda, a donning of a mask created by the enemy. But Benjamin's reference to the hunchback as an imagined construct, imagined by himself, does not necessarily imply self-hatred. Instead, it indicates and articulates a consciousness of the powers that work to force us to construct ourselves negatively. Before I continue with this idea, let me turn to an examination of the hunchback as a representation of anti-Semitic propaganda.

Doctrines of racial purity and eugenics demanded that the dominant ("Aryan") group be imaged as physically healthy, attractive, and without defect. Carol Poore has written on disability under Hitler, arguing that any physical condition constructed as "abnormal" was considered tantamount to a form of political defiance (Poore 1982, 161). Concomitantly, those identified as "enemies" of the Reich were often portrayed in propanganda material as physically "deformed." A "hunchback" is one of the many physical abnormalities ascribed to Jews in anti-Semitic propaganda; images (mediated either by cinema or in print) of a "Jew" with stooped posture and hands rubbing together were taken as a sign for "Jewish avarice." The little hunchback's habit of snatching food and wine from the hand of the (presumably German) child reader of *Deutsches Kinderbuch* brings him into the anti-Semitic traditions of Jewish greed and Jewish malevolence toward German Christian children. (Figure 3.6 portrays two

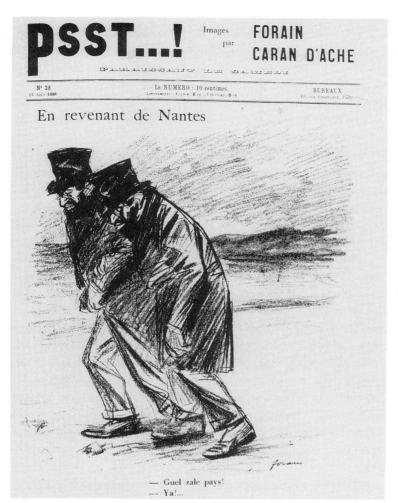

3.6 *"Returning from Nantes" "Vat a dirty country!" "Ja . . ." Two Jews in France after the Dreyfus trial, from page 1 of* Psst . . . , *a Parisian journal, 13 August 1898*

"Jewish" figures in a milder form of the stooped posture; one might suppose that the two men were leaning into the wind if the caption did not make clear the cartoonist's attempt to characterize them as stereotypical Jews.)

The association of deformity with evil is of course not a phenomenon that began with Hitler's rise to power; the association of misshapen bodies and depraved natures existed in the folkloric and literary traditions to a sufficient degree for the propagandists of the Third Reich merely to draw on available imagery. For instance, the German folkloric tradition of the *Giftzwerg* (poisonous dwarf) found echoes in a Nazi-era propaganda book for children entitled *Der Giftpilz* (The poison mushroom), which depicted the dangerous Jew. In this way the National Socialist propaganda fuses the notion of a malevolent dwarf, capable of bringing small children under an evil spell, with that of the deceptive poisonous mushroom, which masquerades as an edible plant. Benjamin's wording in his description of the hunchback and his cohorts reveals a relationship between them and the "Others" attacked by the inflammatory rhetoric of the Nazi period; the child imagines the uncanny figures as a "race" of "gnomes with pointed caps," "set on pranks and mischief"—in short, "riff-raff" (*Lumpengesindel*). This hunchback, then, belongs to a foreign race of shysters, whose resemblance to propaganda images during the Third Reich is unmistakable.

The use of photography in the production of propaganda provides, of course, a new twist, particularly when the image appears in what seems to be a "scientific" context. Photographic typologies achieved popularity shortly after the invention of the medium in the nineteenth century, with Bertillon's images of criminals, Charcot's of the insane, Darwin's typology of human and animal emotion, and "racial" typologies produced most extensively by the colonial powers Britain and France, in the racist setting of the United States, and in National Socialist Germany. Photographs can be manipulated in order to seem scientifically to prove difference when arranged in particular constellations. Photographs can, in effect, create categories of difference.

Benjamin's interest in typology can be excavated from "A Short History of Photography," where he expresses admiration for the work of August Sander, a documentary photographer who recorded in portraits the various classes of German society. I mentioned Sander briefly in connection with Strindberg's interest in documenting the lives of French farmers; motivated by a desire to record the physiognomy of the German class system, Sander's widely acclaimed effort betrays the same prejudices in itself that it hopes to extinguish elsewhere. While the images of Westpha-

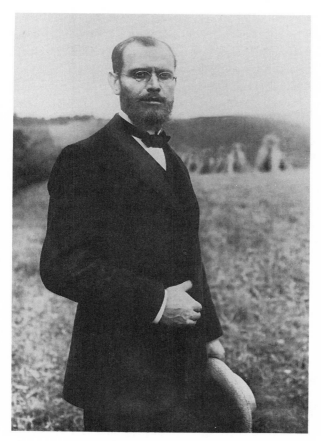

3.7 *"The Teacher," from* Antlitz der Zeit *(1913), photograph by August Sander.*
Courtesy Schirmer / Mosel Verlag GmbH, Munich

lian farm families, pastry cooks, and teachers are cast as representative of
their respective groups, those of "celebrities" are captioned with their
initials—these individuals are, in fact, individuals (figures 3.7 and 3.8).
That such typologies can serve destructive purposes is not lost on Benja-
min; he defends his praise for Sander by protesting that "the author . . .
was not guided by racial theorists or social researchers, but rather, as the
publisher says, 'by direct observation'" (Benjamin 1980a, 380). But such
observation, no matter how "tender" (as Benjamin chooses to describe
it), necessarily has an ideological focus; Benjamin's protest confesses
as much.

In the photographs of Kafka and himself as children described in the
earlier version of his autobiography, Benjamin offers a kind of photo- **183**

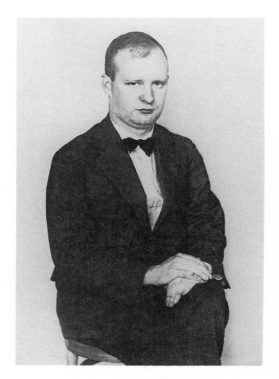

3.8 *"The Composer P.H.," from* Antlitz der Zeit *(1926), photograph by August Sander.*
Courtesy Schirmer/Mosel Verlag GmbH, Munich

graphic typology. As a conclusion to his analysis of the two photographs, Bernd Witte notes that "the involved reader of Benjamin grasps that the text of *Berliner Kindheit* is concerned not so much with the private self of the author, as with the social construction of an individual growing up among the Jewish upper bourgeoisie before the turn of the century" (Witte 1991, 140). But Benjamin removes the photographs, and he removes all explicit references to his Judaism. For the reader of the last version of *Berlin Childhood,* the Kafka-Benjamin association has been totally extinguished.[37]

Manfred Schneider imagines that Benjamin leaves out the physiognomies of his autobiography in order to create a desperately needed incognito. But even Schneider does not suggest that the need might be for a non-Jewish incognito, or a Jewish identity wrapped in a secret cloak, preferring to emphasize Benjamin's status as Marxist opponent of National Socialism. Is it possible that Benjamin recognized the danger of creating a photographic typology of the "Jewish upper bourgeoisie"? That

even when formed with "tender" hands, such a typology could be made to cut both ways? But if he disposes of the photographs for that reason, why does he retain the little hunchback? How and why does he integrate this distorted image into his construction of self-image, if at all?

Sander Gilman contends in *Jewish Self-Hatred* that a reiteration of stereotypes can occur in cases where the dominant group's judgments of the outsider have been internalized by the outsider, creating a double bind:

> On the one hand is the liberal fantasy that anyone is welcome to share in the power of the reference group *if* he abides by the rules that define that group. But these rules are the very definition of the Other. The Other comprises precisely those who are not permitted to share power within the society. . . . On the other hand is the hidden qualification of the internalized reference group, the conservative curse: The more you are like me, the more I know the true value of my power, which you wish to share, and the more I am aware that you are but a shoddy counterfeit, an outsider. . . . the liberal promise and the conservative curse exist on both sides of the abyss that divides the outsider from the world of privilege. (Gilman 1986, 2)

In Gilman's terms, Benjamin's situation as an assimilated Jew might lead him to the repetition of ugly anti-Semitic propaganda, and Benjamin's use of the little hunchback as self-image could be seen as a symptom of Jewish self-hatred.

But the problem with being an outsider is that one is not only an outsider; one can also (and otherwise) be constructed (and construct oneself) as an insider. Benjamin positioned himself, for example, outside (opposed to) the bourgeois concerns of his secular Jewish family, but also outside the Zionist circle of his friend Gershom Scholem. His autobiography makes clear his position within the privileged class of Berlin society—the boy looking down through the grille at the city's less economically secure inhabitants. Benjamin's Jewishness is not, taken by itself, simply an expression of otherness in relation to German culture. And his Germanness is not simply an array of traits taken on in the vain hope of joining the dominant group. His nemesis and alter ego, the little hunchback, comes out of the pages of the *Deutsches Kinderbuch* (German children's book), a volume which undoubtedly formed his notion of what he, a German child, ought to be. The little hunchback is born of the conjunction of particular readings of both Germanness (as a fragile, threatened

essence) and Jewishness (as a threatening force) with which, in some sense, Benjamin could identify. But Jewishness and Germanness can be (and were) constructed differently as well.

In his recollection of the *Deutsches Kinderbuch,* Benjamin reproduces the images that were used to frighten children (to frighten him as a child) and would be later manipulated to arouse dark and buried fears in German adults. The eye of his own German childhood is trained against him, creating a mirror that distorts his image—he becomes the fears that were whispered in his childhood ear. Nevertheless, he cannot separate himself from his origin as part of the dominant group. Aside from some translations into French, he writes exclusively in German, and in *Berlin Chronicle* he makes the following telling observation: "If I write a better German than most of the authors of my generation, I must credit this in large part to the twenty-year-long observance of a single little rule. It goes: never use the word 'I,' except in letters" (Benjamin 1988, 24). The exception to this long-standing rule could be said to exist in his autobiographical writings, where he does use the pronoun "I"—but we have seen the lengths to which he has gone to continue writing good German by erasing the features of his I, and leaving nothing but the "eye" of the little hunchback.

And so the photographic images of Benjamin and Kafka disappear, and even the photographic apparatus vanishes in an attempt to conceal the writer's hand. The photographic structure of the autobiography, which works to convey Benjamin's theses of history, remains implicitly present. In retaining the photographic structure, Benjamin also retains the presence of an all-seeing eye, the eye of the little hunchback, which, because of its privileged status, implicates the narrator as well. The identification of the authorial eye with a distorted self-image provokes speculation on the function of vision of photography in the authoritarian state. If we imagine, as does Foucault, that the eye of surveillance represents the oppressive power in society, and if we accept that the structuring visual mode works to subjugate the marginalized in that society, what do we make of the little hunchback, who represents both the oppressed and the oppressor?

In the little hunchback, Benjamin constructs an image for otherness and dominance within the same body. That he removes photographs, physiognomies and the photographic apparatus from his autobiography may not imply simply the need for an incognito—it may reflect the impossibility of structuring the body as he experiences it, as a complex interplay of subject and object, within the frame of a photograph. To ignore

Benjamin's physical positionality and its representation in the anti-Semitic image of the little hunchback is to adopt a totalitarian position; it is to deny Benjamin the plurality of selfhood he experienced in his singular and truncated life.

Benjamin's skill in designing a *Tarnkappe* (a cloak of invisibility) rests with his intimate knowledge of the hidden powers of language and image, and in his expert elucidation of the photographic image and its significance for historiography. In the next chapter, I will discuss another autobiographer in need of a disguise, who likewise writes to deconstruct the strictures of totalitarianism. Where Benjamin gives no name for his childhood self, she invents a new one; where he erases all explicit reference to photographs and photography, she reveals the way in which photographs insiduously take over memory. His act of deconstruction occurs in an extensive use of *unsinnliche Ähnlichkeiten;* she approaches photographs head-on and takes apart their frames in order to reenter them as an ordering and active subject. In both cases, however, the autobiographer recognizes the threat of certain kinds of readings of photography and proposes a new way of looking at both photographs and the idea of photography, a task that seems imperative in the latter half of the twentieth century.

Every photograph snuffs.

CATHY N. DAVIDSON, "Photographs of the Dead"

You can destroy people this way.

CHRISTA WOLF (quoted in "Auf mir bestehen")

The Lost Photo Album of Christa Wolf's
Patterns of Childhood

In this final chapter, I would like to examine a contemporary author's image, both as she has constructed it in her work and as it has been constructed in the public eye. This particular author, Christa Wolf, has attracted an unusual amount of attention—in part, I would argue, because of the extraordinary complexity and beauty of much of her work, and in part because of the pivotal place and time where her life took shape. Her autobiography, *Kindheitsmuster* (Patterns of childhood) treats the thorny matter of living under National Socialism in Germany; not as Benjamin did, as an outsider, but as an enthusiastic adherent of Adolf Hitler, a model child from the pages of the *Deutsches Kinderbuch. Patterns of Childhood* represents an autobiographer's attempt to reclaim a childhood under Hitler from which she is completely alienated as an adult living and writing in East Germany. The narrative structure of the autobiography reflects the peculiar mixture of estrangement and desire in Wolf's relation to her own past, and her use of lost photographs as the basis for reconstructing her memories reveals her ambivalence toward the issue of material evidence in autobiography, for evidence can be used to support more than one thesis of selfhood and history; evidence can be turned against you.

Too often it goes unnoted that Wolf's writing of *Patterns of Childhood* constituted an act of courage. In exposing herself as a former fascist in a state that defined itself precisely through its antifascism, in acknowledging her childhood and attempting to come to grips with those elements from her discarded past that form a continuum with the present, Wolf

exhumes unwanted and buried memories not only for herself, but for many others, her readers, her critics. The lost family photo album, left behind as her family flees from the advancing Soviet army at the end of the war, stands for the lost memories of a generation. Not surprisingly, Wolf came under fire from critics who took issue either with her autobiographical method or her object; in a sense, she wrote the autobiography not only for herself but for all of her contemporaries, a risky undertaking.

More recently, Wolf has been harshly censored for her loyalty to the dissolved communist East German state that replaced the National Socialist state of her childhood. The past several years have seen the development of a furious debate over the merits of literature produced in the former German Democratic Republic, with the work of Christa Wolf occupying the most contested territory of the fray. Particularly in the wake of the 1991 publication of *Was bleibt* (What remains), and after the 1993 revelation of Wolf's early cooperation with the East German secret police (the Stasi), her detractors have taken up increasingly extreme positions, while her defenders have felt obliged to reexamine her books in the light of these new discoveries.[1] Marilyn Sibley Fries, an American Germanist whose work on Wolf has been both rigorous and essentially positive, describes her new feeling of alienation and uncertainty regarding the author:

> Recalling Kassandra's words to Aineias in *Kassandra,* "I do not want to see your transformation into a statue [*Standbild*]," while studying the full-page photograph of their author in a recent issue of *The New York Times Magazine* brings home the sense of inertia, not to mention loss, in an uncanny way. The Christa Wolf portrayed there, her makeup-mask visible to the camera's eye, her gold-silken blouse chosen to coordinate with the elaborate tapestry of the priceless chair on which she sits as guest of the Getty Center for the History of Art and the Humanities in Santa Monica, California, is a greater stranger than she ever was in the GDR: an alien figure frozen in an image constructed by the photographer, the article's author, and, one has to suppose—although this is the most alienating aspect of all—by Christa Wolf herself. . . . I, as a reader, have lost my interlocutor, the author. (Fries 1993, 276)

Fries's remarks become even more intriguing when we consider that the word *Standbild* (literally "standing image") used in the quote from Wolf's own novel, *Cassandra,* means not only "statue" but "still photograph." The

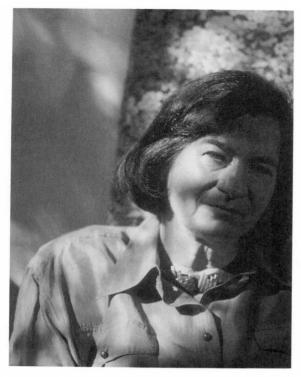

4.1 *Christa Wolf, Getty Center, Los Angeles, 1993, photograph by Alastair Thain. Courtesy Onyx Enterprises, Inc., Los Angeles*

photograph (which reveals Wolf's "mask") and its stillness are at the heart of the critic's problem; this photograph snuffs the image of Wolf maintained by decades of Wolf scholarship (figure 4.1).

But how can we be sure that the "gold-silken blouse" was "chosen to coordinate with the elaborate tapestry of the priceless chair"? We do not know the circumstances of the photograph or the actions leading to its framing, beyond the alienating fact that Wolf is "guest of the Getty Center for the History of Art and the Humanities in Santa Monica, California." The photograph estranges because of its surrounding context, its construction in a historical and cultural moment. We interpret it through its construction (the connotative factor), yet we take it as evidence of something (denotative). This offers a perfect example of the photographic paradox. Is it because Wolf allows herself to be framed here in this setting that we imagine her complicity in the construction of the photograph, down to choosing the piece of clothing most likely to make

her fit into her surroundings? Christa Wolf, up to this moment perceived by her supporters as a canny practitioner of resistance to patriarchal framing, now becomes a poseable doll. Both foes and friends imagine the author as putty in the hands of her photographers; her critics see her as she was framed by the lens of the secret police, who had Wolf and her husband under intense surveillance from 1969 on,[2] and her supporters are shocked to find her between the pages of the *New York Times Magazine,* enclosed in elegant clothes and makeup, framed by the walls of the Getty Center.

In a 1993 interview, Wolf confronts the revelation of her cooperation with the Stasi during the early 1960s and the effects of the publication of her involvement. Her interviewer, attempting to offer her a graceful way out of the insinuations of cowardice voiced by some of her detractors, asks "do you . . . by nature shy away from conflict, and did you—or do you still—aim for harmony at almost any price? Was that the reason that you did not pull back [from the Stasi]?" This particular question infuriates Wolf, and her response, a German idiomatic phrase, is telling: "Gestatten Sie, daß ich jetzt mal aus der Haut fahre." (Please allow me to lose my composure—literally, "to fly out of my skin.") In making her reply, she intends to destroy the image the interviewer has set up of her, to shed the "skin" he perceives.[3] The notion of Wolf as "intellectually afraid," she avers, comes directly from her Stasi files: "That is one of the obscene consequences of the description of these files in the press, that people adopt the Stasi's characterization and the Stasi's language and apply them to me. It is unbelievable" (Gaus 1993, 32). The (West) German journal *Der Spiegel,* in an article which reiterates, in essence, the Stasi reading of Wolf, publishes an accompanying "illustrative" photograph: a young Christa Wolf shaking hands with East German head of state Walter Ulbricht, captioned "A Child of the GDR" ("Margarete" 1993, 159).

It is precisely because of the power of images to frame, objectify, and elicit easy captions that Wolf resists photographic stasis in her writing. In a 1968 essay, she decries memory's tendency to harden into "a collection of colored miniatures with captions," a process that compromises the immediacy and accuracy of the most painful memories, rendering them "cool and smooth." The miniatures Wolf describes produce the same effect as photographs; they make one's own history the history of a photographed double, they allow distance, and consequently invite self-exculpation. Like photographs in family albums, these miniatures are "taken out and passed around," their captions acting as the commentary that places them safely within an acceptable version of history (Wolf

1980b, 23–24). But ultimately far from safe, the frozen historic minia-
tures uphold life-lies and make easily graspable objects of the complex
subjects portrayed in them.[4] In a 1988 interview Wolf describes how au-
thors, who in her view have come to serve as secular substitutes for now-
vanished sacred authority, are expected to conform to a public image,
and describes her own reaction to that situation: "Above all, I know that
it is not I who act as [the authority], but the image that people create of
me. It is difficult for me to resist that image" (Hörnigk 1989, 39).

The image of Wolf at the Getty Center is one miniature; the one of
Wolf and Walter Ulbricht is another. These two photographs appeared
within weeks of each other in 1993, in the wake of the revelation of
Wolf's early cooperation with the Stasi. How are Wolf's readers to re-
solve them? Or should resolution be our aim? It is the author herself who
gives us some guidance in reading and resisting images as miniatures. Her
autobiography, *Patterns of Childhood,* evokes the authoritarian structures of
National Socialism by presenting scenes in which photographs act as a
metaphor for the strictly enforced (framed) limits placed on lives under
National Socialism; but at the same time, the fact that these photographs
have disappeared and are reconstructed in the narrator's memory opens
up the possibility for a subjective reentry into the image of the objectified
past that can work toward breaking its frame. "Im Rahmen bleiben" (stay-
ing within the frame) is one of the homely expressions used by the nar-
rator's mother, Charlotte Jordan, who is anxious that one of the aunts,
disguised as a gypsy at a family gathering, should conduct herself appro-
priately. In English idiom, the reference to a frame is unfortunately lost,
although we can express the idea similarly as "staying within limits."[5]

"The frame," explains the narrator, "was the natural sense of propri-
ety which a person did or did not possess."[6] The idea of staying within the
frame, however, is challenged by Wolf's narrator's use of photographic
images within the text, images that fail to stay within limits, in part be-
cause they no longer exist as concrete objects; they were lost at the end
of the war. With the danger of oversimplification or distortion through
captions and frames, either actual or mental, firmly in mind, the loss of
the photographs acts as a strategy to undo the confining effects of the
frame; but still Wolf wants to keep them in some state as evidence: "You
started sifting through photographs, which are scarce; the subsequent in-
habitants of the house on Soldinerstrasse probably burned the fat brown
family album" (Wolf 1979a, 8). Why must the album, "brown" like the
Nazis, burn? The narrator tells us that one of her mother's last acts before
fleeing was to burn the portrait of the Führer that had hung in their parlor

(26). In the narrator's mind, the burned family photographs are linked not only to the photograph of the Führer, but to those of bodies of concentration camp victims mentioned much later in the text: "Nelly saw stacks of corpses only in photographs or in films. As they were being doused with gasoline and burned" (321).

I do not want to argue that the narrator intends to plead innocence through identifying herself with the victims of Hitler; such an assertion would ride roughshod over the text's careful exploration of her own complicity in the National Socialist movement. Rather, the bodies, the photo album, and the Führer portrait are all pieces of evidence, documents of the repressed. The narrator thus recreates Nelly's body, the body of her lost childhood, through memories of burned photographs. "But photos," she continues, "that have been looked at often and long do not burn easily. Immutable stills [*unveränderliche Standbilder*], they are stamped into the memory, whether or not one can produce them as material proof."[7] The relationship between photographs and memory outlined here seems at first glance to privilege the photograph as an indelible source for memory. Yet if one considers the accepted value of photographs—that they achieve their authenticity because of their objective quality, that is, their status as objects, divorced from the singularities of subjective human perception—it becomes evident that Wolf's narrator is once again shifting the parameters of referentiality. Her assertion that it makes no difference whether the incriminating pieces of evidence can be produced makes sense only if subjective interpretation of the images takes ultimate priority.

In fact, the single most important thing about the photographs is that they were lost; for being lost, they can no longer perform as effectively as delimiting objects. Their unavailability thus offers a certain liberty to the narrator's account, but it also symbolizes the repression of memory and consequent loss of history among the members of the narrator's generation. Dieter Saalmann, in arguing for Wolf's classification as a "deconstructed socialist" rather than an "unreconstructed 'Marxist,'" points out the importance of "traces" in her work: "By underscoring the 'presence' of . . . absence, Wolf is able to do justice to the evidential indeterminancy and attendant suspension of the subject" (Saalmann 1992, 165, 160). The missing photographs Wolf describes act as a marker for an absence, just as photographs always do, but because the photographs are lost, they indicate a "hyperabsence," an absence squared. Further, the subject's suspension to which Saalmann refers has obvious significance for *Patterns of Child-*

hood, in which the use of the pronoun "I" is held in abeyance until the end of the text.

But caution is advised for those junctures where we become tempted to label Wolf definitively as either a deconstructionist or a socialist. Some scholars tend to emphasize Wolf's destabilization of documentation's evidential power, downplaying the important position historical documentation is accorded in Wolf's work (Frieden 1989; Wilke 1991). But the narrator does turn to "hard" historical documentation in order to challenge her subjective vision: photographs, maps, books, and old newspapers. These are held up to the photographs in her memory for comparison, and it is in comparison that old structures are uncovered and broken down. Warning against a tendency to ignore the importance of materialism in Wolf's work, Helen Fehervary writes: "History is not displaced by subjectivity, political discourse by individualism, nor the public sphere by the personal. The radicalism of [Wolf's] work lies neither in a transcendent nor a private quality but in an immanent historicity" (Fehervary 1989, 171).

Wolf's manipulation of photography as metaphor offers a key to understanding how she manages to have it both ways, blending deconstruction with materialism. To understand how this works, a comparison with Walter Benjamin's concept of photographic stasis and history may prove helpful. Wolf, like Benjamin, imagines history as an arresting confrontation in the present with the past in the realm of subjective experience (Fehervary 1989; Wilke 1990; Köpnick 1992). This confrontation takes place in her text when the narrator visits, for the first time in more than twenty years, the city of her birth and childhood. Suddenly the self she has carefully constructed in communist East Germany over a period of decades is brought face-to-face with the architecture of her National Socialist self, evoked in the streets and buildings of the city where she was a child (figure 4.2).[8] This experience is not Wordsworth's "tranquil restoration" of "sweet sounds and harmonies," but rather like Benjamin's lightning shock, flashed upon the photographic plate of memory, which has been kept so many years in the sheltering dark.[9] Thus a parallel emerges between Benjamin's use of photographic imagery in describing his concept of history as shock and Wolf's notion of painted miniatures as moments of frozen history; both involve a traumatic confrontation with the past and a resultant stasis, captured in an image (Köpnick 1992, 78). But the play with lost photographic images in *Patterns of Childhood* reflects Wolf's desire, first expressed in her essays on historic miniatures, to dis-

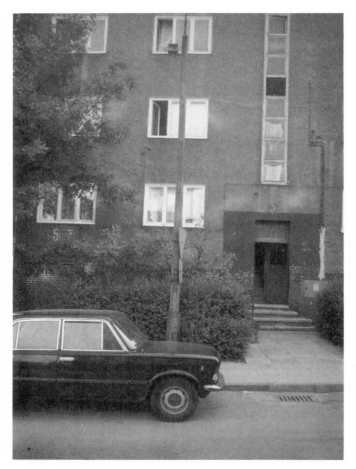

4.2 *Plac Słoneczny 5, Gorzów Wielkopolski (formerly Sonnenplatz 5, Landsberg an der Warthe), photograph by Brian Rugg*

rupt the static moment of historical awareness and reactivate the static surface of such images, while Benjamin's *Dialektik im Stillstand* emphasizes the galvanizing moment of stasis.[10]

The differences in their approaches are clearly visible on a structural level; while Benjamin adopts a monadic structure for his autobiography, dividing the text into unconnected "images" (*Bilder*), Wolf constructs a narrative that follows three strands of chronology: the years of her childhood from 1929 to 1946, a visit she makes in 1971 to the city where she lived as a child, and the period of composing the text from 1972 to 1975. The monadic, severely separated images of Benjamin's *Berlin Childhood* en-

act his concept of *Dialektik im Stillstand,* while Wolf's narrative in *Patterns of Childhood* confronts past with present in the moments at which three flowing rivers of narrative touch one another in passing. Her text emphasizes motion and connection rather than stasis (Frieden 1989, 270).

Further, while Benjamin's "images" in *Berliner Kindheit* do reflect a layering of past, present, and future time, there is an absence of confrontation with the Other in the form of interrogating subjects who refuse to allow the narrator to continue in a state of *Stillstand* (like her brother, husband, and daughter). Benjamin's *Stillstand* seems to take place in solitude, in a confrontation with place, time, and the divided self, but not with community. Similarly, though Benjamin's work (his later work, especially) revolves around the concatenation and quotation of found objects and words, he does not integrate documentary material (the voice of the Other) into his autobiographical account of childhood as Wolf does.

It is perhaps partly because Wolf is a woman and partly because she also, unlike Benjamin, plays a role in the subjugating side of National Socialism that she adheres in some greater (or different) measure to historical materialism, documentation, and the body's experience in the world. It can be argued that Benjamin's vision of messianic stasis is not accessible to her as either a woman or a strict materialist (Fehervary 1989, 166; Wilke 1990, 504). Her position as someone who grew up under National Socialism, who supported (however unwittingly) Hitler until the end and beyond, demands that she take into account the body as historical agent—not just as discursive practice.[11] On the other hand (and there seems with Wolf always to be another hand), she has felt as a woman the strictures of being constructed culturally as sheer corporeality, and deconstruction offers a way of breaking through the framing structures that have defined her experience too glibly. Leslie Adelson captures Wolf's position best when she posits that "feminist writing may well provide the meeting ground between theories that assume the primacy of material relations and those that assume the primacy of discourse and signification" (Adelson 1993, 41).

One of Wolf's most quoted, pondered, and analyzed utterances comes from her novel *Reflections on Christa T.:* "the difficulty of saying I." Feminist scholars in particular have discussed this difficulty, ascribing it to the inhibited process of self-realization for women: lacking authority in society, women also lack the power to say "I." Helen Fehervary offers a slightly altered reading: "The 'difficulty of saying "I"' is ultimately the desire *not* to say 'I.' For it is the desire to say more than 'I.'" Rather than establishing an authoritative narrative voice, an "I," Wolf aims to set in

motion a "landscape of masks": "The mask, a form of relational being, enables the stripping away of an isolated individual identity. It is the wish to participate in a body of affinities and not to become the summation of an individual or collective teleology" (Fehervary 1989, 174).

The difficulty of saying "I" emerges from the same source as the desire to disrupt the confining surface of documentary images, and this becomes particularly clear in Wolf's autobiography and its use of the photographic metaphor. Both Helen Fehervary and Sidonie Smith suggest that the use of masks is a gender issue; when the Western dichotomies between reason and nature, between mind and and body are drawn, women are placed among the ranks of nature and body, wordless, all flesh. Placed in such a position, women do not have access to the authoritative voice of male subjecthood: "Woman so defined cannot fully know or reflect upon herself. She harbors no unified, atomic, Adamic core to be discovered and represented. There are no masks to uncover because paradoxically there are only masks, only roles and communal expectations" (Smith 1993, 15). Christa Wolf's autobiographical *Patterns of Childhood* enacts a play of masks (through use of shifting pronouns) that places her squarely in the feminist tradition of autobiography from Gertrude Stein to Virginia Woolf to the present. The narrative seems, in fact, to be a woman's journey toward the authority of the subject "I," for on the last page the narrator (who has addressed her adult self as "you" and called her childhood self "she" throughout the text) finally utters the word "I."

Yet a cautionary note must be inserted here before we espouse the idea of a "feminist tradition"; recently feminists have recognized the dangers of constructing *a* feminism that itself reverts to the notion of universality in women, another kind of false miniature for female experience.[12] Christa Wolf introduces a complexity into the notion of the marginalized woman; in *Patterns of Childhood,* she is both the girl framed by a childhood under National Socialism, and a German who actively participated, even as a child, in the oppression of others. It would thus be too simple to say that *Patterns of Childhood* deconstructs the oppressive power of objectivity through a dissolution of the subject-object dichotomy. While such a line of argument is tempting, given Wolf's distrust of static images and her childhood as a young girl subjugated by an authoritarian system, the dichotomy between oppressor and oppressed, observer and observed, becomes much more difficult to define when both are the same person. Judith Mayne, in her discussion of female authorship in film, observes that it has been "customary in much feminist film theory to read 'subject'

to 'object' as 'male' is to 'female.'" She suggests that "a more productive exploration of female authorship . . . may result when subject-object relationships are considered within and among women" (Mayne 1990, 97–98). Wolf's work acknowledges the relation between oppressed and oppressor through her acknowledgment of both division within herself and her complicity in the system of subjugation.

Photographs provide an especially appropriate structure for the confrontation of the self with the self, between subject and object. The pronominal strategy Wolf develops for the narrative reflects a photographic structure as well, which becomes particularly evident when we analyze the visual image that lays the foundation for her strategy. The barrier between selves that must be broken in order to repair the flow of memory finds expression in the three personal pronouns used to designate the narrator. A third-person child (she/Nelly) inhabits the book's earliest historical period from 1932 to 1945, a second-person adult (you/unnamed) ponders the child from the time of the trip to Poland in 1971 through most of the writing process in the early 1970s, and finally, an "I" emerges on the last page of the text, in the sentence "I don't know" (Wolf 1980a, 406). Gerhart Pickerodt has pointed out that this "I" "makes itself known as a synthesis of memory work, reflection, and transcription" (Pickerodt 1985, 298). This is an "I," in Pickerodt's estimation, that is created through the text, and does not precede it or function as a source.

The absence of the "I" in the narrative becomes all the more significant in light of the scene in which the child, Nelly, first discovers the word "I" in reference to herself:

> Yours is an authentic memory, even if it's slightly worn at the edges, because it is more than improbable that an outsider had watched the child and had later told her how she had sat on the doorstep of her father's store, trying the new word out in her mind: I . . . I . . . I . . . I. (Wolf 1980, 5)

The narrator can claim this moment as an authentic memory because it must originate from the "I"; it is an interior moment, impossible for another to witness. An abyss between the child and the narrator, who pronounces the child "inaccessible" (7), necessarily remains open for historical reasons: "Because it is unbearable to think the tiny word 'I' in connection with the word 'Auschwitz'" (230). At the same time, although the narrator strictly enforces her separation from the child and the "I" through her use of the second- and third-person pronouns, her

presentation of the memory of her childhood self saying "I" reveals a consonance between the remembering and experiencing selves bordering on the autobiographical use of the first-person pronoun:

> The stone step. . . . The irregular brick pavement that leads to the door of her father's store, a path in the shifting sand of Sonnenplatz. The afternoon light is falling onto the street from the right, and is reflected in the yellowish fronts of the Pflesser houses. The stiff-jointed doll Lieselotte with her golden braids and her eternal red silk dress. The smell of this particular doll's hair. . . . But what about the child herself? No image. This is where forgery would set in. You'd have to cut her out of a photograph and paste her into the memory, which you'd spoil in the process. Making collages can't be what you have in mind. (5–6)

Despite the narrator's claim of unbridgeable distance, in this scene she sits in the child's place, in the child's body, seeing the light, smelling the doll's hair. She does not see the child because, as in all cases of extreme consonance in narration, she occupies the child's perceptual space.[13] The memory is drawn into the present tense (the light "is falling" and "is reflected"), so that the narrator's "eye" occupies the position of the child's "I," even though historical inhibitions refuse the narrator the use of the child's pronoun. This is Wolf's strategy for the inclusion of (absent or nonexistent) "photographs" in the text; she begins to remember the image from the outside, seeing herself in the photograph as a child; but then she performs the trick of entering the frame of the photograph, of taking up the child's position and seeing through the child's eye from the perspective of being photographed. This happens most palpably in the photograph I will discuss in more detail below, in which the narrator first remembers a photograph of herself taken while on a summer vacation, and then "sees" her uncle taking the photograph, her aunt standing beside him, and finally the whole context of the photographic event. Once the narrator establishes a locus for the "eye," she begins the slow movement toward the provisional reintegration of the "eye" with the "I" at the text's close. At this point, to try to form an image of the child and integrate that image within her memory would be a false double exposure; she cannot see with both the child's eye and her own.

Other scholars, reading *Patterns of Childhood* for widely divergent reasons and using a variety of methodologies, have noted the extent to which Wolf depends on *Verbildlichung* (the making of visual images) to present

her memories. Heinrich Böll likens the narrator's account of the National Socialist years as "album-like anecdotes, of the sort that might be told while thumbing through photo albums or digging through photos" (Böll 1990, 97). Christel Zahlmann, who stresses the psychoanalytic implications of visualization, describes scenes in the text as "a series of snapshots" (Zahlmann 1986, 41), while Sabine Wilke refers to an "archeology of images from [the narrator's] childhood" (Wilke 1991, 169). And Marilyn Sibley Fries, in an article on visual images in Wolf's work, asserts that "Snapshots are permissible, even necessary" to Wolf's project, which "faces the challenge of simultaneously making visible and withholding closure. The image which succeeds in fulfilling this contradictory aim contains past, present, and future; it contains being and becoming, stasis and development" (Fries 1982, 63). It will be my purpose in this chapter to demonstrate how Wolf accomplishes the aim Fries describes.

The lost family album forces the narrator to rely upon her visual memory, her subjectivity, reversing the process of looking at photographs to create or gain access to memory. She uses her memory to gain access to photographs, or more accurately, the moment of being photographed. The absence of the photo album creates a free field for interpretation by mixing numerous categories of images within the text: memories of the lost photographs, apparently surviving photographs, images created in the memory, news photographs, photographs taken on the trip to G., images from textbooks, films, dreams, etc. The result is a field of vision in which the "real" images exist on the same plane as images imagined. In memory, the photograph is not a static image but an event. The act of photographing and being photographed belong to the same moment, and the frame of the remembered photograph expands to include the photographer as well as his subjects. For instance, "The picture—presumably snapped by Uncle Walter Menzel at a family outing . . . —brings motion into the system of satellite family figures . . . Uncle Walter Menzel, Charlotte Jordan's younger brother, still aiming his Kodak at Nelly, his niece. Right next to him must have been Aunt Lucie, radiantly happy, engaged to Walter" (Wolf 1980a, 27–28).

It is unclear whether this is one of the photographs that survives the hypothetical fire or not—the narrator tells us that the snapshot is one of the "immutable images . . . stamped into the memory" and at her "disposal on demand" (26). "Looking" at the image, the narrator describes herself and her surroundings: "the slender, pale birch leaning slightly to the left, on the edge of the darker pine grove which forms the background. Nelly, three years old, stark naked, as the focus of the picture

. . . her body wreathed with oak garlands" (27). A composition takes shape within the frame of this early photograph, with the "slender birch" acting as a visual counterpart to the naked white child. Both the dark background of pines and the wreath of oak garlands surround the child at the center of the image, and as always, such a frame does not act as a simple visual boundary, but has associative power: nature, innocence, childhood, happiness: "The littler, the happier—perhaps there's really something to it" (27). But Uncle Walter Menzel's snapshot contains, despite its apparent simplicity, a paradox: it is a consciously constructed and composed image of unconsciousness, of freedom from constraint.

As attractive as this image may seem, the narrator recognizes its tendency toward a miniaturization of history, and so she steps in to open up its frame. She moves first from "viewing" the image (imagined or not) and hazarding a guess at the identity of the photographer, to a reconstruction of what she was (probably) looking at when she was photographed, thus reinstating her visual and pronomial "eye/I." Once she has regained the child's visual perspective, interestingly, the child disappears from view, thus underscoring the need in the text for both an objective and subjective angle. First the photograph is employed as a document, then as an experience. The image creates a vehicle for moving from a consideration of the past into the present tense: the girl "waves at the camera," her uncle is "still aiming his Kodak at Nelly" (27, 28). At what narrative level does this "still" occur? When is "still" if not now? This still (as in "yet," as in "still photograph") is the peculiar work of photography.

Further, when the narrator first begins to enter the photographic frame, her vision of the situation beyond the frame finds expression in the conditional voice: "right next to [Walter] *must have been* Aunt Lucie" (28, emphasis mine). But by the end of her description, she seems to have found an angle of vision that permits a crossing over into the indicative: "Now she is standing there, waving her white handkerchief at Nelly: Look up, Nelly baby, here into the black box, look at the birdie!" (28). Now the narrator has crafted a perspective wholly in line with that of her three-year-old self, however impossible or transgressive such an act might seem. Photographs, and in particular these lost photographs, permit the crossing of normally uncrossable lines by opening a door onto the past.

James Olney reminds us that the integration of past and present also represents a hallmark of autobiographical narrative: "Memory can be imagined as the narrative course of the past becoming present and . . . it can be imagined also as the reflective, retrospective gathering up of that past-in-becoming into this present-in-being" (Olney 1980, 241). Wolf's

"photographs" in *Patterns of Childhood* perform much the same function, but they also demonstrate the necessity for and danger in framing and objectification. Given the political situations of Nelly, the child of *Patterns of Childhood,* and of the narrator (whose childhood and adulthood are haunted by state surveillance), the practice of objectification for political ends (under whatever banner those politics might exist) becomes particularly pertinent. Once I have explored the act of photographic objectification in *Patterns of Childhood,* I will revisit my discussion of Christa Wolf's public image, with the hope that my analysis of her work will lead to an illumination of the practice of destructive "miniaturization" in the press.

Fotoobjekte/Families and Fascism

English speakers prefer the term *subject* when speaking of photographed persons or things; the German word *Fotoobjekt* renders more successfully the thoughts of theorists such as Michel Foucault, Laura Mulvey, and Susan Sontag, who concern themselves with the power of the unseen observer over the observed, a power inherent in photography.[14] Wolf, too, expresses uneasiness with photographs as spaces that frame their objects and fix them in a position of subordination to the eye of the viewer: her resistance to such framing demonstrates not only a concern with gender matters, but with a particular historical and cultural context. The examples of photographic subjugation under National Socialism in *Patterns of Childhood* reveal the complex communion between public and private forms of repression and domination, particularly as they occur in the family.

The objectifying power of photographic framing is articulated most explicitly in the narrator's recollection of the photographer Richard Andrack:

> The Jordans have a family photo, taken by the non-commissioned officer Richard Andrack, who was . . . a photographer by profession and a hypnotist on the side. Parents and children sit in two armchairs and on the couch, next to each other and across from each other. A certain stiffness in front of the camera could be due to their lack of experience in posing. Nonetheless, sitting stiffly erect, they look smilingly past each other into the four corners of the parlor.
>
> One will never be able to prove that millions of similar family photos stacked one on top of the other had anything to do with the outbreak of the war. (Wolf 1980, 173–74)

The narrator's curious denial that millions of such family photographs could offer an explanation for the onset of war leads the reader to consider the possibility for the first time. What is there about the photograph that prophesies war? Heinrich Böll meditates on the incongruousness of this type of photograph when it is produced in the context of National Socialism: "family idylls and extermination camps—and those who were carted off to the camps probably had similar family photographs, which they showed to people with a similar commentary" (Böll 1990, 99). The narrator's references to posing, to offering a false and strained front, and to the lack of eye contact or honest emotional expression among the photo-objects, support the studies by Klaus Theweleit and Alexander and Margarete Mitscherlich on the repressed nature of family life under National Socialism (cf. Theweleit 1977 and Mitscherlich and Mitscherlich 1977).

The photograph taken by Richard Andrack is a genre study: "The Family Portrait." The very fact that there are "millions" of such images throws into doubt the possibility that the photograph expresses any originality or individuality; subjective experience must be subsumed under the generic category "family," which demands smiles and poses, however unnatural. An irony emerges in the image of the four family members gazing into the four corners of the room, in that the photograph is intended as an image of "togetherness," family unity in the family home. It reveals a family alienation so thoroughgoing that Wolf claims that it can be taken as a symptom of the coming war.

The twelfth chapter of *Patterns of Childhood* opens with a single word that sets the stage for Richard Andrack's appearance: "Hypnosis." Nelly's family invites Andrack to photograph the party after Nelly's confirmation, and there he proceeds from taking stiffly posed photographs to a demonstration of mesmerism. By the end of the session Andrack has hypnotized Cousin Astrid and convinced her to climb onto the table and begin to march, salute, present arms, and take aim at Uncle Walter: "On the table, Astrid performed drill exercises like a recruit, obeying noncommissioned officer Andrack's commands. Right face, left face, about-face seemed to come as naturally to her as saluting with and without head covering, goose-stepping in place . . . and the present-arms routine, which she certainly had never practiced before" (270).

Wolf's constellation of hypnosis-photography-militarism does not occur coincidentally: Richard Andrack is a framer and a sadist. He sets up the icy family shot. He determines the shape, texture, taste, smell, and feel of reality for his hypnotized subjects, compelling Astrid, for in-

stance, to slap her mother and "kill" her uncle. The figure of Andrack relates the spectre of "obedience" as practiced in a totalitarian state to a photographic subject's relation to the photographer. That Wolf's narrator associates him, his photography, and hypnosis with the outbreak of the war asserts the negative power of delimiting, finite images in an authoritarian relationship. Andrack's images reflect bourgeois society's conception of itself: the family in the parlor, the confirmation child. They help complete the official picture of life in National Socialist Germany, working along with the other images Wolf's narrator mentions: photographs of military planes and vessels, "Mothers at the Plow," and the family's photographic portrait of the Führer, to which we will return. With Richard Andrack, a National Socialist who creates destructive and seductive illusions, the narrator exposes the rhetoric of propaganda and her own culture's susceptibility to its images.

The word *seduction* contains both political and sexual connotations in the hypnosis episode. Standing, as most children do, at the margins of the party, Nelly watches her cousin Astrid with a mixture of revulsion and envy: "Nelly had stoutly and consciously resisted all Herr Andrack's attempts to gain power over her. She would have felt flawed had she been that easily seduced" (270). Andrack's mediums tend to be women, and the roles he forces Astrid to perform underscore the connection Wolf's narrator draws between psychosexual domination and patriarchal militarism. First Astrid goosesteps on command, and then she slithers into a belly dance, having climbed onto the dining table in imitation of an erotic dancer. ("Once a girl climbs on a table, [Nelly's mother] said, there's no limit to what she'll do.") Part of Andrack's agenda, then, is the destruction of female consciousness and the objectification of the female body in a militaristic context, which ultimately denies the dignity of any body. In Andrack's photography, the human body is made to perform as a representative of a cultural and political agenda, and thus loses its power to represent an individual and the individual's integrity.

Richard Andrack's performance in the text pegs him easily as the male/patriarchal/fascist/objectifier. In fact, the label adheres just a little too easily, and so here the reader should be aware that caution is advised. As with all captions under miniatures, this captioning of Andrack deserves interrogation, because it can lead to a problematic reading of National Socialism. Andrack's ability to elicit militaristic behavior with a Svengali gaze (a corporeal representation of the camera that takes the fascistic family photographs) could move the reader to identify Andrack with Hitler himself, whose eyes somehow hypnotized the German people

into going to war, framed them, posed them according to his design. Such an interpretation would imply that the German people relinquished their collective will to a great hypnotist when they went to war and established concentration and extermination camps. Wolf's narrator offers a more complicated image; the subject-object relationship is not as simple as the apparent evocation of a typical patriarchal male versus objectified female would imply.

The first warning against an easy interpretation of the word "Hypnosis" that heads the twelfth chapter should come when we consider the label's function in miniatures. The very reduction of the complex factors of guilt and power under this rubric should move the reader to a closer examination of the text. In fact, many of the book's chapters are formulated with such key words in mind, all of which invite analysis: "Final Solution," "Decay—A German Word," "Obedience," etc. Andrack himself tells us that his power does not extend to compelling his mediums to perform actions with which they have no acquaintance; everything Cousin Astrid does, he explains, is "from [her] own repertory" (270). And so the question arises: where does Astrid's knowledge of the military originate? The narrator assumes that Astrid has never before performed military exercises, but for the hypnotist to be able to force the subject to do something, the subject must have some notion of what the hypnotist means. Clearly, Astrid has seen military drills, either in person or on film, and her performance reflects the culture in which she lives. The hypnotic situation, whether imagined as particular and concrete in the case of Andrack and Astrid, or as generalized and metaphorical, in the case of Hitler and the German people, does not arise from nothing, but depends on a preexistent proclivity.

Another way in which the narrator complicates the simple subject-object relationship of both photography and hypnosis relates back to the breaking of the photographic frame described earlier in my analysis of the photograph by Walter Menzel. As in that case, the narrator alludes to sightlines that exist outside the normal pattern of domination and subjugation. Nelly, who is the point of identification for the reader within the hypnosis episode, resists Andrack's influence:

> [wouldn't it be amusing]—oh, more than amusing: exciting, delicious—simply to let herself sink back under Herr Andrack's magnetic hands; he'd be sure to catch her. To climb on the table in front of everybody and to undulate, as her cousin was now doing.

> At the same time she knew: it wasn't like her. Her role was
> to observe the one—her cousin—and to envy her a little, and
> to see through the other—Herr Andrack. And to hide it all—
> the secret longing, the envy, the feeling of superiority—from
> everybody. (271)

Nelly has the eye that undoes the apparently unseverable bond between hypnotist and subject. From her observation point outside their interlocking gaze, she sees through both of them: Andrack's "scientific" interest becomes seduction, and Astrid demonstrates the desire to be seduced. While this is not a particularly gratifying feminist reading, it must be admitted that the hypnotized subject is a volunteer.

Nelly's position reveals that it is possible to assess and reject the system of domination, even if that implies renouncing a kind of pleasure. Like her mother, who is granted the dubious gift of being able to prophesy doom (*Schwarzsehen*, literally "seeing black"), Nelly possesses an unusual clarity of vision at certain moments. But again like her mother, she experiences her vision under a kind of enforced silence: hiding it all. It is not until after the war that Charlotte Jordan feels able to call Hitler "that goddamned lousy criminal," though stray remarks and a general attitude throughout the course of the war indicate that she saw the truth well enough (167).

The narrator calls Nelly's mother "Cassandra," alluding to both her gift (if it can be called a gift) of dark vision and, it is presumed, the opposition both in her culture and in her family to the truth of that vision. Wolf's later work *Cassandra* explores a tradition of the prophetess who sees the brutality of the male-dominated culture in which she lives, and who is punished for her insight. This reading of women's position within the circle of domination places rather a large responsibility on these women who can see; once again in Wolf's work the point is made that the perpetrator/victim dichotomy cannot be glibly mapped onto a male/female dichotomy. Under such circumstances, breaking silence becomes an imperative, though speaking invites disastrous consequences.

Andrack's family photograph, as static and silent as a tomb, offers nevertheless another challenge to the subject/object structure of photographic situations. The sightlines of the four family members gaze from Richard Andrack's frame into the four corners of the parlor. Although earlier I offered this as an example of alienation within the family, an additional reading could be placed alongside: the family's refusal to meet

the gaze of the camera might indicate a resistance to Andrack's frame. The separate directions of their looks indicate a lack of cohesion in both a negative and a positive sense; while they lack a sense of fellowship, they also elude the attempt to incorporate them as objects within a single authoritarian vision. The problem again, as in the hypnosis episode, is the practice of complicity and silence. In the arrangement and selection of their furniture, their postures before the camera, and even the circumstances of the photograph (Nelly's confirmation), the Jordans express their eagerness to conform to bourgeois values. Like Nelly's resistance to the charms of the hypnotist, their refusal to return the camera's gaze remains silent and unshared, and thus ultimately ineffective.

As a child, Nelly is not yet ready to challenge the parameters of her universe, and Charlotte seems too deeply (and comfortably) enmeshed in the structure of her culture to want to break free. It is up to the narrator of *Patterns of Childhood* to return to the scenes of her childhood, see once again the circumstances surrounding her, and speak. While writing the book, the narrator has a dream about a funeral procession for Stalin, who has already died and been memorialized: "After you dreamed the dream for the first time, you asked [your husband]: When will we start speaking about that, too?" The answer is, of course, in writing *Patterns of Childhood*. Speaking of Stalin, like speaking of Hitler, means breaking an enforced silence. The interrogation of authoritarian photographs opens up forbidden topics.

Considering Wolf's apparent position (not unlike that of Theweleit and the Mitscherlichs) that fascism begins at home, it is not surprising that much of Nelly's interrogation of her culture concerns family photographs. It is important for the narrator's disruption of the photographic frame that the surface of remembered photographs be "disturbed" or "disturbing." In one instance, two family portraits work together to create a disturbance in the photographic surface: one of her father and her maternal grandmother, shortly before her parents' marriage; and the other an "art photograph" of her mother, posed in a gigantic hat; the disturbance occurs "because . . . another photo . . . always appeared before Nelly's eyes when she thought of the picture at the beach in Swinemünde [of her father and grandmother]: A portrait of her mother" (Wolf 1980a, 89).

The narrator does not explain why such a juxtaposition was either necessary or irritating; she simply lays the pictures before the reader's inner eye for comparison, depending upon her description of the images to call up the same sense of disturbance in the reader. Along with the disturbance that Nelly feels with the comparison of the two photographs

is a sense of discontent with each individual image, which apparently has to do with photography's impenetrable surfaces.

Nelly finds herself compelled to imagine a caption for the photograph of her father and grandmother: "And they lived happily ever after" (89). The photograph presents an idyllic relationship between a son-in-law and mother-in-law, a relationship traditionally cast as antagonistic. In this particular instance the man places his arm protectively (possessively?) around the woman's shoulders as the two of them stand on a beach. Nelly scans the picture in search of what irritates her; is it the straw hat in her father's left hand? The freedom with which he embraces her grand-mother? The beach chairs arranged like a chorus behind them, a chorus that seems to whisper: "And they lived happily ever after . . ."? For the reader, who has learned suspicion of framed images as truisms, the dis-turbing quality arises from the snapshot's resemblance to miniatures; it is an emblem of its time, meant to represent family harmony, like the photograph by Richard Andrack.

Indeed, the fairy-tale ending that springs to Nelly's mind is reminis-cent of the captions described in Wolf's essay "Miniatures," with its pat summary of a scene embedded in a nostalgic past. In German, this effect is even more evident, because the traditional German ending for fairy tales is a sentence that only seems to contain meaning: "Und wenn sie nicht gestorben sind, so leben sie heute noch" (Wolf 1979a, 126; And if they haven't died, they're living yet today). Nelly realizes (and this may be the ultimate source of her irritation) that this "ending" is in fact empty of meaning, making no commitment to the actual historical fate of the two pictured there. Like the smooth surface of the photograph and its easy allusion to "happiness," the smooth ending for German fairy tales serves mainly to silence the questions of children.

The photograph of her mother produces a disturbance of quite a different nature, and so it strikes the reader as odd that the two images are inextricably linked in her memory. Unlike the snapshot of her father, the framed studio portrait of her mother gives Nelly pleasure, because it reveals her mother's beauty and, perhaps more importantly, her mother's awareness of her own beauty: "Even a blind man could see that her mother was beautiful, no matter what she wore. But Nelly couldn't say why she derived such infinite consolation from the fact that there had been a time when her mother had wanted to be beautiful. (Not only the hat. No: especially the look, a slanted look from under the hat!)" (Wolf 1980a, 90).

In his *Camera Lucida,* Roland Barthes discusses the "look" of photo- **209**

graphed subjects in terms that prove useful in unlocking the significance of the photographed mother in a hat. The entirety of *Camera Lucida,* in fact, rests upon and weaves around a photograph of Barthes's own mother as a child. When Barthes begins his book (itself a sort of photographic autobiography), his mother has recently died, and the photograph of her provides the impetus for his exploration of the meaning of photographs—and in particular, the meaning of his own attraction to photographs. In essence, the photograph of his mother is the only thing left of her, and it depicts the mother as enigma, because the image originates from a time when the mother was not yet his mother—the photograph both affirms and cancels the relationship between mother and son.

Interestingly, although Barthes reproduces the other photographs discussed in his study, he intentionally withholds the picture of his mother, because, as he explains, the photograph cannot represent what he wants to say about it. Indeed, the photograph's meaning resides in the relationship between mother and son that it both creates and abrogates, and this relationship does not exist between the reader and Barthes's mother. The notion of relational viewing of photographs plays a significant role in defining the "look," which revolves around the viewer's perception of how the photograph "sees" its viewer.

The photographed subject who looks "into" the camera engages visually with the photographer, but only in an interrupted fashion; the photographer's look is not visible to the subject and therefore cannot be returned. When a person subsequently views the photograph, the photographer is of course erased, and the viewer takes up the vacant position, becoming the object of the photographed subject's gaze. Thus we acquire the sensation of being "looked at" when looking at a photograph, and the image's meaning becomes invested with our perception of the imaginary relationship between the viewer and the viewed. In Barthes's reading, the "look" becomes an almost flirtatious encounter, for the person in the photograph offers the intimacy of meeting the viewer's eyes, while withholding both actual physical presence and any explanation or elaboration of the "look." And of course we know, as viewers, that the "look" may not be meant for us at all, but that we may be intercepting a look invested with the meaning of quite a different relationship from the one we imagine with our photographed partner. In the case of both Barthes and Wolf's narrator, it is necessarily an illusion that the person in the photograph can "see" them at all, for these are photographs of mothers taken before they became mothers.

Nelly is proposed as the viewer of the portrait with a hat, but the

adult narrator describes the act of viewing the photograph in such a way as to render the child's view indistinguishable from her own. At the time of writing *Patterns of Childhood,* the narrator's mother has died, and it is the irrecoverable mother that both Nelly and the narrator see in the photograph with the hat. The significance of the photograph lies in the way it "looks" at both Nelly and the narrator.

One clue for tying this image to the one of the father and grandmother is the word *einstmals* (rendered "once there had been a time" in translation), which refers the reader back to the fairy-tale nature of the first photograph. Once upon a time, Nelly had a mother (in that mythic time before she was Nelly's mother) who considered it important to be beautiful, who put on a "wagon wheel of a hat" in order to appear so. The golden fairy-tale age of the narrator's tale exists in the realm before Nelly's birth, but it also refers to the time before the war, before Nelly's mother and father were so changed by the war that they failed to recognize each other when they finally meet again (398).

The loss of youth and beauty after a trip into a mythic underworld is also a fairy-tale motif, popular as well with writers of *Kunstmärchen,* as in Ludwig Tieck's "Der Runenberg." An explicit reference to the fairy-tale world occurs in the scene of the father's return: "Fairy tales prepare us for it from childhood on: The hero, the king, the prince, the lover, falls under a spell in foreign lands; he returns a stranger" (398). But not only the father has changed; upon his return the narrator's mother realizes her own transformation for the first time: "Only now—since she rarely looked in a mirror—only by her husband's vacant glance, which went right through her, did she learn of her own transformation into an unrecognizable person. . . . With a single blow she had lost herself and her husband" (398). In this landscape, it is the photographs that maintain the fairy tale of a normal life, uninterrupted relationships, bodies intact and unscarred. Nelly comes to experience these images as lying miniatures.

Wolf's narrator first plays upon the fairy-tale motif obliquely, calling up the traditional fairy-tale ending for use as the first photograph's "caption" and making a speaking statue of her mother's photograph by assigning it a caption as well: "And marble statues gaze with eyes so mild. . . . What has been done to you, my poor dear child!" (90) ("Und Marmorbilder stehn und sehn dich an: Was hat man dir, du armes Kind, getan?" [Wolf 1989a, 127]). This is a line from a song, but it recalls "Das Marmorbild" by Eichendorff, in which a statue of a beautiful woman comes to life. Nelly remembers this line of verse "against her will" as she returns the gaze of her photographed mother. If we imagine the look as

focused on Nelly, it seems to be a question directed at her, the "poor child," who, as she tells us, does not own a photograph of herself in a hat (that is, a picture of herself as a young beauty). This seems to be the view taken by Per Øhrgaard in his essay on *Patterns of Childhood* (Øhrgaard 1987). But the gaze directed outward from the photograph is rebounded in the eyes of the daughter, and Nelly's citation of the bit of verse could just as well be taken as a question to her young mother, who is so transformed by the war. There is a symbiotic relationship imagined here, which is further underscored by the narrator's remark about her irrepressible propensity for imitating her mother's gestures, words, and looks (90). With the imagining of a "look" directed at the viewer ("marble statues look at you" / "sehn dich an"), the surface of photography once more opens up and yields much more than a miniature.

Per Øhrgaard, in his admiration of Charlotte in her hat, reads *Patterns of Childhood* as "a belated tribute to the mother" (Øhrgaard 1987, 382), in which Charlotte is identified as the only person in Nelly's environment "equipped with the prerequisite for a conscience: the possibility to be sensitive to people" (327). While it is true that Charlotte possesses this ability (along with many other admirable qualities), it is important to keep in mind that the narrator defines it only as a "prerequisite" for a conscience.

Perhaps it is precisely Charlotte's lack of conscience that implies the near impossibility of a life with conscience under Nazism; in any case, another photographic episode reveals the extent to which Charlotte (who pushes her children to remain "within the frame") hopes to conform at least to the family values promoted by National Socialism. While living with other refugees after the war, Charlotte passes around the family photograph taken by Richard Andrack, in which her husband, now a prisoner of war in the Soviet Union, appears in his uniform. "A good marriage," is her commentary. "We always got along well with one another" (123). Heinrich Böll, going over the details of the furnishings and the pose of the photograph (as framed by Richard Andrack) and setting it against Charlotte's caption of the image, voices this reaction: "This itself is enough to frighten you" (Böll 1990, 98), recalling the narrator's question as to whether an accumulation of such images could have led to war.

In Charlotte's hands and in the absence of her husband, the little photograph becomes a nostalgic miniature for a lost time, a time rather more mixed in emotion than the caption "A good marriage" would imply. The narrator situates this scene immediately following an episode in which her father, returning tipsy from a party meeting, is directed by Charlotte

to sleep on the couch. She cuts off his protestations with the epithet "derelict," a word Nelly preserves for later meditation. Such juxtapositions destroy the smooth surface that Charlotte hopes to create. The child's memory and the eye she keeps on her mother as she shows the photograph around determines the reader's critical attitude; the process of covering over a rough marital surface with an impenetrable photographic veil and pat caption is coupled to a reappearance of the Andrack photograph, and with that the image of Charlotte as a possible heroine is disrupted. The photograph of the mother in a hat, while clearly a positively valued memory in contrast to the memory of the father's photograph, is called into question precisely because of its inextricable placement next to the irritating image. That the narrator cannot think of the father's image without also thinking of the mother's arises from her dark knowledge that something is wrong with both of these pictures.

The Positive Power of Objectification

In the previous section I focused on the delimiting function of photography—how the medium pretends to have easy answers, how it cooperates so readily with propaganda campaigns, how it transforms a subject into a photo-object. In particular, the insistence on "happy" family structures and the situation of women within these structures brings to mind feminist film theory, with its emphasis on the subjugating power of the male gaze and its objectification of the female body. But in autobiography, the self as subject gazes at the self as object, and this position is underscored in Wolf's text through the use of the third-person pronoun for the child Nelly. And not only does the narrator look at Nelly; Nelly also looks at herself: "she had developed the habit of watching herself walk and talk and act, which meant that she had to judge herself incessantly" (Wolf 1980a, 228).

The word *judge* illuminates the necessity for self-objectification; the selves, both the younger and the older, are on a kind of trial in the autobiographical text, which deals in part with the examination of guilt. Photographs in such a setting function positively—as evidence. The narrator enters the archives to page through old issues of her local childhood newspaper, examining the photographs and holding them up against her memory. On the journey to her hometown, she takes a photograph of her daughter drinking iced tea from a red Thermos: "She won't deny that she drank from the thermos, the photo is proof of that. You're already dealing with the second generation of photographs; incessantly time transforms

itself into the past and requires clues, such as exposed celluloid, notes on all kinds of paper, pads, letters, clippings" (82).

Naturally it would be naive to draw too many conclusions from the photograph of the daughter with the Thermos. But that she was there, that she drank from the Thermos, that the Thermos was red; these details are taken as important, as "proof." For Wolf, the photograph does have referential power—it is only important to remember that the image is the beginning, and not the end, of a narrative. This is perhaps why many of the memories in the text, memories that do not refer to "real" images, are imagined as photographs; in framing her memories as if they were photographs, the narrator calls upon the testimonial power of photography.

The image the narrator retains of the burned-out synagogue on the day after *Kristallnacht* (the Night of the Broken Glass) demonstrates her use of photograph as metaphor. She tells us that if she had not retained an "inner image" of the smoking ruin, "whose authenticity is undeniable," she "wouldn't be able to claim with such certainty that Nelly, a child with imagination, was near the synagogue that afternoon" (160). Authenticity is claimed for this mental image as if it were a photograph, a document that is unassailable despite the fact that Nelly is an imaginative child and perhaps given to creating her own images. It is perhaps, then, for the borrowed trait of authenticity that the narrator often chooses to cast her memories not only in visual terms but as photographs, even when the memory does not seem to be derived from a photographic image:

> When does a person stop making pictures of things? . . . Bardikow is the last place preserved in your memory as a series of images. . . . Not that there are no more pictures: flash photos, also sequences. But their luminosity has diminished, as if the colors of reality no longer had the same quality as before. (336)

The strong identification between memory and photography, which we have seen in the work of autobiographers from the invention of the medium on, plays a new, more central and more problematic role in Wolf's work. The importance of photographs as documentation or testimony exists simultaneously with the necessity to regard static images (and especially the captions they call forth) with suspicion. Christa Wolf's narrator uses the photographic medium to capture herself both as subject and object of her discourse, struggling to break out of the objectifying frame of the viewfinder even as she acknowledges her position in the picture.

In the end, it becomes necessary to imagine the self as photo-object

in order to begin the process of self-knowledge. The episode that best illustrates the positive power of objectification unfolds in connection with a final family portrait, though the image does not depict a member of the family, precisely. Instead, it is an image that is adopted into the family, taken under its roof, and made an actor in the household's "repertoire of images." It is an image of Adolf Hitler, the *Führerbild,* which is enshrined in the Jordan home at the instigation of the family friend Leo Siegmann, an ardent Nazi and anti-Semite. The reader learns the exact specifications for the photograph: "format 20 × 30, semi-profile with peaked cap, collar of the trench coat turned up, steel-gray eyes gazing into the far distance, behind him a grayish swirling turbulence designed to show—and showing—the Führer 'braving the storm'" (132–33).

While the reader suspects that the measurements for the image must have been dredged up by the narrator's research, the other details belong to the language of Nelly's world. For instance, Hitler's "steel-gray eyes" that "gaze into the distance" clearly derive from the child's vision of the photograph rather than the narrator's; the description is as much a cliché as the image. In this context it is worthwhile to recall that *Klischee* in German (as in French) also refers to typographic plates, used to mass-produce print and images. The "original" for a mass-produced photograph of this type was both a physical and political cliché, and the implied caption "Braving the Storm" unmasks the *Führerbild* as a "miniature."

The narrator first introduces Hitler's portrait by arranging it in a particular position and in relationship to a specific figure: "[Leo Siegmann] is sitting directly across from the Führer's picture, which hangs above the desk, and which he himself sold to his friend Bruno Jordan" (132). Literally under the blind eyes of the photographed *Führer* ("The *Führer* must be able to have blind confidence in you, that's what counts," 134), Leo Siegmann tells the story of the Jewish boy in his class, who was so repellent that all of the true German pupils felt "instinctively" compelled to kick him as they walked by (133). As he relates the story, the bookseller is framed between the *Führerbild,* which hangs opposite him, and the family bookcase, "its center still bare of the books Leo Siegmann will gradually supply," which stands directly behind him. The books that will later be added to the bookshelf are classics of Nazi "thought," such as *A Nation Hemmed In* (*Volk ohne Raum*); thus framed in the Jordans' parlor, he is in his element, depicted among the emblems of his character much like a figure from an allegorical painting. Leo Siegmann, framed, provides a mirror of the Hitler image on the wall.

Another point of view must be introduced to break up the strict lines 215

of this frame, and this perspective comes of course from Nelly, who sits, unnoticed, in the next room. The narrator, recalling Nelly's point of view, looks into the picture from the outside: "Suddenly the picture memory [*Bild-Gedächtnis*] becomes very clear: like the lens of a camera it focuses on a single image: Leo Siegmann, leaning slightly forward, his hand on the wineglass, illuminated from the side by the floor lamp, which creates reflections on his bald pate" (133). The "suddenly" pinpoints the moment when the bookseller begins his story; it is at that instant that the picture of him clicks into focus for the narrator.

The story of the Jewish boy is of consequence for Nelly because it places her own position in question; she must ask herself if she, too, would "instinctively" punch him as she walked by: "Or will she? Because he [the Jewish boy] thinks she'll be a chicken" (133). Nelly lays a stumbling block in her own path with her insertion of *another's* point of view into the picture: what does the Jewish boy see in her? She imagines the scene in which she passes the boy as a film:

> She braces herself, she knows: she must walk by this desk, she absolutely must, it's her duty. She's doing her very best. She makes the film run faster. But never, not once during the whole time, as she becomes acquainted with the Jew boy, as she begins to know every thought in his head, especially about her, not once does she succeed in getting past him. At the crucial moment the film always snaps. It always turns dark when she stands close to him, when he's ready to lift his head, also his eyes, unfortunately. She doesn't find out whether she'd be able to do her duty. What she does find out, but would rather not know is: she wouldn't want to be in a situation where she must do her duty. Anyway, not in the case of this boy, whom she knows so well and therefore cannot hate. It's her fault. "Blind hate," yes, that would work, would be the only way. Seeing hate is simply too difficult. (133–34)

I have cited this passage at length because it reveals the ways in which visual perspective can open up a hole in the framed existence of an authoritarian dictatorship. Nelly does not really "know" the Jewish boy of Leo Siegmann's school years. She only "knows" him in the sense that she allows herself to imagine *his* visual image of *her*. The narrative of persecution, that is, the film Nelly imagines in which she must strike him as she passes, is "torn" by the redirection of perspective from her vantage to his, when he lifts his eyes and looks at her. The "freeze frame" effect that

seemed problematic in the "Miniatures" essay is in this context the vehicle for stopping destructive motion and forcing the oppressor's objectifying gaze to revert to the position of the oppressed. That the film is torn at this moment graphically demonstrates the idea advanced in "Miniatures"—the resolution of this scene is literally unfilmable, it destroys film. On the other hand, the visualization of the story as film allows Nelly to imagine the notion of "looking" in the first place; in this way she learns the difference between "blind hate" and "seeing hate."

It is important, but scarcely perceptible, that the initial perspective in the Leo Siegmann episode belongs to the narrator, who describes her perception of the scene as a product of *Bild-Gedächtnis* (picture memory), which cannot belong to Nelly, who experiences the episode in her own present. Then we move imperceptibly to Nelly's visual perspective: "The Jew boy. Nelly can see him clearly" (133). Since "the Jew boy" does not in fact physically exist in the scene, it is in this case a question of Nelly's *inner* eye, which the narrator now inhabits. A similar movement takes place when the narrator discovers the photograph of "the white ship" during her research in Landsberg's newspaper. She had preserved a memory of this image from her childhood, but was uncertain as to whether it belonged to the realm of "fantasy memory" or "reality memory." (The introduction of these two categories offers the reader a hint of the complexity of the process of memory and historiography.) The narrator is delighted to find her powers of visual memory verified: "You were triumphant the minute you realized that your memory was storing not random nonsense but reality—no matter how intricately coded" (143). In this instance, the point of view seems to move in the opposite direction; from the child's memory (preserved by the adult with some confusion) to the adult's confrontation with the documentation that validates the child's perspective. In both cases, there is evidence of a shared eye, and of that eye's capacity for reversing and repositioning perspective in such a way as to redraw sightlines and lines of delimitation.

In the moment that the "Jew boy" looks at Nelly and interrupts her "film," we have an instance of positive objectification. By this I mean that looking at the self as object can be the first step toward seeing the self at all. Nelly cannot place herself; she must adopt the gaze of another, the "Jew boy," who recognizes her as part of a subjugating structure, to see the way in which she herself has been framed by the likes of Leo Siegmann. *Patterns of Childhood* turns on moments of self-recognition like this one. As a child, Nelly observes herself, as the narrator tells us, walking and talking and acting: "It often kept her from speaking freely, from tak-

ing action when it was necessary" (228). "Necessary action" can be re-phrased as "duty," the word Nelly uses in her conversation with herself about the necessity of striking the "Jew boy."

Another stumbling block for Nelly in the performance of her duty is the ambivalence she feels about her role as leader in the National Socialist group for girls. The narrator introduces Nelly's trait of watching herself in connection with the girl's sense of dis-ease in performing her duty:

> Once, on Ludendorffstrasse, she ran into a girl from her Jung-mädel unit who rarely showed up for "Duty," and to whom Nelly had therefore sent a written admonition. The girl's mother took issue with Nelly, publicly, in the street, making it quite clear that a young thing such as Nelly had no right to give her daughter orders. And Nelly just stood by, instead of in-sisting on her rights, hastily agreeing with the mother, because the side of her that was not standing in the street, but was look-ing down on the incident, was telling her that she ought to be ashamed of herself. (228)

A child divided against herself will have difficulties in the definition of "duty." Presented with the order to unthinkingly obey authority and two conflicting voices of authority—the National Socialist leadership and the other girl's mother—the child falters, moves outside herself, takes up the position of the judge on a high bench. These scenes are reminiscent of the famous moment in *Huckleberry Finn* when Huck rips up the note he has written to betray his friend, the escaped slave, and decides to "go to hell" as a consequence. But unlike Huck, Wolf's Nelly remains torn be-tween two alternatives, unlike him, she remains embedded in the struc-ture of her society, and cannot "light out for the territories." Unlike Huck, she has a mother and father living happily within the walls of the culture, and the love of her parents holds her in a pattern of behavior that tears at her being, creates two of her.

No one but the reader of *Huckleberry Finn* and, presumably, the God whom Huck defies, observes the boy as he destroys what he takes to be his final chance for salvation. But not only does Nelly watch Nelly in *Patterns of Childhood;* the narrator also watches, and it is her line of vision that helps to define the nature of Nelly's experience. The insertion of a sentinel observer who can pass a kind of judgment, whether it be a judg-ment of the self by the self or of the self by another, plays a central role in the structure of *Patterns of Childhood,* and this structure finds its image in the frequent evocation of photography.

Surveillance; or, Picturing the Blind Spot

One might well ask, now that I have identified the narrator of *Patterns of Childhood* as the corrective eye for a childhood under National Socialism: who is watching the narrator? And why would she need to be watched? This question may be answered in two ways, one of which returns to observation as a positive, interrogative position; the other alludes once again to the specter of authoritarian framing, this time in the form of state surveillance.

The title of *Patterns of Childhood* seems to refer obviously to the structures of society that governed growing up under National Socialism. But Nelly is not the only child who plays a significant role in the text. The other is the narrator's daughter, Lenka, who accompanies the narrator, her husband, and her brother on the trip to the narrator's hometown. Numerous scholars have noted the importance of Lenka's position within the narrative; like all children (and especially, like the child Nelly), Lenka stands at the margins of the adult world, commenting, interrogating, criticizing, sometimes not understanding, sometimes understanding better than anyone else. The title of the book, then, refers not only to the patterns of Nelly's childhood, but those of Lenka's, and although these are not precisely parallel (and certainly not to be imagined as precisely equivalent), there is a sense of repetition here, a repetition that creates at times a feeling of helplessness in the narrator. Lenka's presence as an observer in the narrative points up the need to continue to insert a critical eye into the proceedings of the present (figure 4.3).[15]

Gerhart Pickerodt has argued that *Patterns of Childhood* does not represent an attempt at *Vergangenheitsbewältigung* (the German term meaning, loosely, "coming to terms with the meaning of National Socialism and the Second World War") (Pickerodt 1985, 293). Wolf herself explicitly rejects the idea of *Bewältigung* (coming to terms) in connection with the war: "Is this something with which we can come to terms? . . . No. We cannot come to terms with the murder of six million Jews. We cannot 'come to terms' with the fact that twenty million Soviet people were killed. With all of that, there is no coming to terms" (Wolf 1979, 41). The German word carries with it a connotation of "mastery" of the past, "overcoming" it, or worse, "getting over" it. If there is an inclination toward *Bewältigung* in *Patterns of Childhood*, it is a coming to terms with or mastery of the present, which means both the present of the novel at the time of writing (1972–1975) and the present of the reader's reading.

Two questions relevant to my analysis were asked of Wolf after a

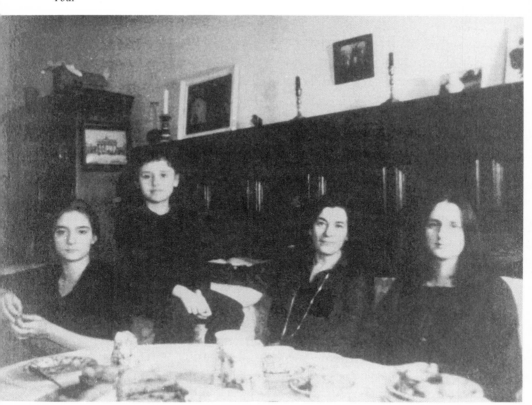

4.3 *Christa Wolf with her daughters and granddaughter, 1980, photograph by Helga Paris*

reading of an excerpt from the novel in the Akademie der Künste in East Berlin in 1975. The first, "Why did you choose this theme? Wouldn't it be more important to write about the present?" provoked a response from Wolf that most readers of *Patterns of Childhood* would be able to predict easily: "Don't you think that I am writing about the present here?" (Wolf 1979b, 34). There are numerous references to contemporary events in the text, but more importantly, Wolf's insistence that "the past is not past" serves as her point of departure. It is in fact the present, in the sense that the present is the only place from which to experience the past, that concerns Wolf most vitally in her book, and it is Lenka's point of view that helps to see the present in a new light.

A second question posed in the discussion period after Wolf's reading from *Patterns of Childhood* touches once again upon the problem of the "present" in the text, although this questioner recognizes that the narrator does indeed deal with contemporary matters: "You said that you also

would like to make a contribution to the process of coming to terms with our [East German] past. So why do you take your examples from contemporary Chile, USA, and Vietnam—why not from socialist countries, too?" (Wolf 1979b, 48). Wolf's responds curtly, reminding the listener that he or she has only heard a small piece of the manuscript: "I already said that in other chapters there are such examples. It isn't as one-sided as all that" (Wolf 1979b, 48).

The questioner, operating at a disadvantage because of his or her unfamiliarity with the entire novel, is thus obliged to take it on Wolf's word that the instances of criticism raised against the East Bloc in the other chapters would represent a more evenhanded attempt at "coming to terms with the present" (Pickerodt 1985). An uneasiness remains, however, even when the reader has finished the text, as comments on the subject by some (Western) scholars demonstrate: on the niveau of the narrating present, the narrator frequently draws an easy equation between the German past and the present in the United States, Chile, and Vietnam (Stephan 1991; Wiesehan 1992).

This is not the place to revive the debate surrounding the war in Vietnam; that there was an acrimonious debate in the United States during the war offers sufficient evidence that easy parallels with Hitler's Germany are unjustifiable. For my purposes I will continue to concentrate on the use of images and perspective, for I believe that it is not a balance of negative images from the West and from the communist East that would provide a proper response to the questioner at Wolf's reading, but something much more complex; the book handles parallel situations in vastly different cultures roughly, but at the same time offers a delicate complex of perspectives from which to view such parallels. To illustrate the more subtle aspect of social criticism in *Patterns of Childhood,* I will turn to an examination of the perspective introduced by the narrator's daughter, Lenka.

In her account of the book's genesis, the narrator describes her research, looking through the "dust-coated volumes of [her] hometown newspaper" and her school books, "quarantined" in a securely locked room (Wolf 1980a, 7–8). The remarkable thing here, the thing that the narrator emphasizes, is that these relics of the unspeakable past have been saved at all. Their preservation under lock and key, with access only under limited and special conditions, illustrates the official relationship to the past in modern Germany, both the former East and West.

While the narrator's pursuit of documentation is important in its emphasis on the importance of material referentiality, it is only in part a 221

pursuit of proof—in the main, her research is a quest for exposure and confrontation. She wants to re-view these documents—to superimpose them upon her present experience and thus see them in a new light. The reader is given a glimpse into the dangers of this process when Lenka returns one of her mother's quarantined schoolbooks: "Do you remember what Lenka said when she looked at the pages of *Tenth-grade Biology,* which depict members of inferior races—Semites, Middle Easterners? She said nothing. Wordlessly she handed you back the book she had secretly borrowed and expressed no desire to look at it again. You had the feeling that she was looking at you with different eyes that day."[16] The act of exposure and review becomes an act of self-exposure and self-review, one that makes the narrator into an object of her daughter's critical gaze: the daughter looks at her as never before. In looking at the eyes of her daughter and readjusting her own gaze to see what her daughter sees, the narrator achieves a new and uncomfortable perspective on herself; she makes herself into an object of her own speculation.

It is Lenka who points out the most disturbing Vietnam photograph in a newspaper: "It shows an old Vietnamese woman with a gun barrel at her temple, a G.I.'s right index finger on the trigger" (157). In *Patterns of Childhood,* it is characteristic of the images from the United States, Chile, and Vietnam that they stand uninterrogated. Unlike the images from the narrator's hometown newspaper, the representations from the news of the day are taken at face value. This is true of the photograph of concentration camps in Chile, television reports of bombing expeditions in Vietnam, Nixon's speeches, and whatever else the media presents to the narrator regarding fascist tendencies in the West. In this particular instance, however, Lenka's view of the photograph differs enough from that of the older generation to place their perspective of the image in question:

> Look here. Just look at this and tell me what sort of a person takes these photos. . . . She always thinks of the man behind the camera who is taking pictures instead of helping. She rejects the common division of roles: the one who must die, the one who will be the cause of the death, but the third person stands by and records what the second does to the first. (157)

In response, Lutz, the narrator's brother, asks "Why don't you save your anger for that soldier?" (157).

Lenka's criticism of the American presence in Vietnam does not differ significantly from that of her family. She does, however, bring another eye into the picture, one that sees what it means to hold passively

a camera (or a pen). In this sense, she acts as a critic of her parents' generation, who remain content to direct their anger at the man holding the gun, without interrogating their own position as bystanders. In bringing in Lenka's perspective, Wolf's narrator has of course accomplished what she at that time failed to do; incorporate another perspective.

Lenka performs this function for her on other occasions as well, perhaps most pointedly (in terms of establishing a critical perspective) in the episode about a Nazi song sung by some East German youths on vacation in Czechoslovakia. Can you guess, asks Lenka, "what our tourists sing when they are in socialist foreign countries?" Then she repeats what she remembers from the song they sang: "In a Little Polish Town" (286). The song involves a young girl from a little Polish town who at first manages to fight off the advances of her German attacker. After being forced to have intercourse, she commits suicide, leaving a note reading: "I did give it a try / and I had to die." The song ends "You better take a German lass, / who's not afraid at the first stroke / that she might croak."[17]

Lenka's outrage at witnessing the scene is countered by her mother's shocked disbelief: "Were those really our people, Lenka?" Wolf's narrator prefers to assume that the singers, who happily take off where their parents' generation left off in the figural rape of Poland, who either have no acquaintance with their immediate history or fail to recognize its gravity, must be from the "other side." In the discussion period after the reading mentioned above, Wolf refers once more to "coming to terms with the past": "I do not believe that we have 'come to terms' with the fascist period, even if the attempt has been made in our state in an incomparably more thorough way than in West Germany" (36).

The narrator of *Patterns of Childhood* is obviously not equivalent to Christa Wolf. While Wolf shares the narrator's inclination to rank the East far above the West in terms of the work that has been done to establish a response to the National Socialist past, she also places small markers in the text for other possible positions, as when Lenka answers the narrator's "Were those really our people, Lenka?" with "Well, who else?" (286). Lenka's perspective on the society in which she grew up allows her to recognize that the singers just as easily can be "our people," an insight that disrupts any easy identification with the socialist state. Her mother's perspective includes a blind spot that prefers to imagine the border between East and West as the dividing line between sensitive and insensitive approaches to the past.

Wolf has written elsewhere of the problem of the *blinder Fleck* (blind spot) in perceiving history:

Every human being experiences—if he experiences himself at all—that he has, at every stage of his life, a blind spot. Something that he does not see. This is connected with his powers of perception, with his history. Similarly, a society or a civilization has a blind spot. It is precisely this spot which brings about self-destruction. To not only describe, but rather to penetrate into this blind spot, to so to speak enter the center of the hurricane: that is, in my opinion, the task of literature. (Kuhn 1988, 105)

Wolf creates the imbricated perspectives of the narrator and Nelly and the narrator and Lenka in order to picture the blind spot. Though the narrator in *Patterns of Childhood* sometimes seems dimly aware (or is made aware) of the blind spot in her own society, this a place she only rarely approaches on her own, for entering it entails yet another total inversion of her worldview, another breaking point with the past, akin to the one that takes place after the war: "Nelly discovered that she'd been living under a dictatorship for twelve years, apparently without noticing it" (394). By 1989 Christa Wolf gives full voice to the nature of the blind spot in her own society: "Twice in their lifetime, members of my generation were hindered—or allowed themselves to be hindered—from confronting the quite horrible, criminal, or deeply contradictory nature of [their] reality. I believe that this is unique in human experience. . . . Now the younger generation has begun to ask us about it, and our self-examination has reached an acute stage" (Hörnigk 1989, 40). And in 1993, after the discovery of her involvement with the Stasi, she remarks, "I didn't expect this, that at my age I would once again be shaken to my foundation" (Gaus 1993, 40).

The thing that shakes Wolf to her foundation ("sie von Grund auf erschüttert") is the sudden revelation of her complicity in a system of surveillance. In closing, I would like to return to 1994, the time of this writing. In early 1993, Stasi files revealing Wolf's cooperation with that organization were brought to light. During the years 1959–1962, Christa Wolf served as an observer and reporter of the actions and character of a number of her colleagues within GDR literary circles, assessing, among other things, their loyalty to the party, their literary merit, and their personal dependability.[18] Upon the publication of this news it seemed clear to many that Wolf, a figure who had been perceived (by her more supportive readers) as an intelligently critical eye within the socialist system, and who had been the victim of Stasi surveillance herself (as depicted in *What*

Remains), was not in fact not only one of the *Opfer* (victims), but also one of the *Täter* (perpetrators).

I do not want to enter the ethical debate surrounding Wolf's actions here, though I will say that in connection with this issue, I have asked myself with what degree of tolerance I would accept that an author I admired had worked secretly for a time in support of the McCarthy witchhunt. The first and best answer to that question is that it is of course impossible to set up exact parallels between two such situations; that each person's case must be examined in the cultural and personal and political context in which actions took place. And so I prefer not to address directly the questions of whether Christa Wolf has been in every situation an exemplary figure, or whether her earlier actions completely overshadow or in some way negate her later actions, or whether she should have been more forthcoming regarding her work for the Stasi, or whether she was a critic or a tool of the GDR government. To issue statements on these matters would be to subscribe to what Wolf herself has called *Rechthaberei* (usually translated as "dogmatism," but more literally, the quality of obsessively believing oneself in the right).[19] Speaking from such a posture often assumes a false position of transcendent objectivity, with the speaker imagining that he or she need not examine or present his or her own situation (i.e., biases), and while such an "objective" stance may pass in the world of popular journalism, it does not seem sufficiently subtle or sensitive for an academic analysis.

Instead, I would like to continue to work from the vantage of this study, namely, to study Wolf's use of photographic metaphor in order to understand more fully her position regarding surveillance. *Patterns of Childhood* contains a scene in which Lenka and her mother describe a shared sense of being secretly observed. "The other day," the narrator begins, Lenka told her of a dream:

> A movie camera was watching every one of her gestures day and night, and a huge movie house, filled with unsuspecting spectators who had come in off the street to see a random two-hour feature and were obliged to stay in their seats and watch Lenka's life unfold on a giant screen. For days, for weeks. (230)

The narrator's response catches her daughter by surprise:

> But how well I know all that! She raised her eyebrows. What do you mean? Did you ever have the feeling that you were being filmed? No, I didn't think along those technical lines: in my

case, the camera was the eye of God, and the permanent audi-
ence was God himself. You believed in God that long? Believed
sounds as though not believing might have been a choice, but
that wasn't so. Incidentally, what's the difference between the
eye of God and the eye of your camera?

Lenka wanted to think that over. (231)

Both the mother and the daughter imagine themselves under the eye of
surveillance. Both of them grow up and live in societies where the state
uses observation to keep citizens in line (or within the lines, to follow
the metaphor of staying within the frame). In *Patterns of Childhood,* the
surveillance practiced by the Germans under National Socialism becomes
apparent when two agents from the Gestapo arrive at the Jordan resi-
dence in response to a remark made by Charlotte Jordan in 1944 that the
Germans had lost the war (165–66). Only three customers, people
"whom she thought she knew well," were in the store when she voiced
this opinion; one of them apparently reports the comment. Fortunately
for Charlotte Jordan, the other two deny having heard anything of that
nature.

In the society where Nelly grows up, the omniscient God comes
dressed in a trenchcoat. Where stray remarks in a private setting can
bring down this kind of wrath, the traditional practice of inculcating chil-
dren with a sense of God's all-seeing eye takes on a new and disturbing
urgency. Under the imagined eye of the new "God," even a child must
maintain the proper political attitude. It is no coincidence, then, that the
photographic session with Richard Andrack occurs in conjunction with
Nelly's confirmation ceremony; God's eye and the eye of the Nazi photog-
rapher focus in the same way on their objects, with the idea of keeping
them in line with the larger picture.

Lenka's dream brings the technological aspect of surveillance to the
fore, but it offers a feature similar to her mother's childhood experience
of actual surveillance in that it alludes to the presence of an audience. The
authoritarian state depends not only on the powers of its own eye (imag-
ined in Lenka's dream as the camera), but on the eyes of society, which
are supposed to act as extensions of the camera's perspective. Charlotte
Jordan's remark would have passed without notice had the state not had
a willing witness in one of her customers. In Lenka's dream, the public is
forced to watch the banal details of her life, much as the citizens in an
authoritarian state are pressed into observing one another. It is interesting
to see how Lenka emphasizes the dreariness of the task of watching; this

is not the thrill of forbidden voyeurism's power over the observed object, but the bone-crunching boredom of life in a situation where no action can be uninhibited or sweep outside the frame of the camera's eye.

While Wolf has been taken to task by some scholars for the way in which *Patterns of Childhood* criticizes Western totalitarian tendencies and (apparently) overlooks the sins of the Warsaw Pact countries (Stephan 1991; Wiesehan 1992), I would argue that the moment in which the narrator and Lenka exchange fantasies of surveillance not only criticizes the policies of the East German state, but damns them. That this moment of shared surveillance fantasies is easily overlooked by scholars should not come as a surprise; naturally the reference is veiled, for the daughter and the narrator and the book Wolf writes are all under surveillance.

By the time she wrote *Patterns of Childhood,* Wolf had been on both sides of the camera. During the years she cooperated with the Stasi, she learned something about the workings of bureaucratic surveillance, but even as a child she had already absorbed the structure of watching and being watched. Once she had publicly voiced criticism of GDR policy and won critical acclaim in the West, she found herself under surveillance by the state she had supported—indeed, the most intensive level of surveillance (Die ängstliche Margarete 1993, 165). Of course, given her experience on the other side of the camera, Christa Wolf was aware that such observation would be taking place, and in fact it is necessary for the object of surveillance to be aware of being watched if the surveillance is to have the desired effect: keeping the object in line. This is the phenomenon Wolf describes in *What Remains,* when Stasi observers watch her apartment from a fully exposed position, even returning Wolf's ironic wave from her window.[20]

What Remains merely articulates explicitly the surveillance implied in *Patterns of Childhood*. It is the comparison drawn between Lenka's dream and the narrator's childhood fantasy that implies the totalitarian nature of the East German security apparatus. Not coincidentally, Lenka is the figure who has this particular dream, for while Lenka does not refer specifically to an incident of experienced surveillance, elsewhere she takes up a critical role regarding the state where she lives; not the ideal of socialism, but the reality of the GDR. The narrator herself makes the connection between Lenka's dream and her own sense of being watched—it is she who insists on the similarity of their experience. She does not ask her daughter or herself "Where did this dream of the film camera come from?" because she understands its source. Lenka's dream, like the narrator's notion of God's omniscient eye, originates in the experience of a

state that watches its members and forces them to watch one another.

In a society in which the hidden camera is the guiding metaphor, each person in that society acts as an emissary of the camera, called upon to develop captioned miniatures of fellow citizens. Wolf's observation work for the Stasi must be read in the context of the Stasi's surveillance of her. Further, it seems a useless exercise for those outside Wolf's society (those "not in the picture," to use another of Charlotte's phrases) to assess Wolf's situation. A task awaits those of us who want to interrogate Wolf's actions that is not unlike the narrator's task in *Patterns of Childhood;* and this is a complex and difficult task, as complex and difficult as reading Wolf's writing. Like the narrator, we must try to invent ourselves as the objects of the hidden camera, to insert an eye/I into the picture's circumstance.

Franz Kafka wrote a "shorter story" called "On Parables," which is itself a parable. In it he describes the attempt to cross over into the ideal world of the parable from the "real" world:

> Concerning this a man once said: . . . If you only followed the parables you yourselves would become parables and with that rid of all your daily cares.
>
> Another said: I bet that is also a parable.
>
> The first said: You have won.
>
> The second said: But unfortunately only in parable.
>
> The first said: No, in reality. In parable you have lost.

(Kafka 1976, 457)

A definitive reading of Christa Wolf's situation from an exterior position strikes me as an attempt to construct a parable. Like photographs, which are and are not the things they depict, readings live in a land of parable, and can only approximate the things they describe. It is for this reason that the use of readings in the land of parables to assassinate characters in the real world seems suspect; keeping in mind as well that photographs snuff, we should frame our readings of them, as well, more openly. To offer another parable: making a miniature of Wolf from the reading of her Stasi files and the "illustrative" photographs that accompany their release is a reenactment of what she was asked to do in 1959–1962.

To counter this impulse, I would like to offer a reading from an interior position. That the narrator of *Patterns of Childhood* concentrates on Vietnam (the weakness of the other side) to show the reader how "the past is not past" is something that I, as an American reader, must accommodate by shifting my line of perspective. I am forced to interrogate my own position, which, while critical of our involvement in Vietnam,

would like to reject categorically any association with National Socialist Germany. I must recognize that from the perspective of Wolf's narrator, the continued presence of aggression in the world is a symptom of the continued presence of the forces of her childhood. I must remind myself of my own country's tolerance of former National Socialist industrial and political leadership after the war and imagine how this appears from the perspective of Wolf's narrator. Like the moments when the child's perspective is reinstated in the static photographic images, those moments where my/our position is called into question are instances of an expanded field of vision, one in which "history" and our connection to it are held up to the light and turned this way, then that. Wolf's use of the photographic metaphor enables her to bring this interrogation even into the present, creating that imbrication of past and present inherent in photography and necessary for any real self-criticism. Her distrust and deconstruction of the stasis of photographs points to a new direction both in the treatment of photography as metaphor and in the narration of self-history.

Conclusion

Àll autobiographers of the photographic age must in some way reckon with photography when they take account of themselves; in this way they move to reclaim the control of self-image inherent in the autobiographical act and threatened by the advent of photography. Photographs are potentially dangerous; this point has been brought home repeatedly by writers who have contemplated the voyeuristic nature of photography, its objectification of and alienation from the subjects and time pictured within its frames, its capacity for deception, its untoward power in institutional settings, its presentation of the individual as ideal or as degraded type, its publication of the private spaces of our lives, and on and on. Most intimately, photographs mean to tell us how we ourselves look; they are the fixation of the gaze of the unseen Other. Taking these dangers into consideration, it is clear why the control of photographs occupies one of the central positions of power in our society. The textualization of photography (either within or as text) offers the photographed subject a means of control.

But by this I do not mean that all autobiographies must include actual photographs; rather, the autobiographer must come to terms with the existence of photography in creating a textual self-image, for the mere presence of photography challenges traditional forms of autobiographical narrative by calling into question essential assumptions about the nature of referentiality, time, history, and selfhood.

In this study, I have examined the work of four authors, each grap-

pling with the implications of photography and photographs for history, both personal and global. Mark Twain struggles with the issue of copyright and economic control of his photographic and literary image, always keeping in mind the persuasive and deceptive power of the photograph. August Strindberg aims to mold a public image through photography and autobiography as well, but his personal relationship to the photograph is that of the Orthodox Christian to the icon; where Twain applies cynicism, he practices faith in the referential and ultimately revelatory power of the image.

Walter Benjamin contemplates photography at a meta-level, not as photographs but as the idea of photographs. In his writing, the photographic idea becomes the determinant metaphor for aesthetics, politics, and history in the twentieth century. Where ancient people read stars, entrails, and runes, modern people read mechanically reproduced images. He shares with Christa Wolf the experience of life under the shadow of National Socialism; the state's use of photographs in identification and surveillance exercises a profound effect on both authors. They recognize photography as an essential factor in the historiography of the twentieth century, and in their autobiographies they work to reclaim their own images from the dominance of an all-seeing authority, positioning themselves as the person looking through the camera. The absence of actual photographs from their autobiographies and their emphasis on that absence (in Benjamin's case, the erased physiognomies; in Wolf's, the lost photograph album) illustrate a denial of photography's power to unequivocally denote reality, even as the presence of photography as metaphor stresses the power of photography in the imagination.

Is it possible to draw conclusions about an historical curve in the integration of photography (as object or idea) and autobiography, looking at a mere four examples? Yes and no. Obviously, the range of use of photography in autobiography is much broader than the spectrum I was able to cover here. Missing from these pages are photographs and popular autobiography, autobiographical or self-imaging texts composed primarily of photographs, other experimental forms of self-portraiture involving photographic image and text, and the autobiographical work of many authors whose thoughts on and use of photography would have shed light on the subject from different angles: Walt Whitman, Marcel Proust, Roland Barthes, Wright Morris, Cindy Sherman, and many others. To take only highly self-conscious autobiographers as examples for a broad cultural phenomenon seems unfairly slanted.

Yet I chose these authors self-consciously myself, for I saw **something**

in their work that illuminated what I take to be essential questions about the possibility of creating a self-image, whether textual or photographic; indeed, questions about the creation of a "self." Not only that, but a study of their work would have to bridge the abyss between the world before the two world wars and after. When I say "essential" questions regarding selfhood and self-image, I mean questions that are not time-bound, not even history-bound but that exist from the earliest record of human thought up into the present. But these questions are of course asked and answered differently in different historical and cultural contexts. And when I indicate the world wars as the abyss that must be bridged, I place the autobiographers of this study into a particular historical context, emphasizing the break that occurs between the first and second pair of authors.

This dual vision, both ahistorical and historical, resides in the artifacts themselves: photographs and autobiographies. Autobiographical texts and photographs exist as actual objects in the world, and they refer to actual persons and things. In this they might seem to resemble works of fiction and painted portraits, but there is a qualitative difference in their reception. The autobiography, as signed document (here I remember Lejeune's autobiographical pact), functions as a kind of testament, while the photograph of a living person enters the record as evidence of a living body, a moment lived. From this concrete realm of denotation, however, they pass very quickly into the transcendent—bound by their nature to the moment of their production (connected to the writing hand, the pictured body), the two media transcend time by bringing a real past into a real present, casting the shadow of a real present onto the wall of an unknown future. If we focus on photographs for a moment, we see that not only actual photographs perform in this way, but the very idea of photography offers us an image for that which is truly present yet also truly absent. This accounts for the forcefulness of the association between photographs and death, an association shared to a lesser degree by autobiography.

Benjamin's writings on photography pronounce the historical/ahistorical paradox most forcibly. There, the photograph interrupts time, spatializes time, and makes time achronological. The invention of photography, on the other hand (precisely because of the disruptive nature of the photograph), is a historical event that, while it exists on a continuum of invention from printmaking through lithography and onward, still represents a revolution in aesthetics, politics, and history. Both historical and anti-historical, both simple signs of reference and complex and poten-

tially deceptive constructions, photographs and autobiography elude easy reading—or at least, they ought to.

Benjamin's message in his "Doctrine of Likeness" suggests that signs, be they textual, imagistic, or "natural," should be broken into, disarrayed into their component parts or placed in strange context. His approach to language and to photographs inches toward a kind of deconstruction; in fact, his theories hint that deconstruction may in fact be prompted by the development of ever more "natural" signs, which demand ever more denaturalizing readings. Interestingly, this "deconstruction" (which is not exactly the same thing as postmodern deconstruction, but its forebear) exists already with Twain, as he reverses the letters of his name to make them come out correctly for the daguerreotypist. In so doing, he shows his ability to become like his own photograph, which, as he understands perfectly, will not create a "natural" image at all. Strindberg, too, understands the doctrine of likeness in his own way, as he struggles to understand the meaning of "signs" all around him, in clouds, stones, strange sounds, and the street signs of Paris. Nothing, not even a natural object, is only itself. It is always a sign of mysterious import—the more natural, the more mysterious.

Thus photographs, as our most natural sign, become the most troublesome. This is evident in all four authors of this study, and thus it would seem that there are certain aspects of photography and autobiography that are inherent in the media in their role as signs, that do not change appreciably over time: the relation of the sign to death, the problem of identifying a unique and/or integrated self in the flurry of signs, the desire to textualize (and thus control) photographic images, the sense of photography as a metaphor for memory, the relation of the photograph to the name or word, the publication of the private.

On the other hand, there are distinct differences between the writers of the first half of the book and the second, differences that I would ascribe to the historical and political contexts in which the writers worked. Most striking of these is that Twain and Strindberg, writers at the last turn of the century, still feel that they can and should exercise a significant amount of control over the production and dissemination of their own images, and that the control they enjoy can be turned toward a profit (either financial or personal) in the long (or short) run. Consequently, both authors want to include actual photographs in their autobiographical texts—highly textualized photographs, to be sure, but actual photographs.

Benjamin and Wolf, living in a society where technological develop-

ment and industrial growth were particularly geared toward militarism, where the state appropriated technology for its own use in order to keep a tighter rein on its citizens, no longer have the same sense of strength. Their autobiographical texts reveal a struggle to redefine the parameters of power by attempting to reappropriate photography (their vision of photography) for themselves. It is interesting that the reappropriation of photography is synonymous with the reappropriation of the autobiographical voice, which also comes under threat in their societies. Real photographs do not have a place in such a setting, for real photographs present the unnatural (the politically constructed) as natural; instead, the two authors make use of the idea, the metaphor of photography, to blast out of the strictures of their historical moment.

It is not the case that Twain and Strindberg feel utterly confident about their control of self-image, nor is it true that Benjamin and Wolf feel utterly powerless or stymied by the heavy weight of totalitarianism. But the events of the twentieth century do seem to have brought the danger of photography and certain kinds of historiography to the fore, thus leading to the current leaning toward deconstruction. It seems more important than ever for us to be able to recognize the unnatural in "natural" signs, to be able to reconstruct and deconstruct the setting in which a photograph was taken or a text written. Photographs themselves are an auger of our growing distrust, something that we see in Twain as well as in Benjamin.

Still it is crucial to ask why it seems so important to us to be able to get behind photographs, to undo their smooth surface of nonmeaning, their "pure" representation. I think the answer to that must be that there is something special about photographs, about their relationship to their subjects. There is a truth in photographs, what Barthes calls the "having-been-there," which is after all of enormous significance.

During the course of writing this book, I traveled to many of the places where the authors of this study were photographed. I spent two snowy nights in Mark Twain's summer residence in Elmira and stood in the small hexagonal study where the stereographs of him were made in 1874. In Hartford I walked through the rooms of his former home with a group of other tourists, recognizing pieces of furniture and architectural settings from many of the photographs I had viewed in the Twain archives in Berkeley. Strindberg's last residence, a small Stockholm apartment in a cornice tower on Drottninggatan (Queen's Street), now houses the Strindberg Museum and Library. Scholars may request to live there and study for a nominal fee; I did not live there but spent a good number of

afternoons in the rooms where Strindberg once lived, going through the museum's large collection of negatives, holding them up to the Swedish summer light as it came through Strindberg's windows.

That same summer I worked in the reading room of the Bibliothèque Nationale, where Benjamin was photographed during the desperate years of his exile in Paris. It is easy to imagine that the calm and dignity of the library helped him continue to write and survive. The town of his childhood, Berlin, was my home for seven months in 1987; the Victory Column, the Tiergarten, the streets and neighborhoods and suburbs mentioned in *A Berlin Childhood* were all on the route of my wanderings there.

Perhaps the most memorable journey, however, was to Christa Wolf's childhood hometown, formerly the German city of Landsberg, now the Polish city Gorzow Wielkepolski. Equipped with a copy of *Patterns of Childhood,* I planned to locate various sites mentioned in the book in order to photograph them: Wolf's former homes, her school, the I. G. Farben factory, the sports stadium, the mental hospital, the old German cemetery. Though maps of the city were readily available, they of course listed the names of streets, parks, museums, and churches only in Polish. *Patterns of Childhood,* on the other hand, made reference only to German place-names, and these were from the period of National Socialism.

Finding that a Polish map and a dictionary were not sufficient aids in locating landmarks, I turned to an antiquarian bookseller and inquired about old maps or guides for the town. He was a young man, friendly and clearly hoping to be helpful, but when I finally was able to make my wishes understood in broken phrasebook Polish, he sadly shook his head. "Nie ma," he answered. Since *nie ma* can mean either "we don't carry it, we don't have it," or "there isn't any, it doesn't exist," I pressed the question. "Do you mean from before the war?" he asked. "Landsberg," I said, and this name started him shaking his head immediately. "Nie. Nie ma." He suggested that I might try the Municipal Museum; they had a library and would surely have what I wanted.

The trip to the museum the following morning was an educational journey. There, in a large, darkly somber merchant's home of the eighteenth century resides the record of a vanished German city—not only suits of armor and mural paintings of the ruling burghers of Landsberg, but sets of porcelain, combs and brushes, furniture and common household items. There was a display of clocks, and not all of them were of intrinsic aesthetic value. One of them was a common kitchen wall clock, plain and black. A label beside it noted "German Clock, 1920s." What

236

was the purpose of this display? It seemed to me that the museum was a storehouse of loot or, alternatively, the detritus of German culture that had been left behind as the Germans fled before Soviet troops in 1945. Had the clock been removed from the wall of a kitchen by the new owners of the home and donated to the museum? At any moment I expected to see the brown photo album of *Patterns of Childhood.*

The woman who had admitted us to the museum and supervised the wearing of the slippers declared that no map of the German city Landsberg existed in the museum's library. I wandered off to try to find the German cemetery, using clues from Wolf's book. The psychiatric hospital with its invitingly shady grounds was easy enough to locate, and the cemetery was supposed to be somewhere nearby, according to Wolf. But repeated turns around the hospital failed to reveal anything. I was particularly anxious to find the vandalized German gravestones described in Wolf's book, to see whether the situation had changed in the last twenty years. Finally we stopped to talk to a groundsman who was engaged in painting a fence. "Yes, yes, there had been a cemetery. Right here. But now it was finished." He made a sweeping motion with his hand, a gesture of erasure. "Gone."

Gone? Where does a cemetery go? I was finally able to ascertain that there was now a park in the place of the cemetery. The expression on the man's face indicated that the park was a change for the better, which it undoubtedly was, for many reasons. The history of Landsberg an der Warthe poses a serious threat to the residents of Gorzow Wielkepolski, and not only because there are still a few Germans who would like to violate the last war's treaty lines to take the city back. All of the pain of the Second World War, the many Poles who died, the policies of racial inferiority that were used to "justify" the German invasion of Poland, the destruction of Warsaw and other cities, the wrongs that could not be righted through a simple grant of territory—all of this lies just beneath the surface of the apparently thoroughly Polish city. And so the erasure of the cemetery, the disappearance of the German maps and street signs—these things are perfectly understandable. And yet there is something disturbing about their absence.

I was reminded of Ibsen's *Ghosts,* in which hidden or deferred pain emerges in later generations. I had come to take photographs, and I was able to find only one site worth recording: Christa Wolf's childhood home on Sonnenplatz, Plac Słoneczny. It is the sole place she names in Polish in her account of her visit, and this, too, is worth mentioning—despite her apparent acceptance of the transformation of Landsberg into Gorzow

Wielkepolski, she makes no effort to learn the most rudimentary phrases of Polish for her visit, professing an ignorance even of the greeting "Good day." Across the street from her former home was another house of the same type and color, and on the wall of that house was a scrawled anti-Semitic slogan. Some ghosts, banished from their cemeteries, will take up residence elsewhere. We took a photograph of it.

Photography is not only about imbricated time or the construction of self-image, though that is what this study has taken as its focus. It is also about place, disappeared places, and it allows those places to coexist with the places we inhabit now. There is, for better or worse, no longer a Landsberg an der Warthe in the world, nor does the Victory Column stand in quite the same city, and Twain's hexagonal study has been moved from the summer house outside Elmira to a city park in town. But the photographs of these objects affirm their having been in the world and mark the places from which they have vanished. Photography represents a kind of scarring on the world's history, a reminder of things that were, sometimes unpleasant or terrifying things, sometimes the location of love and community. Ingeborg Bachmann writes (and Christa Wolf quotes her): "With my scarred hand I write of the nature of fire." It takes a scar to remind us.

It was for that reason that I visited the sites of photography for this study, though the authors are no longer there and the places are no longer themselves. This is what I had to hold up to my photographs for comparison: empty or altered rooms, a city changed sometimes beyond recognition by the destructive impulses of its own citizens, a grand library that tries to hold back the tide of change with a dam of books and manuscripts, streets and parks and churches bearing new names. Photographs hold our places for us, they act as the storehouse of the detritus of history.

A simultaneous belief in linguistic and photographic referentiality and suspicion of linguistic and photographic referentiality offer the only solution to the conundrum of our age. It is clear that it is as important for us to be able to read photographs as it is to be able to read words, and thus far we have done comparatively little thinking about it. What do photographs represent? The question of self-representation in photographs seems to be one that touches on each of us, and so I have begun with photography and autobiography, taking the thought and works of the authors of this study as my guide.

Notes

Introduction

1. I borrow this phrase from the title of Paul John Eakin's *Touching the World: Reference in Autobiography.* Eakin's book provided inspiration for my conviction that referentiality is the primary common concern of textual and photographic autobiography.

2. I owe the expression "autobiographical act" to Elizabeth Bruss and her book on autobiography, *Autobiographical Acts.*

3. A scene in the film *The Killing Fields* poignantly illustrates my point. An international group of journalists, awaiting rescue evacuation from a dangerously embattled Cambodia, attempts to forge a passport for a Cambodian translator whose life will be endangered if he remains behind. They must create a photograph of him for the passport, but they lack the necessary chemicals in the compound to which they are confined. They try several times, but without the proper chemicals, the image refuses to fix. The cinematic image of the false photograph, which insistently fades to white, seems a reflection of the translator's situation. Without this image, he is nothing, he is dead. Of course, in this instance the passport is a faked document; it does not honestly represent the identity of the translator. Thus we have a situation that reflects perfectly the ambiguous nature of photography—the power to lie, the power to convince. In Swedish, the word for identification card is *legitimation;* and so it is in practice, as we are rendered legitimate by signature and photograph.

4. John Berger eloquently formulates the need to look analytically at photographs, especially those not intended for analysis.

5. Twain's insistence on delayed publication was probably a half-serious joke; his claim was that the material was too inflammatory from a moral perspective to be released to an unenlightened public. In fact, the delayed publica-

tion of his work could have been meant as a patrimony for his surviving daughter. Nevertheless, Twain's kind of playful reticence indicates an underlying suspicion that he will be misunderstood by his contemporaries, and he thus prefers to wait for an audience with sentiments more sympathetic to his—in other words, an audience more of his own mind.

6. I follow the lead of Susan Gillman with my use of the word *imposture* in connection with Twain's work. She and Maria Ornella Marotti also provide a model in their placement of Twain among modern authors.

7. One reason for the silence among English-speaking scholars on the subject of *A Berlin Childhood* is that the English translation has not yet been published.

8. Paul Jay, who contends that "the attempt to differentiate between autobiography and fictional autobiography is finally pointless" and "if the border between autobiography and fiction is erected on a privileged notion of referentiality, then the study of autobiographical works will always be partly founded on an illusion" (Jay 1984, 16, 18).

9. "The genre does not tell us the style or construction of a text as much as how we should expect to 'take' that style or mode of construction" (Bruss 1976, 4).

10. As Stanley Corngold writes, "The sense of a self well lost threatens to annihilate many things that matter greatly to human beings—wholeness, quality, responsibility, even passion" (Corngold 1986, 2).

11. Smith 1994, 267. Leslie Adelson, writing of the body in German history, asserts: "Without taking issue with the notion that history requires narrativity to be perceived as such (and hence does not exist outside narrative), I would like to point out that the emphasis on narrativity as a grounding or as a function of historical consciousness tends to displace or render of somehow peripheral interest the fact that historical consciousness is perforce mediated first and foremost through sentient bodies" (Adelson 1993, 23).

12. Paul John Eakin has noted that Roland Barthes's *Camera Lucida* "proposes . . . an aesthetic of photography founded precisely on [the] bearing of witness. Photography is for Barthes the most referential of all the arts, testifying authoritatively to the existence of what it displays" (Eakin 1992, 18).

13. "The history of photography," continues Trachtenberg, "belongs to this larger history [of the culture in which they are produced and interpreted], was influenced by it and in turn influences how we perceive and understand it" (Trachtenberg 1989, xiii). Alan Sekula agrees, noting that "photographic 'literacy' is learned" (Sekula 1981, 454).

14. W. J. T. Mitchell reiterates Barthes's photographic paradox, and imagines the poles of the dichotomy as linguistic (connotative) and nonlinguistic (denotative). Then Mitchell asks, "How do we account for the stubbornness of the naive, superstitious view of photography? What could possibly motivate the persistence in erroneous beliefs about the radical difference between image and words, and the special status of photography? Are these mistaken beliefs simply conceptual errors, like mistakes in arithmetic? Or are they more on the order of ideological beliefs, convictions that resist change?" (Mitchell 1989, 9).

15. To give Eakin credit, the use of the word curious implies his understanding that indeed there is something that is not at all curious about what he observes; at least this is how I read the word, as a kind of ironic marker.

16. See particularly Michael Sprinker's essay, "The End of Autobiography," which has elicited a storm of responses since its publication in 1980 (Sprinker 1980). Both Paul John Eakin and Janet Varner Gunn address Sprinker's essay in their arguments, for instance (Eakin 1992; Gunn 1982). Elizabeth Bruss also offers the suggestion that autobiography could be dying as a literary form, but she makes her argument on quite different grounds, contending that reference is a necessary factor in autobiographical writing (and, more importantly, reading), but that changes in the cultural context of autobiography's production could lead to a transformation of the genre to an extent that would render it unrecognizable (Bruss 1976, 1980).

17. Eakin goes on to explore the way in which the body's physical reality determines the metaphors of everyday speech as well as metaphors in self-writing; he draws on the work of George Lakoff and Mark Johnson, observing that

> in every case [Lakoff and Johnson] locate the origins of metaphor in cultural and especially in physical, bodily experience. Perhaps the most obviously physical in derivation of the various classes of metaphor they identify are "orientational" metaphors ("up-down, in-out, front-back, on-off, deep-shallow, central-peripheral"), which "arise from the fact that we have bodies of the sort we have and that they function as they do in our physical environment." (Eakin 1992, 181)

18. Jouve 1991, 7. For other feminist readings that protest the deconstruction of the body before it is understood as an active constructive agent, see Smith 1994, Neumann 1994, Adelson 1993, and Bell and Yalom 1990, among others. Particularly Adelson and Smith apply sophisticated poststructuralist readings of the body while insisting on the importance of physical position, the historical, cultural, and embodied place from which texts are voiced and written.

To offer another example of the feminist position that maintains the referential power of autobiographical texts, I cite Susan Bell and Marilyn Yalom's introduction:

> The contemporary debate on autobiography is frequently grounded in various post-structuralist theories that deconstruct texts and decenter subjects so as to deny or at least question the familiar concept of a mimetic relationship between literature and life. As editors of this collection, we, on the contrary, reclaim that relationship. Yes, we believe like Philippe Lejeune that the autobiographical "I," however fugitive, partial, and unreliable, is indeed the privileged textual double of a real person, as well as a self-evident textual construct. (2)

19. The erasure of the subject's body from discourse carries dire consequences, as Leslie Adelson argues: "If we as theorists acknowledge the body only as discursive sign, then we assume a role comparable to that which [Elaine]

241

Scarry [in *The Body in Pain*] ascribes to the torturer, who becomes all voice, the arbiter of language, as the prisoner and his or her world become all body" (Adelson 1993, 19). Scarry's argument, cited here by Adelson, appears on pages 51 and 57 of *The Body in Pain: The Making and Unmaking of the World.* In the scenario suggested by Adelson, the torturing subject takes on the power of discourse, while the tortured object is shut out of language and agency, rendered a body without a tongue.

20. Much of the discussion surrounding male voyeurism and the cinematic construction of a female body derives from Laura Mulvey's work on visual pleasure in the cinema (Mulvey 1989). In the final section of my chapter on August Strindberg, I discuss this essay and its respondents in some detail.

21. Carol Shloss's study *In Visible Light* concentrates on the ideological and commodified aspects of photographic practice; she asks, "What means of commerce or human interaction was generated by taking photographs?" (Shloss 1987, 266). Both Shloss and Trachtenberg explore these issues primarily in an American context, however, while I choose to discuss them as international phenomena.

22. Both authors failed to realize their ambition to include photographs in their autobiographies because of prohibitive cost.

23. An immediate and legitimate objection might be raised that it is not the image but the caption that records the subject's thoughts, and that in this function captions cannot be distinguished from other forms of narrative. Indeed, Alan Sekula argues that a photograph can only be understood within a linguistic context: "The photograph, as it stands alone, presents merely the *possibility* of meaning," while Jefferson Hunter contends that "somewhere in the vicinity of every photograph is a hand holding a pen" (Sekula 1981, 457; Hunter 1987, 6). But here I am looking not at the construction of meaning by the autobiographer who links image to text, but at the perception of the reader, who is to see the text as an emanation of image in this context.

24. As Mitchell observes, "If we begin talking as if the mind is a tabula rasa or a camera obscura, it won't be long before the blank page and the camera begin to have minds of their own, and become sites of consciousness in their own right" (Mitchell 1986, 18).

25. In his analysis of Nathalie Sarraute's autobiography *Childhood,* Paul John Eakin discusses her use of "tropisms," "sensations beneath and beyond language though often intimately linked to it." He remarks that her perception of the past seems "absolutely right" to him, for his sense of the past is "that mostly it does not survive as is except—possibly—in flashes. 'Flash' seems the right term for my own experience, for it suggests the intensity, the brevity, and the illumination of the sensation recalled. As to the last quality, though, the flash—for me it is an odor, sometimes an image—if too often a light that blinds" (Eakin 1992, 39). His description of his own experience of the past and his understanding of Sarraute's is strikingly reminiscent of Benjamin's and Twain's. Though he argues convincingly that the narrative thread need not be broken into fragments as a result of such a perception of the past, I think that in some cases it is clear that

the use of the "flash" metaphor does lead to experimental attempts in fragmented narrative.

Chapter One

1. Other scholars, most notably John Seelye (1977), Louis Budd (1983), and James P. Waller (1990), have written on Twain's creation of a public persona through manipulation of his photographed image in conjunction with his published texts and public appearances. Waller has also addressed the idea of photographic influence on the narrative strategies of Twain's texts, including the autobiography.

While I draw upon their findings and am in agreement on many points, I find that my analysis differs from theirs in some important respects. Seelye focuses his attention on the perversity and megalomania of the older Twain, hinting that his obsessive posing with young girls in later photographs unmasks a barely sublimated sexual desire. Except for a short examination of the photographs taken of Twain in bed, I do not explore the realm of sexuality or voyeurism. Seelye's argument does interest me in the sense that it underscores the idea of using the photographed self as a mask, and exposes the act of posing for photographs as a game with unspoken aims. Budd concentrates on cultural history and on Twain's masterful production of a public self. His tendency is, however, to imagine the act of self-construction in published photographs as a sincere and populist gesture, while I would argue somewhere between Budd and Seelye, finding Twain's creation of his persona both an intentional manipulation of the credulity inspired by photographs and an unconscious attempt to overcome the anxiety created by photographic reproducibility of the self.

Waller most closely approaches my own ideas in the link he describes between Twain's narrative strategy and photography. He does not, however, discuss in detail the general nature of photography as a medium; in one place he characterizes the photograph as an anchor for Twain's need for authenticity, and in another he notes Twain's comment that "the sun never looks through a photographic instrument that does not permit a lie" (cited in Waller 1990, 3). He does not seem to reconcile these attitudes (which both exist in Twain) adequately. Further, his study centers on the photographs taken from 1851 to 1885, while mine concentrates on later images.

2. Quoted in Waller 1990 from the *Twainian* 2 (January 1940): 6.

3. Twain deliberately ignores the technical detail that photographic prints (after the daguerreotype era) are positives; once the negative has been made, it is reversed to present a "true" image rather than a mirrored one. By the time he made his observation about the unreliability of the photographic image, the daguerreotype era was long over.

4. Compare Lejeune 1975.

5. Compare de Man 1979.

6. One thinks in this connection of the controversy surrounding the alleged photographs (one is not even sure where to place the "alleged") of prisoners of war in Vietnam, purportedly taken of men still in captivity nearly twenty

years after the end of the war. Some relatives and friends insist upon the veracity of these images, claiming to recognize in the photographs beloved faces from the past, though it is clear that the ravages of imprisonment and war, not to mention age, would have altered the men considerably. Those who are familiar with the catalogue of tricks that can be used to create convincing photographic fakes try in vain to persuade the grieving families that the images are testimony to nothing more than the greed or political agendas of those who made the photographs, but the power of the photographic image itself is such that it stands in for the lost person, now recovered. In these cases, an image is all the more convincing because it is singular—the only alleged image of the person since his disappearance.

7. Compare in Barthes 1977 and Nabokov 1989 the photographic series denoted by August Strindberg as part of his autobiography (examined in my second chapter), and various images from Mark Twain's photographic record.

8. Compare Seeleye 1977; Budd 1983, 77; and Gillman 1989.

9. Paradoxically, William Dean Howells, who was the author's close friend, calls him "Clemens" in his book *My Mark Twain* (Howells 1910). This gesture does not establish distance, but underscores Howells's personal acquaintance with the "real" Mark Twain; he writes that to call his friend by his pseudonym would "mask him from my personal sense" (3). This is an allusion to the advantage Howells assumes over his reader—namely, that he knew the living person and therefore must use the name that referred to the "real" person, now dead. At the same time, he apparently feels he must use the pseudonym in his title in order to attract the outsiders who did not know Samuel Clemens but feel comfortable with Mark Twain. In Howells's case, the name "Clemens" refers both to the man and to their personal relationship, which Howells's book now proposes to publicize in both an expression of personal grief and a bid for his friend's public canonization—"the Lincoln of our literature," he calls him, giving Twain yet another alias (101). Howells's mention of the "masking" effect of the pseudonym, specifically of a mask that obscures the personal or private individual, echoes those scholars of Twain who see in the Twain/Clemens split a possible line between the public and private lives of a man.

10. Nietzsche 1977, 45. For an exploration of the "author function," see Foucault 1977, 113–38.

11. I am thinking here of Derrida's comments in *The Ear of the Other*, in particular Derrida 1988.

12. Leslie A. Adelson's book *Making Bodies, Making History* calls attention to the role of flesh and blood in constructing history, a role I would like to foreground in my discussion of autobiography and photography. I borrow here from her first chapter: "Bodies guard their secrets well and divulge them at every turn," a remark that could have been written to explain Mark Twain (Adelson 1993, 1).

13. The photographs of the 1850s and 1860s are what one might call "safe" images: noncommittal, unimaginative studio poses of Mark Twain in a dark suit typical of the period, though as James P. Waller has noted, Twain often managed

to insert some aspect of his comic persona even into these formal images, such as a patterned tie (Waller 1990).

14. David observes that although Twain actually applied the epithet "Poet Lariat" to one of his fellow passengers on the *Quaker City,* the image indisputably depicts Twain himself (David 1986, 32–33).

15. This was not an unusual practice; ordinary citizens acquired the habit of printing up photographs of themselves on cartes de visite during the 1860s and 1870s, and celebrities had learned to promote themselves through photographic self-advertising before Clemens hit upon the idea. In her book on A. A. E. Disderi and the photographic carte de visite, Elizabeth Anne McCauley notes that "Disderi's cartes de visite, which had been conceived as inexpensive portraits for the bourgeoises, became a means of advertising or propaganda for the rich or talented" (McCauley 1985, 54–55).

16. Now that he has been dead for nearly a hundred years, his image still appears in association with banks, airlines, and other commercial endeavors. Compare Seeleye 1977 and Budd 1983 for further information on Twain's use of his name and face as a trademark in advertising.

17. W. J. T. Mitchell comments on contemporary idolatry in the following terms: "The proper scenario for idolatry, in our view, is a bunch of naked savages bowing and scraping before an obscene stone monolith. But suppose we began to suspect that this scenario was our own ethnocentric projection, a fantasy devised to secure a conviction that *our* images are free from any taint of superstition, fantasy, or compulsive behavior? Suppose we began to think of our ordinary, rational behavior with images as just a bit strange, as permeated with odd, cultish prejudices and ideological determinations?" (Mitchell 1986, 91).

18. The sharp increase in photographic images of Mark Twain (and their extensive reproduction) may be attributed in part to developments in technology that permitted quick, casual snapping of photographs and duplication in newspapers and magazines. In *Our Mark Twain,* Louis Budd chronicles Twain's lifelong association with journalists eager to take his picture (Budd 1983). The presence of photographer Albert Bigelow Paine in the household also contributed to the avalanche of images in Twain's later life, which (along with Hal Holbrook's performances) accounts for most Americans' mental image of Twain as an old man. To give an idea of the distribution of images through Twain's lifetime, I have tallied the images held by the Mark Twain Project in Berkeley, California: 1850–1899, 130 images, 80 of which were taken in studios; 1900–1907, 222 images, 55 in studios (in 1907 alone, 101 separate images were made; Paine entered Twain's employ in 1906); 1908–1910, 118 images, 4 in studios.

19. Isabel Lyon quotes this remark of Twain's in her unpublished notebooks, 8 August 1906, Mark Twain Papers, Bancroft Library, University of California, Berkeley.

20. Twain's impatience with Nietzschean style in *Also sprach Zarathustra* hinges perhaps upon his irritation with Nietzsche's unabashed play behind the Zarathustra mask, which is explicitly a mask. The deliberate confusion of the Mark Twain mask with his own face, orchestrated through a careful management

of images, is in fact much less "lucid" for the viewer than Nietzsche's explicit play, and Twain's poses in bed and elsewhere reflect a need to exercise strong control over the process of duplication.

21. Maria Ornella Marotti presents a vivid proof of Twain's anxiety about duplication in her discussion of the story fragment, "No. 44": "44 [a character in the story] starts a duplicating process [of Bibles] in the print shop, which he later extends to reproductions of the printers themselves. This entire act of duplication, while still retaining the essence of repetition, is an act of creation bearing the features of a larger and deeper transgression of the laws of human mortality" (Marotti 1990, 123–24). Here we see the relationship between print reproduction and reproduction of the human image (as in photography). The hubristic aspect of printing (either books or human images), which violates the sanction against "graven images," carries over into Twain's autobiographical project, which explicitly challenges mortality by claiming an existence for its author beyond the grave. But the doubles in "No. 44," far from allowing for individual immortality, duplicate themselves beyond control, rendering the task of authentication (identification of singular personhood) impossible: "[In these stories involving duplicates] we undergo a decentering experience that throws off balance any stable notions of the real, either literary or psychological or epistemological, and the individual's place in it" (Marotti 1990, 169).

22. On 13 July 1993, a special edition of American Broadcasting Corporation's *Nightline* covering the Mississippi flood featured an unidentified Twain impersonator who performed a short piece by Twain. That the man who played Twain remained unnamed points to the special status of impersonation, which is not regarded precisely as acting but as a representation through *resemblance*. In this case, the impersonator wore both the regulation white suit and white bushy hair and moustache of Twain's later years. He stood in profile against a black background, as if emerging out of the night. This eerie presentation (and the gravity of the sketch) implied the presence of the ghost of Mark Twain.

23. The subjects of the candid photograph might also be understood as being candid or honest in themselves; they are true to themselves in the sense that they are not posing but "natural."

24. Pond's photographs and his impressions of the journey with Mark Twain are collected in Gribben and Karanovich 1992. While the majority of the snapshots taken by Pond on the 1895 tour were not published until this volume appeared, Pond's intent to create "candid" moments resonates throughout the collection.

25. Thanks to Scott Abbott, who first pointed out the possible significance of a veil in this context.

26. In those images in which he is reading, it becomes of some importance to the viewer to identify *what* he is reading, if possible, though most frequently he is posed in such a way that it makes it difficult for the viewer to "look over his shoulder." I make this assertion not only on the basis of personal experience, but because I have observed that those who caption such photographs often provide this information; for instance, in Louis Budd's *Our Mark Twain,* Budd informs

us in a caption that "the edition of the *New York Sun* that Twain holds is dated 7 May 1901" (Budd 1983, 116). Such information is useful, of course, in the historical process of dating photographs, but our need to get at the information proceeds, I would argue, from the need to get inside that photograph.

27. Louis Budd gives a thorough account of the bed photographs and their history in *Our Mark Twain* (Budd 1983, 206).

28. While one might agree with Renza that the resulting autobiography at best represents a failed strategy, the unenthusiastic reception of the work and its many frustrating aspects only raise more critical questions, worthy, in my opinion, of pursuit.

29. Unpublished material from the autobiographical typescripts, Mark Twain Papers, Bancroft Library, University of California, Berkeley.

30. Critics often choose to overlook or underplay the oral aspect of Twain's autobiography. For instance, Louis Renza consistently refers to the autobiography as "written," and the task of creating it as "writing." While I would not argue that the autobiography is a purely oral act (several segments were in fact written, and the stenographer's transcripts of the dictation sessions were edited by Twain and Paine), it is vital to note that Twain meant for the greater part of the autobiography to be experienced as a piece of oral narrative. Hamlin Hill regards the autobiography's orality as one of its most significant features: "The effects [of Twain's autobiographical method] were all the more impressive because the [autobiographical] voice was oral" (Hill 1973, 137), and Marilyn Davis DeEulis maintains that even the written sections of the autobiography resonate like spoken language (DeEulis 1981, 204). Walter Blair expresses the thought that all of Twain's writings, depending as they do on the oral tradition of the Southwest, carry echoes of his speech (Blair 1981).

That Twain's written language often closely approximates oral performance is no hindrance to my argument that the autobiography should be read as a performative act, for in the autobiography, Twain has embedded signs of the presence of actual interlocutors, and refers to himself in the act of narrating.

31. Isabel Lyon's unpublished notebooks, 20 June 1906, Mark Twain Papers, Bancroft Library, University of California, Berkeley.

32. This explanation has been offered and satisfactorily supported by Michael Kiskis (Twain 1990, xix) and by Hamlin Hill, who quotes Twain as saying "I do not need to stay here any longer, for I have completed the only work that was remaining for me to do in this life and that I could not possibly afford to leave uncompleted—my Autobiography. Although that is not finished, and will not be finished until I die, the object which I had in view in compiling it is accomplished: that object was to distribute it through my existing books and give each of them a new copyright life of twenty-eight years. . . . If I could die tomorrow this mass of literature would be quite sufficient for the object which I had in view in manufacturing it" (from the Mark Twain Papers, autobiographical dictations, 26 March 1906, quoted in Hill 1973, 164).

33. Compare Foucault 1977.

34. As Hamlin Hill remarks: "Almost as if to reinforce the deathbed image of

the dictations [portrayed in the frontispiece of the 1924 edition and in the press in 1906 and 1907] the recumbent speaker convinced himself that he was talking 'as from the grave' with complete candor and unrestraint" (Hill 1973, xxiii).

35. Susan Sontag maintains that photographs always function as cenotaphs, marking the moment in which a person once lived—that moment (and therefore, that particular person) is irretrievably lost (Sontag 1973). Roland Barthes, too, stresses that every photograph represents a "That Has Been" (Barthes 1981, 77), while Cathy N. Davidson goes so far as to say that "every photograph snuffs" (Davidson 1990, 672).

36. As Roland Barthes writes: "Photography's inimitable feature . . . is that someone has seen the referent . . . *in flesh and blood,* or . . . *in person*" (Barthes 1981, 79).

37. In "Mark Twain and the Art of Memory," Thomas Walsh and Thomas Zlatic document the author's enthusiasm for mnemonic devices derived from classical models that depend on the integration of *loci* (places) with *imagines* (images) (Walsh and Zlatic 1981, 214–31). A Roman orator would memorize a speech, for instance, by visualizing the Pantheon, attaching an idea from his speech to an architectural feature as he mentally walked through the building, and then retrieving the ideas in sequence by revisualizing his passage through the space. Twain, whose avowedly weak memory brought constant anxiety to his career as platform orator, devised pictograms to remind him of the main points of his lecture. James Preston Waller notes that "at the center of Mark Twain's work is a form of memory as unique as his extraordinary ocular power that made for a particularly retentive, pictorical . . . cast of mind and imagination. . . . [T]his photographic sense in many ways explains why Twain's larger works are episodic" (Waller 1990, xi–xii).

38. Waller holds with this view when he writes, "Twain's primary method of recording the data that formed the substance of his 'self,' that shaped and then became the conception projected as his persona Mark Twain . . . , was to store in the mind discrete moments in just the same method of photography" (Waller 1990, 16–17).

39. Maria Ornella Marotti's comments point up the similarity between Twain's notions of dream vision and dream language, which in turn bears a strong resemblance to his autobiographical language: "Dream language resembles shorthand in its swift reproduction of thought. It is a language that suffers no deferral, a language that combines the immediacy of the oral and the accuracy of the written" (Marotti 1990, 77).

40. Marilyn Davis DeEulis maintains that the structure of the autobiography is meant to produce a "scrapbook" effect, and that Twain's decision to place his "thoroughly literary essay" on the death of his daughter Jean at the conclusion of the autobiography indicates a studied return to the written mode of the first fragmentary chapters (DeEulis 1981, 212). Hamlin Hill, on the other hand, quotes Twain's remark that the autobiography "will not be finished until I die," which strikes one as more in line with the notion that true autobiographies cannot be finished, because they recount the life from one moment to the next, and

thus cannot offer a finish until the biological end of the author (Hill 1973, 164). Considered in this light, the addition of the chapter on Jean's death seems less a part of a scrapbook effect than a substitution of his daughter's death for his own.

41. The photographs and accompanying text were published for the first time in Neider's 1959 edition of the autobiography, which otherwise disdains to follow Twain's editorial instructions.

42. The print obtained for reproduction does not include the caption.

Chapter Two

1. Martin Lamm's two-volume biography of Strindberg, to cite one prominent example, is broken down into "Pre-Inferno" and "After the Conversion."

2. A number of scholars have begun to come to terms with the relationship between naturalism and the occult, naturalism and spiritualism, naturalism and mythic symbolism, and naturalism and expressionism. All of these studies, whether they focus on Strindberg or not, offer insight into Strindberg's aesthetic "conversion" during the Inferno crisis, for all of them indicate that Strindberg's approach to naturalism (which was shared by Huysmans, Gogol, and some German practioners in the movement) carried within it the foundation for his post-Inferno works. (See Bellquist 1988; Brantly 1988; Jackson 1992; Kafitz 1988; and Zielonka 1989.) Even the religious conversion described in *Inferno* had its roots in Strindberg's childhood religious experience and cannot be said to represent a severe break with the past (Brandell 1950, 7).

3. Woolf 1953, 151. Woolf refers here to what she calls "materialists," who practice a kind of realism similar to that of the naturalists, attending assiduously to physical and social detail. From this group she cites particularly "Mr. Wells, Mr. Bennett, and Mr. Galsworthy."

4. It is interesting in this regard to note the title of Henrik Ibsen's *Gengangere,* usually translated as *Ghosts.* In fact, the Norwegian word means literally "those who walk again." The creatures in question are not souls without bodies (ghosts), for which there is another word in Norwegian, but bodies without souls (zombies).

5. Paul John Eakin, in his study on autobiography and referentiality, notes the paradox of Barthes's poststructuralist theories of autobiography and his desire for a means to express the profound self (Eakin 1992, 18–19).

6. Strindberg 1916, 15:38. Strindberg sent similar lists to his publisher and to the author Gustaf af Geijerstam (to whom he also sent a copy of the Gersau photographic series). The list varies a bit each time, which underscores Strindberg's notion of the constantly evolving self-image.

Citations from Strindberg's letters are taken from the Eklund edition (Strindberg 1948–1976), with volume and page number. I have translated the cited passages from Swedish or German.

7. For a full account of the charge of blasphemy and the trial, see Lagercrantz 1979.

8. Photographic studios owned the rights to the images they produced; negatives were kept on file in case friends or relatives needed prints, and photo-

graphic visiting cards were usually imprinted with the address of the studio so that recipients of the card could order reproductions of the image. Strindberg recognized that it would be much easier to obtain images of human beings from a studio, where they had willingly posed for a picture under the best possible photographic circumstances, than it would be to try to persuade the farmers to pose for him or snap their images surreptitiously. He did, however, investigate the possibility of acquiring a so-called revolver camera, which was reputed to be able to produce clear images of people who were not aware of being photographed. He found that the images produced by the "revolver" were muddy and small; it was not until 1888 that Kodak came out with a camera actually capable of taking acceptable candid snapshots.

A project similar to Strindberg's was undertaken by August Sander in Weimar Germany, when Sander photographed individuals from particular professions, regions, and classes to establish a kind of representative iconography of Germans. Both Strindberg in 1886 and Sander in the 1920s operate on the assumption that individuals may be cast as class types on the basis of appearance as yielded up in photographs. Interestingly, Sander tends to leave his images of working class and peasant individuals unidentified; artists and intellectuals, on the other hand, receive a caption including their names. Strindberg, too, feels that each member of the farming class may be taken as a model of type for his "ethnographic collection"—this practice appeared in anthropological studies, attempts to establish physiognomies of criminals or the mentally ill, etc.—but when he sets out to write his naturalist autobiography, he makes a gesture toward applying the same rule of anonymity to himself.

9. The figures included here composed part of an album sent by Strindberg to his friend, Swedish author Gustaf af Geijerstam, as a Christmas present. The copies of the photographs originally sent to Strindberg's publisher, Bonniers, have apparently not survived. We know that the Bonniers series was composed of some of the same images, however. I contacted Per Hemmingsson in the course of investigating the Gersau series, and he assured me that his research had failed to locate the Bonniers images, though he felt sure that the two albums were very similar in both pose and caption.

10. Strindberg's marriage with Siri von Essen broke definitively in 1891 after many years of disharmony, beginning with the publication of *Getting Married II* in 1886. Their divorce was finalized in 1892.

11. John L. Greenway (1991) treats both the amusing and more serious responses to the invention of X-ray photography.

12. That Rejlander was a Scandinavian is, I think, more than just a coincidence. The nascent photographic industry achieved a growth in Scandinavia comparable to that in larger industrialized countries such as France, Britain, and the United States. Not only did a Norwegian claim to have invented the first photographic apparatus (a claim generally unaccepted), but Scandinavian photographic entrepreneurs sprang up throughout the countries, and the Hasselblad camera company was founded in Gothenburg, Sweden, in the 1860s. New photographic discoveries were introduced into Scandinavia just a bit behind the rest

of Western Europe. When the national cinematic industries began their development, Scandinavian companies produced films for export in numbers that rivaled their closest competitors: Britain, France, and the United States. It was only with the advent of sound film that Scandinavian films, produced in languages that relatively few could understand, fell behind. Scandinavian preeminence in photography has continued to the present, with Bergman's cinematographer Sven Nykvist and biological photographer Lennart Nilsson just two outstanding examples in the field. Both Nykvist's and Nilsson's photographs, interestingly, continue the Strindbergian tradition of photographing the interior, with Nykvist active in producing Ingmar Bergman's "psychological portraits" and Nilsson photographing inside the womb.

13. For a complete study of Rejlander's work as an art photographer and his early influence and eventual fall from grace, see Spencer 1985.

14. Such belief in sympathetic magic occurs not only in the case of photographic portraits but also in painted ones—*The Picture of Dorian Gray* provides one example. However, I would argue that the means of reproduction used in photography, the format in which photographs are produced, and the widespread dissemination of photographic portraits all conspire to render photography more powerful in this regard.

15. Discussions of Strindberg's sanity or lack thereof have dominated analyses of his autobiographical text *Inferno* to the extent that his English translator, Mary Sandbach, comments, "*Inferno* has so often been accepted—particularly in England—as conclusive proof that Strindberg was clinically insane, that it seems impossible to discuss the book without saying something about his mental health" (Strindberg 1979, 50).

16. Kafitz 1988, 18. Kafitz's article centers on the work of German naturalists Wilhelm Boelsche, Heinrich and Julius Hart, Ernst Haeckel, and Johannes Schlaf. He makes a fascinating point in noting how the idealized form of German naturalism leads ultimately in some cases to the embrace of eugenics and National Socialism.

17. "When I say that 'I see' the film, I mean thereby a unique mixture of two contrary currents: the film is what I receive, and it is also what I release, since it does not pre-exist my entering the auditorium and I only need close my eyes to suppress it. Releasing it, I am the projector, receiving it, I am the screen; in both these figures together, I am the camera, which points and records" (Metz 1982, 51). Metz refers to the camera rather than the filmmaker, though in *auteur* film criticism, the filmmaker is often figured as looking through or in close proximity to (controlling) the camera.

Chapter Three

1. In this chapter I will make use of a translation of *Berliner Kindheit* graciously lent to me by the translator, Shierry Weber Nicholsen. No translation into English has yet been published, and I was grateful to have the use of Nicholsen's. In some instances I will make my own translations from the 1987 edition; in others I will change details of her translation for the purposes of better

accommodating my argument. These cases will be noted. In that connection I would like to indicate that though the translator chooses *A Berlin Childhood ca. 1900* for her translation of the book's title, I prefer *A Berlin Childhood around 1900;* neither version sounds particularly felicitous in English, and to convey the entire sense of Benjamin's title, something like *A Berlin Childhood on the Threshold of the Twentieth Century* would perhaps be best—but that is not the title Benjamin chose.

2. *Berlin Childhood* does not stand outside Benjamin's philosophical and critical work as a biographical pendant; Manfred Schneider observes that the autobiography "as far as its structure and its implicit theories are concerned, can be considered without much difficulty in the context of Benjamin's great projects of the thirties," including the essay on mechanical reproduction and the Arcades Project (Schneider 1986, 109). I would carry his argument a bit further; *Berlin Childhood* is itself one of Benjamin's "great projects of the thirties," a literary performance of his theoretical concepts. Or as Werner Hamacher puts it, "It cannot be doubted that Benjamin's memoirs represent the impetus as well as the explication, extrapolation and fulfillment of the program that his theoretical writings formulate" (Hamacher 1986, 152). Those scholars who discuss *Berliner Kindheit* in detail (Stüssi, Witte, Schneider, Lindner) touch upon the presence of the autobiography's use of the photographic metaphor to different degrees. Of these, Schneider develops most thoroughly a connection between the autobiographical project and Benjamin's writings on photography, but he concerns himself with what he perceives as a shift from the visual to the acoustic in the text. My focus on photography and autobiography allows for an exploration of the paradoxes inherent in Benjamin's writings on photography as they emerge in his autobiography. It also allows me to propose the new autobiographical model of the disappearing self, who vanishes in response to photographic exposure.

3. Benjamin touches on this idea in his "Short History of Photography," remarking on "the men, working independently of one another toward the same goal: to capture the camera obscura images that had been known at least since the time of Leonardo" (Benjamin 1980b, 368, my translation).

4. Newhall 1982, 129. George Eastman recalls his naming of the company: "It was a purely arbitrary combination of letters, not derived in whole or part from any existing word, arrived at after considerable search for a name that would answer all requirements for a trademark name. The principal of these were that it must be short; incapable of being misspelled so as to destroy its identity; must have a vigorous and distinctive personality; and must meet the requirements of various foreign trademark laws" (cited in Newhall 1982, 129).

5. Jacques Derrida picks up on the Benjaminian conception of *Spuren* in his essay "Spurs" and in his writing on difference.

6. Schneider makes this argument as well, stressing Benjamin's re-invention of an incognito for himself in the disappearing act he performs in his own autobiography (Schneider 1986). The emphasis I would like to bring, however, focuses on the particularity of Benjamin's Jewish identity and the way he subverts

Nazi propaganda images of Jews in the text. This will comprise the final section of my reading of Benjamin's autobiography.

7. W. J. T. Mitchell offers the English phrase "multistable image" as a translation for *Vexierbild*.

8. Following Wittgenstein's lead, W. J. T. Mitchell asserts in his essay "Metapictures" that the Duck-Rabbit is in fact a "curious hybrid that looks like nothing else but itself" (Mitchell 1994, 53). His essay explores in greater detail the meaning and function of the *Vexierbild*.

9. Eduardo Cadava also notes the relation of the essays on mimesis to Benjamin's autobiographical writings and photographic and historiographic theories in his essay "Words of Light: Theses on the Photography of History" (Cadava 1992, 93).

10. Of course, Herr Knoche's name contains contradictory signs as well; while *Knoche* most obviously refers to "bone" and the associated characteristics of hardness, death, and a certain strength (in German, *Mark in den Knochen* refers to spirit or grit), the initial letters "Kn" introduce another range of possiblities: *Knecht* (lackey), *Knolle* (clod, peasant), and *Knoten* (cad or bully). "Kn" in German in fact seems to signal invariably a male of servile or dubious character.

11. I would like to thank native speakers Bernd Fischer, Gregor Hens, and Tobias Bulang for helping me to puzzle through various readings of the more vexing words and phrases of this segment of *Berlin Childhood,* most specifically *gewogenes Herz, Rätselbilder, Au/e,* and *Vexierbild.*

12. One thinks here of the aphorism by Karl Kraus, quoted by Benjamin in his essay on Kraus: "Je näher man ein Wort ansieht, desto ferner sieht es zurück" (the closer one looks at a word, the farther it looks back). Werner Hamacher notes the importance of this thought for Benjamin's use of language in *Berlin Childhood,* as well.

13. Bernd Witte (1984) traces the history of the text.

14. Here we could revisit the issue of pseudonymity in autobiography already discussed at length in the chapter on Twain. Benjamin's case differs significantly from Twain's because Benjamin was living in exile and forced to write under a pseudonym to publish his works in Hitler's Germany. In both cases, however, an alter ego was created to both mask and extend the author and his power. Benjamin's pseudonym, Detlef Holz, receives intensive treatment in Thiel 1992.

15. Beth Sharon Ash's essay, which places a great deal of weight on Benjamin's relationship with his father, briefly cites the section of *Berlin Chronicle* in which Benjamin describes the "sinister" nature of his father's business deals. She also analyzes at greater length the account of a break-in at the Benjamin summer house in which Benjamin's father wants to attack the robbers with a pocketknife but is restrained from this foolhardiness by Benjamin's mother. Ash's Freudian reading depends heavily on these passages from *Berlin Chronicle* (the latter one in particular). It is interesting to consider how her reading might be altered to accommodate Benjamin's deletion of both characterizations of his father from the subsequent versions of his autobiography, one of which was written very

shortly after *Berlin Chronicle.* Ash ignores the textual history of Benjamin's auto-
biography to treat these passages as psychoanalytical evidence for Benjamin's
Oedipal conflict, from which she infers Benjamin's conflict with his own Jewish
identity.

16. Anna Stüssi notes the resemblance between allegorical figures and
Benjamin's objects in her study of *Berlin Childhood* when she discusses Benjamin's
use of a labyrinth he explored as a child in the segment "Zoo": "the labyrinth in
Benjamin's work is no metaphor, but a place in which the child really did wander.
This is the special thing about Benjamin's method of representation: the image
is not an illustration" (Stüessi 1977, 19).

17. For a fuller discussion of photograph as allegory in Benjamin's work,
see Amelunxen 1988.

18. Editors Rolf Tiedemann and Hermann Schweppinghäuser speculate
that the briefcase manuscript was probably a copy of one of the works left by
Benjamin in the hands of a colleague, Georges Bataille, who left the papers given
to him for safekeeping in the Bibliothèque Nationale in Paris. They argue that
Benjamin would have most probably made an extra handwritten copy of those
pieces most important to him, as he feared that the Gestapo could find the mate-
rial left in Paris and destroy it. This seems a likely thesis. On the other hand, it
is not the probable validity of the speculation that is most interesting but rather
the way the hint of a lost manuscript plays into the larger myth of loss and disap-
pointment surrounding Benjamin.

19. One book, *Für Walter Benjamin,* explicitly marks the fiftieth anniversary
of Benjamin's death with interviews, photographs, and documentation recording
the events of his final days. Other works refer more abstractly to the air of
mourning surrounding Benjamin; a collection of essays alludes to a "lost manu-
script" in citing Benjamin in its title: *Was nie geschrieben wurde, lesen* (To read what
was never written). Still others recall the Angel of History from Benjamin's
theses on history, who gazes, horrified, at the detritus of the past: "Engel und
Zwerg" (Angel and dwarf), "Bilder der Endzeit" (Images of the last day), *Aber
ein Sturm weht vom Paradiese her* (But a storm is blowing from paradise—a line
from Benjamin's "Angel" thesis).

20. To understand what Benjamin means about the erasure of equipment
in the cinema, one need only think of those rare moments when careless or
low-budget editing has failed to remove frames in which a microphone dangles
incongruously into a realistic set. At that moment the viewer becomes aware of
the cinematic apparatus, and the impression of "reality" is interrupted by the
interpolation of the equipment between the viewer and the action on-screen.

21. A number of scholars have noted the nostalgia with which Benjamin
writes of the aura's loss, beginning with Theodor Adorno and including Manfred
Schneider, Anna Stüssi, and Bernd Witte.

22. Benjamin discusses this argument of Freud's in "On Some Motifs in
Baudelaire," in conjunction with an analysis of Proust's concept of *memoire invo-
lontaire* (Benjamin 1969, 160–61).

23. Benjamin n.d.; Benjamin 1987. All of the cited passages are taken from

Shierry Weber Nicholsen's translation except for the final one from "Too late," which I translate a bit differently. The German phrase that ends the segment is "Aber es war kein Segen dabei," which Nicholsen gives as "But no good came of it" and I translate more literally as "But there was no blessing in it." Though Nicholsen's version would occur idiomatically in English and thus is preferable in that respect, I think it is important to maintain the secularized religious connotation in this particular passage, which refers to Benjamin's status as "Other" in his school and associates the devil's theft of Peter Schlemihl's shadow (from a German fantastic tale by Adalbart Chamisso) with the teacher's removal of the child's name from the list of active pupils **for** that hour. The figure Peter Schlemihl, though not identified as Jewish in Chamisso's story, nevertheless has a Yiddish name (perhaps more recognizable to Americans than Germans) that identifies him as fool. He, too, is an outsider at the beginning of his story, and the theft of his shadow pushes him even farther beyond the pale. This web of connections offers further substantiation of the argument I want to make in the final section of this chapter about Benjamin's submerged evocation of his Jewish identity.

24. Manfred Schneider maintains that the erasure of these moments relates to a shift that takes place during the revision of Benjamin's autobiography from the visual to the acoustic. He ascribes the erasure of the visual and the substitution of the acoustic to Benjamin's increasing need for an incognito, which demands the destruction of the particularity of visual (particularly photographic) evidence (Schneider 1986, 119–27).

I would hold with Schneider, except that it seems to me that the introduction of the acoustic does not entirely overwhelm the visual, even taking into account Benjamin's deletion of visual allusions. The (invisible) eye remains as the only explicit ordering principle in the text (in "The little hunchback" segment, to be discussed below), while the buzz of sound (in "The telephone," for instance) carries with it the force of vibrating destruction, of shattering. Thus the eye and the ear are dismembered, their functions separated, and the destruction of the aura finds expression alongside its reinscription.

25. Werner Hamacher explores Benjamin's mummery with words in an article dealing with the child's "misunderstanding" of the words he hears: "Muhme Rehlen" becomes "Mummerehlen," "Markthalle" is "Mark-Thalle," "Steglitzerstrasse" is "Stieglitzerstrasse," and so on. Hamacher's essay spins out a complex thesis in interpretation of Benjamin's remark that words are clouds (Hamacher 1986).

26. Manfred Schneider calls the disappearance of the passage describing the disappearance of the Chinese painter into his painting "die Tilgung einer Tilgung," which translates roughly as "the cancellation of a cancellation" or "the extermination of an extermination" (Schneider 1986, 126). The word seems too extreme in its second English connotation, and too burdened with the notion of debt in the first. But it was Schneider's reading that first led me to consider the meaning of these deletions.

27. Bernd Witte identifies and reproduces the two photographs in his in-

tellectual biography of Benjamin. His book provided the impetus for my analysis of the photographs in the context of Benjamin's autobiography, but one other scholar, Hubertus von Amelunxen, also connects the passage from "Mummerehlen" to the Kafka photograph in, for my purposes, a more interesting analytical context (Witte 1991, 11–12; Amelunxen 1988, 10).

28. Benjamin n.d., 58. Translations from the earlier version of "Mummerehlen" are taken from an unpaginated manuscript appended to the translation of the last version. Shierry Weber Nicholsen is the translator in both cases.

29. Benjamin 1969, 223. The word Benjamin uses in this passage for "shell" is not *Muschel* but *Hülle,* which might also be translated as "skin" or "sheath" or "peel." While a *Muschel* is the type of shell that contains (or once contained) a living being, a *Hülle* can sheath vegetable or inanimate objects. The reference to peeling away the aura, however, corresponds in an interesting way to the removal of the self from the shell of the nineteenth century.

30. Derrida 1982. One might suspect that Derrida refers implicitly to Benjamin in his study of the otobiography, but this is not necessarily the case, since Nietzsche, whose *Ecce Homo* provides the focus for Derrida's study, also makes use of the image of the ear. One of Nietzsche's aural images is a grotesque, a man who has given so much weight to the words of others that he is nothing but a man-sized ear.

31. In his book charting the denigration of visual metaphor in the work of French theorists of the twentieth century, Martin Jay notes that Derrida is suspicious of both hearing and sight. However, in *The Ear of the Other,* Derrida's essay on Nietzsche's autobiography, it is clear that hearing (in, as the title suggests, the ear of the *other*) occupies a privileged position (Jay 1993, 496, 497).

32. Michel Beaujour comments on the importance of the notion of flashing images before death or fainting in the construction of self-portraits, citing several self-portraitists who make use of the trope (Beaujour 1991, 120).

33. I am grateful to my colleague Dagmar Lorenz for help with difficult German idioms in the entire text, but particularly for her insights into "Nachsehen haben."

34. Benjamin 1987, 79. Burkhardt Lindner explores the various textual incarnations in Benjamin's work of the angel and the hunchback and concludes that they "exist on the same plane: as figural instances of the theological" (Lindner 1992, 237). In this Lindner refers to Benjamin's belief in the redemptive power of the Messianic age, which will break upon history on the last day.

35. I have borrowed the association between Benjamin's work and Hebrew script from Robert Alter (Alter 1991).

36. Schneider reacts impatiently to what he perceives as purely aesthetic responses to Benjamin: "The state and administration destroy that incognito which, defined . . . as the state's lack of knowledge about the individual, has greater potential for the decoding of Benjamin's esoteric concept of aura than the most beautiful hermeneutic tightrope acts" (Schneider 1986, 111). But even Schneider, with his insistence on a pragmatic and political reading of Benjamin's

personal situation for the analysis of his aesthetics, refrains from any explicit reference to his Jewish identity.

37. In the course of attempting to find a publisher for his autobiography, Benjamin thought of placing it with a publishing house whose interests tended toward Zionism. He wrote to his friend Gershom Scholem in Palestine and asked him to aid his publication efforts by "point[ing] out certain Jewish aspects of [the] book" (Benjamin 1988, 102). Scholem responded: "It is utterly unclear to me how you imagine I . . . could discover *Zionist* elements in your book. . . . The only 'Jewish' passage in your manuscript was the one I urgently asked you to leave out" (Benjamin 1988, 106). The segment Scholem had found objectionable was "Awakening of the sex drive"; he urged its removal because it was the only passage in which Benjamin explicitly identified himself as a Jew, and he made that identification in connection with a sexual desecration of a Jewish high holiday. Scholem worried that Benjamin's text might unwittingly support anti-Semitic connections between Judaism and illicit sexuality, and Benjamin agreed to remove the section, but his wishes escaped Adorno's notice, and so the text has gone into all of the work's editions (Benjamin 1988, 25).

Chapter Four

1. The 1990 publication of *Was bleibt,* a fictionalized autobiographical account of an author who suffers psychologically under the surveillance of state security officers, unleashed an unusually harsh stream of criticism. Wolf, who had enjoyed critical recognition, honorary degrees, and prestigious awards from the West, experienced something of a *Wende* (turn) against herself as the newspapers and journals that once championed her works now published the most hostile and personalized attacks. Her work was so much at the center of the debate surrounding the value of East German literature and the status of East German intellectuals that the title *It Is Not about Christa Wolf* was deemed appropriate for a book that reprinted the most significant attacks and rejoinders (Anz 1991).

West German journalists in particular expressed emotions approaching disgust and disdain; Ulrich Greiner complained in *Die Zeit* that in waiting to publish the text (which was apparently written about events in 1979) until after the fall of the Berlin Wall, Wolf demonstrated her own cowardice in the face of the regime. According to Greiner, Wolf's hesitation betrayed a "lack of finer feeling" in the "state poet" (Anz 1991, 6) because she complained of surveillance while others suffered imprisonment and death. Frank Schirrmacher took the opportunity to voice his opinion that most of Wolf's work was passé and that it had not deserved the attention it received in the first place. In my estimation, Marcel Reich-Reinicke's comments most thoroughly uncover the underlying issue for all of these West German men when he dismisses Wolf as the darling of leftists and feminists. It is telling that there is not a single woman's voice in the collection *It Is Not about Christa Wolf.*

As a kind of antidote to the vituperative tone of the German-German debate, we have the comments and meditations of Wolf scholars like Marilyn Sibley

Fries, Dieter Sevin, Christiane Zehl Romero, and Anna Kuhn who have experienced a significant shift in the world of their studies with the fall of the wall. They have used the scholarly forum not as a means of venting hostility or riding political hobby-horses but as a medium for trying to come to terms with the transformations of the past years (cf. "The Christa Wolf Debate," 1991).

2. In an interview with Günter Gaus in *Neue deutsche Literatur,* Wolf alludes briefly to the fact that she and her husband, Gerhard Wolf, were "intensely observed" by agents of the State Security Service (Staatssicherheitsdienst) starting in 1969, after the publication of her controversial novel *Reflections on Christa T.* (Gaus 1993, 29). The fruits of that prolonged investigation are contained in forty volumes dated from 1969 to 1980, while the files from 1980 to 1989 seem to have been destroyed. Her comments on this matter are corroborated by an otherwise unfriendly article in the German periodical *Der Spiegel* (Die ängstliche Margarete 1993).

3. The final sentence of Wolf's "Buechner Prize Acceptance Speech" alludes to the power of shedding skins (in this case, equivalent to literary personae or masks): "This skin too will be stripped away and [will] hang in shreds." Helen Fehervary notes that Wolf imagines the "mask itself [as] a form of identity, and, as such, only one aspect of multiple literary identities" (Fehervary 1989, 175). While I agree that Wolf's literary masks constitute a liberating multiplicity of identity, it seems to me that the image that she chooses, a skin stripped and hanging in shreds, resonates with pain and violence.

Wolf's practice of inventing literary masks, with its rich possibilities for breaking down the smooth, lying contours of medallions, also entails stripping away comfortable illusion and previously established notions of selfhood. The pain of this process is evident in *Patterns of Childhood,* where the narrator tells of terrifying nightmares, anguish, and shame.

4. Wolf uses the word *Lebenslüge* in her novel *Störfall* (Accident). The notion of "life-lie" appears most prominently, however, in Henrik Ibsen's play *The Wild Duck,* in which, interestingly, the primary practitioner of the life-lie is Hjalmar Ekdahl, a professional photographer.

5. The translators of *Patterns of Childhood,* having no particular reason to concentrate on notions of framing, use the more abstract notion of "control" to stand in for "Rahmen." To get my point across, in this case I will use my own translation.

6. Wolf 1979a, 102. In this chapter, I will refer frequently to the primary text, *Patterns of Childhood.* In references translated from the original German (*Kindheitsmuster*), I will cite Wolf 1979a. If taken from the English translation, the reference will read Wolf 1980a. In a few cases I refer to the English translation with a slight alteration; these will be indicated in the notes.

7. Wolf 1980a, 26. I have slightly altered the English translation to follow more closely both the original text and my argument. The German reads: "Doch Fotos, die man oft und lange betrachtet hat, brennen schlecht. Als unveränderliche Standbilder sind sie dem Gedächtnis eingedrückt, es ist bedeutungslos, ob man sie als Beweisstück vorlegen kann" (Wolf 1979a, 41).

8. Figure 4.2 is an image of Wolf's childhood home, Sonnenplatz 5 (Plac Słoneczny), taken in the summmer of 1992 in Gorzow Wielkepolski. Wolf's narrator describes a visit to the site, in which she notes that the house still retains the outline of the old number 5 that marked the address during her residence there, alongside the Polish number plate.

9. The citation is from William Wordsworth's "Lines, Composed a Few Miles above Tintern Abbey on Revisiting the Banks of the Wye during a Tour: July 13, 1798."

10. Wilke 1990, 504. As I have indicated in my discussion of Benjamin in the preceding chapter, it would overstate matters to say that Benjamin concerns himself solely with shock and stasis; on the contrary, he too brings these isolated moments into narration and aims to regenerate the flow of life from the frozen past. But his fragmented method of narration concentrates more intensely on the moment of historic shock, and he sees the experience of stasis as productive, positive—while Wolf understands her frozen miniatures of the past as false images, which must be shattered in order to regain insight.

11. John D. Barbour points out in *The Conscience of the Autobiographer* the incompatibility of deconstructive notions of selfhood and the concept of the ethical subject, who must needs be an active agent in a real, experienced world (Barbour, 1992).

12. See Adelson 1993, Martin 1983, and Weigel 1984 for examples of Germanist-feminist responses to this issue.

13. I take the concept of "consonant narration" from Dorrit Cohn's *Transparent Minds* (Cohn 1978).

14. Foucault in his work on surveillance and the state (particularly in prisons), Mulvey's writing on the male spectator in cinematic feminist theory, and Sontag in her book *On Photography* all address the power of voyeurism in the process of subjugation.

15. I have included here a photograph (figure 4.3) taken by Helga Paris, depicting Christa Wolf with her two daughters and granddaughter. I take this image, posed in the sturdy surroundings of the German home, as emblematic of the kind of narration Wolf presents in her autobiography, not individual but generational. Not the patterns of a single childhood but the repeated patterns of a series of childhoods, and the need to break out of the stasis of such patterns.

16. Wolf 1979a, 8. I have slightly altered the English translation in this quote. The German reads, "Erinnerst du dich, was Lenka sagte," while the English translation reads, "Do you remember what happened?"

17. "In a Little Polish Town" resonates not only with echoes from the German invasion of Poland, but also with the misogyny of militaristic patriarchy, taken here to the point of rape and murder. The song horrifies Wolf's narrator for its connection between German aggression and masculine subjugation of women, a connection she herself points out in the section on photography and hypnosis.

18. Wolf 1980a, 286. I have taken my information on the contents of the Stasi files from an article in *Der Spiegel* (Die ängstliche Margarete 1993), not

because that particular article reflects my own view of Wolf's involvement with the Stasi, but because the files in question were available only to journalists— not to Wolf herself (Gaus 1993). Wolf's statements on the files have thus dealt with general issues rather than particularities, because she found herself in the peculiar position of being forced to cite her critics' excerpts from the files if she wanted to address details.

19. Wolf in fact uses the term *deutsche Rechthaberei* in the Gaus interview, but since I myself am not German and since the trait seems to me to cross international boundaries with impunity, I choose not to dwell on Wolf's apparent belief in its national significance here.

20. Dr. Dean Rugg, my father-in-law, traveled extensively in the East Bloc during the 1950s and 1960s. During one of his journeys he was "followed" by agents who in fact drove *ahead* of his car. Since this practice was rather awkward (the agents were often forced to backtrack and then pass him again when he turned onto another road), he speculates that it was their intent to make him aware that he was under observation. Indeed, it was an effective practice, in his estimation much more unnerving than having a "tail." He is a specialist in Eastern European urban geography.

Works Cited

Adelson, Leslie. 1993. *Making Bodies, Making History: Feminism and German Identity.* Lincoln and London: University of Nebraska Press.

Ahlström, Stellan, and Torsten Eklund, eds. 1961. *Ögonvittnen II. August Strindberg: Mannaår och Ålderdom.* Stockholm: Walhström and Widstrand.

Alter, Robert. 1991. *Necessary Angels: Tradition and Modernity in Kafka, Benjamin, and Scholem.* Cambridge: Harvard University Press.

Amelunxen, Hubertus von. 1988. D'un état mélancolique en photographie: Walter Benjamin et la conception de l'allégorie. *Revue des Sciences Humaines* 81:8–23.

Anz, Thomas, ed. 1991. *"Es geht nicht um Christa Wolf": Der Literaturstreit im vereinten Deutschland.* Munich: Spangenberg.

Ash, Beth Sharon. 1989. Walter Benjamin: Ethnic Fears, Oedipal Anxieties, Political Consequences. *New German Critique* 18:2–42.

Barbour, John D. 1992. *The Conscience of the Autobiographer: Ethical and Religious Dimensions of Autobiography.* New York: St. Martin's Press.

Barthes, Roland. 1977. *Image-Music-Text.* Trans. Stephen Heath. New York: Hill and Wang.

———. 1981. *Camera Lucida.* Trans. Richard Howard. New York: Farrar, Straus and Giroux.

Beaujour, Michel. 1991. *Poetics of the Literary Self-Portrait.* Trans. Yara Milos. New York and London: New York University Press.

Bell, Susan Groag, and Marilyn Yalom, eds. 1990. *Revealing Lives: Autobiography, Biography, and Gender.* Albany: State University of New York Press.

Bellquist, John. 1988. Rereading *Fröken Julie:* Undercurrents in Strindberg's Naturalistic Intent. *Scandinavian Studies* 60:1–11.

Benjamin, Walter. 1969. Illuminations. Ed. Hannah Arendt. Trans. Harry Zohn. New York: Schocken Books.

———. 1980a. *Gesammelte Schriften.* Ed. Rolf Tiedemann and Hermann Schweppenhuser. Frankfurt/Main: Suhrkamp.

———. 1980b. A Short History of Photography. In *Classical Essays on Photography,* ed. Alan Trachtenberg. New Haven: Leete's Island Books.

———. 1987. *Berliner Kindheit um neunzehnhundert.* Frankfurt/Main: Suhrkamp.

———. 1988. *Berliner Chronik.* Ed. Gerschom Scholem. Frankfurt/Main: Suhrkamp.

———. 1994. *The Correspondence of Walter Benjamin, 1910–1940.* Ed. Gerschom Scholem and Theodor W. Adorno. Trans. Manfred R. Jacobson and Evelyn M. Jacobson. Chicago: University of Chicago Press.

———. n.d. *A Childhood in Berlin ca. 1900.* Trans. Shierry Weber Nicholsen. Unpublished manuscript.

Berger, John. 1974. Understanding a Photograph. In *The Look of Things.* New York: Viking Press.

Blair, Walter. 1981. Mark Twain and the Mind's Ear. In *The American Self: Myth, Ideology and Popular Culture,* ed. Sam Girgus, 231–39. Albuquerque: University of New Mexico Press.

Böll, Heinrich. 1990. Wo habt ihr bloß gelebt? In *Christa Wolf: Ein Arbeitsbuch,* ed. Angela Drescher, 91–100. Frankfurt: Luchterhand.

Brandell, Gunnar. 1950. *Strindbergs infernokris.* Stockholm: Bonniers.

Brantly, Susan. 1988. Naturalism or Expressionism: A Meaningful Mixture of Styles in *The Dance of Death I.* In *Strindberg's Dramaturgy,* ed. Göran Stockenström, 164–73. Minneapolis: University of Minnesota Press.

Bruss, Elizabeth. 1976. *Autobiographical Acts: The Changing Situation of a Literary Genre.* Baltimore and London: Johns Hopkins University Press.

———. 1980. Eye for I: Making and Unmaking Autobiography in Film. In *Autobiography: Essays Theoretical and Critical,* ed. James Olney, 296–320. Princeton: Princeton University Press.

Buck-Morss, Susan. 1989. *The Dialectics of Seeing: Walter Benjamin and the Arcades Project.* Cambridge and London: MIT Press.

Budd, Louis J. 1983. *Our Mark Twain: The Making of His Public Personality.* Philadelphia: University of Pennsylvania Press.

———. 1984. Mark Twain: Still in Bed but Wide Awake. *Amerikastudien: Eine Vierteljahrschrift* 30:179–85.

Cadava, Eduardo. 1992. Words of Light: Theses on the Photography of History. *Diacritics* 22, nos. 3–4:84–114.

The Christa Wolf Debate. 1991. *GDR Bulletin* 17:1–22.

Cohn, Dorrit. 1978. *Transparent Minds: Narrative Modes for Presenting Consciousness in Fiction.* Princeton: Princeton University Press.

Corngold, Stanley. 1986. *The Fate of the Self: German Writers and French Theory.* New York: Columbia University Press.

Cox, James M. 1984. Life on the Mississippi Revisited. In *The Mythologizing of*

Mark Twain, ed. Sara DeSaussure Davis and Philip D. Beider, 99–115. University: University of Alabama Press.

Couser, G. Thomas. 1989. *Altered Egos: Authority in American Autobiography.* Oxford and New York: Oxford University Press.

Crary, Jonathan. 1990. *Techniques of the Observer: On Vision and Modernity in the Nineteenth Century.* Cambridge: MIT Press.

Dahlbäck, Kerstin. 1991. Strindberg's Autobiographical Space. In *Strindberg and Genre,* ed. Michael Robinson, 82–94. Norwich, Eng.: Norvik.

Darwin, Charles. 1955. *The Expression of the Emotions in Man and Animals, with Photographic and Other Illustrations.* New York: Philosophical Library.

David, Beverly R. 1986. *Mark Twain and His Illustrators.* Troy, N.Y.: Whitston.

Davidson, Cathy N. 1990. Photographs of the Dead: Sherman, Daguerre, Hawthorne. *South Atlantic Quarterly* 89:667–701.

DeEulis, Marilyn Davis. 1981. Mark Twain's Experiments in Autobiography. *American Literature* 53:202–13.

de Man, Paul. 1979. Autobiography as De-Facement. *MLN* 94:9130.

Derrida, Jacques. 1988. *The Ear of the Other: Otobiography, Transference, Translation.* Ed. Christie McDonald. Trans. Peggy Kamuf and Avital Ronnell. Lincoln and London: University of Nebraska Press.

Die ängstliche Margarete. 1993. *Der Spiegel* 4:158–65.

Eakin, Paul John. 1992. *Touching the World: Reference in Autobiography.* Princeton: Princeton University Press.

Eggum, Arne. 1989. *Munch and Photography.* Trans. Birgit Holm. New Haven and London: Yale University Press.

Emile-Zola et Massin, François. 1979. *Zola photographe.* Paris: Éditions Denoël.

Falck, August. 1935. *Fem år med Strindberg.* Stockholm: Wahlström and Widstrand.

Fehervary, Helen. 1989. Christa Wolf's Prose: A Landscape of Masks. In *Responses to Christa Wolf: Critical Essays,* ed. Marilyn Sibley, 162–85. Detroit: Wayne State University Press.

Foucault, Michel. 1977. What Is an Author? In *Language, Counter-Memory, Practice,* ed. Donald F. Bouchard, trans. Donald F. Bouchard and Sherry Simon, 113–38. Ithaca: Cornell University Press.

Freud, Sigmund. 1924–1934. *Jenseits des Lustprinzips, Gesammelte Schriften* VI. Vienna.

———. 1953. *The Standard Edition of the Complete Psychological Works.* Ed. and trans. James Strachey. London: Hogarth Press.

Frieden, Sandra. 1989. A Guarded Iconoclasm: The Self as Deconstructing Counterpoint to Documentation. In *Responses to Christa Wolf: Critical Essays,* ed. Marilyn Sibley, 266–278. Detroit: Wayne State University Press.

Fries, Marilyn Sibley. 1982. Christa Wolf's Use of Image and Vision in the Narrative Structuring of Experience. In *Studies in GDR Culture and Society, II,* ed. Margy Gerber, 59–74. Washington, D.C.: American University Press.

———. 1993. A View from a Distance: Thoughts on Contemporary GDR Studies. *Monatshefte* 85:275–83.

Gaus, Günter. 1993. Auf mir bestehen: Christa Wolf im Gespräch mit Günter Gaus. *Neue deutsche Literatur* 41:20–40.

Gillman, Susan. 1989. *Dark Twins: Imposture and Identity in Mark Twain's America.* Chicago: University of Chicago Press.

Gilman, Sander. 1986. *Jewish Self-Hatred: Anti-Semitism and the Hidden Language of the Jews.* Baltimore: Johns Hopkins University Press.

Goodman, Nelson. 1976. *Languages of Art.* Indianapolis: Hackett.

Greenway, John L. 1991. Penetrating Surfaces: X-Rays, Strindberg and *The Ghost Sonata. Nineteenth-Century Studies* 5:29–46.

Gribben, Alan. 1984. Autobiography as Property: Mark Twain and His Legend. In *The Mythologizing of Mark Twain,* ed. Sara DeSaussure Davis and Philip D. Beider, 39–55. University: University of Alabama Press.

Gribben, Alan, and Nick Karanovich, eds. 1992. *Overland with Mark Twain: James B. Pond's Photographs and Journal of the North American Lecture Tour of 1895.* Elmira, N.Y.: Center for Mark Twain Studies at Quarry Farm.

Gunn, Janet Varner. 1982. *Autobiography: Toward a Poetics of Experience.* Philadelphia: University of Pennsylvania Press.

Hamacher, Werner. 1986. The Word *Wolke*—If It Is One. *Studies in Twentieth Century Literature* 11:133–61.

Hansen, Miriam. 1993. With Skin and Hair: Kracauer's Theory of Film, Marseille 1940. *Critical Inquiry* 19:437–69.

Heimer, Ernst. 1938. *Der Giftpilz.* Nuremberg: Verlag der Stürmer.

Heine, Heinrich. 1964. *Heines Werke.* 5 vols. Berlin and Weimar: Aufbau.

Heinemann, Richard. 1992. Interview mit Lisa Fittko. In *Für Walter Benjamin: Dokumente, Essays, und ein Entwurf,* ed. Ingrid Scheurmann and Konrad Scheurmann, 142–57. Frankfurt/Main: Suhrkamp.

Hemmingsson, Per. 1989. *Strindberg som fotograf.* Åhus: Kalejdoskop.

Hill, Hamlin. 1973. *Mark Twain: God's Fool.* New York: Harper and Row.

Holmes, Oliver Wendell. 1859. The Stereoscope and the Stereograph. *Atlantic Monthly* 3:738–48.

Hörnigk, Therese. 1989. *Christa Wolf.* Göttingen: Steidl.

Howells, William Dean. 1910. *My Mark Twain.* New York: Harper's.

Hunter, Jefferson. 1987. *Image and Word: The Interaction of Twentieth Century Photographs and Texts.* Cambridge: Harvard University Press.

Jackson, Robert Louis. 1992. Gogol's *The Portrait:* The Simultaneity of Madness, Naturalism, and the Supernatural. In *Gogol: Logos and the Russian Word,* ed. Susanne Fusso and Priscilla Meyer, 105–11. Evanston, Ill.: Northwestern University Press.

Jay, Martin. 1993. *Downcast Eyes: The Denigration of Vision in Twentieth-Century French Thought.* Berkeley: University of California Press.

Jay, Paul. 1984. *Being in the Text.* Ithaca, N.Y.: Cornell University Press.

———. 1994. Posing: Autobiography and the Subject of Photography. In *Autobiography and Postmodernism,* ed. Kathleen Ashley, Leigh Gilmore, and Gerald Peters, 191–211. Amherst: University of Massachusetts Press.

Jouve, Nicole Ward (1991). *White Woman Speaks with Forked Tongue: Criticism as Autobiography*. London and New York: Routledge.

Kafitz, Dieter. 1988. Tendenzen der Naturalismus-Forschung und Überlegungen zu einer Neubestimmung des Naturalismus-Begriffs. *Der Deutschunterricht* 40:11–29.

Kafka, Franz. 1976. *Franz Kafka: The Complete Stories*. New York: Shocken.

Köpnick, Lutz. 1992. Rettung und Destruktion: Erinnerungs-verfahren und Geschichtsbewußtsein in Christa Wolf's *Kindheitsmuster* und Walter Benjamins Spätwerk. *Monatshefte* 84, no. 1:74–90.

Kracauer, Siegfried. 1995. *The Mass Ornament: Weimar Essays*. Ed. and trans. Thomas Y. Levin. Cambridge: Harvard University Press.

Kuhn, Anna K. 1988. *Christa Wolf's Utopian Vision: From Marxism to Feminism*. Cambridge: Cambridge University Press.

Lagercrantz, Olof. 1979. *August Strindberg*. Stockholm: Wahlström and Widstrand.

Lejeune, Philippe. 1975. *Le pacte autobiographique*. Paris: Éditions de Seuil.

———. 1989. The Autobiographical Pact (bis). In *On Autobiography*. Ed. Paul John Eakin. Trans. Katherine Leary, 119–37. Minneapolis: University of Minnesota Press.

Lejeune, Philippe, Annette Tomarken, and Edward Tomarken. 1977. Autobiography in the Third Person. *New Literary History* 9:27–50.

Lindner, Burkhardt. 1992. Engel und Zwerg: Benjamins geschichtsphilosophische Rätselfiguren und die Heraus-forderung des Mythos. In *"Was nie geschrieben wurde, lesen": Frankfurter Benjamin-Vorträge*, ed. Lorenz Jäger and Thomas Regehly, 234–65. Bielefeld: Aisthesis.

Marotti, Maria Ornella. 1990. *The Duplicating Imagination: Twain and the Twain Papers*. University Park and London: Penn State University Press.

Martin, Biddy. 1983. Weiblichkeit als kulturelle Konstruktion. Trans. Cornelia Holfelder-von der Tann. *Das Argument* 25:210–15.

Mayne, Judith. 1990. *The Woman at the Keyhole: Feminism and Women's Cinema*. Bloomington: Indiana University Press.

McCauley, Elizabeth Anne. 1985. *A. A. E. Disderi and the Carte de Visite Portrait Photograph*. New Haven: Yale University Press.

Metz, Christian. 1982. *The Imaginary Signifier: Psychoanalysis and the Cinema*. Trans. Celia Britton et al. Bloomington: Indiana University Press.

Mitchell, W. J. T. 1986. *Iconology: Image, Text, Ideology*. Chicago: University of Chicago Press.

———. 1989. The Ethics of Form in the Photographic Essay. *Afterimage* 6:8–13.

———. 1994. *Picture Theory*. Chicago: University of Chicago Press.

Mitscherlich, Alexander, and Margarete Mitscherlich. 1977. *Die Unfähigkeit zu Trauern*. Munich: Piper.

Mörner, Birger. 1924. *Den Strindberg jag känt*. Stockholm: n.p.

Mulvey, Laura. 1989. *Visual and Other Pleasures.* Bloomington: Indiana University Press.

Nabokov, Vladimir. 1989. *Speak, Memory.* New York: Vintage.

Neufeldt, Victoria, ed. 1988. *Webster's New World Dictionary of American English.* 3d college ed. Cleveland: Webster's New World.

Neumann, Shirley. 1994. "An Appearance Walking in a Forest the Sexes Burn": Autobiography and the Construction of the Feminine Body. In *Autobiography and Postmodernism,* ed. Kathleen Ashley, Leigh Gilmore, and Gerald Peters, 293–315. Amherst: University of Massachusetts Press.

Newhall, Beaumont. 1982. *The History of Photography.* New York: Museum of Modern Art.

Nietzsche, Friedrich. 1977. *Ecce Homo.* Frankfurt/Main: Insel.

Øhrgaard, Per. 1987. "Ein Foto mit Hut"—Bemerkungen zu Christa Wolf: *Kindheitsmuster. Orbis Litterarum* 47:375–87.

Olney, James. 1980. The Ontology of Autobiography. In *Autobiography: Essays Theoretical and Critical,* ed. James Olney, 236–67. Princeton: Princeton University Press.

Paine, Albert Bigelow. 1912. *Mark Twain: A Biography.* 3 vols. New York: Harper and Brothers.

Paul, Adolf. 1915. *Strindbergminnen och brev.* Stockholm: Åhlen and Åkerlunds.

Pickerodt, Gerhart. 1985. Christa Wolfs Roman *Kindheitsmuster:* Ein Beitrag zur "Vergangenheitsbewältigung"? In *Exil: Wirkung und Wertung,* ed. Donald Daviau and Ludwig F. Fischer, 293–307. Columbia, S.C.: Camden House.

Poore, Carol. 1982. Disability as Disobedience?—An Essay on Germany in the Aftermath of the United Nations Year for Children with Disabilities. *New German Critique* 27:161–95.

Renza, Louis. 1977. Review of *Educated Lives: The Rise of Modern Autobiography in America,* by Thomas Cooley. *American Literary Realism* 10:317–20.

———. 1987. Killing Time with Mark Twain's Autobiographies. *ELH* 54 (Spring): 157–82.

Roach, Joseph R. 1990. Darwin's Passion: The Language of Expression on Nature's Stage. *Discourse: Journal for Theoretical Studies in Media and Culture* 13:40–58.

Robinson, Michael. 1986. *Strindberg and Autobiography: Reading and Writing a Life.* Norwich, England: Norvik.

Rokem, Freddie. 1989. The Camera and the Aesthetics of Repetition: Strindberg's Use of Space and Scenography in *Miss Julie, A Dream Play,* and *The Ghost Sonata.* In *Strindberg's Dramaturgy,* ed. Göran Stockenström, 106–28. Minneapolis: University of Minnesota Press.

Saalmann, Dieter. 1992. "We Erect Our Structure in the Imagination before We Erect It in Reality" (Karl Marx, *Das Kapital*): Postmodern Reflections on Christa Wolf. *The Germanic Review* 67:159–66.

Santayana, George. 1981. The Photograph and the Mental Image. In *Photography in Print: Writings from 1816 to the Present,* ed. Vicki Goldberg, 258–66. New York: Simon and Schuster.

Schneider, Manfred. 1986. *Die erkaltete Herzensschrift: Der autobiographische Text im 20. Jahrhundert.* Munich: Carl Hanser Verlag.

Seeleye, John D. 1977. *Mark Twain in the Movies: A Meditation with Pictures.* New York: Viking.

Sekula, Alan. 1981. On the Invention of Photographic Meaning. In *Photography in Print: Writings from 1816 to the Present,* ed. Vicki Goldberg, 452–73. New York: Simon and Schuster.

Shloss, Carol. 1987. *In Visible Light.* Oxford: Oxford University Press.

Smith, Henry Nash, and William M. Gibson, eds. 1960. *Mark Twain–William Howells Letters.* Cambridge: Harvard University Press.

Smith, Sidonie. 1993. *Subjectivity, Identity, and the Body: Women's Autobiographical Practices in the Twentieth Century.* Bloomington: Indiana University Press.

———. 1994. Identity's Body. In *Autobiography and Postmodernism,* ed. Kathleen Ashley, Leigh Gilmore, and Gerald Peters, 266–92. Amherst: University of Massachusetts Press.

Söderström, Göran. 1991. August Strindbergs fotografiska bildidéer. In *August Strindberg: "Underlandet,"* 21–39. Malmö: Malmö Konsthall.

Sontag, Susan. 1973. *On Photography.* New York: Farrar, Straus and Giroux.

Spencer, Stephanie. 1985. *O. G. Rejlander: Photography as Art.* Ann Arbor, Mich.: UMI Research Press.

Sprinker, Michael. 1980. Fictions of the Self: The End of Autobiography. In *Autobiography: Essays Theoretical and Critical,* ed. James Olney, 321–42. Princeton: Princeton University Press.

Stephan, Alexander. 1991. *Christa Wolf.* Munich: Beck.

Strindberg, August. 1916. *Samlade Skrifter.* Ed. John Landqvist. 55 vols. Stockholm: Bonniers.

———. 1948–1976. *August Strindbergs brev.* Ed. Torsten Eklund. Stockholm: Bonniers.

———. 1975. *The Son of a Servant.* Trans. Evert Sprinchorn. Gloucester, Mass.: Peter Smith.

———. 1976. Preface to *Miss Julie.* In *Pre-Inferno Plays,* ed. and trans. Walter Johnson. New York: Norton.

———. 1979. *Inferno and From an Occult Diary.* Trans. Mary Sandbach. Harmondsworth, U.K.: Penguin.

———. Papers. Kungliga Biblioteket, Stockholm.

Stüssi, Anna. 1977. *Erinnerung an die Zukunft: Walter Benjamins Berliner Kindheit um Neunzehnhundert.* Göttingen: Vandenhoeck and Ruprecht.

Sulloway, Frank J. 1979. *Freud: Biologist of the Mind.* New York: Basic.

Szondi, Peter. 1986. *On Understanding Texts and Other Essays.* Trans. Harvey Mendelsohn. Foreword by Michael Hays. Minneapolis: University of Minnesota Press.

Theweleit, Klaus. 1977. *Männerphantasien.* Reinbek bei Hamburg: Rowohlt.

Thiel, Roger. 1992. Holz: Walter Benjamin's Pseudonym. *Faultline* 1:119–43.

Trachtenberg, Alan. 1989. *Reading American Photographs: Images as History, Mathew Brady to Walker Evans.* New York: Hill and Wang.

Twain, Mark. 1906. Chapters from My Biography. *North American Review* 183:321–30.

———. 1924. *Mark Twain's Autobiography*. Ed. Albert Bigelow Paine. 2 vols. New York and London: Harper and Brothers.

———. 1935. *Mark Twain's Notebook*. Ed. Albert Bigelow Paine. New York: Harper and Brothers.

———. 1959. *The Autobiography of Mark Twain*. Ed. Charles Neider. New York: Harpers.

———. 1982. *Life on the Mississippi*. New York: Library of America.

———. 1990. *Mark Twain's Own Autobiography*. Ed. Michael J. Kiskis. Madison: University of Wisconsin Press.

——— Papers (MTP). Bancroft Library, University of California, Berkeley.

Waller, James Preston. 1990. *The Vision and Revisions of Mark Twain: Samuel L. Clemens in the Camera's Eye, 1851–1885*. Ph.D. diss., Duke University.

Walsh, Thomas M., and Thomas D. Zlatic. 1981. Mark Twain and the Art of Memory. *American Literature* 53:214–31.

Wecter, Dixon, ed. 1949. *Mark Twain to Mrs. Fairbanks*. San Marino, Calif.: Huntington Library.

Weigel, Sigrid. 1984. Frau und "Weiblichkeit": Theoretische Überlegungen zur feministischen Literaturkritik. In *Feministische Literaturwissenschaft,* ed. Inge Stephan and Sigrid Weigel, 103–13. Berlin: Argument.

Wiesehan, Gretchen. 1992. Christa Wolf Reconsidered: National Stereotypes in *Kindheitsmuster*. *The Germanic Review* 68:79–87.

Wilke, Sabine. 1990. "Dieser fatale Hang der Geschichte zur Wiederholung": Geschichtskonstruktionen in Christa Wolfs *Kindheitsmuster*. *German Studies Review* 13:499–512.

———. 1991. "Worüber man nicht sprechen kann, darüber muß man allmählich zu schweigen aufhören": Vergangenheitsbeziehungen in Christa Wolfs *Kindheitsmuster*. *The Germanic Review* 66:169–76.

Witte, Bernd. 1984. Bilder der Endzeit: Zu einem authentischen Text der *Berliner Kindheit* von Walter Benjamin. *Deutsche Vierteljahrsschrift* 58:570–92.

———. 1991. *Walter Benjamin: An Intellectual Biography*. Trans. James Rolleston. Detroit: Wayne State University Press.

Wolf, Christa. 1979a. *Kindheitsmuster*. Frankfurt: Luchterhand.

———. 1979b. *Materialienbuch*. Ed. Klaus Sauer. Darmstadt und Neuwied: Luchterhand.

———. 1980a. *Patterns of Childhood*. Trans. Ursule Molinaro and Hedwig Rappolt. New York: Farrar, Straus, and Giroux.

———. 1980b. *Lesen und Schreiben: Neue Sammlung*. Frankfurt: Luchterhand.

———. 1989. Subjective Authenticity: A Conversation with Hans Kaufmann. In *Responses to Christa Wolf,* ed. Marilyn Sibley, 55–75. Detroit: Wayne State University Press.

———. 1990. *Reden im Herbst*. Berlin: Aufbau.

Woolf, Virginia. 1953. *The Common Reader*. New York: Harcourt, Brace, Jovanovich.

Zahlmann, Christel. 1986. *Christa Wolfs Reise "ins Tertiär": Eine literaturpsychologische Studie zu "Kindheitsmuster."* Würzburg: Königshausen and Neumann.

Zielonka, Anthony. 1989. Huysmans and Grünewald: The Discovery of "Spiritual Naturalism." *Nineteenth-Century French Studies* 18:212–25.

Index

Abbott, Scott, 246n. 25
Adelson, Leslie: on constructing history, 240n. 11, 244n. 12; on erasure of subject's body, 241–42n. 19; on feminist writing, 197; on positionality, 175
Adorno, Gretel, 178
Adorno, Theodor, 164, 167, 254n. 21, 257n. 37
Agassiz, Louis, 19
agency: of photographer, 5; of subject, 18–20, 113–14, 118–19; verification of, 2
Akerman, Chantal, 121
allegory: death as, 154–55; object as, 155–57; photographs as, 152–61; photography as, 171–72
Alter, Robert, 256n. 35
Amelunxen, Hubertus von, 171, 256n. 27
Andersson, Herman, photograph by, 118, *119*
animism, 116, 130–31, 209–10
Arcades Project, 252n. 2

archeology, as metaphor, 157
art, reproducibility of, 42, 163–65
Ash, Beth Sharon, 253–54n. 15
Ashton, H. D., 46
Atget, Eugene: photographs by, *159–60;* significance of, 158, 161
Auden, W. H., 5
aura: destruction of, 163–65, 171–72, 255n. 24; erasures of, 136, 166–71; meanings of, 161–63
authenticity: of autobiography, 4–5, 9–10; definition of, 194–96; of image, 43–44, 243n. 3; and mechanical reproduction, 42–44, 163–65; of memory, 214; objects as evidence for, 49–50, 52–53; and pseudonyms, 34–35. *See also* authority; candidness; truth
author: embodiment of, 13, 15, 21; and narrative dishabille, 60. *See also* autobiographer; writing
authority: autobiographer as, 106, 116–17; and body, 43; of cap-